MW01007235

DeVilbiss Perfume Bottles

and their glass company suppliers

1907-1968

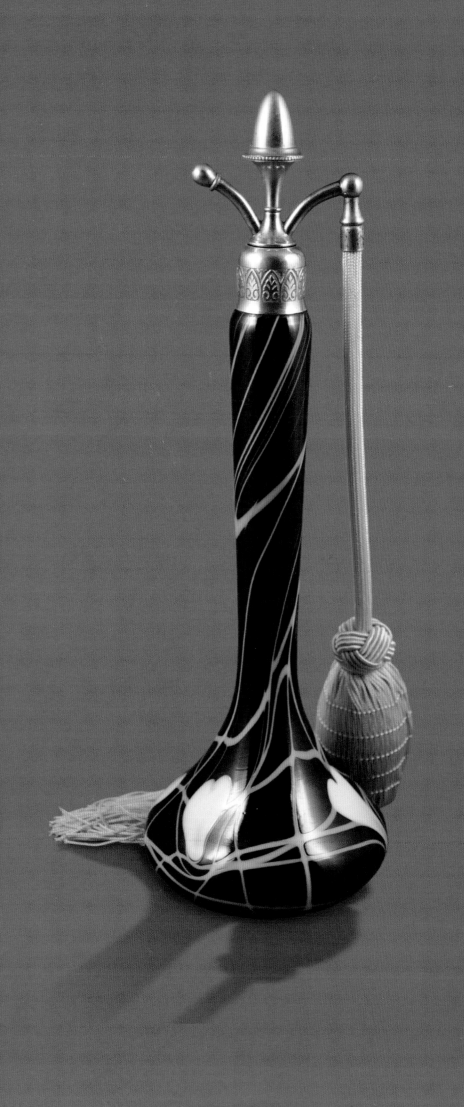

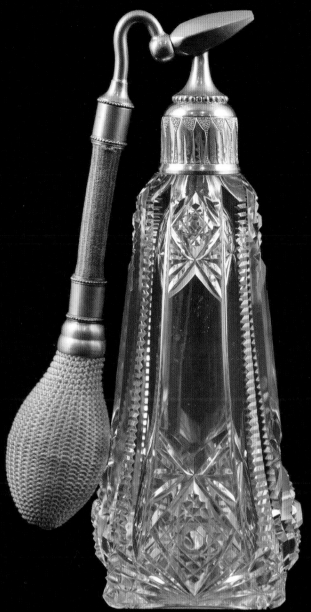

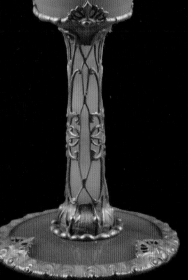

DeVilbiss
Perfume
Bottles

and their glass company suppliers

1907–1968

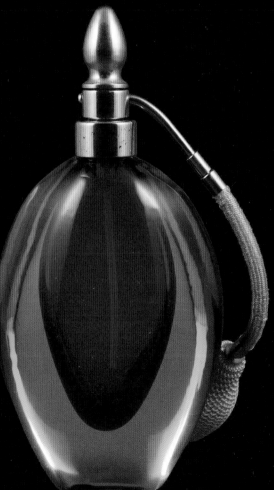

Marti DeGraaf & Toby Mack

Schiffer Publishing Ltd

4880 Lower Valley Road • Atglen, PA 19310

Published by Schiffer Publishing, Ltd.
4880 Lower Valley Road
Atglen, PA 19310
Phone: (610) 593-1777; Fax: (610) 593-2002
E-mail: Info@schifferbooks.com

For our complete selection of fine books on this and related subjects, please visit our website at www
.schifferbooks.com. You may also write for a free catalog.

This book may be purchased from the publisher. Please try your bookstore first.

We are always looking for people to write books on new and related subjects. If you have an idea for
a book, please contact us at proposals@schifferbooks.com.

Schiffer Publishing's titles are available at special discounts for bulk purchases for sales promotions
or premiums. Special editions, including personalized covers, corporate imprints, and excerpts can
be created in large quantities for special needs. For more information, contact the publisher.

Other Schiffer Books on Related Subjects:
Classic Perfume Advertising: 1920–1970, J. Johnson.
 ISBN: 978-0-7643-2741-4. $39.95
Commercial Perfume Bottles, J. Jones-North.
 ISBN: 978-0-7643-0150-6. $69.95
Miniature Perfume Bottles, G. Bowman.
 ISBN: 978-0-88740-628-7. $29.95

Copyright © 2014 by Marti De Graaf and Toby Mack

Library of Congress Control Number: 2013957112

All rights reserved. No part of this work may be reproduced or used in any form or by any means—
graphic, electronic, or mechanical, including photocopying or information storage and retrieval
systems—without written permission from the publisher.

The scanning, uploading, and distribution of this book or any part thereof via the Internet or via
any other means without the permission of the publisher is illegal and punishable by law. Please
purchase only authorized editions and do not participate in or encourage the electronic piracy of
copyrighted materials.
"Schiffer," "Schiffer Publishing, Ltd. & Design," and the "Design of pen and inkwell" are registered
trademarks of Schiffer Publishing, Ltd.

Cover design: Bruce Waters

ISBN: 978-0-7643-4576-0
Printed in China

Dedication

This book is dedicated to

the leadership and foresight of Thomas A. DeVilbiss

and those executives that followed him at the DeVilbiss Company,

and to the many talented artisans who worked at DeVilbiss

from 1907 to 1968

to create such remarkable gifts to the future.

Without them, the beauty and passion

for collecting these treasures

would not have lived on. This book is also

in honor and memory of our parents,

who instilled in us the determination

and tenacity necessary

for its completion.

Contents

Preface

"A drop of perfume bursting
into a myriad atoms of fragrance
makes the use of Perfume
an added delight."

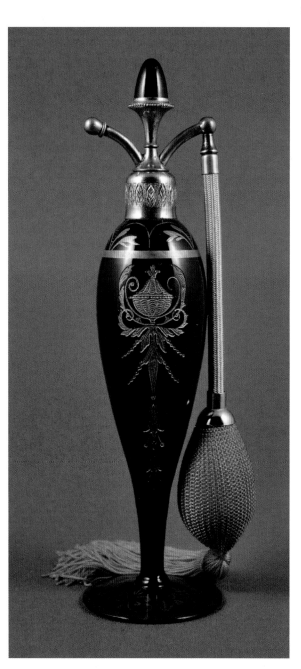

Life is an adventure, with each twist and turn leading us down new and exciting paths, with each decision made along the way affecting the outcome. And so it has been with the development of this book. The work of many years is now complete and, although there were many times when the authors wished the book were done, the paths taken have been well worth the time and effort. They have culminated in an entirely different scope than originally planned.

We initially outlined a book that would cover primarily the 1920s and 1930s, for—early on—that is where most of our knowledge, research, and bottle collection was centered. But over the years, we were fortunate to acquire more and more original corporate records and materials. This was coupled with extensive research, including with several outstanding libraries and museums, along with new finds and discoveries about the different eras of bottle and fitting styles. In fact the bottles themselves led us to a ever-deepening appreciation of all of the periods of production, and hence to the conclusion that this book must take the reader through the entire spectrum of the DeVilbiss Company perfume bottle division from 1907 until its close in 1968. Along the way, our collection has expanded to mirror that spectrum as well.

The authors are also fortunate to have in their collection company records, correspondence, catalogs, specification books, design and engineering drawings, extensive patent information and more, spanning the entire 1907–1968 period of production. In the process of examining our archives and others in detail, we have, among other bits of knowledge, found no less than fifty-six glass companies in the United States and around the world that provided glass blanks (the bottles) to the DeVilbiss Company. The authors have attempted, wherever known and supported by documentation, to indicate the glass company that supplied the bottle. In addition, throughout the text, wherever appropriate we have provided close-up inset photographs next to a bottle to help the reader see the details of different metal fittings (spray heads or collars) or specific designs and decorations. With many of the bottles, the labels or markings used to identify the bottle as DeVilbiss are shown. Last but not least, we have taken care to ensure that the metal fittings on each bottle are accurate to the original design and date represented.

We hope you find the book engaging, useful, informative, and entertaining. Notwithstanding some sleepless nights and a chaotic home totally given over to the project, we sure did have fun and learned much, in the writing of it. May you enjoy this adventure!

Acknowledgments and Credits

Throughout the years of the development of this book, there have been numerous people along the way who helped with unique and valuable insights. We extend sincerest appreciation to everyone who has helped this book become a reality, even if in a small way.

Shari Maxson Hopper

It's been our pleasure and invaluable asset, throughout the development of this book, to work closely with Shari Maxson Hopper, from Paradise, California. We've spent much time together at both of our respective homes and shared and sorted through many DeVilbiss related materials. We've travelled together to the reference libraries at Bowling Green State University and the Toledo Museum of Art in Ohio, and spent hours sifting through the DeVilbiss company archives at both institutions, as we documented the amazing story of the DeVilbiss Company's success in the business.

Shari and David Hopper have worked together in the glass business since the late 1960s and are internationally recognized for their contributions, including founding, in the early 1970s, the innovative art glass company Orient & Flume. Shari has been a wonderful resource to collectors in the field of atomizer repair and is a specialist on identification of the countless styles of atomizer spray hardware. She is also renowned in glass bead-making circles.

Shari has served on the Board of the International Perfume Bottle Association and has been a fixture at IPBA conventions, providing atomizer repair and replacement parts service. She has authored many presentations, workshops, and articles on glass-making techniques and atomizer repair.

Tragically, in June of 2008, Shari and David's home and studios were destroyed in a devastating wildfire that swept through the Paradise, California area and consumed all of their extensive and irreplaceable collections of Orient & Flume glass, perfume bottles, bead-making and atomizer repair equipment, and inventories, as well as DeVilbiss factory records. Shari's knowledge has remained a valuable contribution to this book.

Other Special Acknowledgments

Our sincere and warmest thanks go to the following people and organizations, who have generously provided support and their knowledge, photographs, and/or made their collections available for photography: Cindy Arent, Amy and Mark Bergman, Sue Blue, Marsha Crafts, Carole and Jim Fuller, Woody Griffith, Shari Hopper, Jay Kaplan, Cheryl Linville, Mary Sue Lyon, Dick and Cecile Miller, Linda Roberts, and Lynn Welker. Our thanks to each one for contributing such eloquent passages about their passion.

Sincere appreciation and thanks go as well to people in the libraries and museums who so warmly welcomed us and supported our research over the years, especially: Toledo Art Museum, Toledo, Ohio; Toledo History Museum, Toledo, Ohio; OhioLINK; Bowling Green State University, Bowling Green, Ohio; National Museum of Cambridge Glass, Cambridge, Ohio; Rakow Library, Corning Museum of Glass, Corning, New York.

We are especially grateful to all who have shared their knowledge about perfume bottles and glass over the years, and who helped us along the way in assembling our collection and increasing our knowledge and, at times, offering emotional support: Joan Miller with her love of all things Steuben; the late Harvey Littleton, the father of studio glass and a passionate DeVilbiss collector; The International Perfume Bottle Association, the organization that brings all perfume bottle collectors together; Madeleine France, who furthered our passion in collecting DeVilbiss, and invited us to our first International Perfume Bottle Association convention; Nancy Schiffer, for her assistance and guidance in making this book a reality.

And, finally, we thank each of the authors of the books listed in the bibliography for their many hours of research and dedication to the advancement of knowledge in the glass and perfume bottle fields.

Introduction

Thomas A. DeVilbiss hit upon a perfect and well-timed business concept in 1907, with his creative designs and patents for Perfumizers and their unconditional guarantee, and an additional focus on dropper bottles, perfume lamps, vanity items and more. The DeVilbiss Manufacturing Company began its Perfumizer division just when the market's need for perfume and bottles was significantly on the rise. Thomas's business acumen was excellent. He jumped into the market at a perfect time with a unique product to serve that market: the perfume atomizer with its exquisitely fine spray, just as his father had done years earlier with the nose and throat atomizer to fulfill a medical need.

DeVilbiss was an exceptional and well-run company that diversified early in its history into both into consumer and industrial products, which allowed it to succeed through many challenging economic and war-time crises. In the perfume bottle division (often known as the Perfumizer division), DeVilbiss was a leader in design and decoration, innovation, and production excellence. Over time, styles continually evolved to meet customer tastes and needs, and DeVilbiss was nearly always ahead of its competitors, which often came out with very similar products, substantially afterward. As is noted in the early chapters of this book, people came to work for DeVilbiss, and stayed. Their pride in and dedication to this company and the perfume bottle products they made was evident throughout the many company records the authors have reviewed, and in the bottles and accessories themselves. DeVilbiss perfume bottles and other products had two unwavering characteristics: quality and beautiful design. Today DeVilbiss perfume bottles, both atomizers and Dropper Perfumes, are prized objects of art in many private collections, museums and exhibits.

A Passion for DeVilbiss Through the Eyes of Collectors

Collecting interests are highly individualized. With DeVilbiss, the collector's passion can be excited, among other reasons, by the:

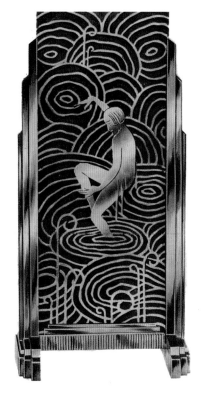

- grace and beauty of a particular bottle
- period and/or series of the bottle
- unique differences in the styles of the bottle
- fittings — spray heads and collars
- specific glass company that provided the bottles: e.g., Steuben, Cambridge, Fenton, Seguso
- area of the world and types of bottles provided from that region: e.g., Czechoslovakia, Germany, Italy, France
- bottles that represent the richness of history across each of the time-frames
- imagination, the eye of the beholder and what made her or his heart skip a beat
- and the accidental find that blossoms into a collecting passion for DeVilbiss.

Ball and Torem, in their book *Fragrance Bottle Masterpieces*, sum up the sensory emotions well, that often come into play in the selection and appeal of a particular bottle: "admirers can be struck by the seemingly impossible execution of its design, the glitter of light on its multi-faceted surface, colors that glimmer like rainbows, the perfection of its engraving or enameling…if the word 'masterpiece' passes the lips, it is most often used to express one's individual appreciation for an object that pleases the senses."

The Authors

We began our extensive journey that brought us to DeVilbiss and their perfume bottles through many years of collecting glass, initially from the Cambridge Glass Company, and then expanding to and researching other glass companies. We discovered Cambridge perfume bottles first and that path led us directly to DeVilbiss, for whom Cambridge both made and often decorated bottles, beginning in 1912. Cambridge produced many cologne and perfume bottles for its own product offerings, and sold its bottles to the both the wholesale and retail trade. They also supplied perfume bottle blanks to other manufacturers, including the DeVilbiss Company. Thus, in our early collecting we discovered, and began acquiring, bottles having Cambridge glass blanks but fittings from other companies, and DeVilbiss seemed almost always to have the most beautiful and extraordinary bottles. And so, as most collectors will empathize, we naturally then became passionate collectors of DeVilbiss products, Cambridge-equipped or no. Becoming involved with the International Perfume Bottle Association (IPBA) in 1991 only accelerated our knowledge

and appreciation of the fine artistry of all DeVilbiss perfume bottles and of the many glass companies that supplied the bottles.

When one collects something with great determination, it seems natural, as it did for us, that we were driven to learn everything we could about the bottles: who made them, how, when, and in what cultural and economic context. It becomes a giant puzzle, and part of the thrill is to connect the dots and see the whole mosaic of the story.

It is easy to be passionate about DeVilbiss, and certainly we as the authors have discovered such exquisite beauty in the perfume bottles across each era, and have gained a deep appreciation for the results of the exceptional design, decoration artistry, and manufacturing excellence of The DeVilbiss Company Perfume Atomizer Division.

For us, this knowledge matrix took a quantum leap when we were able to acquire, over time and with a few major opportunities, a vast trove of DeVilbiss factory documentation that contained records largely not in existence elsewhere. It covers the DeVilbiss atomizer business from the beginning of the perfume division literally until the closing of production in 1968. When we began to mine in infinite detail our own archives, things jumped off the pages—nuggets of knowledge—that we simply didn't see over many previous reviews.

While they were almost too much to digest, we nevertheless preserved the records in archival storage, but within easy reach. With a rapidly growing collection, it soon became apparent that a book on DeVilbiss perfume atomizers was in our future—not just out of love for the subject, but to share the knowledge and perpetuate interest in collecting with our friends and associates in the field, and with others around the world, who are both present and future collectors who share our wonderful affliction. In short, we were motivated to tell the story.

The project has taken us much longer than originally envisioned, but we believe the result is a much more comprehensive body of knowledge than we intended.

On the following pages are thoughts from a few DeVilbiss collectors that illustrate their perspectives about collecting DeVilbiss bottles. Our thanks to each one for contributing such eloquent passages about their passions.

Carole and Jim Fuller

DeVilbiss is a story of metamorphosis. To collect DeVilbiss is to watch a caterpillar you placed in a jar turn into a beautiful butterfly. The entire DeVilbiss story IS the reason that makes them so collectible. It was their ever changing and constant reinventing themselves that makes them desirable. And so, this continuous transformation opens a doorway and excites any number of people to want a part of that history no matter what their background or interests might be. The transformation of the simple medical sprayer to the butterfly Perfumizer; the lovely Perfumizer becoming the beautiful atomizer; the atomizer growing into the world-changing "Air Power" mechanical sprayer; the simple rebirth of a salt shaker to a perfume bottle; the common glass receptacles to beautiful artistic flacons and lamps all play the rebirth concert.

Collecting DeVilbiss is to own a model of that evolution. It offers the collector a sample of the art trends of the stark industrial revolution. It also offers the collector examples of the flamboyant Art Nouveau period. It then moves into the Art Deco period followed by the simplistic clean-cut designs of the war years, which were tempered by the European influences. All these changes, all this metamorphosis was designed with the specificity of the machinist's micrometer, the museum quality of the artist designers they employed, and the attentive caring for beauty and style to the highest degree of perfection they could achieve. It was their persistence to excellence in every product they created that made them desirable then and now. They knew the more senses that were affected the more appealing and more appreciated would be the product. The DeVilbiss

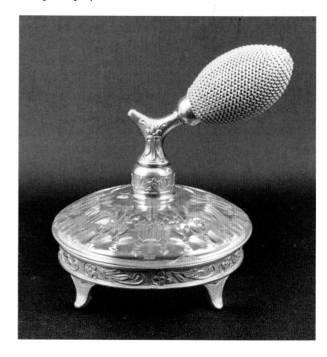

perfume division gave us and the world the ability to put a simple fragrance in a beautiful container with the ultimate pleasure of changing the aroma of the air around us—somewhat like drinking cheap wine out of a beautiful glass. Collecting DeVilbiss, then, is a turn-on for all. No matter whether a person is a history buff, a science devotee, an artistic buff, a medical or mechanical buff all can find a reason to collect DeVilbiss…WE do!

Amy Bergman

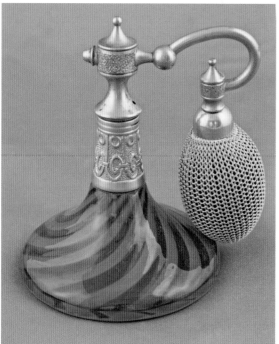

I have always had an affinity for all things Art Deco, especially glass. My first DeVilbiss perfume atomizer was purchased approximately 35 years ago. It has become a life-long passion. DeVilbiss perfume atomizers are the epitome of fabulous style and functionality. They are available in a seemingly endless variety of styles and art glass design. The many techniques of art glass design include etching, gold encrusting, hand enameling, and jewelling plus glass finishes, like Aurene, all done with masterful precision by talented artisans. I also admire the great attention to detail work. DeVilbiss hardware is often intricately designed with masterful Deco embossing that mimics the shape or geometric designs in the glass. Collecting DeVilbiss has satisfied my desire to collect both gorgeous art glass and perfume bottles. My passion has not waned in all these years, and I know I will continue to enjoy and admire my collection for many years to come.

Cheryl Linville

My love affair with DeVilbiss began when I attended the Wintermute Antiques Show in Dayton, Ohio in the summer of 1990. It was a wonderful, high quality antique show which first started in the mid-1960s. I only wish I had known about DeVilbiss perfumes then. I went to the show just to look, not really for anything specific; however my eye caught this gorgeous pink and gold perfume atomizer and I was hooked. The antiques dealer told me it was a DeVilbiss perfume, and showed me the signature on the bottom of the bottle. I wasn't familiar with DeVilbiss at the time, but I decided at that moment I wanted more of these incredible Art Deco perfume bottles. When I learned that the DeVilbiss hardware (metal fittings) were made in Toledo, Ohio, they were even more desirable to me because I thought, what fun to start a collection of something so beautiful and made so close to my home. I learned more about not only the metal hardware, but also the beautiful glass bottles, many of which were undecorated, that were purchased by DeVilbiss from many different glass companies, and often then decorated by DeVilbiss artists into fabulous Art Deco presentations. I especially love the enameled bottles for the artistic and creative Deco designs, and in particular, the pieces in which the design of the metal collar and the enameled design on the glass bottle were matched.

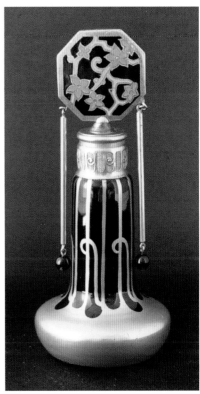

I started going to more antique shows, antique malls, and auctions looking for DeVilbiss. I purchased perfume bottle books, and found so many beautiful pieces that I wanted for my collection. I soon learned that DeVilbiss made matching dropper bottles, perfume trays, powder jars, pin trays and even cigarette boxes. So I had more to look for now. When I went to antique shows, I always wanted to be the first in when the doors opened, and my heart was pounding as I almost frantically looked for DeVilbiss.

I had been collecting less than a year, and had managed to acquire just a few really special pieces. When I attended the Wintermute show the next time it came again on the schedule, I saw a lady holding a fabulous DeVilbiss atomizer. We exchanged glances and she smiled and asked if I collected DeVilbiss, too. I will always be grateful to Ellen Teller as she shared her knowledge of DeVilbiss with me and also told me about the IPBA. I attended my first IPBA (International Perfume Bottle Association) Convention in 1992 in Atlanta.

I still get that heart-pounding feeling when walking into a fabulous antique show or auction. Collecting DeVilbiss has been a wonderful hobby, and I've made great DeVilbiss friends for which I am thankful.

Shari Hopper

For my husband and me, entertainment was going to antique shops. I bought my first perfume atomizer because it was an example of exquisite iridescent glass. It wasn't Tiffany, it was Steuben Aurene. In the early 1970s the most affordable piece of iridescent glass was a perfume bottle rather than a vase. We had a studio making glass and we were starting to make iridescent glass, so this was a piece to compare to our results. When I began to look for hardware (the metal fittings) to put on our perfume bottles, I quickly realized the style of hardware on the antique Steuben bottle made in the 1920s far exceeded the beauty of those made in Europe in the 1970s! This became even more important when I began doing antique perfume atomizer repairs. The new parts available did not suit the beautiful antique bottles nearly as well as the original hardware.

I became fascinated with the range of designs that I found when I began looking for more examples of perfume bottles. The DeVilbiss Company stood out among all the others. Every bottle had hardware designed especially for it! The hardware made by DeVilbiss followed all the current design trends for each decade, or stylistic period, from Art Nouveau through Art Deco to Modern. Not only were they excellent workmanship in function, but extremely creative. Other companies like Holmes Spray, for example, often had cracked metal on the bottle collar. Still others had very little variety or tried to copy DeVilbiss. I was hooked on collecting DeVilbiss. They bought glass from all the best companies, but made to their own specifications. More research revealed they often hired designers and craftsmen trained in Europe, which added not only to their exclusive designs, but to their quality and creativity. They had more design and mechanism patents than all other competitor companies combined. If Tiffany and Steuben were the epitome of quality glass, DeVilbiss was the counterpart for perfume atomizers.

Woody Griffith

My love affair with DeVilbiss started well over thirty years ago with a perfume lamp, not an atomizer. My humble beginnings of rummaging local swap drive-in flea markets had progressed to "advanced collecting" at local flea markets and monthly antique markets. This was back in the day when $100 was my spending budget and you could come home with multiple bags. On one particular Sunday, I stopped at a small antique shop after shopping the local antique market. In the shop was this wonderful lamp, glowing orange from the light diffusion with stenciled nymphs dancing around the base. I was mesmerized. I asked about it, and the dealer showed me it was a perfume lamp, and there was a sticker inside of the glass cylinder with the words "DeVilbiss, Toledo Ohio." I can remember the shop and everything about that lamp. Even thought it was more than my budget allowed, I purchased that lamp. I began to think about who would have had this lamp and loved it so much…

On future antique outings, I started to look for things with the DeVilbiss name. The first things I saw were several Perfume Sprayers in enameled colors. I began to purchase these whenever I saw them. As my collecting knowledge grew, I began to attend larger and what I called the "fancy" shows. I saw more DeVilbiss in different shapes, colors and glass. When I could afford it, I would buy more expensive bottles. Luckily for me, I purchased some very nice bottles, without really knowing what they were. At the time, the weekly *Antique Trader* was the source for antiques across the country. I saw an ad for the International Perfume Bottle Association and they were having a show in Chicago and DeVilbiss was mentioned. I joined the club and attended my first show in the early 1990s, I believe. I began to learn so much. DeVilbiss procured glass from wonderful glass houses of the 1920s and 1930s, Steuben, Fry, Cambridge, Durand just to name a few. The hardware to adorn the bottles was the company's forte and their Art Deco bottles of the mid to late 1920s are exceptional. My love of the perfume lamps has always been my major obsession. The idea of mixing light and perfume to scent the air with perfume has always been appealing to me. Meeting dealers and other collectors helped to expand my knowledge of the company and their wares, and I searched with a passion to add new and wonderful things to my collection.

But I always come back to that lamp, which I still have. And with all the pieces I have, I think about who would have owned them, what were they like, and why they treasured these items so I can admire them today. My love affair continues.

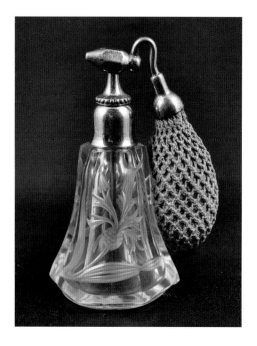

Mary Sue Lyon

I have acquired a small, but special collection of very early DeVilbiss atomizers as a result of my interest in the cologne bottles and related dresser and bath items manufactured by the Fostoria Glass Company. Fostoria, headquartered for most of its 99 years of production in Moundsville, West Virginia, provided bottles to The DeVilbiss Company in the first decades of the 20th century. At that time, the Fostoria Glass Company was known for its production of tableware, candelabra, opal ware lamps and vases, as well as its desk and dresser accessories. Collecting Fostoria produced DeVilbiss bottles allows me to broaden my knowledge and perspectives of both Fostoria as a supplier of glass to other companies and DeVilbiss as well.

General Motors formed
Ford builds the Model T
Orville Wright readies his airplane for an endurance flight
Frank Lloyd Wright completes the "prairie house style" Robie House
in Chicago, Illinois
United States population is 92 million
Boy Scouts, Camp Fire Girls founded
Titanic goes down on maiden voyage
Women get vote in three states – Michigan, Ohio and Wisconsin
Federal Reserve Bank created by Congress
Panama Canal opens
The Coast Guard formed to protect United States coastal shores
United States enters World War I in 1917
World War I over in 1918

1907–1919

Prohibition begins: America goes dry
Suffrage succeeds: women can vote (1920)
Lincoln Memorial in Washington, D.C. dedicated
George Gershwin's *Rhapsody in Blue* debuts
The first issue of *The New Yorker* magazine comes out
F. Scott Fitzgerald pens *The Great Gatsby* (1925)
NBC is incorporated
Rudolph Valentino dies at age 31, causing mass hysteria among female fans
Television is introduced to the American public (1927)
The Roaring '20s: Fads, fashions, and flappers in the morning,
in the evening, ain't we got fun!
Black Tuesday! Wall Street in chaos as stocks crash (1929)
400,000 depositors in New York City find bank is closed
4 to 5 million jobless
"The Star Spangled Banner" is dedicated as the national anthem
Facing the run on banks (1931)
America's "descent from respectability" – jobless rate in some cities over 50%

1920–1932

"The only thing to fear is fear itself," Franklin D. Roosevelt
"Century of Progress" expo in Chicago
Prohibition law goes down the drain
Disney's Donald Duck debuts
W.P.A. formed, biggest work program yet
Social Security is passed
Shirley Temple, 8, is a box-office queen
FDR: "One-third of a nation ill-housed, ill-clad, ill-nourished"
Hindenburg explodes
Opening of the Golden Gate Bridge in San Francisco
Now shopping carts make buying easier
Japan apologizes for sinking U.S. gunboat
Photographers document the Depression
It's Superman! Superman comic debuts
Hitler takes over Czechoslovakia (1939)
U.S. neutral as war erupts in Europe
388 movies issued in 1939 among them *Gone with the Wind*,
The Wizard of Oz
As France falls, U.S. moves from neutrality to non-belligerency
Mount Rushmore Memorial, a monument to American freedom, completed
Japanese launch surprise attack on Pearl Harbor
America declares war

1933–1941

1942–1949

American forces surrender on Bataan, Philippines
Sugar, gas rationed
American navy turns tide at the Battle of Midway
King of swoon – Frank Sinatra
Clark Gable, James Stewart, Cesar Romero, and Spencer Tracy join the armed forces
American war production is at its peak (1943)
"Use it up, wear it out, make it do, or do without" – Americans pitching in to conserve wartime materials. Food staples rationed.
The Big War: Sixteen million Americans in uniform
Japan surrenders: Peace settles over the world (1945)
Rosie abandons her rivets to raise babies
4 million are taking advantage of G.I. Bill
Polaroid Magic – Polaroid Land Camera instant snapshots
McDonald's first store opens

1950–1959

Auto industry fueling postwar economy
U.S. backs South Korea against North
Census: 150 million
UNIVAC, electronic computer, unveiled
Millions love *I Love Lucy,* Roy Rogers and color TV
Crewcuts are cool
Television offers fantasy, facts and fun
Elvis rocks America
Troops help integrate in Little Rock, Arkansas
Americans go crazy for Hula Hoops
Fly coast to coast with American Airlines – same day passenger service east-to-west
Alaska, Hawaii are 49th and 50th states
The 1950s: A time of tranquility and prosperity when the United States of America leads the world
The baby boom, when America is a special land for kids
The Barbie doll introduced in 1959. Is she a symbol of the ideal woman of the future?

1960–1968

The Beehive hairdo is in: whole lot of teasin' goin on
President Kennedy: "Ask what you can do for your country"
"Come on, baby, let's do the twist"
Americans are in space – Friendship 7 puts John Glenn in orbit
Martin Luther King Jr. to 200,000: "I have a dream"
Art going pop
President Kennedy and Martin Luther King are slain
Beatles invade America
Civil Rights Act passed
The Rolling Stones are introduced to Americans on *The Ed Sullivan Show*
U.S. goes on the offensive in Vietnam (1965)
Good vibes from overseas. Everyone smokes. Girls in go-go boots do the watusi, the frug and the swim
American astronaut takes a stroll in space
Wave of anti-war protests sweeps country
It's a mod, mod, mod world – mini-skirts, flower children, the Stones and the Grateful Dead

The insights and excerpts above were drawn from *Chronicle of America*, Chronicle Publications, Inc., Mount Kisco, N.Y.

The Structure of This Book by Historic and Economic Periods

From 1907 to 1968, the DeVilbiss Company designed, manufactured, and sold some of the finest perfume atomizers, dropper bottles, and related vanity products available anywhere in the world. Through periods of war, recession, depression, and prosperity; during eras marked by profound changes in consumer tastes and styles; throughout the widespread adoption of radio and then television and the advent of the automobile, and rapid advances in manufacturing processes and materials technology, the company endured and flourished. The period of DeVilbiss' presence in the vanity market coincided with some of the greatest changes in culture, lifestyle, technology, and economic circumstance the world had yet experienced.

Like many successful companies, DeVilbiss adapted and innovated to keep pace with change. For today's enthusiasts, studying and collecting DeVilbiss Perfumizers is not merely a treasure hunt. It is an exploration of the cultural and historical context within which those treasures were produced, sold, and used. It is also a history lesson and a trip through this incredible period spanning the first two-thirds of the twentieth century.

As we address the spectrum of DeVilbiss vanity products in this book, the chapters are organized according to the major periods of style and production. Recognizing that there will be overlap between periods, and that there are few clean delineations where one period ends and another begins, nevertheless there are clearly defined eras. Perhaps by historical coincidence, these breaks occur roughly on or near the turns of the decades.

The chapters following are organized around the following periods:

CHAPTER 2: 1907 to 1919. Launching of the Perfumizer business; refinement of atomizer designs, new sources of fine glass. Salt shakers, American Brilliant Cut Glass bottles, Bohemian art glass. The vision and passion of Thomas DeVilbiss. Post-war expansion and growing popularity of perfume.

CHAPTER 3: 1920 to 1932. Explosive growth of the Roaring Twenties; equally dramatic decline with the onset of the Great Depression. Transition from Art Nouveau to Art Deco designs. Opening of major new factory in Toledo in 1924. The design brilliance of Frederic Vuillemenot. Sourcing from fine quality U.S. glass houses: Steuben, Cambridge, Fry, Durand, Tiffin, Imperial and many more. Use of opaque and transparent colored glassware. Greatly expanded in-house decorating, including extensive use of acid cutback. Development of extensive line of perfume lights. Experimentation with the ultimate luxury and ornamentation of the Imperial Line. The untimely death of Thomas DeVilbiss in 1928. Last color catalog in 1932 until 1950s.

CHAPTER 4: 1933 to 1941. The Great Depression. Reduced consumerism; utilitarian styles; continuation of Art Deco styles. Demise of the stem-and-foot style. Major incorporation of Czechoslovakian glass and designs in late 1930s. Significant contraction in scope of product line. Major collaboration with Lenox including co-branding. Beginning of collaboration with Fenton. Introduction of leather-cased travel atomizers.

Gradual return of discretionary consumption; war in Europe and then America.

CHAPTER 5: 1942 to 1949. World War Two. Suspension of perfume atomizer production. From 1942 to 1946, DeVilbiss Company's total dedication to war production. From 1946, a resumption of production and gradual recovery of consumer demand. Continuation of major sourcing collaboration with Fenton and other key highest quality glass houses.

CHAPTER 6: 1950 to 1959. America recovers and prospers. Return to the fine glass houses of Europe. Top Italian, West German and French art glass houses to augment traditional American suppliers. Modern designs and new decorated porcelain containers from Japan. Re-emergence of pump spray tops. Atomizer production moved from Toledo plant to Somerset, Pennsylvania in 1951.

CHAPTER 7: 1960 to 1968. Continuation of 1950s styles, with introduction of figural and novelty bottles and perfume lights, then closing of production.

CHAPTER 8: DeVilbiss Special-order Products. The characteristic products of these eras demonstrate that while styles and tastes changed dramatically over the periods, the DeVilbiss Company and its Atomizer Division continued throughout to produce and market some of most beautiful and highest quality perfume atomizers available anywhere in the world, offering a full line from the very inexpensive to high luxury items.

We hope you find the book engaging, useful, informative, and entertaining. Notwithstanding some sleepless nights and a chaotic home totally given over to the project, we surely did have fun and learned much by writing it.

CHAPTER I

The DeVilbiss Company

1907—1968

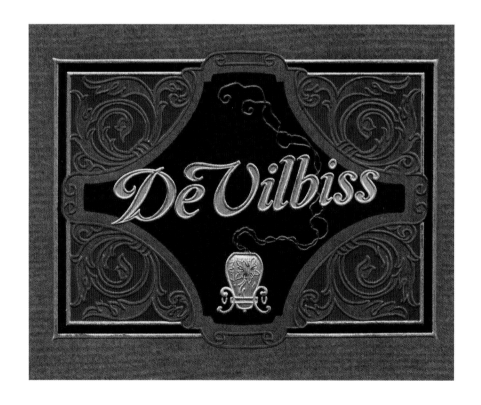

DeVilbiss 1925 Catalog Cover, *Courtesy of the Toledo Museum of Art.*

An Extraordinary Company

Dr. Allen DeVilbiss invented the DeVilbiss medical atomizer in 1887. Dr. DeVilbiss and his son, Thomas A. DeVilbiss, formed a father-son partnership in 1903, which they subsequently dissolved in 1905 when they formed the DeVilbiss Company, in which Dr. DeVilbiss was president and Thomas was vice president and general manager. In 1905, Thomas made a pivotal trip to a drugstore client in New York City and found French perfume atomizers in a state of disrepair and difficult for the owner to repair or re-order. Armed with the idea of building American perfume atomizers using the knowledge and success achieved with their medical atomizers, he fitted their metal atomizer spray top to a cut-glass salt shaker, to form a perfume atomizer. Even against his father's initial disagreement with forging ahead into this new business line, Tom prevailed, and by 1907 the DeVilbiss Perfumizer was a business of its own.

From the inception of the perfume atomizer, the "Perfumizer," in 1907 and until its end in 1968, the DeVilbiss Company designed, produced and supplied consumers in America and around the world with a dazzling array of exquisitely beautiful, finest-quality perfume atomizers and related vanity products. Their products evolved through many distinct phases of style, production, and the economic and cultural lives of the consuming public. These periods were marked by the company's growing sophistication of design and production excellence, and the visionary zeal combined with industrial expertise and artistic brilliance of Thomas A. DeVilbiss. After Tom's death in 1928, the company continued with the fine designs of Frederic Vuillemenot and the many other talented workers in the design, production, and decorating departments. Subsequent company leadership maintained the same high values throughout the DeVilbiss Perfumizer's history.

Over its first twenty years, the company had tremendous growth in its Perfumizer business, characterized by largely unchallenged market leadership, notwithstanding growing competition from other producers seeking to capitalize on the growing popularity and demand for perfume atomizers and ancillary products. The DeVilbiss company quickly became an international corporation as well, as an exporter and an importer, initially with production and sales in Canada and glass imports from Bohemia. The Perfumizer business grew in the first twenty years in sales volume both in the United States and internationally. After the market crash of 1929, DeVilbiss continued to lead the industry in successfully designing and producing quality Perfumizers and vanity items for nearly forty years.

Had the DeVilbiss Company relied solely on its Perfumizer business, it is doubtful that it would have survived the period of the Great Depression. But company leaders were shrewd and resourceful, relentlessly focused on quality and growth of the overall enterprise. For example, they leveraged their atomizer spray technology, originally developed for the medical market, into uses in the rapidly growing industrial world. In the 1920s and 1930s, the DeVilbiss paint sprayer's popularity grew. Overall, company employment reached 700 people in 1927, and grew to 800 in 1934, at the depth of the Depression. Then, it doubled to 1,600 employees just before World War II. Because the company did not rely on once-dominant Perfumizer sales for its survival, it remained strong through most of the next four decades.

Throughout its history, quality and design excellence were fundamental to DeVilbiss business values. They characterized development of their various Perfumizer and related product lines, and those values were maintained despite ever-changing tastes, design styles, and rising and falling financial circumstances of the consuming public. There were economic and cultural stresses in this period, and excesses of two World Wars, the Roaring Twenties, and the Great Depression. The post–World War II economic recovery, accompanied by the evolution of a new American culture, played heavily into the rise and fall of the company's fortunes in perfume atomizers, Perfume Droppers, and vanity products, markets that it dominated throughout most of its history.

Corporate Values and Style

Thomas A. DeVilbiss led the company with a strong sense of business values and respect for the skill, talent, and happiness of his employees. Within a few years of the company's founding, he joined a newly formed (1911) business group, the Rotary Club and, throughout his leadership of The DeVilbiss Company, he was an active member and subscribed to its objectives of service, in both his business and community life.

A savvy marketer as well, he advertised Perfumizers to the ready market of drugstores that already carried the DeVilbiss medicinal atomizers and through advertisements to his fellow Rotary members in *The Rotarian*, at least as early as 1913 and 1915.[1]

DeVilbiss' Guiding Principles

Jumping ahead to later years, the 1953 Annual Report relates the DeVilbiss Company's continuing philosophy towards its products and its people: "We have consistently endeavored to adhere to standards of the highest quality in our product. We will continue to place emphasis on the importance of personnel in DeVilbiss operations as our performance depends, and always will, on the human factor."[2]

DeVilbiss and the Welfare of Its Workforce

From the beginning, DeVilbiss was concerned with the welfare and happiness of their employees. People came and they generally stayed; long tenure was the norm. Employees found a business "home" where they worked together, played together, and were encouraged to make suggestions to do their jobs better or more creatively. The DeVilbiss Company valued employees in many ways, by encouraging athletic teams, picnics, employee concerts and plays, honors for length of tenure in the DeVilbiss Employees' Association, and more. A few examples demonstrate this attitude.

The earliest indication of a "company team" is reflected with the 1907 Champion Shinny Team.

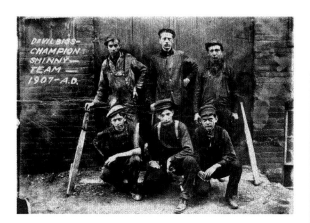

Probably the first DeVilbiss athletic activity. *Courtesy of BGSU Center for Archival Collections/DeVilbiss Corporation Collection MS-604.*

DeVilbiss 1915 Annual Picnic at Sugar Island. *Courtesy of BGSU Center for Archival Collections/DeVilbiss Corporation Collection MS-604.*

Other examples of involving and appreciating its employees appear in the various events and company programs shown here.

THE DeVILBISS MANUFACTURING CO.
CORDIALLY INVITES YOU
TO ATTEND A
PARTY
TO BE GIVEN AT
THE LENK WINE PLANT
ON
MONDAY EVENING OCTOBER SIXTH
NINETEEN NINETEEN
DANCING EIGHT O'CLOCK

1919 invitation to a festive company party at the Lenk Wine Company plant shortly after its purchase by DeVilbiss.

"11th ANNUAL DeVILBISS PICNIC"

AUGUST 12th ~ 1922

Program of Events

8:30 A. M.
Boat leaves dock at foot of *Madison Avenue*
8:31
Some late comer will miss the 1922 picnic completely
11:30
Boat arrives at Sugar Island. Bring your own lunch with you
1:00 P. M.
Ball Game begins
2:00
Dancing
3:00
Games and Contests will take place within the enclosure
4:15
Prize Fox Trot at Pavilion
5:20
Boat returns to Toledo
8:30
The end of a perfect day

1922 Annual DeVilbiss Picnic at Sugar Island.

The Toledo Institute of Musical Art
Presents
The Members of
THE DEVILBISS MANUFACTURING COMPANY
In Recital
at the
Y. W. C. A. AUDITORIUM
Thursday Evening, April 22nd, 1920, at 8:15 o'clock.
———
PROGRAM
Selections from the Comic Opera "Sho-Gun"
The DeVilbiss Orchestra

DeVilbiss Manufacturing Company Presents Selections from the Comic Opera "Sho-Gun."

DeVilbiss Christmas Dance
Tuesday Evening, December 21, 1926
AT THE COLISEUM
to 11:30 Admit One Couple

Christmas Dinner Dance and festivities at no less than the Coliseum in 1926.

DeVilbiss Play Is A Hit
By WILLIAM MACK.
Employes of the DeVilbiss plant presented a comic opera in the Auditorium on Saturday evening that was a surprise to everyone but the members of the cast. The performers told their friends that they had a wonderful show, but such comments are heard so frequently from enthusiastic amateurs that few took the remarks seriously.

Not sure of the year, but the DeVilbiss employees' play was a hit!

Experienced and long-term employees were also valued in this remarkable company. Recognition was given to employees on a consistent basis. A good example was given in a listing of service clubs from 1953, where The DeVilbiss Company was noted for once-a-year giving a banquet for all employees and pensioners with 25 years or more of service. Each employee who had passed the 25 year mark during the preceding twelve months was given a pin with a diamond and a check for $100.

Other forms of employee recognition happened on a continuing basis. Employees were often featured in the company newsletter, *DeVilbiss News*, as the reader will see in other chapters, and contests were held frequently among employees to spur new ideas to improve the company and its products.

Company concern for the welfare of its employees extended way beyond engaging group events and contests to address the health and security of its employees even before such programs were considered the norm in many companies, and it continued with the same dedication to employees throughout the years.

The DeVilbiss Employees' Association was originally organized in 1916 as a means of providing financial aid to its employees during times of sickness and upon death.[3]

A *Salaried Employees' Retirement Income Plan* was put into effect in 1946, that was designed to provide retirement income benefits for all of its salaried employees whose annual basic salary was $3,000 or more per year.[4]

In 1948, a thorough Employee Booklet was created which gave a complete history of the company and then covered everything pertaining to the employee. It covered the Welfare Association, credit union, unemployment compensation, life insurance, social security, savings bonds, bowling, workmen's compensation, medical service, hospitalization, vacation, holidays, employee purchases, the suggestion system, bulletin boards, leaves of absence, service recognition, and continuity of employment and advancement. The introduction describes the spirit of the company: "We have always recognized that getting along well together in our daily work is the surest way to build and maintain an efficient organization to which it will be a pleasure and a privilege to belong. There are many things to be considered in achieving this goal, but first and foremost is making our company a good place to work. Naturally your company is very much interested in your work, your progress, and your health. We fully appreciate that you are entitled to an opportunity to advance, to security on the job, and to recognition of a job well done. In these terms we believe that DeVilbiss is a good place to work, and we are proud of the fact that 20% of our organization have been with us twenty years, and 90% more than five years. We feel that this record speaks for itself."[5]

By 1950, a health and welfare program for all employees was implemented and outlined in the Annual Report: "Adopted after careful study and discussion, a very broad and comprehensive health and welfare program covering all employees was inaugurated. It provides life insurance, accidental death benefits and weekly sickness and accident benefits for our employees together with hospitalization and surgical fee benefits for our employees and their dependents. The entire cost of this will be paid by the Company, the total of which is estimated to be $150,000 annually."[6]

Example of a multi-year employee pin. *Photo and pin courtesy of Shari Maxson Hopper.*

Example of employee service pin. *Photo and pin courtesy of Shari Maxson Hopper.*

DeVilbiss: A Good Place to Work—Employee Recollections and Perspectives

Interviews with DeVilbiss former employees were conducted by Shari Maxson Hopper.

Lucy Marquart decorated atomizers in the Toledo plant. She decided not to move to Somerset, PA in 1951, and was given the job using her artistic background to make a new catalog. When asked how she liked working for DeVilbiss, she replied, "I loved it. They did all right by us. I made more friends there. It was kind of a family." She was 92 at the time of the interview and still living in Toledo.

Dale Heffner, at 88, was also still in Toledo. He worked for DeVilbiss from 1936 to 1975 as a purchasing agent for glass bottles. He told a lot of great stories. When he went to a glass company he would bring a black and white pencil sketch or a watercolor of the atomizer done by the women artists in the company. The glass companies would get molds made to produce the bottles. The bottles were produced by the turn, a glassmakers' work shift, because some designs would vary if produced by various workers. Dale indicated that in the metal department of the company, he saw that one man would work at a machine making the same part for so long that he would wear a depression in the concrete! The atomizer bulbs, at the time, were made in the DeVilbiss rubber plant. The Lenk building had been a winery, and they stored the rubber in the cellars. Women would pick up a grocery bag full of bulbs and take them home to crochet the coverings on them. Artists and cutters were hired for a couple months at a time from Libbey Glass and others to work in the DeVilbiss glass cutting shop. The company created an executive dining room with a stainless steel kitchen where the huge wine cask had been; employees could pay a few dollars a month to be able to eat there. DeVilbiss also developed a research department, which would be reduced or cut during periods of austerity, that brought people in from all over the world.

Hurst Eckels was a territory manager/salesman from 1924 to 1942, as well as President of the Philadelphia Cosmetic Association from 1956 to 1957. His daughter, Mrs. Stansbury, discussed what it was like to be a salesman in the 1920s. There were awards of money and gifts as incentives that Hurst won each year. He moved around a lot setting up displays. The Ohio office had a yearly convention where he would show the new line. She said DeVilbiss Perfumizers always sold in the "prettiest and nicest stores."

When interviewed in 2003, Allen DeVilbiss Gutchess, Jr. was age 75. He did design patent work for DeVilbiss in the 1950s and 1960s and had many fond memories of the company and his years spent working there. During the interview, he shared these tidbits about his father, Allen D. Gutchess, Sr., who was the grandson and namesake of Dr. Allen DeVilbiss. Tom DeVilbiss hired his father Allen, at the age of 14, to work after school to run a foot treadle printing press to imprint labels for the atomizer boxes. He continued to work for the company for forty years, including as Secretary to Tom DeVilbiss in 1914, Secretary of the DeVilbiss Employees Association in 1916, President after Tom died from 1929 to 1944, and Chairman of the Board until 1949. In his farewell letter printed in the *DeVilbiss News* in September 1949, he said, "I am mighty glad I had the chance to know so many of you so well and for so long a time. It will not be easy to relinquish my close association with you … I shall miss every one of you."

When Ruby Miller retired in 2001, Allen DeVilbiss Gutchess, Jr. (the son) called her to thank her for her service. She was the oldest employee at that time. He also sent her some DeVilbiss family history. When Ruby started in 1960, she focused on gathering together company records and information, which consisted mostly of the period after the division had moved to Somerset, PA, in 1951. These materials were eventually donated, through her efforts, to the Toledo Art Museum in the late 1990s.

Ruby was full of details about the history of the company, and among those related, she said they would make up a kit including a nebulizer with flowers and a quart jar with a metal lid filled with a perfume mixture and would run it with one of their air compressors 24 hours. It would send fragrance all over the store and attract customers to the perfume counter.

Ruby said the people she worked with were like family and that it was a wonderful place to work. They were always bringing in consultants and having seminars. She learned so much that she went into marketing consulting. Thanks to Ruby saving the old Somerset records, we were able to do some of the research on DeVilbiss.

The perspectives and stories of the employees interviewed add a special context to understanding the DeVilbiss Company and its success in each of its industries. Today, companies work to understand how best to value their employees. DeVilbiss put those beliefs about employee value to work from the very formation of the company.

Family History

For the legions of fans of the DeVilbiss Company's Perfumizers, Perfume Sprayers, Perfume Atomizers, and Vanity Items, here is a brief history of the company's exploits through the first two-thirds of the 20th century.

Dr. Allen DeVilbiss and Early Beginnings—Medical Atomizer Production, 1887 to 1907

Dr. Allen DeVilbiss was born on December 5, 1841, in Licking County, Ohio. In 1887, he moved his family from Indiana to Toledo. His plan was not only to practice medicine as an ear, nose and throat specialist, but also to manufacture a medical atomizer to replace cotton swabs used to medicate the mouth and throat.

Among other important medical inventions, Dr. DeVilbiss developed the first throat atomizer, in a small woodshed behind the DeVilbiss home on Warren Street in Toledo. The concept was to melt goose grease or Vaseline in a small metal can equipped with a tube and a squeeze ball, so that when activated the substance would cool while being sprayed into the patient's mouth, throat, or nose without burning.

He added a patented, adjustable tip, so the patient could regulate the spray. Because goose grease was not always efficacious, he worked with a New York specialist to develop a light oil that could be sprayed at room temperature.

The operation of the medical atomizer was simple. A vacuum was created by the passage of air through the spray head and nozzle, causing the solution in the bottle to rise through a tube to the spray point, where it mixed with air to emerge in the form of a spray.

Dr. Allen DeVilbiss in Toledo, Ohio, c. 1893. *Courtesy of BGSU Center for Archival Collections/DeVilbiss Corporation Collection MS-604.*

DeVilbiss Historical Tidbit —

Pronunciation of the Name
Dr. Allen DeVilbiss "capitalized the letter 'V' in the name to avoid a 'Devil-biss' pronunciation."[7]

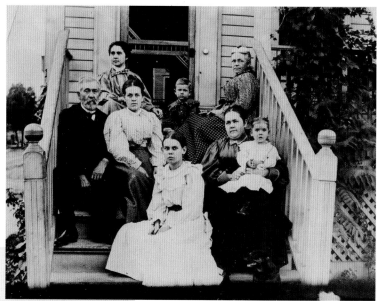

Dr. Allen DeVilbiss and family at their Warren Street home in Toledo, c. 1893. Dr. DeVilbiss is in the center row left. The young boy at top center is grandson and future President, Allen D. Gutchess, whose mother, Lida DeVilbiss Gutchess, is seated at front right. *Courtesy of BGSU Center for Archival Collections/DeVilbiss Corporation Collection MS-604.*

The shed at right, behind the DeVilbiss Warren Street home, was the site of the beginning of the DeVilbiss Manufacturing Company. *Courtesy of BGSU Center for Archival Collections/DeVilbiss Corporation Collection MS-604.*

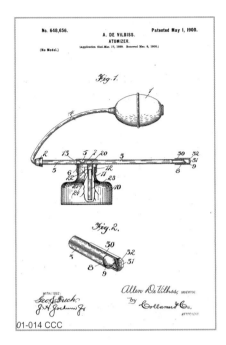

No. 648,656.
A. DE VILBISS.
Patented May 1, 1900.
ATOMIZER.
(No Model.)
(Application filed Mar. 17, 1899. Renewed Mar. 8, 1900.)

Fig. 1.

Fig. 2.

Dr. Allen DeVilbiss' patent for a medical atomizer applied for in March 1899.

Medical Atomizers—From 1887

Collectors and dealers sometimes confuse "atomizers" from the company's medical atomizer product line with DeVilbiss Perfumizers, which were also called atomizers and Perfume Sprays at various times. DeVilbiss sold and was known over the years for excellent quality medicinal atomizers and nebulizers. Occasionally, early in the company's history, medicinal atomizer bottles were also used as Perfumizer bottles, but the differences are clear. Some examples of more commonly found medical atomizers appear below.

As a result of Dr. DeVilbiss' experiments and product development, by 1888 he was ready to form the DeVilbiss Manufacturing Company, to manufacture and market his new products, from the rear of his Warren Street residence.

Young Tom DeVilbiss and his brother, Allen Jr., served as their father's assistants, printing labels and assembling atomizers, while sisters Mary and Lida kept the books of the new company.

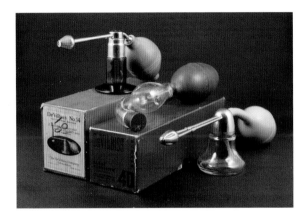

Three examples of the many DeVilbiss medical atomizers — early to mid–1900s.

As the product was perfected, orders increased, the company's organization grew, and a larger facility was needed. In 1895, the family moved to 1220 Jackson Street, near Toledo's growing downtown district. An addition was built onto the residence to house the factory. The basement contained the punch press, lathe, and other production machinery; while the first floor housed the office, assembly and shipping departments. The family lived on the second floor.

The DeVilbiss Manufacturing Company continued to grow, and Dr. DeVilbiss' stature in the medical community grew with it. On one occasion, he was invited to speak before the American Medical Association, but withdrew both from the invitation and the association itself when he learned that AMA had no nose and throat specialty section. This led to AMA's establishment of a laryngeal section, along with Dr. DeVilbiss' return to the organization.

Dr. DeVilbiss wanted one of his sons to follow his example and become a doctor. Allen Jr. declined, so Tom decided to study medicine to please his father. He discovered that he disliked the subject matter and that his real passion was for creating things. So his enrollment in medical school lasted only one year. In 1901, at age 23, he joined his brother Allen in his scale business.

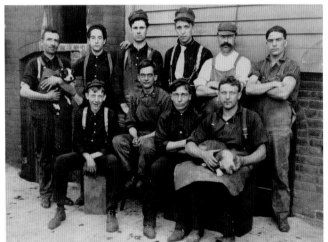

DeVilbiss production employees outside Jackson Street factory, c. 1905. *Courtesy of BGSU Center for Archival Collections/DeVilbiss Corporation Collection MS-604.*

Allen Jr. had invented a springless automatic scale in 1897, and he decided to build the DeVilbiss Scale Company a short distance from his father's company. A few years later, Allen Jr. sold the company, which then became the Toledo Scale Company.

In 1903, Dr. DeVilbiss' rapidly expanding business employed fifteen people, and he decided it needed greater management expertise. He persuaded Tom to return to the company. In 1905, Tom bought a 50% interest and became a full partner with his father and took charge of operations for the DeVilbiss Manufacturing Company, whose products at the time remained medical tools and medical atomizers.[8] That year, medical atomizer and tools sales reached $40,000.

Like his brother and father, Tom was also an inventor. In 1907, he experimented with his father's atomizers, which soon thereafter led to the development of the DeVilbiss paint spray gun.

The Advent of the Perfumizer—1907 to 1915

One day in 1905, Tom DeVilbiss was in New York's Times Square, and stepped into a drug store to visit the druggist, a friend. He noticed a number of broken French perfume atomizers which had been returned and which the druggist was unable to repair or replace. Tom asked his friend if he thought he would be able to sell an American-made product. The answer was, "Maybe." Armed with a potential order, he returned to Toledo and fitted a metal spray top to a cut-glass salt shaker, thus resulting in the first De-Vilbiss perfume atomizer. He argued for establishing a division of the company to make and sell perfume atomizers.

While pleased with his son's initiative and creativity, Dr. DeVilbiss was nevertheless opposed on the grounds that he felt perfume was an unnecessary luxury and demand would not justify the investment in the necessary new equipment. He also objected that the company was a respected member of the medical community, and that a perfume product would be considered frivolous and demeaning. But, as noted earlier, son Tom prevailed, and in 1907 he began production of a line of perfume atomizers; within a short time the atomizers were marketed under the name "DeVilbiss Perfumizers."[9]

With sales of both medical and perfume atomizers growing, the father and son partners decided to dissolve the partnership of the DeVilbiss Manufacturing Company and establish a corporation, The De-Vilbiss Company, with starting capital of $25,000. Dr. DeVilbiss became its first President and Tom was Vice President and General Manager. Son-in-law Frank Gutchess, husband of Allen's daughter Lida and father of future President Allen D. Gutchess, was named Secretary-Treasurer.

In 1907, the company wisely expanded internationally with the establishment of a Windsor, Ontario, plant under a partnership with Allen DeVilbiss, Jr., Tom DeVilbiss, and Frank Gutchess. It was to serve initially as a warehouse and distribution center for DeVilbiss products in the U.S. and Canada.

DeVilbiss Historical Tidbit —

What's in a Name?

Most DeVilbiss collectors and historians identify the term Perfumizer as the DeVilbiss name often used for their perfume atomizers and may know that DeVilbiss trademarked the name as well.

But was the DeVilbiss Manufacturing Company first to come up with the name? It appears likely that they did not. An advertisement dated 1904 is for a company named Walter Sams of Chicago, Illinois, selling Perfumizers. It appears likely that the Walter Sams Company did not trademark the name "Perfumizers" or sold the rights to the name to DeVilbiss, for only a few years later, DeVilbiss applied for and received the registered trademark. The future of the Walter Sams Company is unknown.

Image of the DeVilbiss "Perfumizer" trademark registration from a Perfumizer box, c.1914.

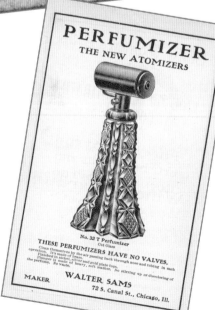

1904 advertisement for Perfumizers by the Walter Sams Company *The Spatula*, edited by Irving P. Fox, Vol. II, 1904.

Thomas A. DeVilbiss

Thomas A. DeVilbiss was born on July 29, 1878. In December 1906, Tom DeVilbiss married Miss Edna Parker. A son, Howard Parker DeVilbiss, was born in 1908. In 1914, his sister, Virginia, came into the world. Throughout his career, Tom was very active in Toledo community affairs; among many civic involvements, he served as president of the Toledo Industrial Exposition in 1921, and he headed the Masonic Drive for a new temple building. In addition, he was general chairman of the city-wide Community Chest Campaign, which developed into the War Chest organization during World War I.[10]

For many years, Tom was a trustee of the Toledo Art Museum and was a generous philanthropist to the museum's exhibits and fund-raising drives. In 1917, he was elected president of the Toledo Board of Education, where he served with Edward Libbey. He also loved yachting and served as Commodore of the Toledo Yacht Club and Commodore of the Interlake Yachting Association. He helped establish and served as president of the Toledo Rotary Club.[11]

Thomas A. DeVilbiss c. 1918.
Courtesy of BGSU Center for Archival Collections/DeVilbiss Corporation Collection MS-604.

Early Growth of DeVilbiss Perfumizers

Over the eight-year period 1907 to 1915, the DeVilbiss Perfumizer business grew rapidly and far exceeded the sales of medical atomizers. With a newly-designed stylish spray mechanism adapted for perfume, and after the initial introduction of salt-shaker bottle perfume atomizers, Tom DeVilbiss sought to expand and improve the Perfumizer line. He made several trips to Bohemia (a region later to become part of Czechoslovakia and now the Czech Republic) to purchase high-quality glass "blanks" (decorated glass bottles, both colored and clear, with no atomizer fittings) and to recruit skilled artisans—glass cutters and decorators—to relocate to Toledo to help establish DeVilbiss' own decorating department. From this period, we find beautifully cut, engraved, and hand-enameled colored and clear Bohemian glass bottles, alongside American-made pressed and cut crystal bottles.

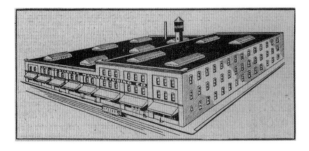

Sketch of new Dorr Street plant, c. 1910. *Courtesy of BGSU Center for Archival Collections/DeVilbiss Corporation Collection MS-604.*

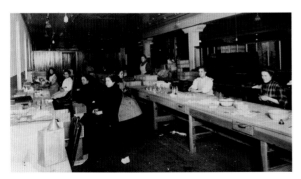

Dorr Street plant Perfumizer assembly and decorating department. *Courtesy of BGSU Center for Archival Collections/DeVilbiss Corporation Collection MS-604.*

Advent of the Paint Spray Business

At about the same time, during 1910, the DeVilbiss team realized that their spray technology had other potential applications. A paint spray gun was developed and became a standard item in the company's product line. It sold principally to furniture manufacturers for applying varnish finishes. By 1911, sales of paint sprayers reached over $30,000 (equal to $670,000 in today's dollars), an amount that had taken the medical atomizer product line almost 17 years to reach. By the early 1920s, the paint spray business expanded rapidly into the burgeoning and close-by Detroit-area automobile manufacturing industry, with the introduction of quick-drying lacquers for automobile finishes. This development was critical to the success of the mass-production process. As we shall see, the growth of the paint spray business would later, during the Depression era, provide the resources to permit DeVilbiss to remain in the Perfumizer business.[12]

In 1908, the Jackson Street plant housed fifty employees. The following year, the corporation's capital was increased to $150,000. This rapid growth made a newer and larger factory needed. In 1910, the company moved into a factory building at 1302 Dorr Street, with over 30,000 square feet of space. This plant had been the Kieper Brothers Furniture factory, which Thomas DeVilbiss bought at a sheriff's sale and remodeled into a first-class manufacturing plant. By 1912, employment had doubled to 100, to keep pace with the company's tremendous growth.

Notwithstanding rapid growth, the company remained a family-owned business, with all company shares owned by Dr. Allen DeVilbiss, his wife Lydia DeVilbiss, son Thomas DeVilbiss, daughter Lida DeVilbiss, and her husband Frank Gutchess.

Dr. Allen DeVilbiss' Death, World War I and the Immediate Post-War era: 1917–1919

In 1917, just as the United States was entering World War I, Dr. Allen DeVilbiss passed away at age 75. Son Tom was named president of the company. At 39, he was beyond military enlistment age, but took an active role in the War Chest and Liberty Loan drives to raise money for the war effort. The DeVilbiss Manufacturing Company also participated in war production by shipping great quantities of medical atomizers to Europe for the hospitals. In one week of 1918, during the height of the war and an influenza epidemic in the United States, demand for the company's medical atomizers increased from 10,000 to 100,000. DeVilbiss also developed a spray process for coating the interior cavities of artillery shells to prevent chemical reaction between the steel casing and the explosive charge, which might cause premature detonation. Remarkably, this same process was adapted after the war to applying enamel coatings to the insides of perfume bottles.

The war in Europe interrupted DeVilbiss' access to supplies of Bohemian glass blanks, so, by 1916, the Perfumizer product lines changed to using cut and blown American-made crystal bottles. These were often made to order, to Tom DeVilbiss' patented design specifications, and were adorned with elaborate metal collars, spray fittings, and finely crocheted silk nets covering rubber squeeze bulbs.

This period fortuitously coincided with the emergence of a rapidly expanding era of excellence in American glassmaking. Many new glassware companies produced high-quality cut, etched, hand-blown, and enameled colored glass and crystal. This industry, centered in Ohio, Pennsylvania, West Virginia and New York, was perfectly situated to supply DeVilbiss with top-quality glass blanks, some decorated but often undecorated, ready for Tom DeVilbiss' designs and the growing ranks of skilled artisans in the De-Vilbiss decorating department.

Glass bottle and accessory blanks were at various times purchased from many of the finest American glasshouses, including Cambridge Glass Company, Fostoria Glass Co., U.S. Glass Co. (Tiffin), Westmoreland Glass Co., Fenton Art Glass Co., H. C. Fry Glass Co., Imperial Glass Corporation, Morgantown Glass, Owens-Illinois, Carr-Lowrey, Steuben Glass Works, Vineland Flint Glassworks (Durand art glass), Quezal Art Glass & Decorating Company, and T. J. Hawkes Co.

See the Appendix: Glass and Porcelain Company Suppliers to DeVilbiss, page 311.

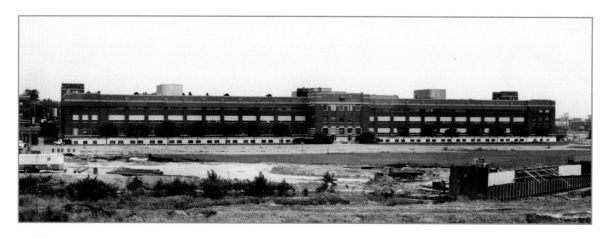

New West Toledo factory nearing completion, c. 1923. *Courtesy of BGSU Center for Archival Collections/DeVilbiss Corporation Collection MS-604.*

Rapid Growth and a Large New Factory: 1920–1926

At the end of World War I, America entered a period of rapidly growing prosperity and Tom DeVilbiss continued to lead the growth of his company. By 1919, it became apparent that another major expansion of DeVilbiss facilities was needed to accommodate increasing demands for their products. Tom's vision was for a large, modern plant housing all the company's divisions in one place.

To begin implementation of his plan, in 1919, the company purchased a property in West Toledo vacated by the Lenk Wine Company, whose business was ended by Prohibition. The paint spray manufacturing business was moved into the old winery building, while Perfumizer and medical atomizer production remained at the Dorr Street factory. In 1923, construction of a large, new, modern manufacturing facility was begun at the old Lenk property.

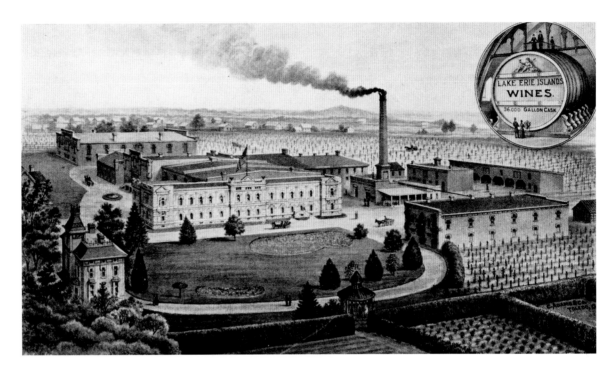

Lenk Wine Company West Toledo property c. 1900. *Courtesy of BGSU Center for Archival Collections/DeVilbiss Corporation Collection MS-604.*

Completed and fully occupied by all divisions by the end of 1924, this impressive new building measured 580 feet long by 80 feet deep, with three stories and a basement that provided 200,000 square feet of manufacturing, operations and administrative space. The old Dorr Street plant was then abandoned, and the Lenk Wine headquarters building was converted into a warehouse.

The year 1924 also marked a significant milestone in the company's artistic design development. Tom DeVilbiss recruited Frederic Alexandre Vuillemenot, a brilliant French designer who immigrated to the United States in 1915 and had worked at the Libbey Glass Company in Toledo, Ohio. Vuillemenot augmented Tom's already substantial excellence in artistic design and expertise in industrial processes and manufacturing. Highly accomplished in the style of Art Nouveau popular in the late 1800s and early 1900s, Vuillemenot was a graduate of Paris' Ecole des Arts Décoratifs. Both Tom DeVilbiss and Frederic Vuillemenot journeyed to Paris, France, in 1925, to visit the highly acclaimed Exposition Internationale des Arts Décoratifs et Industriels Modernes. This was the event that led to the Art Deco style, both in its popularity and its name. The trip would have a remarkable effect on DeVilbiss Perfumizers and its product lines. As the Art Deco style overtook the public's design tastes, in the last half of the 1920s, Vuillemenot introduced exquisite new bottle, collar, spray head, and box designs to DeVilbiss products, as well as new marketing materials and catalogs. Vuillemenot continued as head designer until 1932, when the Depression's impact on the perfume atomizer market forced DeVilbiss to have Vuillemenot design for them on a part-time, freelance basis. In the interim, he also worked for other companies, including Libbey Glass Company where he was the designer attributed to Libbey's famous Silhouette pattern of stemware. Back full-time at DeVilbiss later in 1932, he would remain there until 1948.

The end of World War I also brought a period of rapid growth in wealth, luxury goods, and opulence characterized as the "Roaring Twenties." Growing popularity of perfume created a fast-rising demand for expensive fragrances and quality decorative containers. These forces converged with DeVilbiss' unchallenged market leadership to result in company sales of over 1.5 million units by 1926, its peak year of Perfumizer production and sales. This amounted to revenues of $2,184,000 (the equivalent of about $28 million in today's dollars), broken out as follows according to company records:[13]

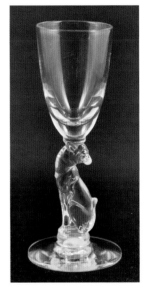

Example of a Vuillemenot-designed Libbey Glass Company cordial in the Silhouette pattern, c. 1932.

Perfumizers and Droppers:.........$1,988,000

Perfume Lights:..................................82,000

Fancy Boxes:.......................................12,000

Ash Trays: ..10,000

Vanity Sets: ..92,000

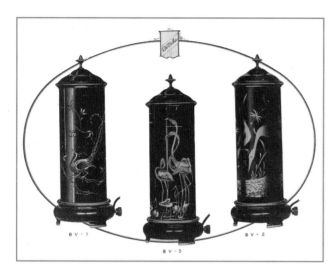

Page from 1925 hand-colored company portfolio showing BV Series perfume lights

The DeVilbiss Perfume Light

In 1921, DeVilbiss began producing what it called a "Perfume Burner and Night Light," with two offerings: one featuring as its shade an art glass globe and the other a plain cylindrical shade. Both styles were on either silver- or gold-plated ornate metal stands with matching caps. These were advertised as "wonderfully attractive perfume burner(s) which, when lighted, diffuses one's favorite perfume as it is evaporated by the heat of the electric bulb. It is also a charming night light for the sick room or nursery," according to the 1921 catalog.

The line was expanded to three types in 1922. In 1923, DeVilbiss began referring to them as "perfume lights" and continued expanding the offering to seventeen styles, and again to twenty-two in 1925 and 1926. Notwithstanding their innovative and lovely designs, perfume lights, even at the peak of sales, never grew beyond four percent of total perfume and vanity product sales. By 1928, the offering had been reduced to five designs and by 1929, perfume lights had all but disappeared entirely from the product line. DeVilbiss did, however, reintroduce a limited offering of perfume lamps at various times and in different forms until the division's closing in 1968.

Thus, while sales of perfume lights and lamps never realized full potential, this effort has left collectors today with some exquisitely beautiful treasures to find. One magnificent perfume light model, with a hand-painted scene showing a nude woman standing beside a Greek fountain, was the most expensive single item in the DeVilbiss Perfumizer line: in 1926 it retailed for the princely sum of $75, the equivalent of $950 today. (See also Chapter 3, page 186 on perfume lights.)

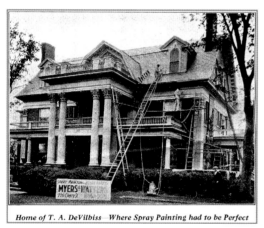
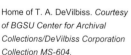

Home of T. A. DeVilbiss—Where Spray Painting had to be Perfect

Home of T. A. DeVilbiss. *Courtesy of BGSU Center for Archival Collections/DeVilbiss Corporation Collection MS-604.*

DeVilbiss home today.

The Perfumizer Sales Pinnacle, the Death of Tom DeVilbiss, and the Beginning of Leaner Times

By 1926, DeVilbiss employed 700 people and another 500 piece-workers who worked from home, in and around Toledo, to hand-crochet the silk nets that covered the rubber bulbs. Half of the new factory was devoted to Perfumizer production; the rest to the company's rapidly growing paint-spray business. In fact, when it came time to repaint his stately home in Toledo, Tom DeVilbiss demonstrated his innovation by having the home painted by DeVilbiss spray equipment, as reported by *Toledo Business* in April 1927.

As is usually true in business, DeVilbiss's great success in Perfumizers attracted competitors. Several new atomizer houses came onto the market, with offerings that clearly emulated, and today are often confused with, DeVilbiss perfume atomizers and dropper bottles.

The Major Competitors

Foremost among their major competitors were Pyramid, Volupte, Mignon, T. J. Holmes Company Inc., Gironde, Aristo, Vant Woud, Lorna, Irice and Apollo. Some of these competitor firms were also able to acquire similar, and in some cases identical, glass bottle blanks from U.S. glassmakers already supplying DeVilbiss. More often, another glass company would be contracted to supply similar, but not identical, glass blanks of popular DeVilbiss styles. Competitors often also mimicked the spray head and collar styles of DeVilbiss, sometimes several years after the original DeVilbiss production. These can be confusing to the beginning collector. The savvy collector today soon becomes familiar with the very small differences in designs between competitors' products. It is our hope that this book will enhance the collector's ability to correctly identify DeVilbiss products, including correct collars and spray heads, versus those of competitors.

Thomas A. DeVilbiss (7/29/1878–11/1/1928).
According to his Memoriam booklet in 1928, "this photograph was taken in May, 1928. A few days after the sitting, he sailed for Europe and while he apparently enjoyed the voyage, he was ill when he returned."[14]

Toward the end of 1926, the company's Atomizer Executive Committee considered whether to produce a new 1927 catalog; it concluded as late as December 31, 1926, that "the 1926 catalog be retained for 1927." Beginning with 1928, customers would see a fresh, new line of items each year. Those that were carried over would have to be specifically approved by the Atomizer Executive Committee. At the meeting, it was also approved that products newly introduced for 1927 could be shown by salesmen "using the Photo Book in conjunction with the catalog." It was also suggested "that a new catalog has great advertising value and that there may be some loss from this angle," according to official minutes of Atomizer Executive Committee meeting on December 31, 1926.

Indeed, this turned out to be prophetic. In spite of a company forecast of Perfumizer sales of $2,200,000, sales for 1927 fell 33% from the previous year to $1,452,000. The volume had grown so quickly in 1926 that the Atomizer Executive Committee was diligent in their review of its products and processes in bringing products to market, and getting them to its customers. Customers' concerns on accurate delivery times in the previous year were addressed. The company struggled to keep up with demand, even as competition grew at a rapid pace. As a result, many new procedures were put into place to have Perfumizers arrive on time, in sufficient quantity, and in good condition, whether in the United States or abroad. Not having a new catalog (which customers had said they wanted each year) most certainly influenced company sales in 1927, and yet, demand for DeVilbiss Perfumizers was also softening in the months prior to the market crash of 1929. Perhaps this foretold the soon-approaching end of opulent consumerism in the Roaring Twenties.

Were this not bad enough, after a period of rapidly declining health, Tom DeVilbiss died at the young age of 50, in 1928.

Tom's nephew, Allen DeVilbiss Gutchess, son of Tom's sister Lida DeVilbiss Gutchess and Frank Gutchess, succeeded to the presidency of the company. The new executive team also included Frank A. Bailey, Vice President and General Manager; Walter W. Conklin, Secretary and Treasurer; Howard P. DeVilbiss (Tom's son), Assistant Secretary and Assistant Treasurer; and William F. Gradolph, General Sales Manager.[15]

Allen DeVilbiss Gutchess.
Courtesy of BGSU Center for Archival Collections/DeVilbiss Corporation Collection MS-604.[16]

The Crash of 1929 and the Depression Years

The stock market crash of 1929, followed by the Great Depression, saw a predictably rapid further contraction in the DeVilbiss Perfumizer business, as the American public's discretionary spending on luxury and non-essential items plummeted. Making matters more difficult, this was accompanied by a marked change in the public's design tastes, as the luxury and elegance of the Roaring Twenties gave way to more austere, simple, utilitarian styles, not to mention the reduced wealth and capacity of consumers to buy luxury goods of all kinds.

At a meeting held on Christmas Eve 1929, the company's new management team, following the significant discussions that had been held in previous meetings, decided to declare as "obsolete" all remaining inventory from the 1928 Perfumizer line, which led to a planned cut-rate disposition of these prized items of today. Significantly, at the same time, the two magnificent annealing lehrs, the pride of the new plant in 1924, were also declared obsolete, thus ending the practice of application, at least in-house, of fired-on enamel bottle decorations for which the company was famous during the 1920s.

As tastes changed, markets shrank, and consumer discretionary purchasing power evaporated, the company successfully found ways to cut costs while responding to changing customer demand and at the same time keeping quality high. In a meeting of the Atomizer Executive Committee in March 1932, led by company President Allen Gutchess, the company decided to return to Czechoslovakian glassmakers—a favored source during the company's early years from 1907 to 1915. Meeting minutes report that:

> It was decided to place orders in Czechoslovakia for approximately 50,000 ground and polished Perfumizer bottles of the squat type in clear and colored glass to cost approximately $9,000 landed in this country. *The landed cost of this foreign merchandise amounts to only about one-third of the domestic cost.*[17]

That average cost per bottle of $.18 included the cost of shipping the order from Czechoslovakia to Toledo!

All the while, the company's paint spray gun business was growing. By 1930, total company sales had grown to $4,000,000, of which both domestic and industrial paint sprayers accounted for fully 65%, while Perfumizer sales had shrunk to $640,000. This was produced by sales of 900,000 bottles at an average price of $.71, down from the 1926 average Perfumizer wholesale selling price of $1.33. The Perfumizer business, which had occupied half of the company's new 200,000 square foot factory in 1925, now accounted for only 16% of the company's sales.[18]

For the 1931 Perfumizer line, due to the unpredictability of economic conditions and of Perfumizer demand, after careful consideration, management decided to end the prior practice of producing in advance the year's estimated sales, and instead adopted a policy of producing only enough Perfumizers to fill sample orders, and then subsequently only producing to fill actual orders received.

Alas, none of the company's products were immune from the Great Depression. By 1932, the company's total sales had plummeted to $1,816,000—down 64% from the peak sales years of the late 1920s—which resulted in the first net loss in the company's history.[19]

Of DeVilbiss' Perfumizer competitors, many were also struggling, and some failing, during this period—particularly those without the benefit of a diversified product portfolio. At an Atomizer Executive Committee meeting in January 1934, DeVilbiss management considered a proposal from a company that had been a formidable competitor in the 1920s. Notes of the meeting reflect "the offer of the Volupte Company to sell us their Perfumizer stock and equipment for manufacture of Perfumizers was considered and turned down."[20]

Nevertheless, throughout the 1930s and right up to the outbreak of World War II, the company continued to design and produce a full range of perfume atomizers, from inexpensive bottles to costly, top-of-the line offerings. Exquisitely beautiful perfume atomizers and other vanity items continued to owe much to Fred Vuillemenot's design artistry, and the company's concentration on production excellence and commitment to quality.

This period was also characterized by continued design and product innovation, seeing the introduction of an extensive line of fine porcelain bottles designed by Vuillemenot and produced by Lenox, a leading U.S. manufacturer of china, between 1935 and 1937. Glass bottles continued to be sourced

from both American and European glass houses. The rising popularity of Czechoslovakian decorative glassware was fully reflected in DeVilbiss catalogs, as was U.S.-made gold and silver-enameled "crackled" glass. Green-gold (an alloy of silver and gold) filigree ornaments were featured in 1937 and 1938 catalogs. The year 1940 also saw the introduction of the swirled, colored opalescent glassware of the Fenton Art Glass Company.

Excellence in War Production

The entry of the United States into World War II, in late 1941, abruptly ended American perfume atomizer production, including at DeVilbiss, as all of the United States' productive capacity and raw

materials were converted to war production. DeVilbiss zealously changed its production capacity to a variety of the war's essentials, including paint coating equipment, air compressors, and like products, that leveraged the company's existing engineering and production expertise in those product areas.

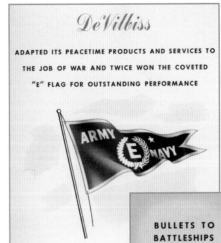

According to a company wartime brochure, "DeVilbiss adapted its peacetime products and services to the job of war, and four times won the coveted 'E' flag for outstanding performance." The brochure goes on to state that "in the eyes of the Army and Navy the performance of the people of DeVilbiss has been most outstanding, not because DeVilbiss produced guns, tanks or bullets, but because they have distinguished themselves in the difficult job of adapting their peacetime products to the job of war…it was for this adaptation that DeVilbiss was cited. For their unusual ingenuity and flexibility in developing, designing, and building the equipment that has contributed so much to the production and operation of America's war machine."[21]

DeVilbiss wartime brochure section showing the Army/ Navy "E" Flag, c. 1944. *Courtesy of BGSU Center for Archival Collections/ DeVilbiss Corporation Collection MS-604.*

DeVilbiss spray coating equipment provided protective covering for Quonset huts, bomb cases, depth charges, tanks, soldiers' helmets, amphibious landing craft, aircraft, PT boats, ships and submarines, and indeed much of the military hardware that required durable paint coatings. The company's air compressors were adapted to provide air supplies to Navy divers in ship salvage operations.

In 1944, at the height of the war production effort, Thomas DeVilbiss' son, Howard P. DeVilbiss, was named president, succeeding Allen Gutchess, who became Chairman of the Board.

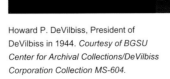

Howard P. DeVilbiss, President of DeVilbiss in 1944. *Courtesy of BGSU Center for Archival Collections/DeVilbiss Corporation Collection MS-604.*

BULLETS TO BATTLESHIPS

Huts

Thirteen-foot-wide corrugated metal sheets for fighters' huts receive a lusterless paint protection from ten DeVilbiss Automatic Guns that spray 120 gallons an hour.

Bombs

DeVilbiss Equipment helps keep up Allied bombing attacks by painting bomb cases inside and out—inside to guard the metal from the chemical reaction of the charge.

Depth Charges

The "ash cans" that are helping to blast the Axis subs out of the sea are given rugged paint protection against salt air corrosion with DeVilbiss Spray Equipment.

Pages from DeVilbiss wartime brochure describing its war production achievements, c. 1944. DeVilbiss would win a total of four "E" awards by the end of the war. *Courtesy of BGSU Center for Archival Collections/ DeVilbiss Corporation Collection MS-604.*

The End of the War, and Back in the Perfume Atomizer Business

The end of the war signaled the resumption of perfume atomizer production in 1946. The immediate post-war product line was relatively limited, constrained by scarcity of the necessary production supplies and bottles, and relied primarily on designs from the late pre-war period. By 1948, in an optimistic report to company shareholders, management reported that

> despite the unavailability of sufficient quantities of high quality bottles with which to manufacture perfume atomizers, excellent progress was made not only in filling a large percentage of orders for this line, but in reestablishing that market after discontinuing this luxury line during the war. With new products which are ready for release this year and improved deliveries of needed materials to manufacture them, we anticipate for 1948 a substantial increase in sales and production.[22]

Notwithstanding the departure of Mr. Vuillemenot in 1948, the company gradually expanded its perfume atomizer offerings as the peacetime economy developed and prosperity returned. DeVilbiss again relied on high quality imported glass, from Italy, France, and Germany, as well as some of its traditional American sources. By 1948, the company's industrial product lines had grown to account for 75% of the company's sales, with medical atomizers contributing another 15%. Perfume atomizers now accounted for just 10% of the DeVilbiss business. But the company remained committed to the perfume atomizer business. Again reporting to shareholders on the 1949 outlook, management noted that "the program of developing perfume atomizers entirely new in design is being accelerated."[23]

In 1951, the atomizer division, including both perfume atomizers and dropper bottles, Perfumizers, and medical products, was moved from the Toledo factory to a new Somerset, Pennsylvania plant on a site still occupied today by DeVilbiss Healthcare, clearly visible right beside the Pennsylvania Turnpike. In fact, when announcing plans for the plant in the company newsletter in June of 1950, it was noted that the location "has the important extra advantage of being seen from one of the world's busiest highways."[24]

In 1953, the shareholder report noted that "a luxury line of atomizers, utilizing imported glass, was added and proved to be very successful."[25]

From the 1950s until the company finally terminated perfume atomizer production in 1968, product offerings continued to include a broad range designed to meet changing consumer needs and tastes. Perfume atomizer lines included, among others, beautiful designs with top-quality glass from legendary Italian glassmakers Archimede Seguso, Toso and Moretti; West German firms Fuger & Taube, Hessen Glasswerks, Kristallglas, Steiner & Vogel and Wittig; and French glassmakers Waltersperger and Brosse. DeVilbiss also continued its U.S. glass sourcing relationship with the Fenton Art Glass Company, which began in 1940, and continued until 1953. Other American glass houses were also frequent suppliers in the 1950s and 1960s, including Carr-Lowrey, Morgantown, Imperial, Wheaton, and Kimble. In the final few years, there was also an addition to *The DeVilbiss Collection* lines of now highly-collectible Fairfield of Japan porcelain bottles, including figural bottles, children's items and the notable series of "Umbrella Girl" atomizers first introduced in 1960.

Collectors would be wise to add examples of these DeVilbiss post-war to plant closing creations, which carry on the company's long tradition of marrying the highest quality of metal fittings with the finest designs and production of some of the world's premiere glass houses.

Smart Innovations In Atomizers Now Available In DeVilbiss Line

President Howard P. DeVilbiss, left, discusses new atomizer designs with Willis Sanders and Don Fenstermaker, right. Fenstermaker was head of atomizer sales. *DeVilbiss News*, June 1950. *Courtesy of BGSU Center for Archival Collections/DeVilbiss Corporation Collection MS-604.*

From Design to Dresser: Making DeVilbiss Perfumizers, 1924–1929

How did a beautiful DeVilbiss Perfumizer come into being, and then find its way to a lady's dresser table? The process included several key steps. During the 1920s, principal DeVilbiss Company designers were Tom DeVilbiss and Frederic Vuillemenot. The process began by envisioning a new design, and then transforming the vision into a detailed artistic drawing of the soon-to-be new Perfumizer. The rendering would depict the finished product—the glass container, its decorations, and the metal atomizer or dropper fittings. When a design was finalized and agreed upon as a new addition to the product line, it was given to the production department for conversion to a detailed engineering specification and blueprint. Design patents would be applied for.

Decisions were made about the color or colors of the glass to be offered, metal fitting styles and finishes (gold, platinum, rhodium, chromium, nickel, etc.), cord and ball styles and colors, and estimated production quantities. Blueprints of the bottle blanks would be provided to selected glass manufacturing houses for price quotes, which often involved the cost of production of the required molds. Copies of blueprints in the authors' collection often are annotated on their reverse with penciled notes recording the names of glass companies quoting on production of the item, along with their quoted costs per unit as well as mold production costs, and in some cases which company was given the production contract.

When the finished blanks were received from the glass manufacturer, they would be routed to the decorating department's highly skilled artisans. Here, depending upon the bottles' design specification, they might be hand-engraved, given acid treatments to produce distinctive cut-back designs, have hand-applied enamel decorations, or receive enamel or iridized coatings on both the inside and the outside of the bottle. In the case of enamel coatings and designs, completed bottles would be loaded into the front side of the decorating lehr for the multi-hour, 80-foot conveyor belt trip that featured a gradual heat-up to over 1,000 degrees Fahrenheit, followed by gradual cooling back to room temperature, to fire on the enameling. Next, the bottles would be fitted with atomizer or dropper fittings: collars, spray tops, and in some cases, metal stems. Finally, the completed Perfumizer would be sent to the Packaging Department, and then either to shipping for immediate order fulfillment, or to inventory for future sale.

After a completed new bottle prototype was produced, it was professionally photographed. Beautiful photos were created for inclusion in the next product catalog, as well as for salesmen's specification and product description notebooks, and for internal production records. Photos were also used for both consumer magazine and trade publication advertising.

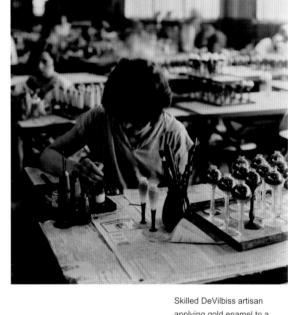

Skilled DeVilbiss artisan applying gold enamel to a Perfumizer, c. 1926, at a decorating table. *Courtesy of BGSU Center for Archival Collections/DeVilbiss Corporation Collection MS-604.*

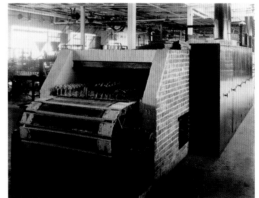

Decorating lehr installed at the new West Toledo factory with bottles beginning the trip through, c. 1925. *Courtesy of BGSU Center for Archival Collections/DeVilbiss Corporation Collection MS-604.*

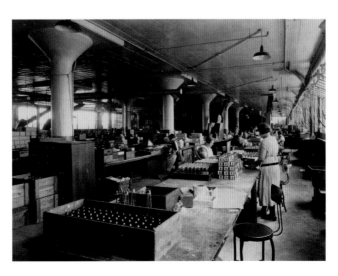

DeVilbiss Perfumizer packaging department, c. 1925. *Courtesy of BGSU Center for Archival Collections/DeVilbiss Corporation Collection MS-604.*

DeVilbiss Designers

In addition to the outstanding and creative designs of Tom DeVilbiss and Frederic Vuillemenot, other product designers authored Perfumizer and Perfume Sprayer and atomizer design patent applications on behalf of DeVilbiss. Those identified to date from patent applications are J. Schneider (1922), Paul B. Brown (1930–1934), an independent designer, John G. Rideout (1933), Joy B. Schmitt (1940) and Carl W. Sundberg (1941–1952).

Tom DeVilbiss and his team recognized that for a luxury item such as an expensive perfume bottle or set, which was often given as a very special gift, product packaging could be a very important part of the appeal and the sale of the product. Therefore in the early 1920s, the company developed its own package-making equipment. The Packaging Department designed and produced some exceptionally beautiful presentation boxes and cases. These were usually lined in padded satin, silk or velvet, adorned with silk tassels, and finished with beautifully colored and texturized coverings. Higher-end bottles were often sold packaged in luxury presentation cases. Cases were also offered to retailers separately, designed to accommodate a range of products—both single bottles and sets. Some very high-end packaging was also acquired from outside sources, such as the F. Zimmerman Company.

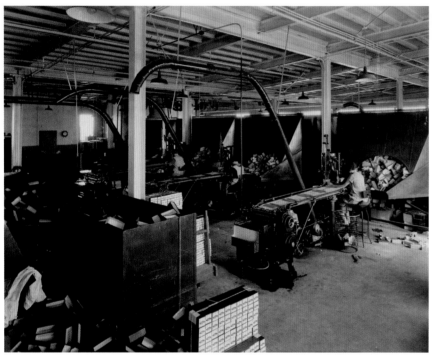

DeVilbiss box-making machinery and workers, West Toledo plant, c. 1925. *Courtesy of BGSU Center for Archival Collections/DeVilbiss Corporation Collection MS-604.*

DeVilbiss Perfumizer and Perfume Dropper bottles were known for their distinctively beautiful and creative metal collars, spray heads, and stopper designs. Today, atomizer collar and spray head designs often serve as one of the factors in the knowledgeable collector's confirmation that a bottle is a DeVilbiss product.

Metal fittings, usually the spray head and collar (or cap), were often gold-plated, but are also found with nickel, chromium, and rhodium plating, with both polished and matte finishes. "Green gold" was sometimes used to impart an antique finish. Green gold is an alloy of approximately 75 percent gold and 25 percent silver, resulting in a dull finish with a very slight green tint. DeVilbiss' plating quality was very high, as is evidenced by collectors often finding DeVilbiss bottles today with fittings that look nearly new—without any pitting, corrosion, or plating loss. DeVilbiss produced and plated its own metal fittings throughout the company's history. Exceptional attention was paid to the design and quality of fittings as they served to differentiate DeVilbiss bottles from its competitors' often lower-quality offerings.

Tom DeVilbiss' manufacturing philosophy called for making as many of the components of the company's product lines in-house as was possible. In fact, until 1951, all major components except for the glass bottles were produced by DeVilbiss. The engineers even designed and constructed the production machinery that made the Perfumizer metal parts, coatings, and rubber components. Beginning in 1925, Tom's son Howard ran a subsidiary company, the Howard Manufacturing Company, that produced the hoses and squeeze bulbs from raw rubber. The silk crocheted squeeze bulb nets were initially made on a piece-work basis by as many as 500 people working from home in and around Toledo. Tom had the vision of eventually producing his own glass, but passed away before he was able to put his dream into effect.

A fascinating process used a machine called the Maypole, which wound the silk thread coverings onto the Perfumizer hoses. Pure Italian silk twine of the finest quality obtainable was wound from spools in a system similar to the way children wind the Maypole with ribbon. Parts were assembled into Perfumizers mostly by women in a long production line, and packaged into both practical and exquisite boxes also produced by DeVilbiss in their Packaging Department. The process ended in the shipping department, where orders were assembled for fulfillment.

The Winning Concept

DeVilbiss was a creative company and involved its employees in product development. For example, in 1925, DeVilbiss held a contest and offered prizes for new ideas about how to make the crocheted coverings for the balls even more beautiful. Many entries were submitted, and the winner was the suggestion to crochet a pattern of beads into the silk threads. This was adopted for production and adorned some of the most luxurious Perfumizers.[26]

In a variation of the design process, occasionally DeVilbiss would purchase quantities of an existing design from a glass manufacturer already producing that perfume or cologne bottle for its own sales. It would have the manufacturer produce the same bottle, sometimes decorated and sometimes not, but with the bottle's neck unfinished and ready for a DeVilbiss atomizer or dropper fitting. Therefore, collectors today can find DeVilbiss Perfumizers featuring familiar bottles made, decorated, and sold by Steuben Glass Works, the Cambridge Glass Company, the Fenton Art Glass Company, H. C. Fry Glass Company, and Josef Riedel Glass, to name a few.

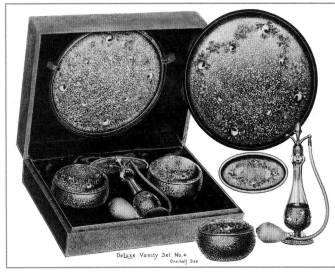

DeVilbiss deluxe vanity set Number 4, from the company portfolio of 1925.

Especially with the higher-end Perfumizers, often DeVilbiss would produce and offer related, similarly decorated products as sets for the dresser-top. Perfume atomizer and dropper sets can sometimes be found with matching dresser trays, powder jars, pin trays, hair receivers, bathroom bottles, vases, candlesticks, ash trays, cigarette boxes, and even tobacco humidors. In 1928, the company adapted a perfume bottle design—minus the stem and foot—to a line of salt and pepper shakers. These product ensembles were often packaged together with the perfume bottles in elaborate, luxurious wooden or leather-covered cases. Sometimes, the cases were suggested for secondary use after unpacking the sets, such as for handkerchief boxes, traveling vanity cases, or jewelry boxes.

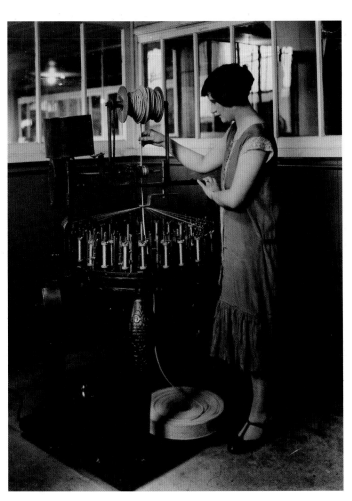

Employee operating the "Maypole"—the machine that braided the silk coverings for the atomizer tubes. *Courtesy of BGSU Center for Archival Collections/DeVilbiss Corporation Collection MS-604.*

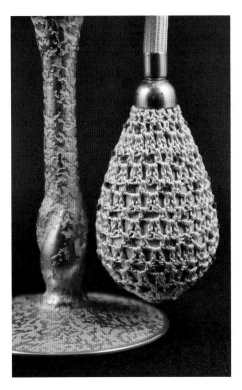

Hand-crocheted ball with orange beads which match the bottle color.

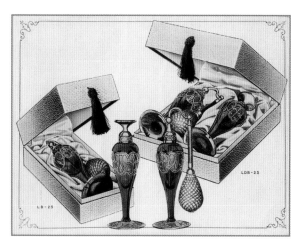

1925 salesman's portfolio depicting L-25 and DL-25 Perfumizer and dropper in satin-lined and tasseled presentation boxes.

Catalogs, Brochures, Advertising and Sales Promotion

Throughout its history in the Perfumizer business, DeVilbiss produced product catalogs nearly every year, as well as brochures, sales flyers, posters and more. These marketing materials were produced for the wholesale and retail trade, and not intended for consumers. Catalogs often listed wholesale quantity pricing as well as suggested retail prices. Sales materials took a variety of formats.

Full-color trade catalogs were produced annually from 1921 through 1932, with a few exceptions. While an earlier catalog from 1918 relied exclusively on monochrome photography, the widespread introduction of brightly colored glass and enamel decorations around 1920 occurred prior to the development of high-quality color photography. Nevertheless, the company needed to showcase these products in all their beauty. Product line portfolios from this period were produced from artists' skillfully hand-drawn and brightly colored product images arranged in luxurious leather bindings.

The catalogs were themselves works of art. In a mid-1920s flyer, circulated by DeVilbiss' Detroit-based catalog printer Stubbs Company, the printer quoted a DeVilbiss customer's tribute: *"We wish to compliment you on your recent catalogue; it is a work of art and gives promise of something more than dollar interest entering the commercial world."*

Stubbs goes on to assert, *"The DeVilbiss Catalogue, a gorgeous symposium of art and beauty, is subtly expressive of a certain rare quality of idealism blended with ideas; a torch to the imagination – persuasive, potent, compelling."* Here too we see the design genius of Fred Vuillemenot, who was often responsible for design of sales catalogs, advertising pieces and even product packaging.

Reversion to monochrome photography for catalogs in 1933 coincided with a substantial contraction of the product line, owing to the Great Depression and elimination of color from catalog product images. The August 1, 1933 catalog and price list is a four-page flyer with only fifteen products shown. As some strength returned to the economy in 1934, the product line was expanded to include over sixty items. Full-color catalogs were not re-issued until 1957.

During the 1920s, DeVilbiss produced small, colored, fold-out brochures for the consumer. These were sometimes included within the newly purchased Perfumizer's packaging, but also supplied in quantity to retailers as hand-outs with space on the brochure for the store to print its name, address, sales slogans, etc. These brochures were adorned by both originally-produced product images and those from existing catalogs, and sometimes included retail prices.

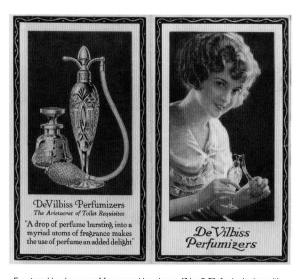

Front and back cover of four-panel brochure, 4" by 2.5", for inclusion with customer purchases, from 1921. The reverse of the brochure promoted medical atomizer sales.

DeVilbiss provided other forms of sales support materials to their retailers. The Sales Department created and supplied pre-designed store displays, featuring large posters surrounded by suggested assortments of Perfumizers and related vanity items that could be set up in store windows or on counter tops. The company also often offered electrotype images, which could be ordered for incorporation into store flyers or local advertising placements. Window and counter-top posters, measuring 34" in height, could also be ordered from DeVilbiss, and promotional copy was suggested for inclusion with local advertising.

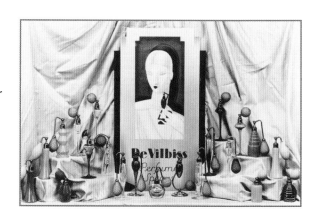

DeVilbiss Company mock-up of a suggested retail display featuring a poster surrounded by a pre-set DeVilbiss assortment of Perfumizers, 1929.

DeVilbiss Company Chronology

1878 — Thomas A. DeVilbiss born on July 29 in Hoagland, Indiana.

1885 — Dr. Allen DeVilbiss (1841–1917), a medical ear, nose and throat specialist, moves his family to Toledo and begins experimentation on a new type of medical atomizer to spray medicine into the nose and throat.

1888 — Dr. DeVilbiss forms the DeVilbiss Manufacturing Company in a garage at his home on Warren Street to produce medical atomizers, with five employees.

1895 — Dr. DeVilbiss moves his family to 1220 Jackson Street and builds an addition to house his growing business.

1903 — Company has grown to employ 15 factory workers.

1905 — Son Thomas A. DeVilbiss joins the company, purchases a one-half interest in the firm, and is placed in charge of operations. Medical atomizer sales reach $40,000 for the year.

1907 — Thomas DeVilbiss convinces his father, over his objections, to develop and market perfume atomizers. DeVilbiss Perfumizer production begins. New facility established in Windsor, Ontario for warehousing and distribution in Canada.

1908 — Employment at Jackson Street plant grows to 50.

1910 — The company moves from the home factory to larger quarters in a 30,000 square foot industrial building at 1302 Dorr Street in Toledo's west end. Paint spray gun production begins, with $30,000 in sales in the first year.

1912 — Rapidly growing company's employment reaches 100.

1915 — Company assets valued at $638,000.

1917 — Dr. Allen DeVilbiss dies, and Tom DeVilbiss takes over as president of the company.

1918 — DeVilbiss Manufacturing Company engages in production of supplies for World War I; ships 100,000 medical atomizers to Europe in one week. DeVilbiss pioneers technique for spray coating of the inside chamber of artillery shells to prevent premature detonation.

1919 — Company purchases 55-acre property in West Toledo from the Lenk Wine Company, closed due to Prohibition. Paint spray business moved into the winery while medical atomizer and Perfumizer production remain at Dorr Avenue plant.

1921 — Perfumizer sales for the year were $481,000.

1923 — Construction begins on large new manufacturing facility at the Lenk Wine Company property.

1924 — Construction completed on a new 200,000 square foot, three-story factory and all manufacturing operations move in. Winery building remains as a warehouse. Dorr Street plant closed.

— DeVilbiss sets up the Howard Manufacturing Company to produce rubber atomizer bulbs and tubes and paint sprayer hose from crude rubber.

— Tom DeVilbiss recruits Frederic Vuillemenot, a graduate of Ecole des Arts Décoratifs in Paris, who previously worked at the Libbey Glass Company, to join the company as head designer.

1925 — Tom DeVilbiss and Frederic Vuillemenot attend the Paris Exposition—*Exposition Internationale des Arts Décoratifs et Industriels Modernes*—a key influence on design through the 1930s.

— The DeVilbiss spray paint system is used on the buildings in the Paris Exposition of Fine Arts. "The French, acknowledged masters of all forms of perfume manufacture, have been hopefully outdistanced by the beauty and perfection of DeVilbiss Perfumizers, which are in demand even by the smart Parisienne herself." *Times*, May 1925 (drawn from company records).

1926 — Company's name changed from The DeVilbiss Manufacturing Company to The DeVilbiss Company. Sales of DeVilbiss Perfumizers peak at 1.5 million units and $2,200,000 worldwide.

1927 — Employment reaches 700 in Toledo, plus 500 piece-workers employed to crochet silk nets for squeeze bulbs. Perfumizer sales slump 33% during the year from the original estimate of $2,200,000 to actual sales of $1,452,000.

— 198,000 bulb nets imported from Germany. An additional 200,000 were ordered in October and an additional 200,000 were ordered on Jan. 1, 1928.

— Production of air compressors begins for the expanding market of gasoline filling stations.

1928 — Thomas DeVilbiss dies at age 50. Allen DeVilbiss Gutchess, son of Tom's sister Lida, becomes president.

1929 — In addition to new President Allen Gutchess, a new management team is elected including Frank A. Bailey, Vice President and General Manager; Walter W. Conklin, Secretary and Treasurer; Howard P. DeVilbiss, Assistant Secretary and Treasurer; and William F. Gradolph, General Sales Manager.

1934 — The DeVilbiss Company employs 800 people.

1939 — DeVilbiss spray equipment paints the Perisphere at the New York World's Fair.

1942 — Perfumizer production suspended to concentrate on war production.

1943 — The Under Secretary of War Awards the men and women of DeVilbiss the Army-Navy 'E,' officially known as the Army-Navy Production Award, recognizing the company for exceptional performance on the war production front. (Source: *DeVilbiss News*, January 7, 1943)

1944 — Howard P. DeVilbiss, Thomas' son, becomes President. Allen Gutchess continues on as Chairman of the Board.

1948 — DeVilbiss paint spray equipment accounts for 75% of the company's sales. Medical atomizers are 15% while Perfumizers are 10%.

1949 — Allen Gutchess resigns as Chairman of the Board for reasons of health. Floyd Green retires as sales manager of the atomizer division, after 32-year career with DeVilbiss beginning in 1916.

1951 — New plant built at Somerset, PA, for medical product and perfume atomizer production. DeVilbiss acquires Globe Products Company which manufactures spray gun fluid tips.

1955 — Elizabeth Arden, the owner of the Elizabeth Arden Beauty Salons, singles out the DeVilbiss booth at the Chicago Cosmetic Show and then placed a substantial order.

1957 — DeVilbiss acquires Newcomb-Detroit Company, manufacturing custom-built industrial finishing equipment.

1963 — New plant built on 23-acre site near the Detroit Metropolitan Airport. Plant sized doubled one year later.

1965 — Somerset plant expansion doubles its size.

1968 — Perfume atomizer and Dropper Perfume production terminated.

CHAPTER 2

The Early Years

1907—1919

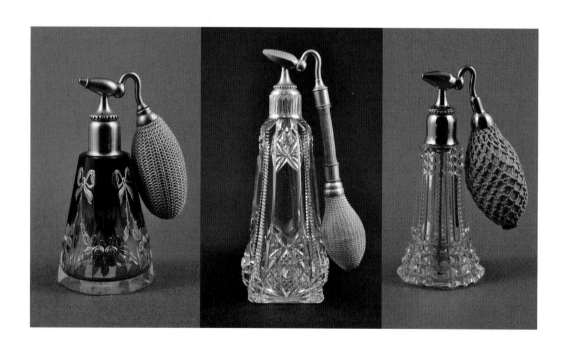

Bohemian cut and pressed glass examples of the period.

A New Business

The years immediately following the beginning of Perfumizer production surely were both excit-
ing and challenging for both the company and Tom DeVilbiss. He was introducing a new perfume-spray
product into the American market, capitalizing on his father's pioneering development of medical atomizer
technology, and expanding into a new and growing consumer market.

DeVilbiss needed to satisfy some necessary requirements to succeed in this new business. First, he
needed to design and produce attractive atomizer spray tops, since ones designed for medical purposes
were neither sufficiently visually appealing for a lady's dressing table nor suitable for the very fine spray of
perfume. Second, he needed new sources of attractive, decorative glass containers, since his new products
would appeal to the eyes and the heart, rather than utilitarian needs of medical necessity. Finally, he needed
retail distribution networks to sell his Perfumizers to consumers.

A Ready Retailer Network

With the DeVilbiss Manufacturing Company already a well-respected and established brand produc-
ing and selling medical atomizers, one of his biggest advantages, and surely one that he would have consid-
ered when deciding to go into the Perfumizer business, was that the company already had an established
network of retailers.

The many drug store outlets already selling DeVilbiss medical atomizers were often also in the busi-
ness of selling perfume and perfume bottles. So he could send his sales force, now equipped not only with
medical atomizers but also with Perfumizer samples, demonstrators and product literature, to his existing
customers. The two very different product lines were complementary, and he could leverage the company's
strong reputation for service and quality into a completely new product and market.

Tom DeVilbiss realized early in his assessment of the potential business opportunities that ineffective
and damaged perfume atomizers that were difficult to return and have repaired, presented a problem and
irritation for retailers. To respond to that customer need, he extended his company's guarantee to perfume
atomizers, long in place with medical atomizers, and it became the standard that represented company and
product quality—*The DeVilbiss Unconditional Guarantee.*

The DeVilbiss Unconditional Guarantee

*DeVilbiss Products are guaranteed to give complete satisfaction. Should the
least irregularity develop at any time, we will be pleased to promptly repair or
replace any that are returned to us, or to make any further adjustments to the
entire satisfaction of the dealer or user.*

In other words, if anything at all goes wrong with your Perfumizer, ever,
send it back and we'll fix it or replace it free of charge, no questions asked.

DeVilbiss was proud of its guarantee and used it both as a marketing
tool and a way to help differentiate itself from its competitors.

Early Merchandising

From the beginning, DeVilbiss marketed both product lines together at medical trade shows and industrial expositions, because of the strong overlap in the retailer base that attended such shows as buyers for their stores. Seen here is a DeVilbiss display at the Southern Medical Association Exposition in Hattiesburg, Mississippi, in November 1911, showing both Perfumizers and medical atomizers displayed together.

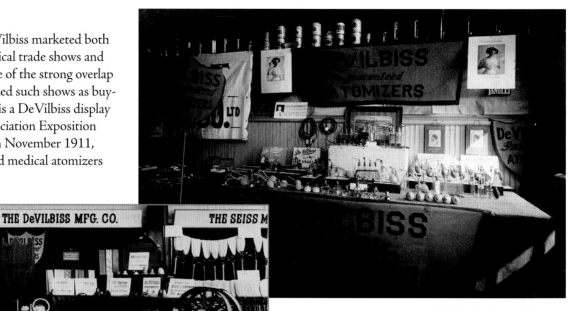

DeVilbiss Manufacturing Co. 1913 Toledo Industrial Exposition display. *Courtesy of BGSU Center for Archival Collections/DeVilbiss Corporation Collection MS-604.*

DeVilbiss Manufacturing Company display at 1911 Southern Medical Exposition. *Courtesy of BGSU Center for Archival Collections/ DeVilbiss Corporation Collection MS-604.*

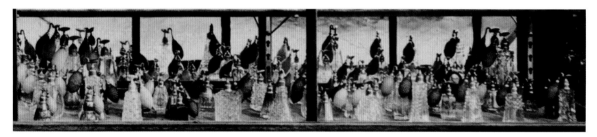

Expanded view of Perfumizer display shelf at 1913 Toledo exhibit. Note the many different types and sizes of bottles. *Courtesy of BGSU Center for Archival Collections/DeVilbiss Corporation Collection MS-604.*

A DeVilbiss display at the 1913 Toledo Industrial Exposition also shows both product lines, with medical products on the top two shelves and a very extensive variety of Perfumizers on the bottom shelf.

The striking array of Perfumizers—from large brilliant cut to smaller salt shaker types to colored and decorated Bohemian bottles—can be seen in the enlarged detail from the picture above.

With a common drugstore customer base, DeVilbiss marketed its medical and Perfumizer products together in company literature as well, as shown in this 1914 four-fold flyer depicting both lines. It is interesting to note that medical atomizers and nebulizers were at that time prescription, rather than over-the-counter, products, thus confining their sales to pharmacies.

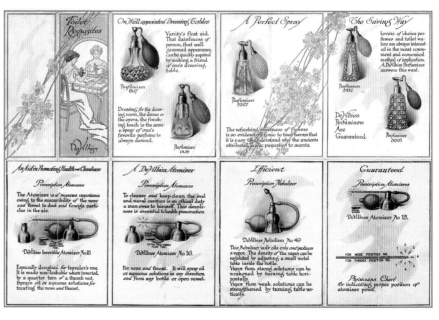

DeVilbiss 1914 product flyer promoting both Perfumizers and medical atomizers.

Merchandising Support

As noted earlier, both medical and Perfumizer products were sold side-by-side to the consumer at retail drug stores. DeVilbiss provided encouragement and assistance to its retailers, by attractively merchandising and displaying its products on counters and in store windows. It included what it considered excellent examples of in-store displays in its salesmen's catalogs, so they could provide merchandising ideas to their customers during sales calls.

The two photographs below, from 1915, showcase what DeVilbiss considered exemplary retail displays of both Perfumizers and medical atomizers together. A drug-store retailer by the name of Newcomer's, which was also merchandising soda, candy, camera supplies, and perfumes (much like today's drug stores), shows a store-front display window with five shelves of DeVilbiss products: medical atomizers to the left and Perfumizers to the right.

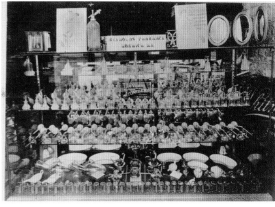

Reynolds Pharmacy, Norwich, New York display window (c. 1916).

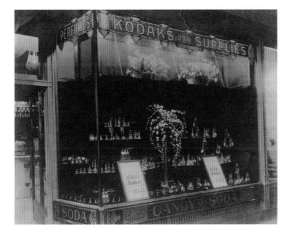

Newcomer's Drug Store display window (1915)

Another display features a customer testimonial from Burton E. Reynolds, of Reynolds Pharmacy in Norwich, New York. It was incorporated into DeVilbiss' 1915–1917 catalog. He sent the factory a photograph of his store window display prominently featuring DeVilbiss products along with this note:

> *Under separate cover I am mailing you a photo of a 6 foot American Beauty case in which I have maintained a permanent display of DeVilbiss Atomizers for the past year. I have more than trebled my sales on this line during that time, due I believe, to the display as well as to the well-known excellence of the goods.*

Again, products are displayed together, along with a sign announcing *"DeVilbiss Guaranteed Atomizers—Toilet—Medicinal."* DeVilbiss is encouraging its retailers to improve their merchandise displays on the promise of significantly increased sales.

Finally, DeVilbiss produced and made available display stands for its retailers. At right is a 1916 catalog offering of two sizes of displays: a two-shelf and a three-shelf design. Both are decorated with labels announcing the DeVilbiss Perfumizer line and guarantee.

One of Tom DeVilbiss' significant marketing challenges was to popularize the perfume atomizer as a mass-market consumer product when high quality atomizers with a product guarantee were not in widespread use. This required his salesmen to demonstrate the advantages of spraying, rather than dabbing or dropping, perfume to retailers and consumers. In December 1907, the year he began Perfumizer production, DeVilbiss applied for a patent for a perfume atomizer demonstrator to be used by his salesmen calling on drugstores and other retailers. It was designed to be fitted onto the tops of bottles already containing perfume.

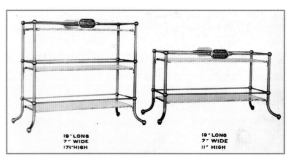

DeVilbiss Perfumizer display stands from the 1915–1917 catalog.

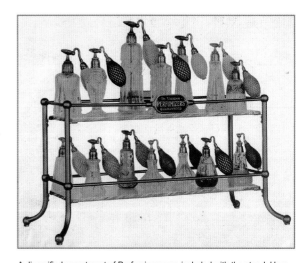

A diversified assortment of Perfumizers was included with the stand. Here Bohemian, cut, and salt shaker type Perfumizers are displayed on the two-shelf stand. This assortment includes a fourteen-item mix of three types: six large cut, five Bohemian, and three salt shaker type Perfumizers (1915–1917).

In describing his invention, DeVilbiss wrote:

The object of my invention is the provision of an apparatus of this class, which is cheap of manufacture, simple in its construction and operation, and capable of being easily cleaned, and which is particularly adapted for use as a demonstrating instrument by agents or other persons selling perfumes or the like.

A further object of my invention is the provision of an atomizer of simple construction, which is adjustable to control the amount of liquid admitted to the spray-head, and also to regulate the density of the spray emitted from the spray-head as the conditions of use or nature of the liquid may require.
—Patent Application for PN 899,007

Early Spray Tops

Having discussed the retail aspects of Tom DeVilbiss' new venture into Perfumizers, we now turn to the new product itself, looking first at the atomizer spray fittings. It appears that among the first, and quite possibly the very first of the spray heads produced by DeVilbiss exclusively for Perfumizers is shown fitted to a finely cut and polished salt shaker type bottle. This hexagonally-shaped spray head Perfumizer is seen with two identifying dates. Not visible in the photo is a tiny inscription stamped into the metal cup at the top of the squeeze bulb reading, "DeVilbiss, Toledo O. Pat'd Sept. 15, 1908." A 1908 patent implies a patent application date during 1907, the first year of Perfumizer production. DeVilbiss referred to this style spray head as the "pipe point top."

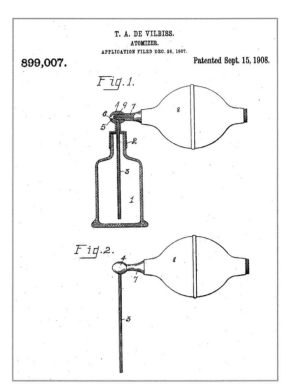

U.S. Patent 889,007 granted September 15, 1908 for perfume atomizer demonstrator.

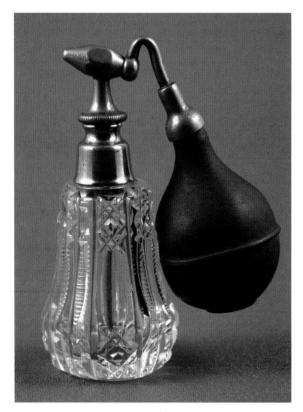

Perfumizer with 1908 spray top, indented collar and 1904 squeeze bulb (1908). Height 4.5".

This bottle, as with many Perfumizers of the period, is fitted with a chromium-plated collar that is indented at the top just below the threaded socket for the spray head. This design appears to have been adapted from the DeVilbiss medical atomizer line, as it is commonly fitted to early medical products. A few years later, collars were made straight-sided from the base to the top.

A second date identifier is the red rubber squeeze bulb, which bears the molded inscription, "Pat'd August 30, 1904. U.S.A." This shows the early use on Perfumizers of squeeze bulbs made for medical atomizers, since the patent date is three years prior to the introduction of Perfumizers.

Small-capacity Perfumizer with cut and polished bottle and nickel finished spray fittings (1910). Collar patented September 15, 1908. Height 3.75".

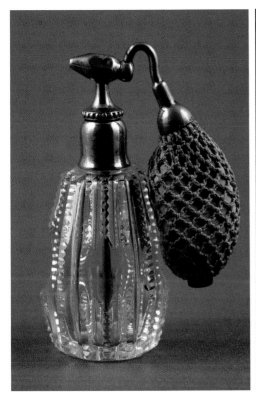

Crystal Perfumizer with hand cut and polished bottle with straight-sided collar (1910). Height 4.5".

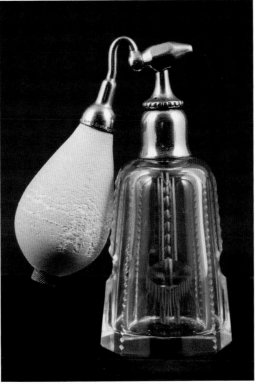

Hand cut and polished octagonal high quality crystal Perfumizer with a distinctive pattern cut into the bottle. Polished nickel spray fittings imprinted with patent date September 15, 1908; with rubber ball (1910). Height 4.75".

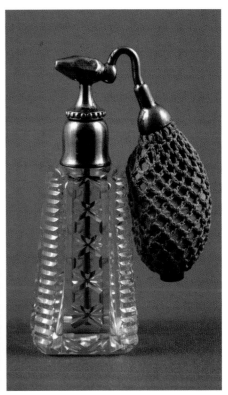

Perfumizer with nickel spray fittings and high quality crystal bottle four-sided, hand cut and polished, with a geometric cross-hatch and button cutting on each of the four sides. Metal siphon tube. Height 4.75".

An interesting variation of this spray top comes from the U.S. Patent and Trademark Office's patent archive, in this case U.S. patent number 932,604 granted August 31, 1909. This patent is not for the spray top itself, which had been patented eleven months earlier, but rather for the addition of a fitting placed between the spray top and the collar, shown in the patent drawing as Figure 3, the purpose of which DeVilbiss described in his patent application, where he wrote:

> My invention has for its object the provision of a simple and improved means for closing the communication both between the liquid receptacle and the spray-head and the atmosphere and such receptacle to enable the instrument to be packed, carried in the pocket, or inverted without liability of spilling the contents of the receptacle, thus enhancing its practicability and commercial value.

This documents an early effort to create "closure" technology to limit evaporation and spilling, which later became an important feature of many high-end DeVilbiss Perfumizers, from 1929 onward.

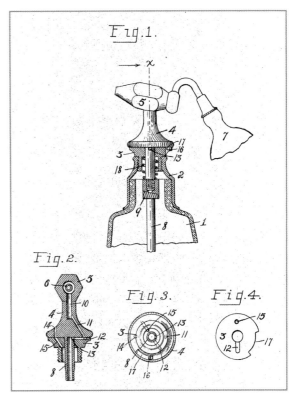

T. A. DeVilbiss Patent 932,604 granted August 31, 1909.

Early Relationship with the Fostoria Glass Company

Fostoria Glass Company was founded in Fostoria, Ohio, in 1887, but subsequently moved to its long-time primary location in Moundsville, West Virginia, in 1891. The company is known for high quality, clear and colored, pressed and blown tableware, candelabra, vases and other decorative items throughout almost a century in business. In the early 1900s, Fostoria provided blanks to DeVilbiss, primarily from shaker molds. Today, one finds identifiable Fostoria shapes and intaglio etched patterns fitted as DeVilbiss Perfumizers from throughout the 1910 decade. Different bottles by Fostoria have been confirmed with DeVilbiss records and early Fostoria catalogs of the period. The salt shaker 505 also corresponds to patterns found on Perfumizers shown in DeVilbiss' 1915–1917 catalogs.

A DeVilbiss Perfumizer with a Fostoria-supplied bottle appears at the left in an advertisement in a 1913 issue of *The Rotarian*, as well as in the DeVilbiss 1915–1917 catalog. Notice that in the ad, DeVilbiss named the bottle "Intaglio," the name given by Fostoria in its etching.

Another example of a bottle shape not found in a known DeVilbiss catalog, but shown in an advertisement in a 1912 *Bramble's Views*, Toledo, Ohio book (which included DeVilbiss Manufacturing Company's products) is the Perfumizer version of a salt shaker found in pattern 1819, shown in an early Fostoria catalog. This pattern was introduced in 1911 and discontinued in 1915. Several more examples establish that in the early years, Fostoria Glass Company was a major glass supplier to DeVilbiss.

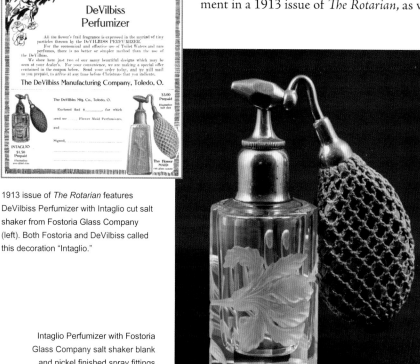

1913 issue of *The Rotarian* features DeVilbiss Perfumizer with Intaglio cut salt shaker from Fostoria Glass Company (left). Both Fostoria and DeVilbiss called this decoration "Intaglio."

Intaglio Perfumizer with Fostoria Glass Company salt shaker blank and nickel finished spray fittings (1913). Height 4.25".

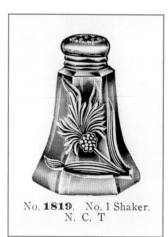

Fostoria catalog image of salt shaker showing Fostoria pattern 1819, Intaglio etched (1912).[1]

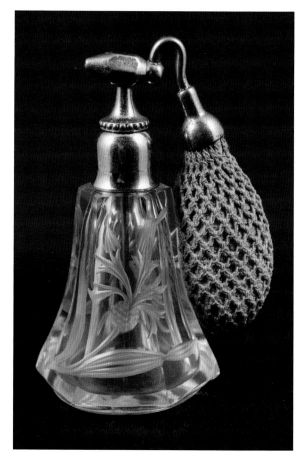

Perfumizer with crystal Fostoria Glass Company bottle faceted and Intaglio etched by Fostoria (1912). Height 4.5"

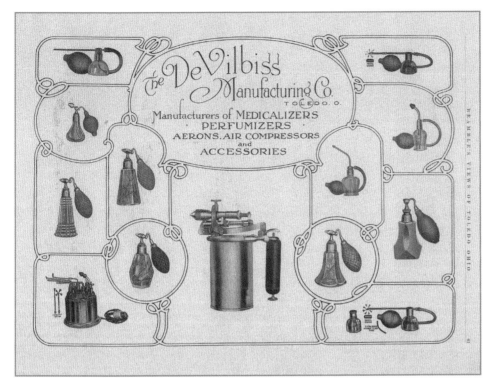

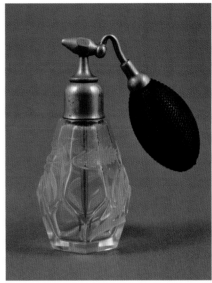

Unusual faceted Perfumizer seen in the ad at left with crystal Fostoria Glass Company bottle and decoration, Intaglio etched (1912). Height 4.5".

DeVilbiss advertisement from *Bramble's Views of Toledo* showing Perfumizers, medical atomizers, and industrial spray equipment (1912). *Courtesy of The Toledo Museum of Art.*

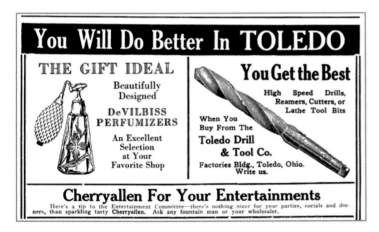

1914 DeVilbiss advertisement in *The Rotarian.*

By 1915, three different spray top designs were in production. This 1915 *Rotarian* advertisement shows each style: 1) the hexagonally-shaped spray barrel, 2) a ball-shaped head, and 3) a four-sided spray barrel. The top and bottom bottles feature the beading pattern at the base of the spray head, where the fitting screws into the collar attached to the bottle. The middle bottle has a finely notched pattern at the base of the spray head.

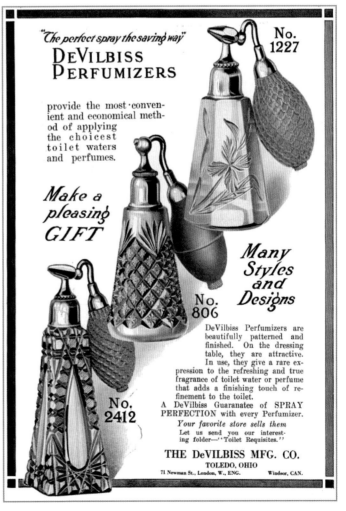

Ad from 1915 issue of *The Rotarian* features the three spray top styles then in use. Glass bottle at top right is by Fostoria Glass Company.

DESIGN.

T. A. DE VILBISS.

PERFUME ATOMIZER TUBE.

APPLICATION FILED AUG. 23, 1909.

40,790. Patented July 26, 1910.

Drawing from Design Patent
40,790 of July 26, 1910.

Bohemian green glass bottle
with distinctive floral enameled
decoration, c. 1910, with cube-
shaped nozzle. *Courtesy of Shari
Maxson Hopper.*

The round ball spray-top design patent was applied for in 1909 and granted on July 26, 1910, as shown in the drawing with Design Patent 40,790. An interesting variation of this design, from those more commonly seen, is the cube-shaped spray nozzle. This apparently saw limited early use and was soon replaced by the small, half-sphere nozzle shown in the *Rotarian* advertisement on page 47.

All three types also appear in the 1915–1917 catalog, but only on a few models. A fourth style, the rounded barrel spray top, was replacing the hexagonal and four-sided shape and it predominated in the majority of bottles shown. By 1918, both the hex and the four-sided barrels had disappeared entirely. The ball-shaped top was used on the less expensive end of the 1915–1917 line, and was used exclusively with screw-on collars. Its use was continued well into the 1920s. The beading pattern at the base of the spray tops was also being phased out and is gone from bottles by publication of the 1918 catalog.

Also noteworthy is that DeVilbiss was embossing their gold-plated Perfumizer collars, and more rarely spray tops, with decorative Art Nouveau patterns as early as 1915 and possibly before. While few are seen today, they appear prominently in the 1915–1917 catalog adorning the higher end of the line, from the 7000 series through the 11000 series. By 1918, all collars were again featuring smooth non-embossed finishes.

An additional design variation worth noting on the early spray tops is the style of the beading pattern at the base. One style features rounded beads and the other a finely notched pattern, and both are seen together in the 1915–1917 catalog. Their presumed purpose is to give the user an extra bit of finger traction when tightening or loosening the spray top from the bottle.

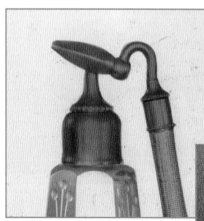

Example of four-sided barrel from
1915–1917 catalog.

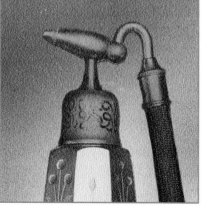

Example of Art Nouveau embossed collar
from 1915–1917 catalog, also showing
rounded spray barrel.

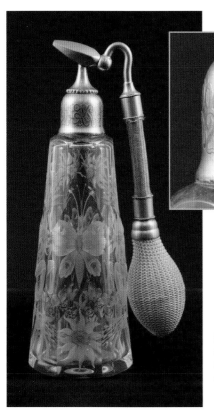

Art Nouveau pattern embossed on collar, close-up.

Rare example of Art Nouveau embossed design on collar, with fine butterfly and ribbon engraving on bottle (1915–1917). Height 8".

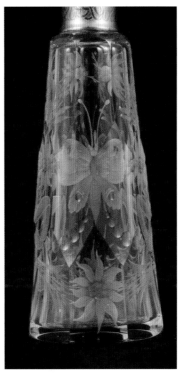

Close-up of butterfly engraving.

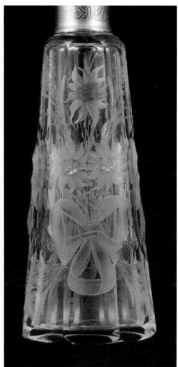

Close-up of ribbon and bow engraving.

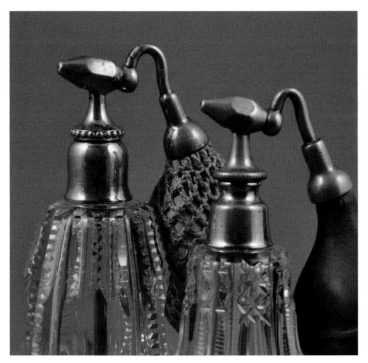

Examples of rounded beading and finely notched pattern at the base of spray tops.

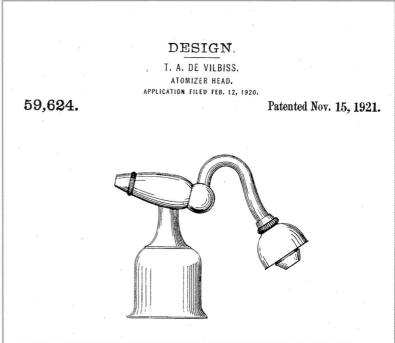

DESIGN.

T. A. DE VILBISS.
ATOMIZER HEAD.
APPLICATION FILED FEB. 12, 1920.

59,624.

Patented Nov. 15, 1921.

Design Patent 59,624 granted to Thomas DeVilbiss on November 15, 1921 for round-barrel Perfumizer spray top.

Perfumizer with Fostoria Glass Company crystal bottle and decoration, Intaglio etched pattern, and rare embossed collar and spray top with leaf pattern (c. 1915). Height 5".

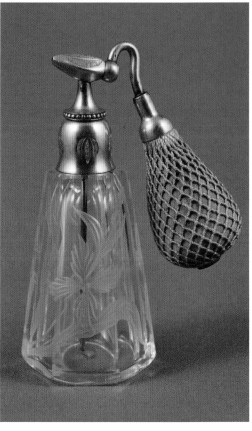

A rare and beautiful Brilliant Cut bottle with gold finished embossed collar and matching embossed pattern on the spray head (c. 1915). Height 7.25".

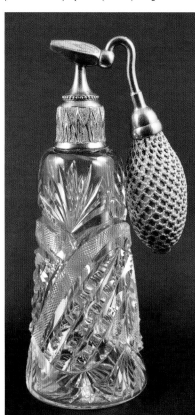

Rarely seen embossed collar and spray top on Intaglio cut Perfumizer. Bottle supplied by the Fostoria Glass Company (c. 1915). Height 5".

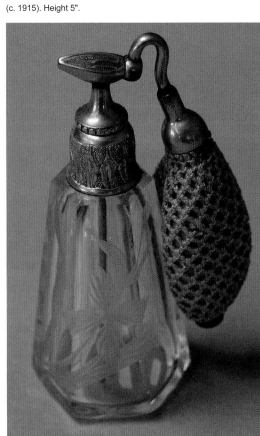

Close-up of the embossed collar and spray top.

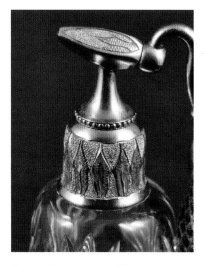

Close-up of embossed spray fittings.

Close-up of cap and spray head.

The six major components of the atomizer fitting include, from the bottom up and to the right as viewed in the photos on these two pages: (1) the collar, fitted to the glass container; (2) the base of the spray top (also known as a spray head), which screws into both the collar below and the spray barrel above; (3) the spray barrel; (4) the tube leading from the spray barrel to the squeeze bulb, which screws into the back of the spray barrel; (5) the bulb cup, which screws onto the tube and onto which the bulb screws; and (6) the bulb itself. These components are usually not detachable from one another, because they were often assembled before being plated, and the plating process created a bond that held the parts together.

A seventh component, which is not visible, is the siphon tube. This tube screws into the bottom of the spray top and extends down into the bottle. Prior to 1920, these tubes were made of either lead (earlier) or brass (later). In 1920, the glass siphon tube was introduced and remained the standard for Perfumizers until much later in DeVilbiss' production history, when it was replaced by plastic.

A final point of interest is that apparently in the early years, and as was allowed by patent law at the time, DeVilbiss did not always file patent applications for their atomizer designs before bringing them to market. In fact, they were often submitted well after, even years after the designs and fittings were in production and for sale. An example is Design Patent 59,624, for the round-barrel spray top, which was applied for by Tom DeVilbiss on February 12, 1920 and granted on November 15, 1921. However, bottles with this spray top appear prominently in the DeVilbiss 1915–1917 catalog. The "Fairy" bottle at right was featured in the 1915–1917 catalog.

Perfumizer 2429 with a four-sided high quality cut and polished crystal bottle, with the front side satin-finished completed by an intaglio relief of a "Fairy" in a garden. Polished nickel spray fittings. Height 4.5".

Close-up of the intaglio Fairy relief.

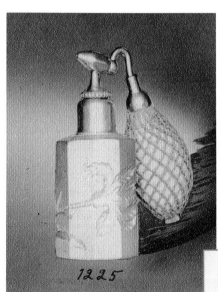

DeVilbiss 1225 Perfumizer with Fostoria Glass Company hexagonal intaglio cut bottle from 1915.

Glass Bottles

To appeal to his market, DeVilbiss needed sources of beautiful glass containers onto which to fit his atomizer hardware. Being a marketing man, he intuitively knew that to maximize his business opportunity, he must offer both a variety of styles and a range of prices, from inexpensive to luxury, all with an emphasis on quality. His product strategies worked early on, for by 1912, DeVilbiss had sold nearly 34,000 Perfumizers of many different types, and projected sales of nearly 50,000 bottles in 1913.[2]

Tom and the other leaders of DeVilbiss capitalized on the fact that Toledo, Ohio, was situated close to a burgeoning American glassware manufacturing industry centered in Ohio, Pennsylvania, and West Virginia. Looking for immediately available bottles to marry to its newly-designed spray heads, the company began by purchasing salt shakers from local area glass companies.

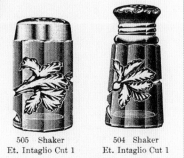

505 Shaker
Et. Intaglio Cut 1

504 Shaker
Et. Intaglio Cut 1

Example on the left, Shaker 505 from the Fostoria Glass Company with Intaglio cutting corresponds to Perfumizer 1225 in 1915.[3]

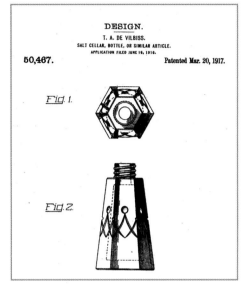

DeVilbiss design patent 50,467 (1917).

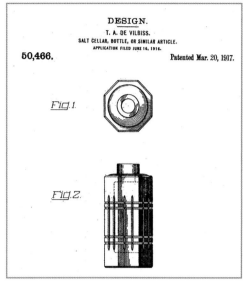

DeVilbiss design patent 50,466 (1917).

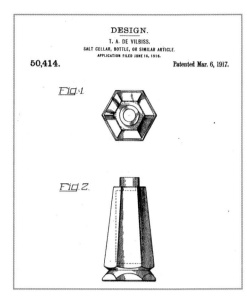

DeVilbiss design patent 50,414 (1917).

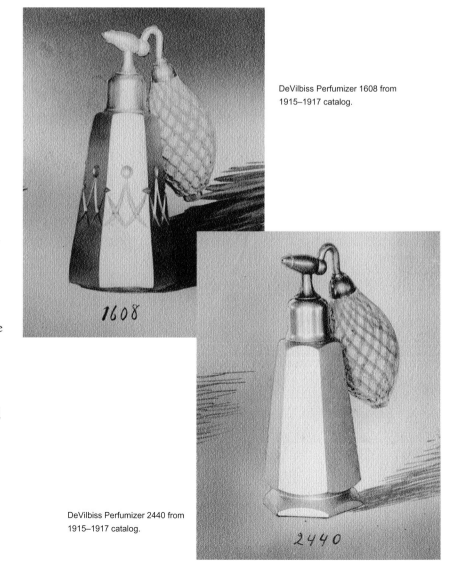

DeVilbiss Perfumizer 1608 from 1915–1917 catalog.

DeVilbiss Perfumizer 2440 from 1915–1917 catalog.

Although actively acquiring salt shakers from glass manufacturers from the beginning, Tom De-Vilbiss did not content himself with only purchasing bottles already designed by the glass suppliers. He designed and patented some of the salt shaker bottles himself, and then bid them out to his glass suppliers for production. Patents for three such designs were applied for by T. A. DeVilbiss on June 16, 1916.

These three patents were granted to T. A. DeVilbiss in March 1917, for "Salt Cellar, Bottle, or Similar Article." Two of Tom DeVilbiss' three 1917-patented bottle designs had already appeared as atomizers in the DeVilbiss 1915–1917 catalog.

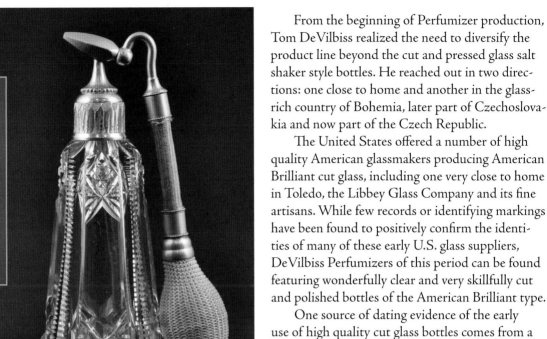

From the beginning of Perfumizer production, Tom DeVilbiss realized the need to diversify the product line beyond the cut and pressed glass salt shaker style bottles. He reached out in two directions: one close to home and another in the glass-rich country of Bohemia, later part of Czechoslovakia and now part of the Czech Republic.

The United States offered a number of high quality American glassmakers producing American Brilliant cut glass, including one very close to home in Toledo, the Libbey Glass Company and its fine artisans. While few records or identifying markings have been found to positively confirm the identities of many of these early U.S. glass suppliers, DeVilbiss Perfumizers of this period can be found featuring wonderfully clear and very skillfully cut and polished bottles of the American Brilliant type.

One source of dating evidence of the early use of high quality cut glass bottles comes from a 1947 DeVilbiss Company internal newsletter. In a sidebar story, Mrs. Myrtle Roth proudly shows a large, beautifully clear, and finely cut Perfumizer. The bottle was given to her personally by Dr. Allen DeVilbiss, as a wedding present in 1910, the same year the company moved from Jackson Avenue to the larger plant on Dorr Street.

Close-up of cap embossed in a leaf pattern.

Tall Perfumizer with brilliant cut bottle, gold finished cap embossed in a leaf pattern (c. 1915). Height 8".

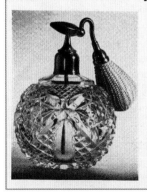

Prized Perfume Spray Was Gift Of Dr. Allen DeVilbiss

The handsome perfume spray on the left was given by the founder of the DeVilbiss Company, Dr. Allen DeVilbiss, as a wedding gift to one of his employees thirty-seven years ago. Today it is cherished highly by that former DeVilbiss associate, Mrs. Myrtle Roth, of 19 Palmer Street, who uses it regularly after all these years. She is pictured on the right with the spray. On the mantel may be seen a photograph of Thomas A. DeVilbiss, son of the founder, who as the late President of the DeVilbiss Co., was also well known to Mrs. Roth. It was in the original factory at Jackson Ave. and 13th Street where Mrs. Roth was employed in the maufacture of early medicinal and perfume sprays and she relates that she was the envy of all the other workers when she received a wedding gift from the hands of "Dr. Allen" himself.

Article from 1947 *DeVilbiss News* company newsletter. *Courtesy of BGSU Center for Archival Collections/DeVilbiss Corporation Collection MS-604.*

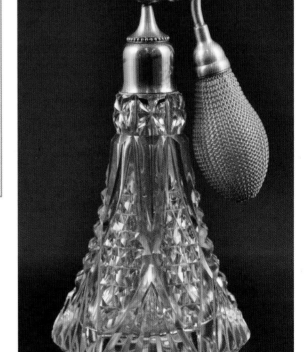

Tall Perfumizer with finely hand cut and polished crystal bottle (c. 1912). Height 6.5" x 3.5" wide.

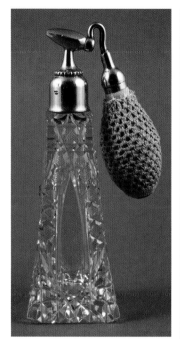

Perfumizer 2412 with hand cut and polished bottle (c. 1914). Height 6". Patent September 15, 1908.

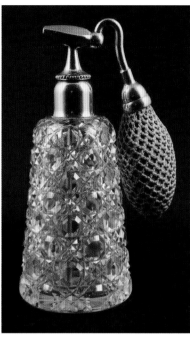

Perfumizer 3003 with finely hand cut and polished bottle (c. 1914). Height 5.5".

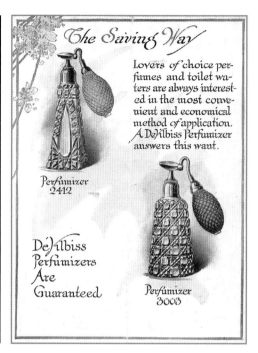

DeVilbiss flyer c. 1914 featuring Perfumizers 2412 and 3003.

The two bottles shown here demonstrate both DeVilbiss and American Brilliant quality in examples that also showcase the high quality gold plating characteristic of DeVilbiss. Both are shown in a 1914 De-Vilbiss flyer as Perfumizer 2412 and Perfumizer 3003, and feature identical spray tops as the one shown on Mrs. Roth's 1910 bottle.

The cut pattern on Perfumizer 3003 was done by a number of glass companies of the period, including C. Dorflinger & Sons, under the pattern name of Hob Diamond & Lace. Other companies had produced the pattern, but most had discontinued making American Brilliant glass by the time this bottle was offered by DeVilbiss. Without a positive identification of the maker(s), it is certain is that both bottles are highly prized, beautifully clear, and finely cut and polished by a highly skilled glassmaker (circa 1910).

Early Packaging

If it is difficult to find great examples of Perfumizers produced nearly a hundred years ago, even more remote is the discovery of the packages they were sold in, no doubt often discarded soon after removal of the contents. Fortunately, a few examples have survived. Shown here is the box and box top of a lovey light cardboard box, 3.75" in height by 5.75" in length by 2.5" in depth.

This lovely box contained the even lovelier cut crystal bottle by the Cambridge Glass Company shown on page 55 with blue silk netting on the bulb matching the color of the floral design of the box. It was wrapped in tissue, and enclosed was an instruction sheet for cleaning the atomizer top. The instructions identify DeVilbiss' terminology for this style spray head as the "pipe point top," and noted a patent date of August 31, 1909.

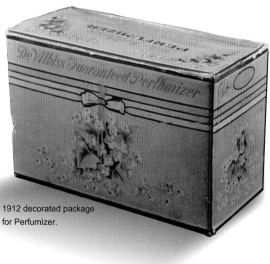

1912 decorated package for Perfumizer.

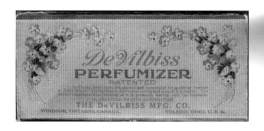

Top panel of package.

An early example of luxury presentation and packaging contains a circa 1918 crystal Perfumizer 3003, with a hand-cut floral pattern and polished bottom. The top of the presentation case is padded red leather, with white border piping and heat-stamping, "Perfumizer—DeVilbiss." "Directions for Cleaning" were enclosed with this product as well.

A factory paper label on the bottom of the Perfumizer identifies it as product number 3003, which points out that at this early stage of its Perfumizer sales, DeVilbiss sometimes re-assigned the same product number to a later bottle. We earlier pictured (see page 54) an entirely different bottle from 1914, also clearly numbered in the catalog as Perfumizer 3003, and sold in the 1915–1917 catalog.

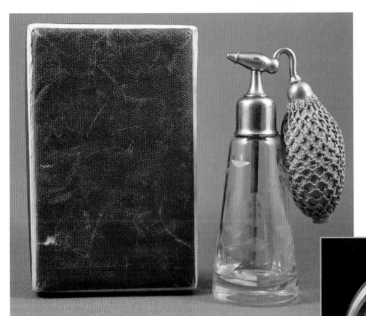

Perfumizer 3003, with a light red silk squeeze ball cover and red leather-topped presentation box (c.1918). Height 5".

DeVilbiss sticker from the 3003 bottle.

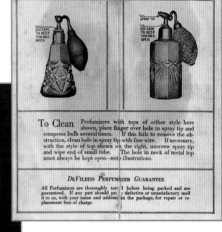

Directions for cleaning Perfumizers, c. 1918.

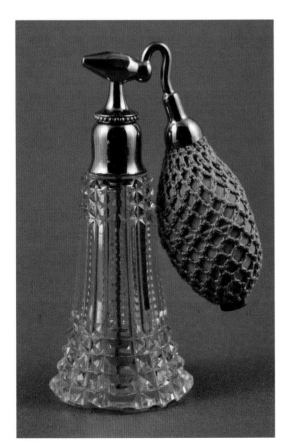

Perfumizer that was packaged inside the box opposite. Cut crystal bottle made by the Cambridge Glass Company; pipe point top, chrome fittings and blue silk net (1912). Height 5".

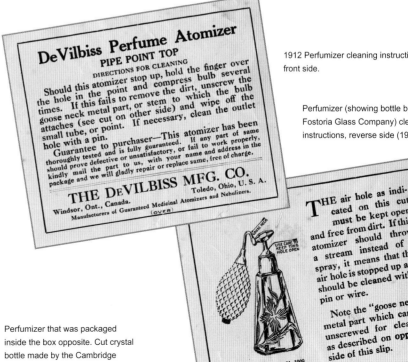

1912 Perfumizer cleaning instructions, front side.

Perfumizer (showing bottle by Fostoria Glass Company) cleaning instructions, reverse side (1912).

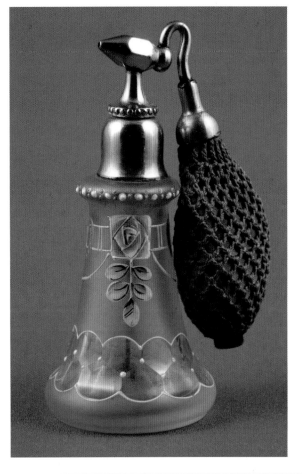

Bohemian Perfumizer with blue satin-finished polished to clear bottle, and enamel rose and leaf pattern and two gold enameled "horseshoes" on either side of the bottle (1908–1913). Height 5".

DeVilbiss acid stamp on base with partial red factory sticker.

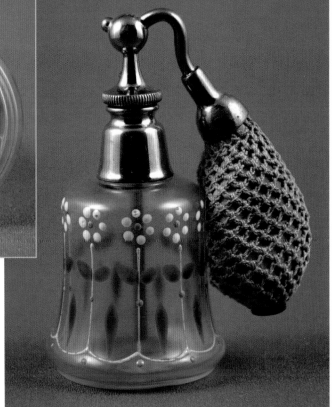

Bohemian bottle satin-finished with green, white and orange enamel floral decoration. Ball-shaped spray top, with older collar from the medical atomizer line (c. 1908–1918). Height 4".

Bohemian Bottles

Soon after the introduction of the initial DeVilbiss Perfumizers, Tom DeVilbiss went to Europe in search of fine bottles, as well as talented artisans to work in his plant in Toledo. He returned with a considerable variety of decorated bottles to be fitted with his atomizer hardware.

Shortly thereafter, there began to appear a prolific variety of DeVilbiss Perfumizers with bottles of both gaily colored and luxuriously elegant Bohemian glass, finely decorated in colorful and often elegant enameled floral patterns, some in gold and sometimes cut.

Catalogs, flyers, or advertisements have not yet been found by the authors depicting these styles, but the bottles themselves have been found that are referred to in company correspondence that discusses the significant variety of Bohemian bottles available to retailers and for salesmen's use. Many are seen in company photographs, store and trade show exhibits, and trade journals of the period. It appears that the supply of these bottles stopped abruptly about 1915, likely a result of World War I overtaking Europe; thus ending any possibility of exports from Bohemia or most other countries on the continent. The atomizer fittings found on Bohemian bottles suggest they were being sold at least through 1916, as several have been seen with the round, spray-top barrel introduced that year. One example is shown (see page 57) with an original c. 1920 collar, and another (see page 59) has a glass siphon tube suggesting 1920 or later. This suggests the possibilities that either DeVilbiss resumed sourcing from Bohemia after the end of the war or, more likely, that the pre-war supply lasted until about 1920. In either case, they were fitted with the spray tops that were current to the year and widely sold in the United States.

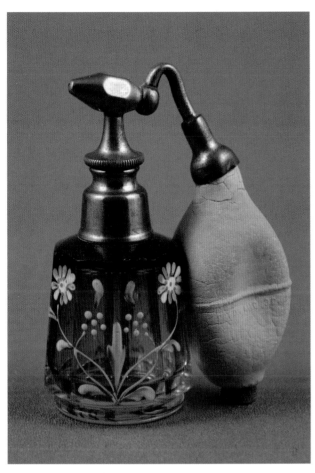

Signature "DE VILBISS TOLEDO, O" molded into the base of the bottle.

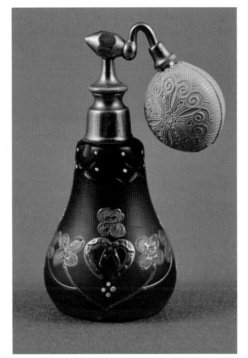

Perfumizer with a smooth satin finished deep red Bohemian bottle with gold enamel horseshoe and four leaf clover decoration and cross-hatch cutting at the neck; design molded into rubber squeeze ball (c. 1908–1918). Height 4.5".

High quality Bohemian Perfumizer with 10 hand-cut and polished facets of cranberry glass fading to clear with enamel floral and leaf decoration and a DeVilbiss acid stamp signature on the bottom (c. 1908–1918). Height 4".

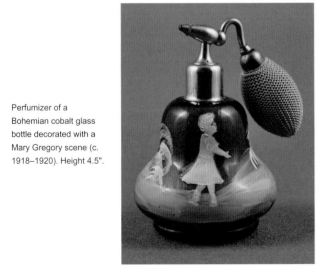

Perfumizer of a Bohemian cobalt glass bottle decorated with a Mary Gregory scene (c. 1918–1920). Height 4.5".

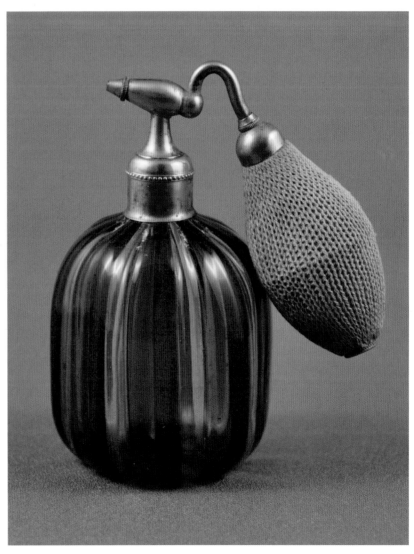

Perfumizer with Bohemian tri-color bottle with vertical ribs (c. 1919). Height 4.5".

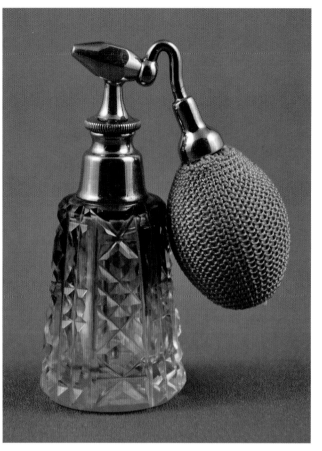

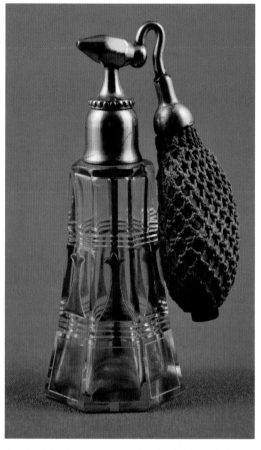

Green shading to clear glass Bohemian Perfumizer, cut and polished, chrome fittings (c. 1908–1918). Height 4".

Beautiful Bohemian clear cut and polished DeVilbiss Perfumizer, octagonal faceted with green and gold flashed enamel decoration (c. 1908–1918). Height 5".

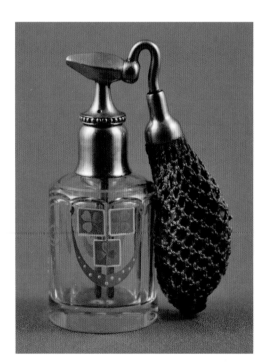

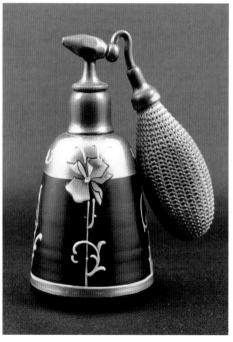

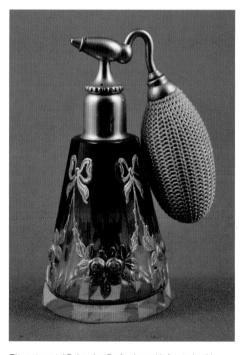

High quality faceted hand cut and polished crystal Bohemian DeVilbiss Perfumizer with green and gold shamrock enameled decoration (c. 1908–1918). Height 4".

Satin cobalt blue with gold enamel Bohemian Perfumizer with a lavender stylized flower decoration (c. 1908–1915). Height 4.5". *Courtesy of Jim and Carole Fuller.*

Elegant crystal Bohemian Perfumizer with faceted gold decorated amethyst glass fading to clear. This Perfumizer is an example that combines the new spray barrel with older spray top base (c. 1915) Height 4.25".

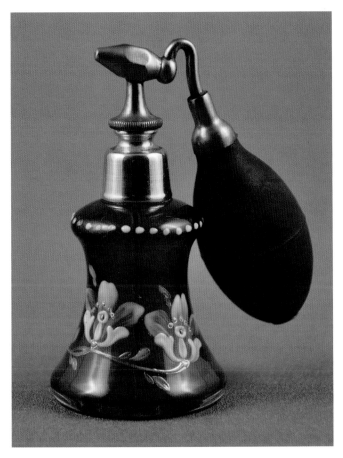

Perfumizer with a Bohemian cranberry bottle and white enamel decoration, and rubber squeeze bulb (c. 1908). Height 4".

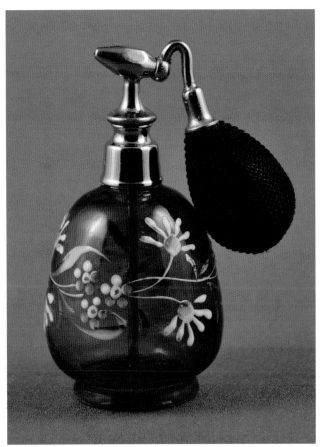

Perfumizer with a Bohemian bottle of cranberry glass with multi-colored enamel floral decoration. Script signature on the bottom, DeVilbiss Toledo. Height 4.5".

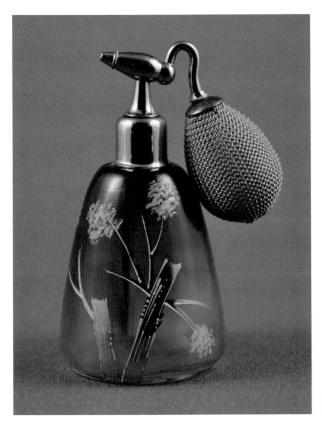

Bohemian enameled bottle with chrome-plated fittings and glass siphon tube (c. 1919). Height 4.5".

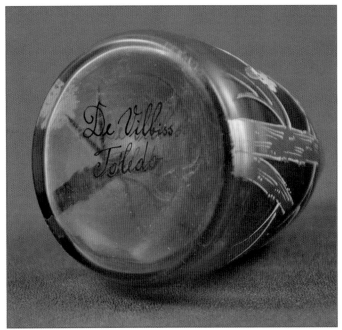

Note the black enamel script signature on base.

DeVilbiss 1915–1917 Catalog Hand-Illustrated and Colored

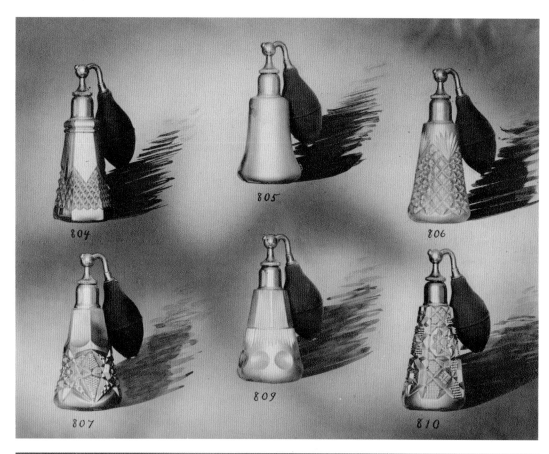

Perfumizers 800 Series.

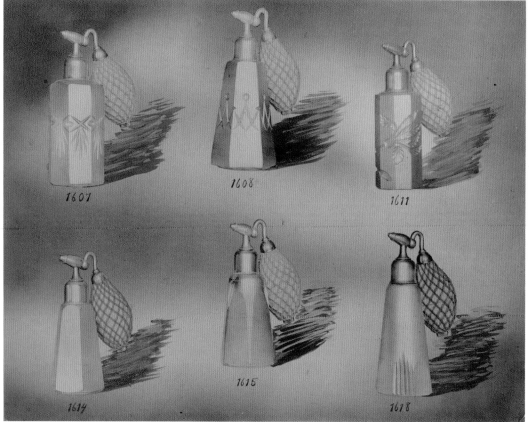

Perfumizers 1600 Series.

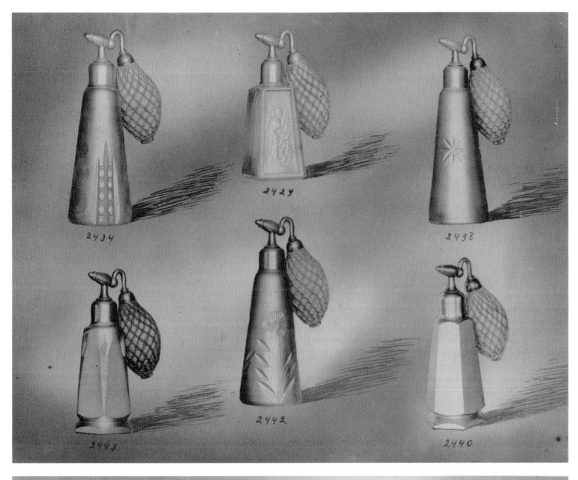

Perfumizers 2400 Series.

Perfumizers 4800 Series.

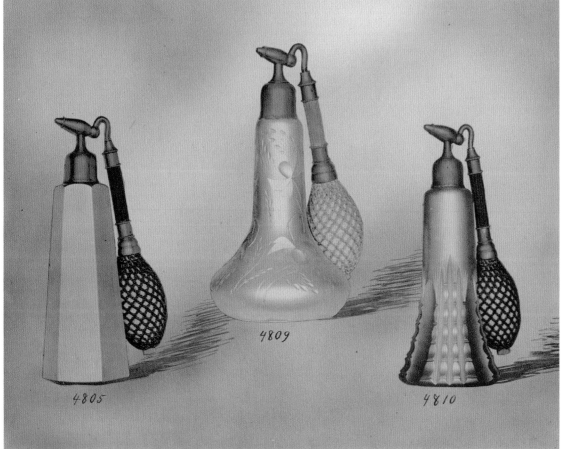

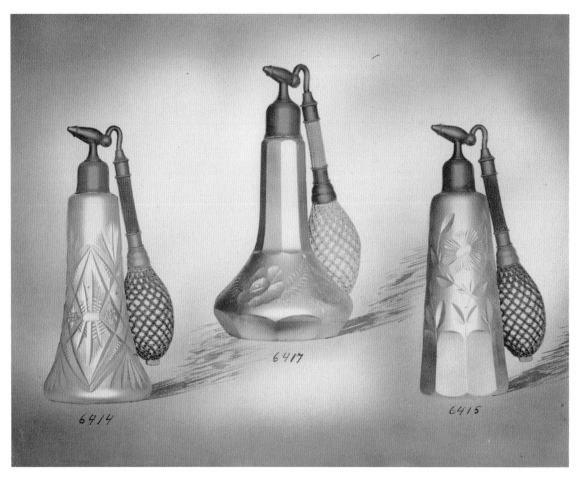

Perfumizers 6400 Series.

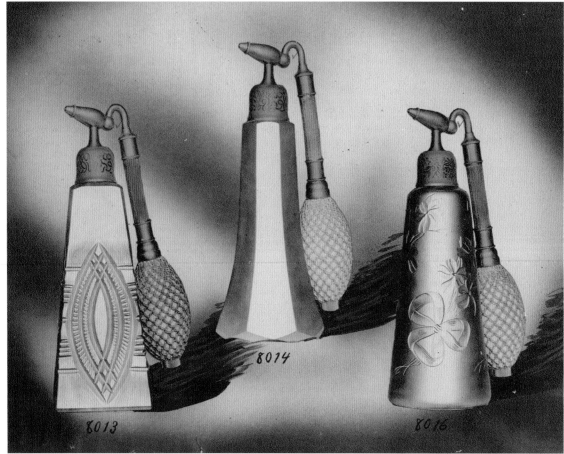

Perfumizers 8000 Series.

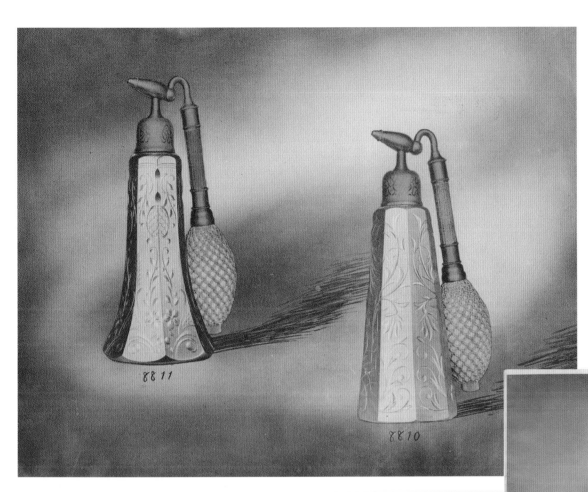

Perfumizers 8000 Series.

8811

8810

6000 Series "Jumbo." Height 14.4".

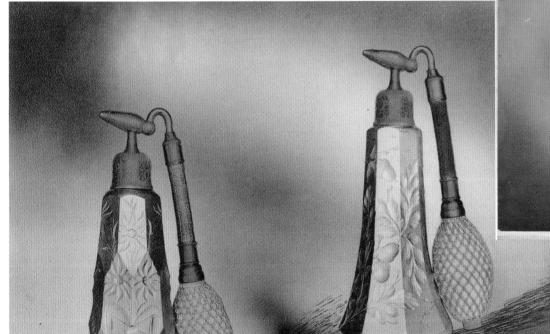

11210

11211

Perfumizers 11000 Series.

1918 Personal Pocket Catalog

The DeVilbiss Perfumizer shown appears on the selected pages that follow, which are from a personal, leather-bound, pocket catalog, known as Catalog "A." It has "T. A. DeVilbiss" and "The DeVilbiss Mfg. Co., Toledo, Ohio" gold-stamped on the front cover. This catalog includes both medical and Perfumizer products.

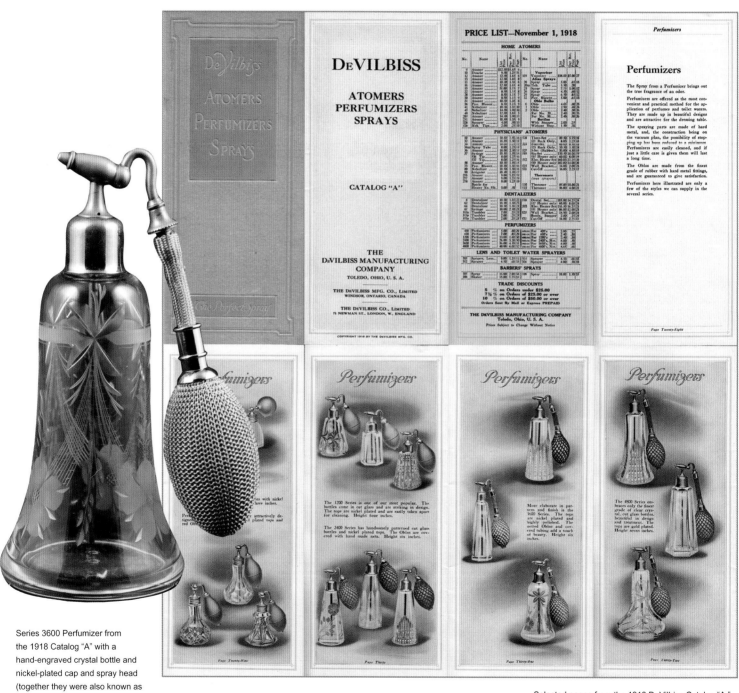

Series 3600 Perfumizer from the 1918 Catalog "A" with a hand-engraved crystal bottle and nickel-plated cap and spray head (together they were also known as "the tops"). Height 6".

Selected pages from the 1918 DeVilbiss Catalog "A."

1918 Salesman's Photo Book

The following images are selected pages from a 1918 DeVilbiss Company salesman's photo book.

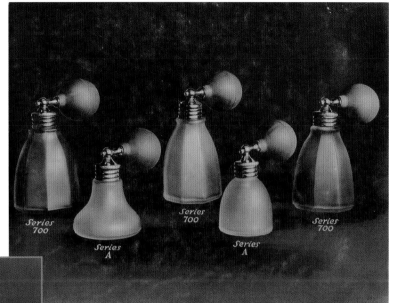

Perfumizer Series A and 700.

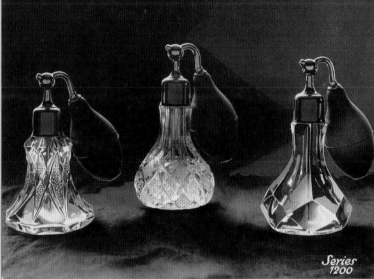

Perfumizer Series 1200.

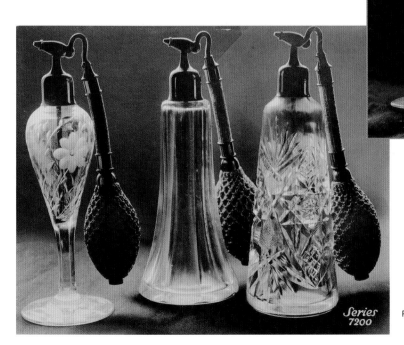

Perfumizer Series 7200.

Perfume droppers 2000, 3000, 6000.

The Roaring Twenties and the Great Depression

1920 –1932

Spectacular Growth

With the war in Europe over, America was a newly emerged economic, political, and military power. The advent of mass-production, the discovery and exploitation of huge reserves of cheap oil, rapidly advancing technology based on widely available electricity, and legions of immigrants seeking a better life, who supplied abundant cheap labor, all contributed to the rapidly growing American economy and culture of consumerism. The huge production capacity developed for the war was now repurposed, to produce automobiles, washing machines, refrigerators, and a host of other consumer products for the daily lives of newly affluent people.

Among the new luxury goods were women's fashions generally and expensive fragrances from France specifically. The great French perfume houses of Dior, Coty, Corday, Chanel, Caron, Guerlain, D'Orsay, Roger et Gallet, Jean Patou, Lanvin, and countless others saw the opportunity and expanded sales aggressively into the United States, where they found a receptive and rapidly growing market.

In the pre-war literature, DeVilbiss promoted its Perfumizers as the most "convenient and economical" method of applying perfume. But later, in a shrewd new marketing strategy, DeVilbiss asserted the notion that perfume sprayed in a fine mist was more alluring. A 1921 DeVilbiss catalog statement that became almost a mantra within the company claimed that "*A drop of perfume bursting into a myriad atoms of fragrance makes the use of Perfume an added delight.*"

The message resonated. What followed over the next few years was a period of the DeVilbiss Company's spectacular growth: a ten-fold increase in DeVilbiss Perfumizer sales, expansion into Europe, and a large, new factory in Toledo to meet exploding demand. Their growth was in concert with their amazing proliferation of avant-garde styles, designs, colors, decorations, and packages, all beautifully portrayed in the opulent, color catalogs of the mid-1920s. DeVilbiss was, in the modern vernacular, on a remarkable roll, driven by the popularity of their products, a relative absence of major competitors, the genius and ambition of Tom DeVilbiss, and—from 1924—the design brilliance of Fred Vuillemenot.

An Explosion of Design Innovation

The years 1920 through 1922 were an important transitional period for DeVilbiss. While continuing to offer the beautiful cut crystal and engraved bottles of 1910–1919, new lines featured significant innovation in style and decoration. A great expansion took place in the range of Perfumizers offered. They introduced the Perfume Dropper bottle in 1920, and the Perfume Burner (or perfume lamp) in 1921. Several new collar and spray top designs were introduced in 1922 and 1923, largely replacing styles used from 1910 to 1919.

Dating 1920s Bottles

A tendency among collectors is to think of DeVilbiss Perfumizer lines in terms of an annual catalog or product line. However, because DeVilbiss served several different markets, they individualized their marketing strategies and product offerings for a given year. Until 1927, bottles from one year may have been continued into the next year under the same number. Bottles made during this period are identified here to the first year they appear.

After 1927, DeVilbiss determined that they would have an "all new" line for the new year. Occasionally, the Atomizer Committee and later the Executive Committee made decisions to continue bottles, but they were indicated with a new number. Why, the reader might ask? DeVilbiss conducted rather extensive research and determined that their customers preferred that they had a "new line" each year.

There were many forms of product literature in the 1920s, including those dated mid-year (generally to prepare for Christmas-season sales) as well as undated catalogs, brochures, flyers, salesmen's photo books, and color portfolios showing the designs they offered. The most reliable and consistent information

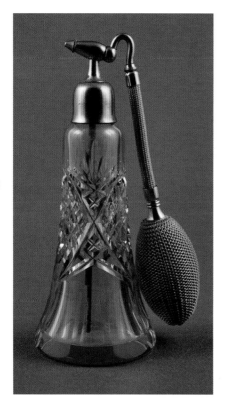

Series 6000 Perfumizer with high quality Czechoslovakian crystal, hand cut and polished, with gold finished fittings (1920). Height 6.5".

about the full product lines offered each year was their total line factory assembly specification books, and their Special Order specification books.

For most of the 1920s through 1926, DeVilbiss would introduce a design and produce a quantity according to their sales forecasts. Usually, bottles would be offered in the product line until inventories were exhausted or the item was so popular that it was continued. The assembly specification books are a meticulous treasure trove of information, and include details and individual part numbers on every single component of the item, from each piece of the spray head and collar, to the glass bottle design to be used, projected sales numbers, actual sales numbers and much more. As will be noted later, decisions about offerings for each year changed in 1927. Still the specification books remained the company constant and the "bible" of product descriptions.

Unknown Bottles

The fortunate collector sometimes finds Perfumizers, dropper bottles, and other vanity items that do not appear in known catalogs or flyers. Often, these "unknown" bottles that people can't verify were described in the specification books. For those few bottles still not found in records, there can be several reasons they are not readily known, ranging from bottles that were special order or custom-produced items for companies or individuals to bottles that employees were allowed to select from existing stock or make for themselves and bring home. Of course, there may be "rogue" bottles that part-time workers created as well. These can be dated with reasonable accuracy to a specific period by comparing similar shapes, collars, spray top styles, and decorations of those listed in this book and catalogs. Sometimes, inaccurate spray heads and caps, often not even from DeVilbiss, have been added or replaced on bottles by dealers or collectors. The value of a bottle can be significantly reduced if non-original fittings have been installed. Throughout this book, the authors provide accurate representations of appropriate collar, spray head, and dropper fittings for the bottles, to help support a collector's knowledge and informed acquisitions.

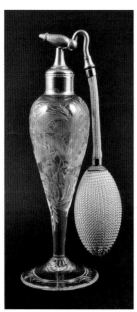

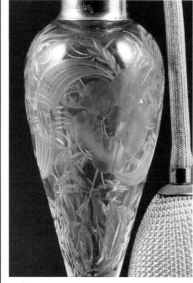

Close-up of the 1920 DeVilbiss engraved crystal bottle.

Series 7200 Perfumizer with intricately DeVilbiss engraved crystal bottle supplied by the Cambridge Glass Company and gold finished collar stamped "DEVILBISS" (1920). Height 6.5".

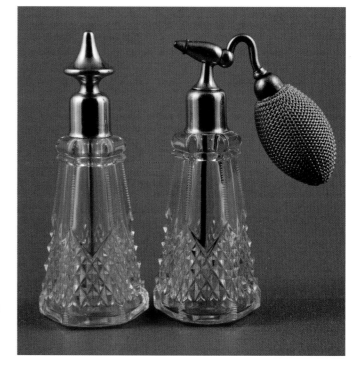

PD 1000 Perfume Dropper and Series 2000 Perfumizer with pressed crystal glass bottles; gold finished fittings and dropper rod (1921). Height 5".

Emil J. Krall signed goblet featuring the Habsburg royal crest—a double-headed eagle—showcasing the engraving skills of the man who would become the head designer and engraver for the A. H. Heisey Company in the 1930s. Height 6.5".

DeVilbiss and the Krall Family of Glass Engravers

The Series 7200, an exceptionally finely detailed and intricately engraved Perfumizer from 1920, raises the interesting possibility of a Krall family hand carefully working it at the DeVilbiss Company's engraving wheel.

The Kralls were a family of master engravers from Austria. Emil J. Krall, Sr. engraved glass for the Austrian court of Emperor Franz Josef while in residence at the Hofberg Palace in Vienna, at the turn of the century. In 1907, Emil, then 26, and his brother Willibald Krall, 36, emigrated to the United States to work as engravers for the Libbey Glass Co. of Toledo, Ohio. In 1909, Emil and Willibald's families followed them to Toledo, including Emil's son, Oscar, and Willibald's sons, Anton and Emil S. In 1910, Emil Krall, Sr. left Libbey to establish Krall Studios in Toledo, where he was joined by his brother Willibald. It is not known, but entirely possible, that the elder Krall brothers may have done outsourced engraving for DeVilbiss during that period. By 1918, the brothers' sons, Anton (20), Oscar (15), and Emil S. (12) were working in glass, and all three were employed at DeVilbiss. Anton and Oscar were perfume bottle engravers and Emil S. was an enamel decorator. It is not known how long Oscar and Emil S. worked for DeVilbiss, but Anton left the company in 1918 to work for a glass engraver in Newark, New Jersey. Both Oscar and Emil S. were working elsewhere by the mid-1920s.[1] Emil J. Krall, Sr. is perhaps best known for having become, in 1932, head designer and engraver for A. H. Heisey & Co., of Newark, Ohio.[2]

Among the earliest Perfume Dropper bottles is Series PD 2000, beautifully cut, polished, and engraved, with floral and band design, from the 1921 sales brochure. This bottle also appeared in the 1920 brochure, with non-beaded collar, along with the announcement, "Introducing DeVilbiss Perfume Dropper Bottles." Dropper rods were "made of metal, specially treated to prevent any action on it by the perfume. The metal feature entirely eliminates the danger of the dropper breaking."[3] However, by 1922, the metal dropper rod was replaced by glass throughout the line.

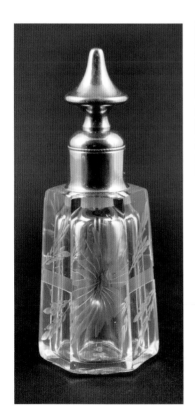

PD 2000 Perfume Dropper bottle with crystal, hand cut and polished bottle, and gold finished fittings and dropper rod (1921). Height 4.5".

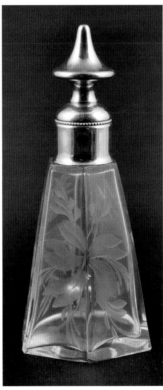

Perfume Dropper bottle with crystal, hand cut and polished bottle and gold finished fittings and dropper rod (1921). Height 4.75".

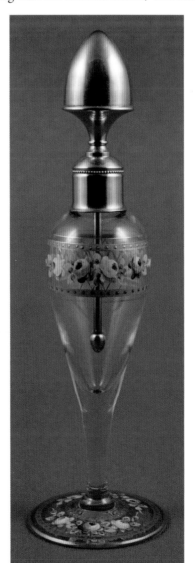

Series PD 6000 Perfume Dropper with crystal bottle from Cambridge Glass Company decorated with raised enamel flowers and gold cross-hatch and band decoration on bottle and foot; large gold finished dropper handle, rod and collar (1921). Height 7.5".

A selection of five Perfumizers from a 1922 DeVilbiss salesman's black and white photo book shows the K Series, with newly introduced designs, decorations, and atomizer fittings. The fourth bottle from the left shows the earliest use of the DeVilbiss gold encrusted sponge acid decoration, which is then seen on other bottles throughout the 1920s. The fifth bottle is a beautiful crystal with gold bands and enameled flowers on the top and foot of the bottle. These five bottles also appeared together in the 1922 color brochure, as seen on page 76

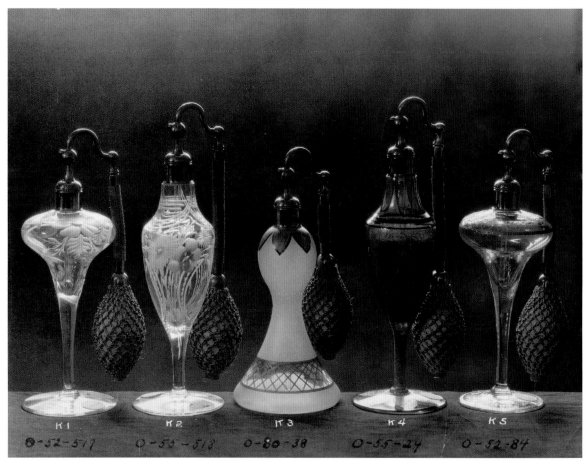

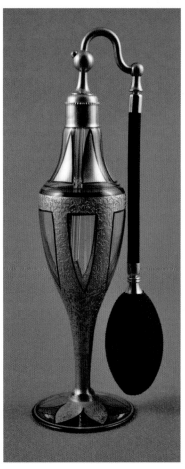

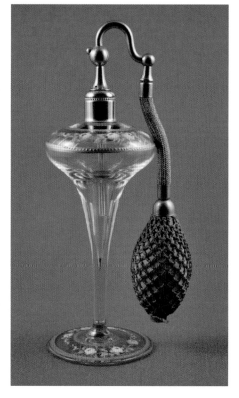

K-5 Perfumizer with detailed multicolor floral and gold enamel band decoration and gold plated fittings (1922). Height 7.5".

K-4 Perfumizer with gold encrusted sponge acid treatment pattern outlined in black enamel, gold finished fittings (1922). Height 8".

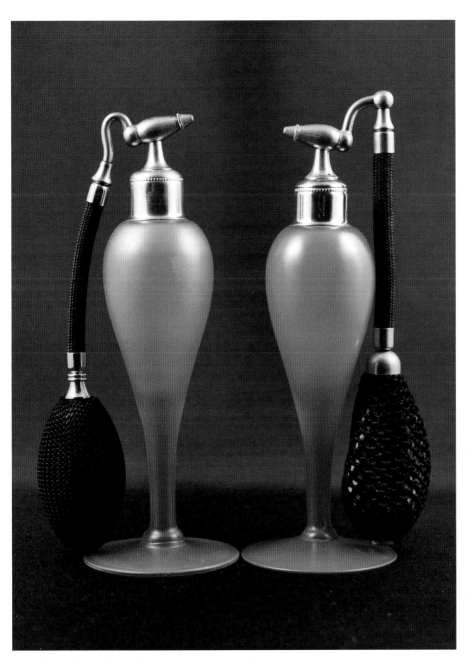

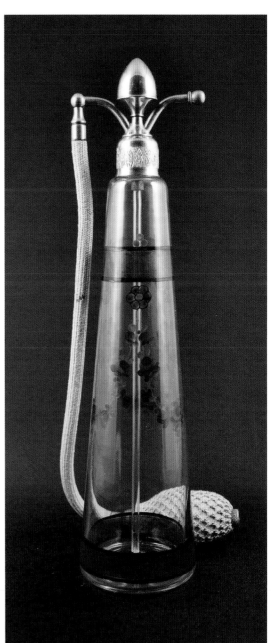

Series 3600 Perfumizer (left) (1921) and F-1 Perfumizer (right) 1922, both with Cambridge Glass Company bottles decorated by DeVilbiss with pink enamel satin and finished with gold plated fittings. Note the transition to the newly introduced (1922) spray head design on the right. Height 6.5".

Series 8002 Tall Perfumizer with crystal bottle and hand-enameled rose floral and band decoration with blue and green highlights, and gold-plated fittings with large finial; original ball and cord (1921). Height 10.5".

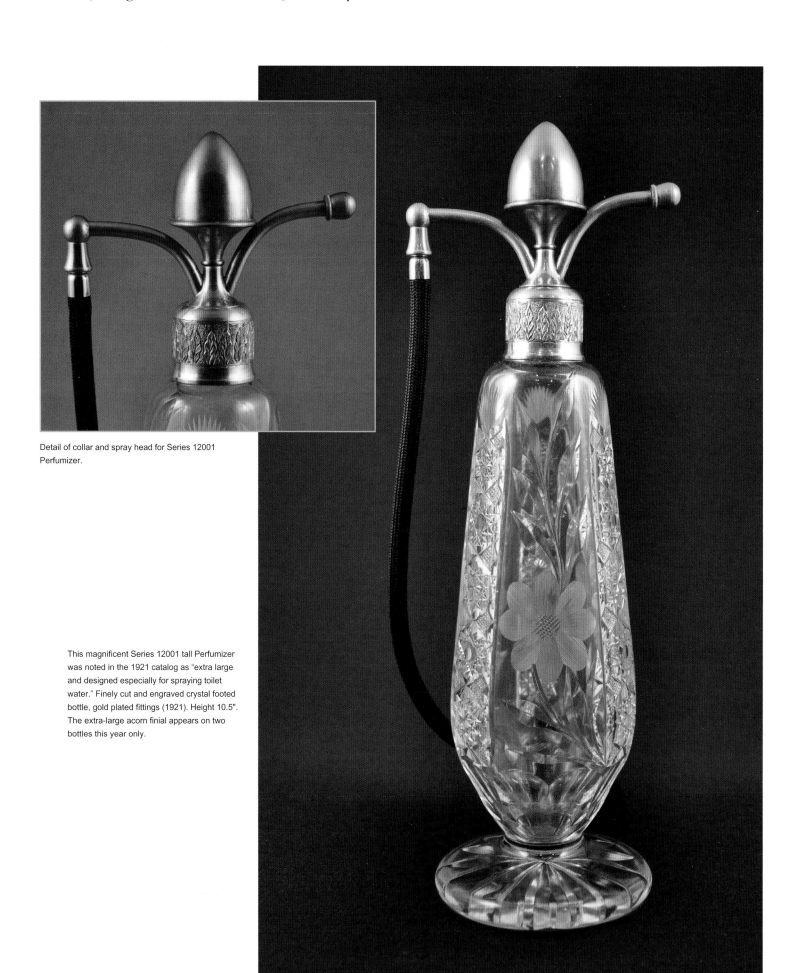

Detail of collar and spray head for Series 12001 Perfumizer.

This magnificent Series 12001 tall Perfumizer was noted in the 1921 catalog as "extra large and designed especially for spraying toilet water." Finely cut and engraved crystal footed bottle, gold plated fittings (1921). Height 10.5". The extra-large acorn finial appears on two bottles this year only.

1922 DeVilbiss Sales Photo Book (selected pages)

Selected pages from the DeVilbiss Company Sales Photo Book for 1922 are revealing to researchers today.

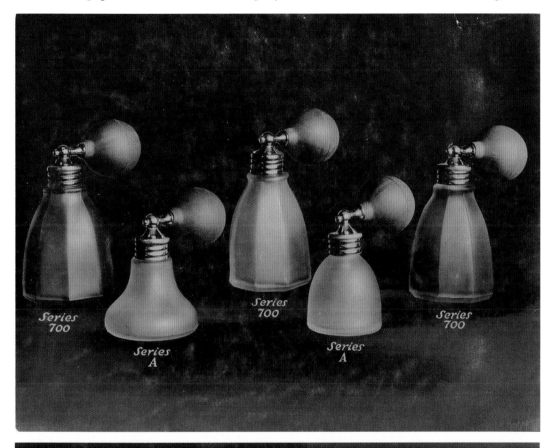

Series A and Series 700 Perfumizers.

Series 1200 Perfumizers.

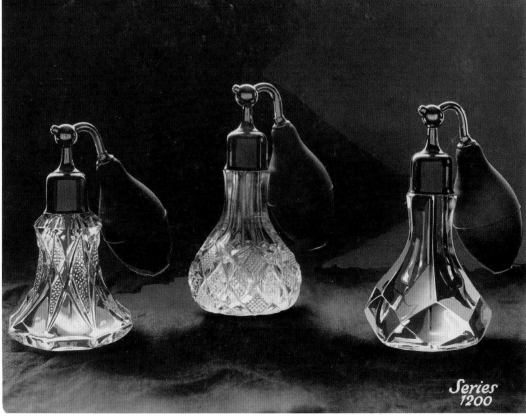

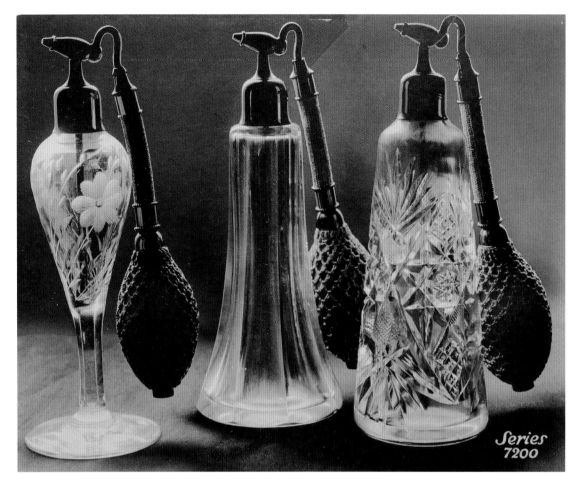

Series 7200 Perfumizers.

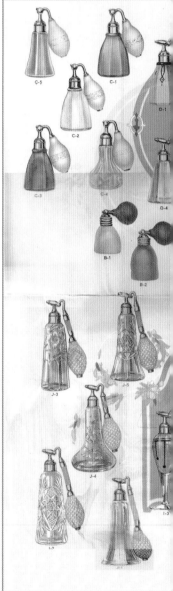

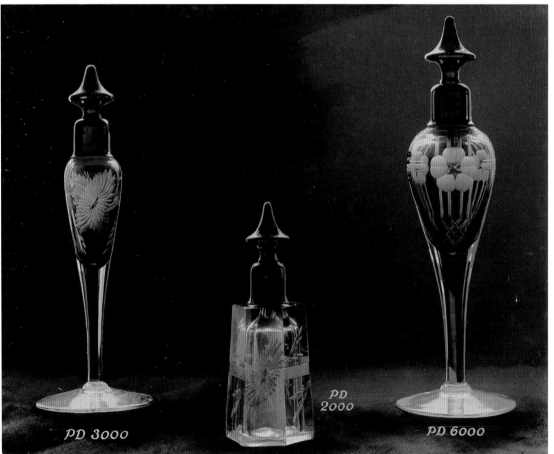

Perfume Droppers.

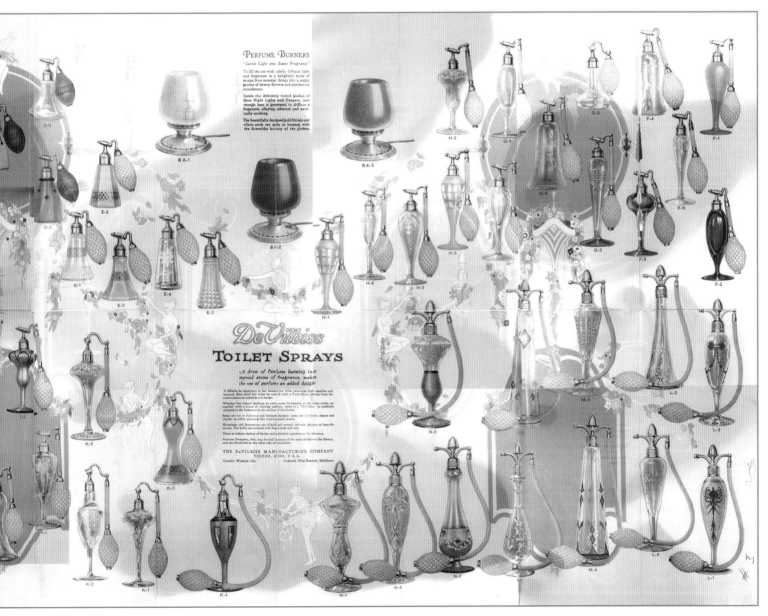

DeVilbiss 1922 line catalog in the form of a fold-out brochure. *Courtesy of the Toledo Museum of Art.*

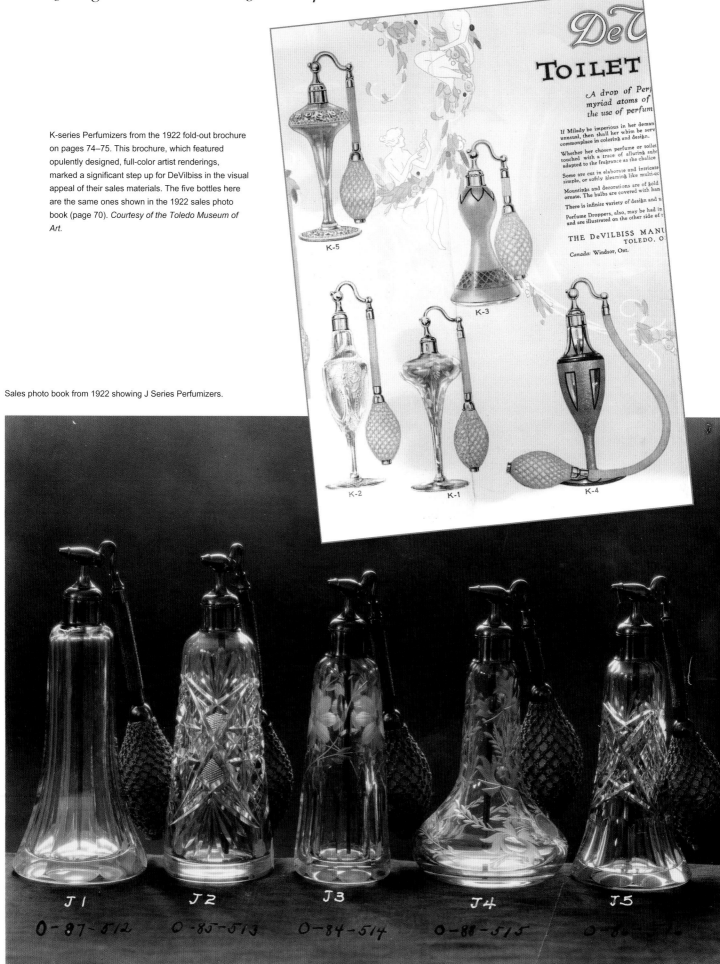

K-series Perfumizers from the 1922 fold-out brochure on pages 74–75. This brochure, which featured opulently designed, full-color artist renderings, marked a significant step up for DeVilbiss in the visual appeal of their sales materials. The five bottles here are the same ones shown in the 1922 sales photo book (page 70). *Courtesy of the Toledo Museum of Art.*

Sales photo book from 1922 showing J Series Perfumizers.

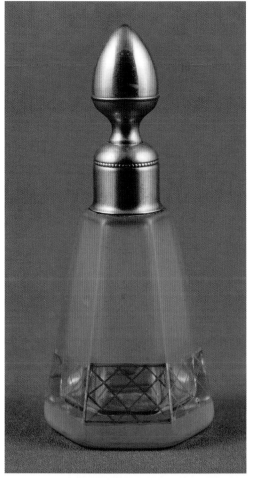

DS-2 Perfume Dropper with blue exterior enamel over satin finish and gold cross-hatch pattern on crystal glass bottle with gold finished fittings (1922). Height 4.75".

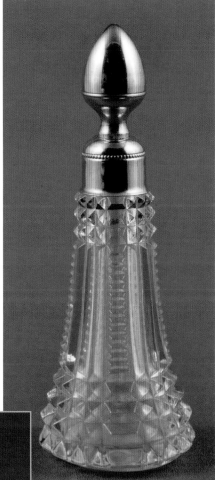

DS-5 Perfume Dropper with Cambridge Glass Company Mt. Vernon pattern crystal bottle with gold finished metal fittings and large finial with glass dropper rod (1922). Height 5.5". This Cambridge glass blank first appeared in the known DeVilbiss lines in 1912.

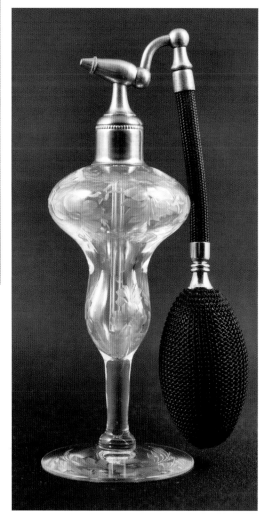

H-2 Perfumizer from 1922; crystal bottle with detailed floral cutting. Height 6".

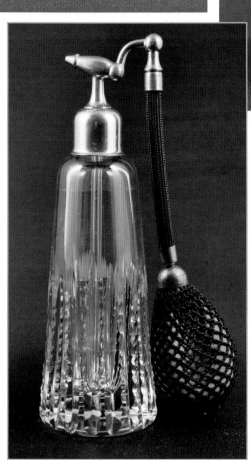

Perfumizer with high quality crystal, finely cut and polished bottle. This cut glass bottle first appears in 1918. This version using this spray head was from 1922. Height 6.75".

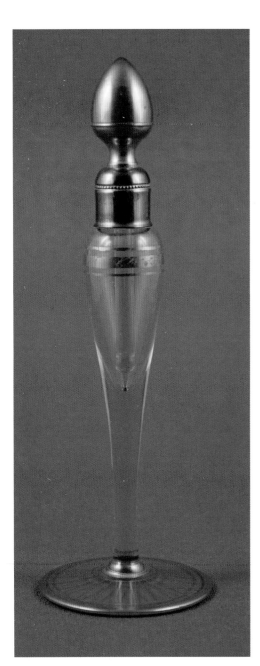

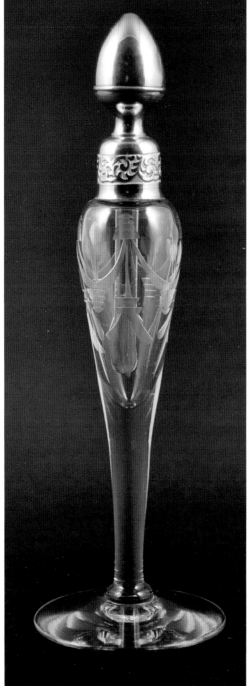

DT-5 Perfume Dropper with a simple but elegant DeVilbiss cut crystal bottle from the Cambridge Glass Company. Large gold finished dropper finial (1922). Height 6.75".

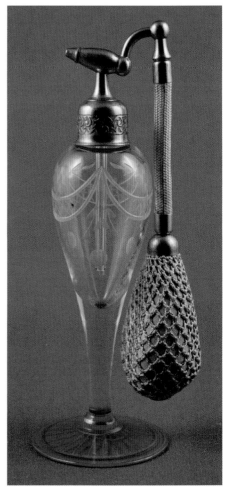

H-5 Perfumizer with Cambridge Glass Company bottle with DeVilbiss drape cutting, and blue and gold decorated foot (1922). Height 6.75".

DV-4 Slender Perfume Dropper bottle by Cambridge Glass Company with crystal bottle, decorated by DeVilbiss with a gold enamel band, and blue and gold enamel foot with gold finished dropper fittings (1922). Height 7".

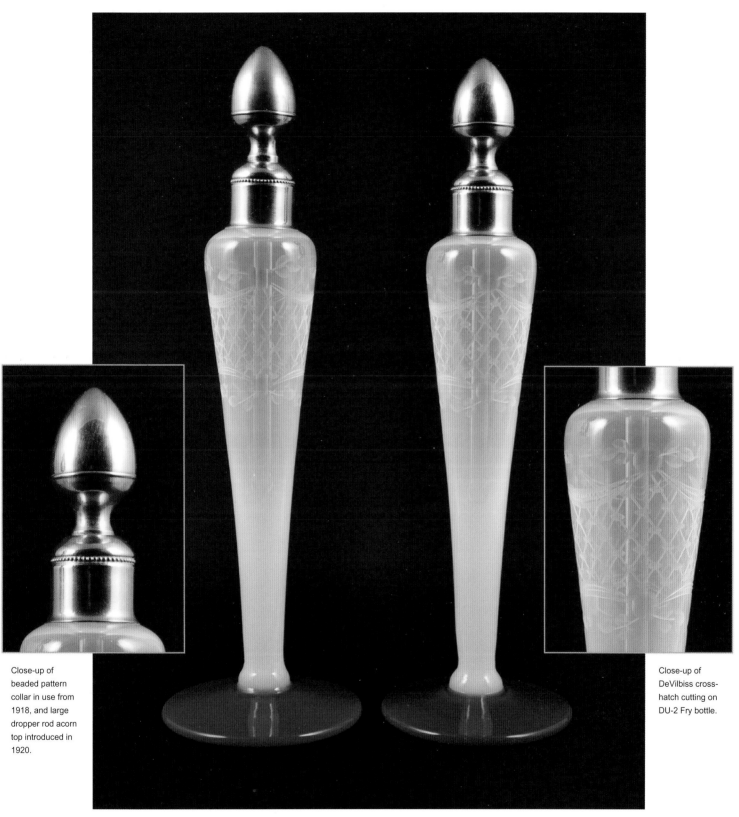

Close-up of beaded pattern collar in use from 1918, and large dropper rod acorn top introduced in 1920.

Close-up of DeVilbiss cross-hatch cutting on DU-2 Fry bottle.

DU-2 Pair of Perfume Droppers with H. C. Fry opalescent Foval bottles with Delft (blue) feet and cross-hatch cutting by DeVilbiss (1922). Height 8.25".

DeVilbiss All Glass Perfume Dropper Bottles by Foval Art Glass

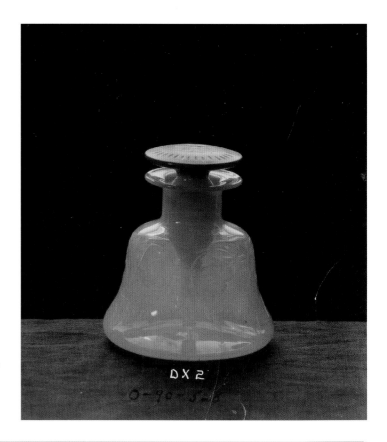

Two pages from a 1922 salesman's photo book showing four dropper bottle styles from H. C. Fry Glass Company with DeVilbiss cuttings on Foval Art Glass. DeVilbiss added new glass products that are not fitted with either dropper or spray hardware (1922).

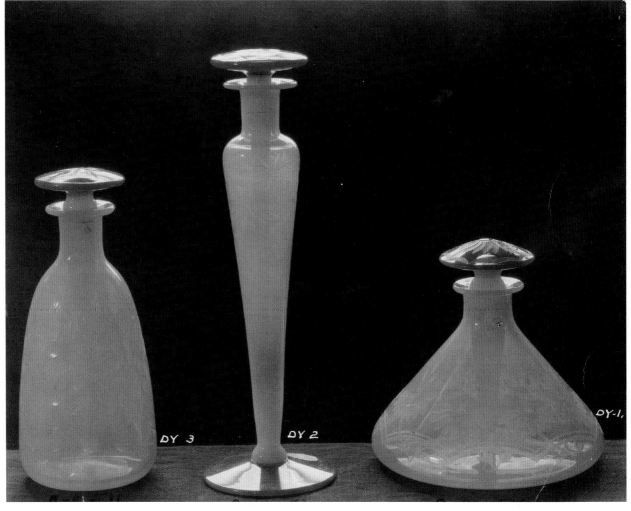

1920s New Cambridge Glass Company Bottles

The Cambridge Glass Company began production in 1902, in a newly completed factory leased from the National Glass Company, in Cambridge, Ohio. When National Glass Company collapsed in 1907, Cambridge's principal owner, A. J. Bennett, purchased the factory; from that point the company was independent under his ownership. By 1920, the trend was toward lighter pressed and blown ware, and Cambridge excelled in this area. It became a major supplier of blown and often etched and enamel decorated bottle blanks for DeVilbiss.

In the early 1920s, Cambridge introduced a series of rich, bright, opaque glass colors and the designers at DeVilbiss were quick to incorporate them into their designs of Perfumizers, Perfume Droppers, and perfume lights throughout the late 1920s. The opaque colors included:

DeVilbiss Electrotype Mat No. 9.

Azurite (a distinctive blue)
Primrose (pale yellow)
Jade (jade blue-green)
Helio (light purple)
Ebony (black)
Ivory (custard white)

By 1923, the DeVilbiss Perfumizer line included them all, with the exception of Jade, which was introduced in 1924. Some had Cambridge-applied etchings and enameling, while some were decorated by DeVilbiss's growing decorating department, which applied detailed cuttings, exterior enamel, and acid treatments. In the late 1920s, DeVilbiss also carried another Cambridge opaque color, which they called Coral; eventually Cambridge referred to this color as Crown Tuscan.

Cambridge continued to provide high quality glass blanks for bottles and powder jars through the 1930s and until World War II. Cambridge also produced and decorated an extensive variety of Dropper Perfumes for its own line, often with the same shapes and sometimes even the same decorations as those they provided to DeVilbiss. During the 1920s, Cambridge also supplied blanks to several of DeVilbiss' competitors. Cambridge continued to operate until 1958 (with a two-year closing during 1954 and 1955), although there is no known record of production for DeVilbiss after 1941.

From 1922 until at least 1928, the Cambridge Glass Company supplied ten known primary shapes to DeVilbiss, all of them blown; four of which had stems and applied feet; three smaller, non-footed versions; and three styles of perfume lamps. A few examples are shown below, side-by-side for comparison. They also supplied many other bottles to DeVilbiss in different shapes in other years, as noted in the subsequent chapters. (See pages 82–88, 90, 94–98.)

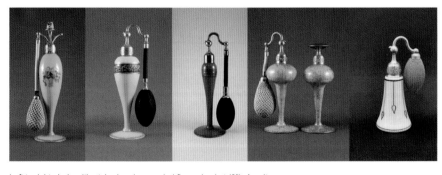

Left to right: Jade with etched and enameled flower basket (9"); Azurite with etched and enameled band (7.75"); Helio with etched and silver-encrusted wreath pattern (6.75"); Jade with gold enamel stippling (6.5" Perfumizer); and Primrose with black and gold enamel (4.75").

The bottles in the second and third images from the left were also made by Cambridge for their own sales, in both opaque and translucent color versions, with glass stoppers and dropper rods. As noted earlier, a few specific blanks, either plain or with different decorations, were also sold by Cambridge to at least two other atomizer houses, along with other unique shapes that DeVilbiss did not carry. All of these shapes, whether opaque colored glass, translucent or clear, were gone from the DeVilbiss Perfumizer line by 1929. Cambridge continued to supply different bottle blanks to DeVilbiss through the 1930s, which are described in the following chapters.

The Cambridge Glass Company was a primary supplier to DeVilbiss for many years. In the 1923–1924 line, Cambridge provided over a third of the bottles in the line.

Here are three sections of a 2.5" by 4", twelve-panel, promotional booklet from 1923, that was used at perfume counters or given to customers with new purchases. Among its messages is the story of the origin of perfume in Egypt, and a comparison to the delights of receiving a Perfumizer as a gift. The cover illustration features the L-1 Perfumizer with a Cambridge Azurite bottle blank.

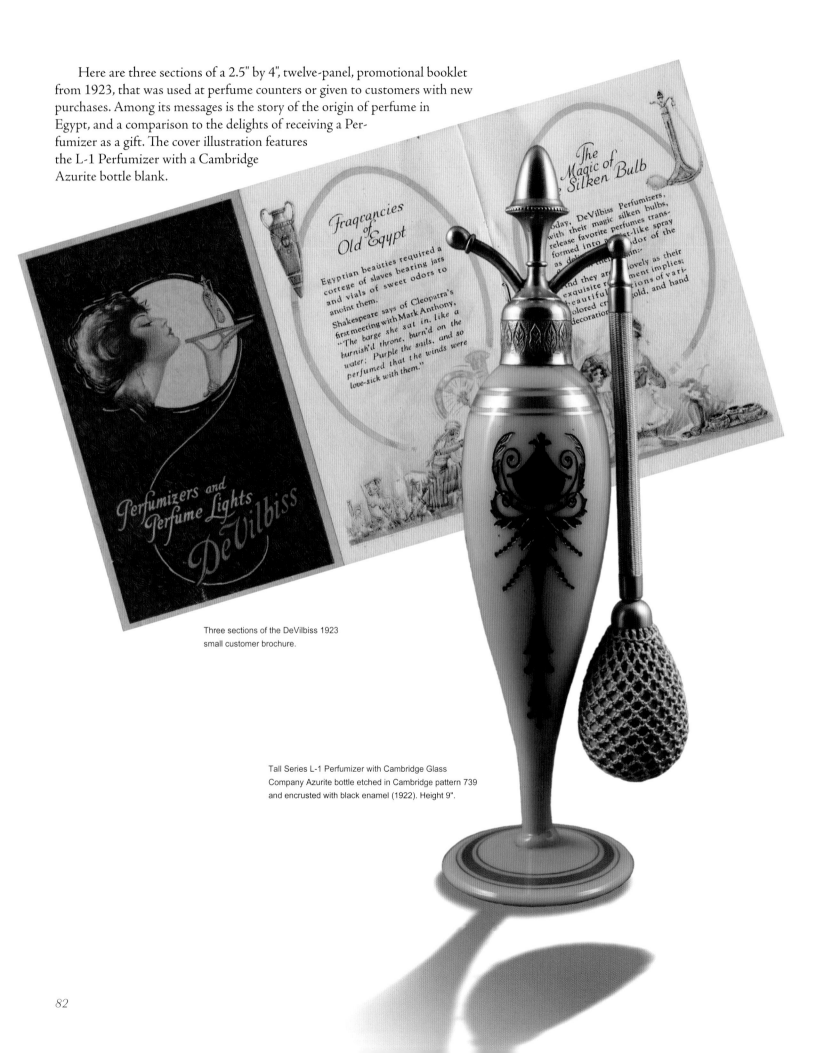

Three sections of the DeVilbiss 1923 small customer brochure.

Tall Series L-1 Perfumizer with Cambridge Glass Company Azurite bottle etched in Cambridge pattern 739 and encrusted with black enamel (1922). Height 9".

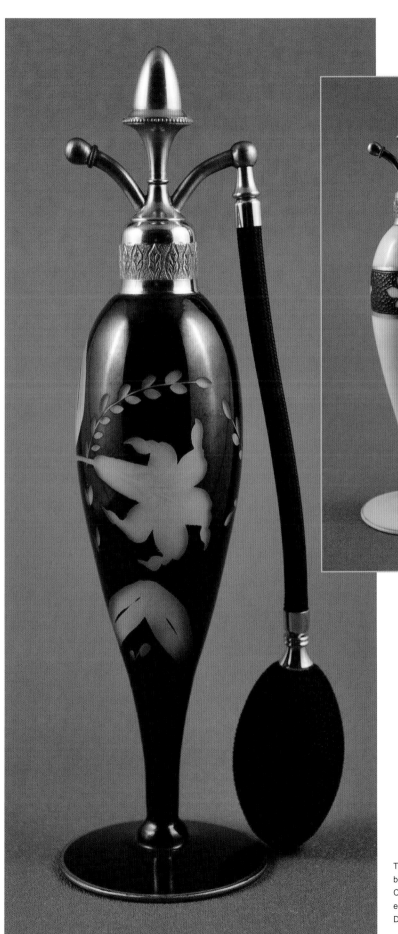

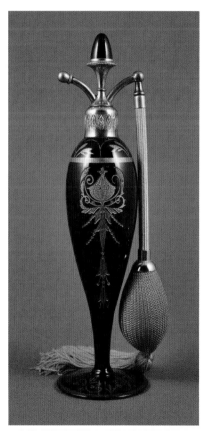

Series L-10 Large DeVilbiss Perfumizer with a small Acorn spray head top using a Cambridge Glass Company Primrose bottle, with a Cambridge-applied black enamel encrusted flower petal etching No. 519 (1923). Height 9".

Series M-6 Perfumizer with Cambridge Glass Company Ebony bottle etched 739 and gold encrusted with gold enamel decoration at the neck and foot (1923). Height 9". Note black glass acorn finial on the spray top. Glass acorns on these series are unusual and desirable.

This L-16 Perfumizer appears in the 1923 salesman's portfolio but not in the retail catalog. Supplied by the Cambridge Glass Company, it is a crystal bottle covered with high-gloss black enamel and engraved to clear in a floral pattern. Decoration by DeVilbiss (1923). Height 9".

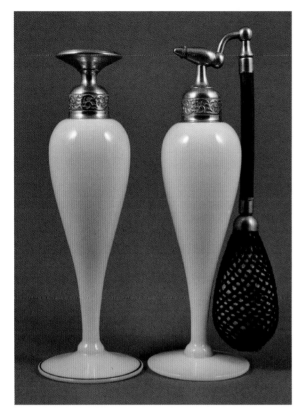

DF-16 Perfume Dropper
and F-16 Perfumizer,
with Cambridge Glass
Company Ivory bottles;
Dropper with black enamel
ring on foot (1923). Height
6.75" (Perfumizer).

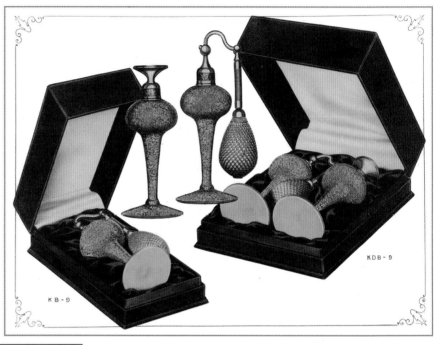

DeVilbiss set in 1925 luxury packaging. Bottles in Jade
by the Cambridge Glass Company with gold stippling.

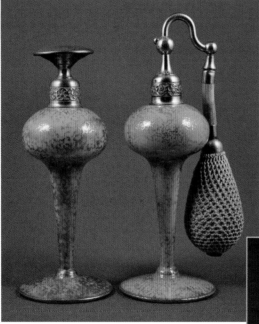

DK-9 Perfume Dropper and K-9 Perfumizer
with Cambridge Glass Company Jade opaque
bottles decorated with gold enamel stipple
pattern and gold finished spray and dropper
fittings (1923). Height (Perfumizer) 5".

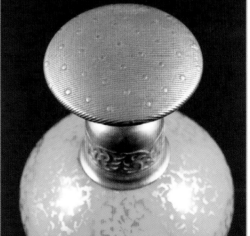

Close-up of DK-9 dropper
handle with embossed
pattern.

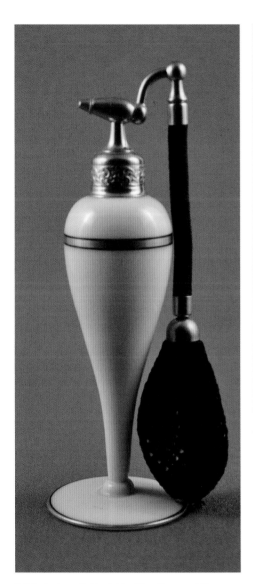

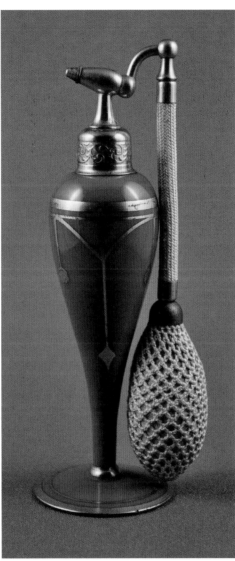

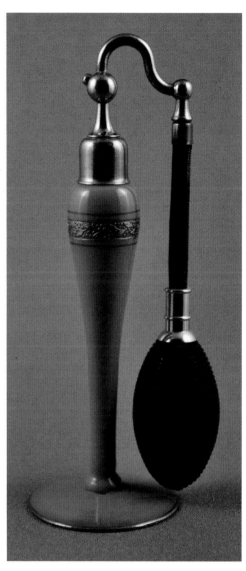

H-8 Perfumizer with Cambridge Glass Company Primrose bottle, gold and black enamel band decoration on bottle and foot (1923). Height 6.75".

I-8 Perfumizer with Cambridge Glass Company opaque Helio bottle and gold enamel decoration with gold finished spray fittings (1923). Height 6.75".

I-7 Perfumizer with Cambridge Glass Company Helio bottle, etched and silver encrusted Cambridge wreath pattern with silver enamel trim on the foot; nickel finished fittings (1923). Height 6.75".

The Roaring Twenties and the Great Depression

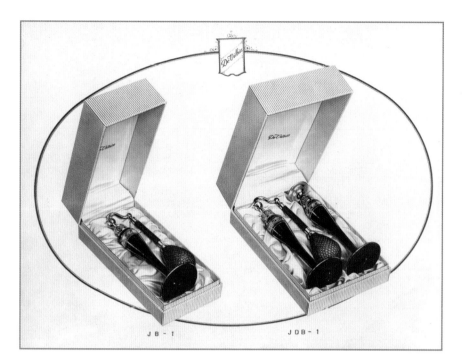

JB-1 JDB-1

Boxed Perfumizer and Perfume Dropper sets JB-1 and JDB-1 in satin lined presentation cases shown in the DeVilbiss 1923 sales portfolio. The "B" in the product number designated a boxed item or items. Thus a J-1 Perfumizer in a presentation box was a JB-1. JDB-1 was a J-1 Perfumizer and a DJ-1 Perfume Dropper in a box.

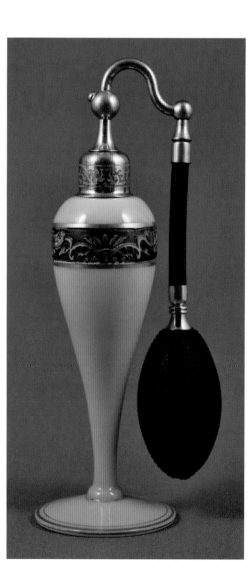

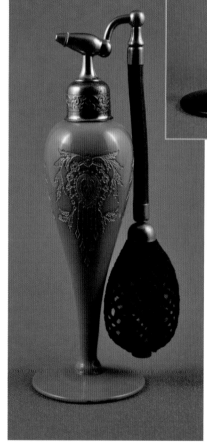

Series J Perfume Dropper and Perfumizer set with Cambridge Glass Company Ebony bottles and chrome fittings and silver encrusted Cambridge wreath etching. Sold both as a boxed set as shown; also produced with gold fittings and enamel (1923). Height 7".

L-5 Perfumizer with Cambridge Glass Company Helio bottle; Cambridge Plate Etching #1, silver encrusted, nickel finished fittings (1923). Height 6.75".

K-8 Perfumizer with Cambridge Glass Company Azurite bottle in Cambridge etched decoration number D/616, gold enamel on raised pattern and foot; black enamel background (1923). Height 6.75".

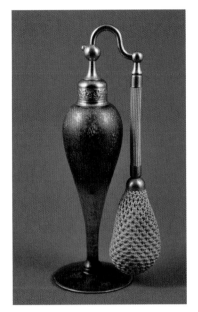

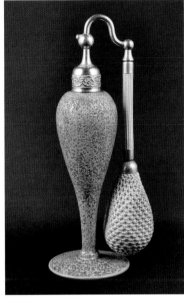

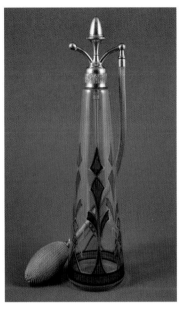

Salesman's portfolio page showing M Series Perfumizers, including M-4 Perfumizer shown above (1923).

L-6 Perfumizer with Cambridge Glass Company clear bottle; sponge acid treatment, heather enamel and gold stippling with gold enamel band on foot (1923). Height 6.75".

L-6 Perfumizer with Cambridge Glass Company bottle with sponge acid finish and blue and gold enamel decoration (1923). Height 6.75".

M-4 Perfumizer, large capacity clear bottle with blue, green, black and gold enamel decoration; gold finished spray fittings (1923). Height 10.5".

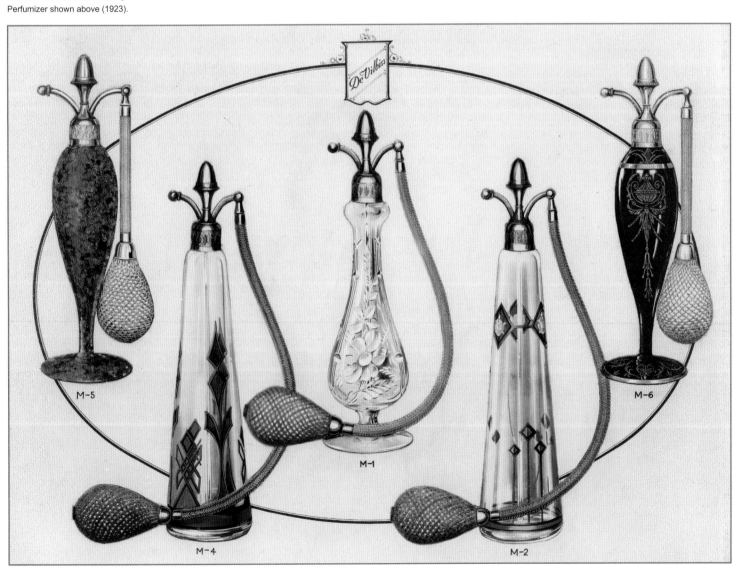

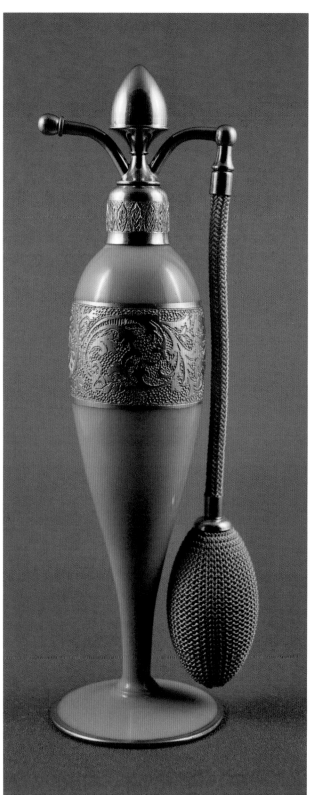

Series Q-1 Tall elegant Perfumizer with Cambridge Glass Company Jade bottle with gold encrusted Cambridge etching number 702, with gold enamel decoration on the foot (1924). Height 9". Note the larger acorn finial, which is the earliest style for this spray top, introduced in 1921 and used through 1924.

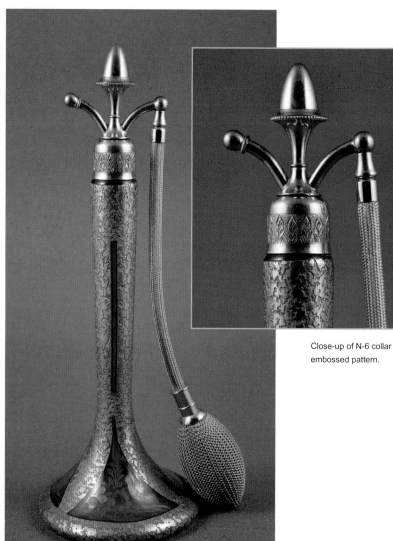

Close-up of N-6 collar embossed pattern.

N-6 Perfumizer with gold encrusted sponge acid and clear cut windows with black enamel outlines; gold finished spray fittings with gold acorn (1923). Height 9.75".

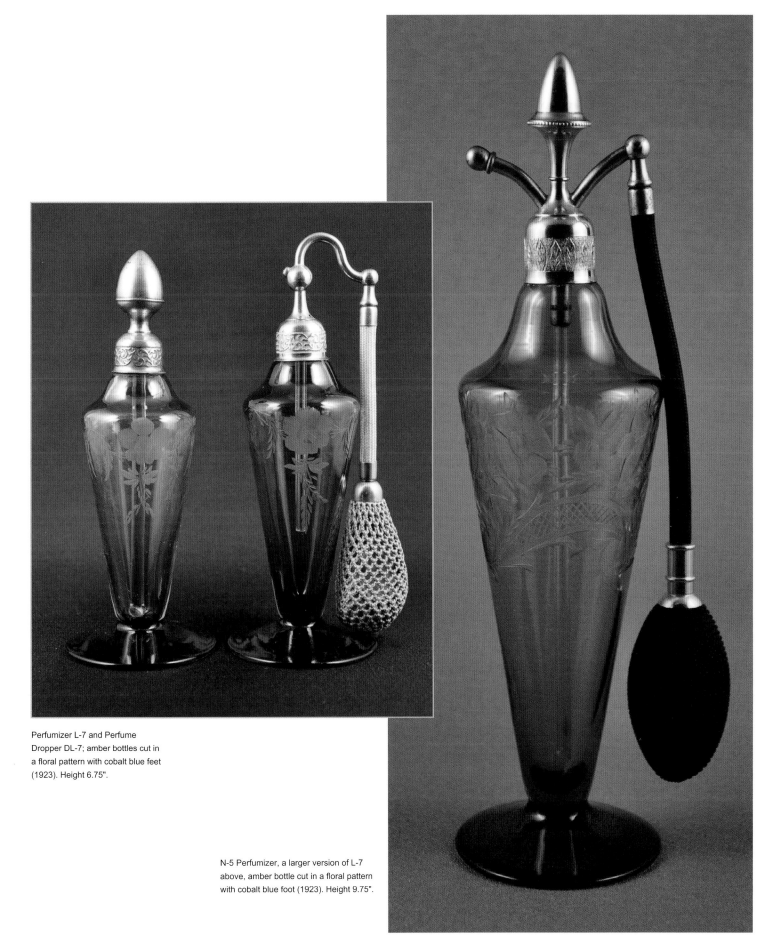

Perfumizer L-7 and Perfume
Dropper DL-7; amber bottles cut in
a floral pattern with cobalt blue feet
(1923). Height 6.75".

N-5 Perfumizer, a larger version of L-7
above, amber bottle cut in a floral pattern
with cobalt blue foot (1923). Height 9.75".

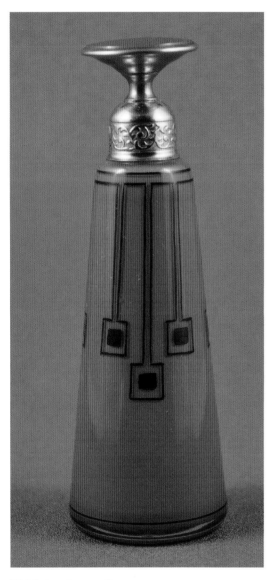

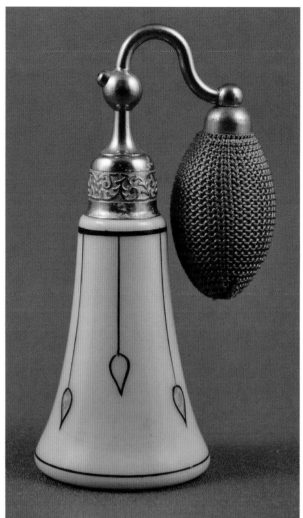

G-11 Perfumizer with Cambridge Glass Company Primrose opaque yellow glass, black and gold enamel decoration and gold finished spray fittings (1923). Height 5".

DG 6 Perfume Dropper with an orange interior enamel and black enamel pattern on the exterior (1923). Height 5.75". This year's line marked the first use of the flat dropper rod handle with a reverse enameled glass insert matching the bottle.

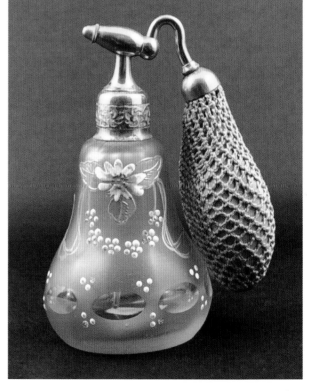

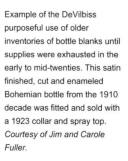

Example of the DeVilbiss purposeful use of older inventories of bottle blanks until supplies were exhausted in the early to mid-twenties. This satin finished, cut and enameled Bohemian bottle from the 1910 decade was fitted and sold with a 1923 collar and spray top. *Courtesy of Jim and Carole Fuller.*

1925: Luxury, Style and Grace

Egyptian King Tutankhamun's tomb was discovered in 1922. In the following few years, Egyptian styles of many items were in vogue. The Egyptian theme was carried through in the DeVilbiss sales materials in 1925, emphasizing the importance of the "receptacle" for perfume and how much "significance" the receptacle added to the perfume. Notice the beautifully illustrated panel from a salesman's catalog, which had these sentiments listed beneath it:

Receptacles worthy of sweet fragrances!
For countless centuries, artisans have lavished their genius
Upon containers worthy of perfumes beloved by peoples of all ages.

Ancient Royalty exchanged gifts of rare perfumes, and
the artistry of the vials which contained them, added
untold value and significance to their gifts.[4]

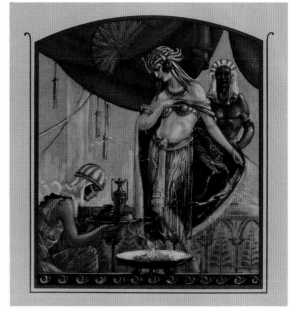

1925 salesman's portfolio page showing H Series Perfumizers, with dropper rod shown to indicate availability of dropper styles to match Perfumizers (except H-11 and H-14).

Interior page illustration of the 1925 DeVilbiss catalog.

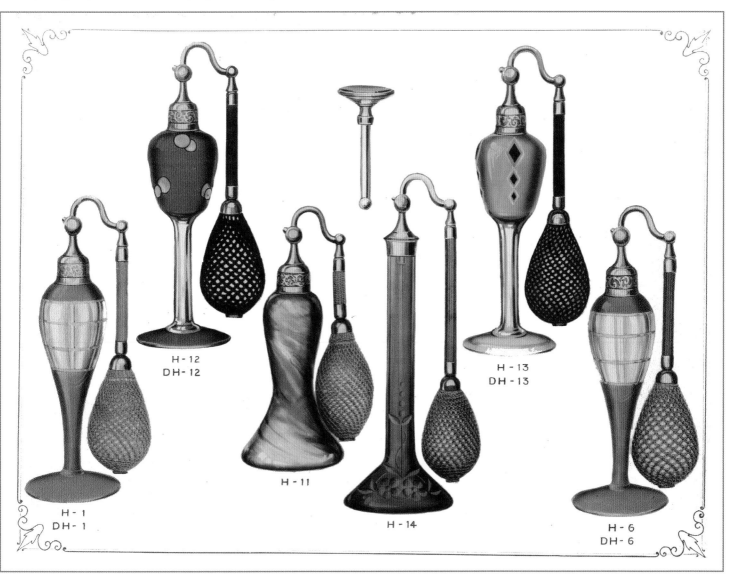

H - 12
DH - 12

H - 11

H - 1
DH - 1

H - 14

H - 13
DH - 13

H - 6
DH - 6

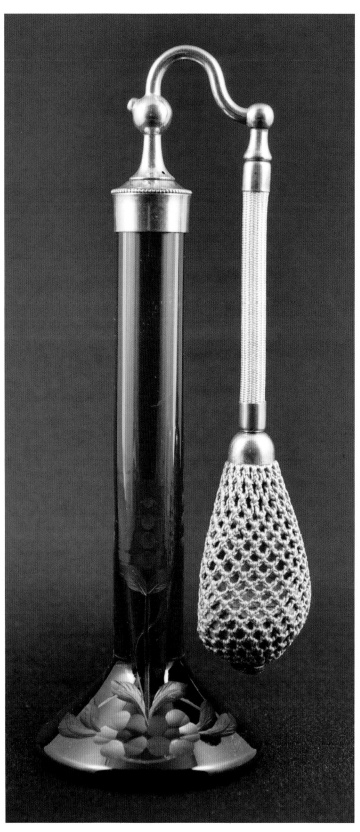

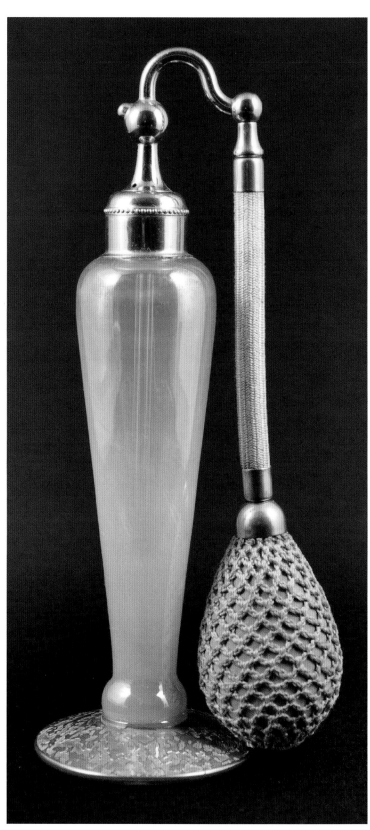

H-14 Perfumizer with rich amber tubular bottle with floral cutting on flared base and gold finished spray fittings (1925). Height 7.5".

I-13 Perfumizer with H. C. Fry Glass Company white opalescent bottle and gold enameled sponge acid foot; gold finished spray fittings (1925). Height 7".

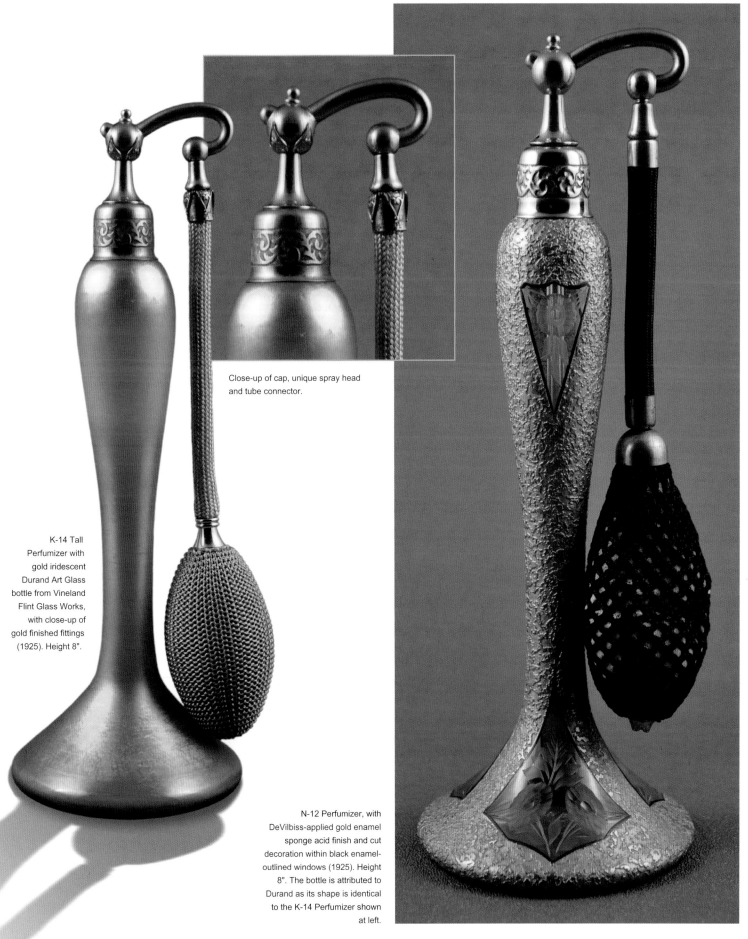

Close-up of cap, unique spray head and tube connector.

K-14 Tall Perfumizer with gold iridescent Durand Art Glass bottle from Vineland Flint Glass Works, with close-up of gold finished fittings (1925). Height 8".

N-12 Perfumizer, with DeVilbiss-applied gold enamel sponge acid finish and cut decoration within black enamel-outlined windows (1925). Height 8". The bottle is attributed to Durand as its shape is identical to the K-14 Perfumizer shown at left.

Durand Art Glass

Victor Durand, Jr., was born in Baccarat, France, in 1870. He immigrated to America with his father, Victor, Sr., and together they founded Vineland Flint Glass Works, in Vineland, New Jersey, in 1892. Victor, Jr. became the sole owner in 1899. In 1924, when Quezal Art Glass closed its doors, Durand convinced its former owner, Martin Bach, Jr., to join him and open an art glass shop within the Vineland glass business. Bach's father, Martin Bach, Sr., had worked in the glass formula department of Tiffany Furnaces in New York. DeVilbiss acquired other blanks from Durand, including blanks for Perfume Lamps as well as Perfumizers and Perfume Droppers.[5] From 1924 until Durand's death in 1931, the company produced beautiful, high quality, decorated and iridescent glassware, including bottle blanks for DeVilbiss Perfumizers. After Durand's death, the Durand company was bought by Kimble in 1931, and the art glass shop closed, with remaining stocks destroyed or sold. In 1933, the Gimbel Brothers Philadelphia department store held a close-out sale of 1,900 Durand vases at 50% off the wholesale price.[6]

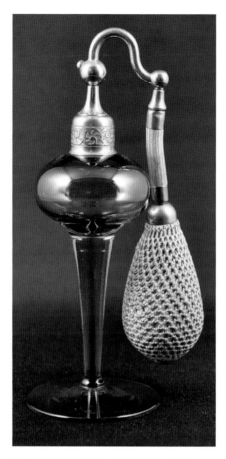

F-8 Perfumizer with Burgundy-stained Cambridge Glass Company bottle; gold finished fittings (1925). Height 6.25".

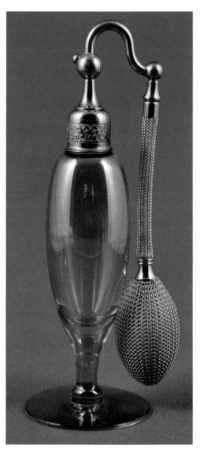

F-9 Perfumizer with Topaz iridized crystal bottle; gold finished spray fittings (1925). Height 6.75".

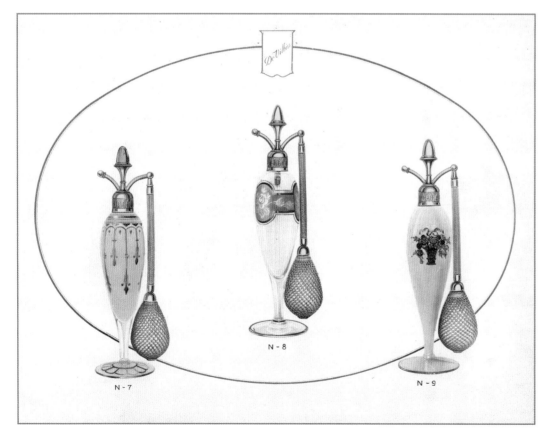

N-7 N-8 N-9

Opposite left: N-9 Tall Perfumizer with Cambridge Glass Company Jade bottle and Cambridge etched and decorated Dresden pattern (1925). Height 9". This color scheme does not appear in the 1923 catalog. Note the opaque blue glass acorn finial with amber glass inclusions. This is the rarest of this type finial.

Opposite right: N-9 Tall Perfumizer with a Cambridge Glass Company supplied Ivory bottle and Cambridge etched and decorated Dresden pattern. Note the blue enamel encrustation in the etching versus the gold encrustation in the same etching on the Jade bottle. Gold finished spray fittings (1925). Height 9".

1925 large leather-bound hand-colored company portfolio page showing three Perfumizers from the N Series, each one with Cambridge supplied bottles. The two bottles on the left were decorated by DeVilbiss with the Ivory bottle on the right decorated by the Cambridge Glass Company.

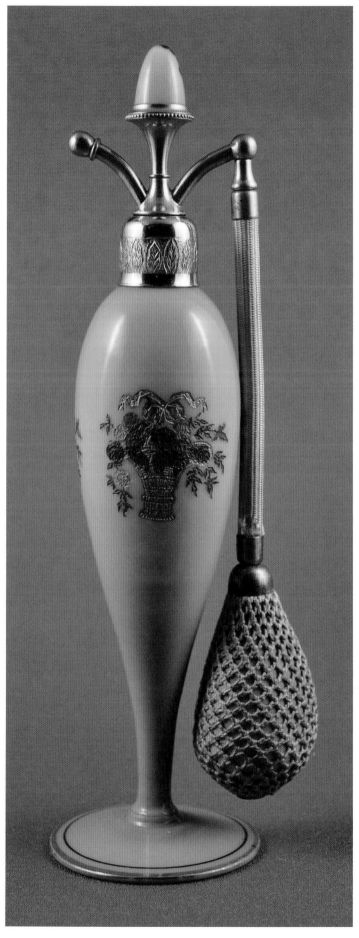
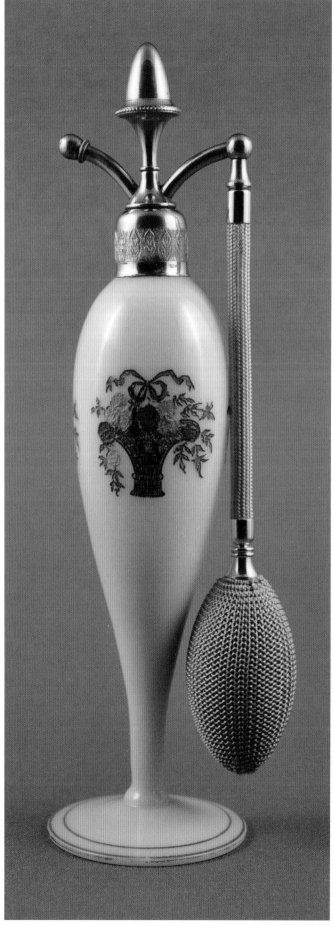

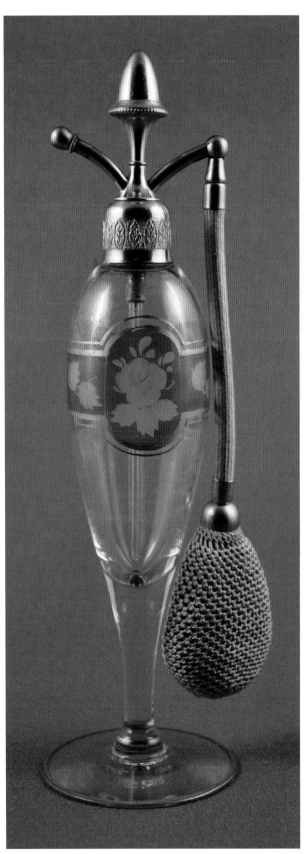

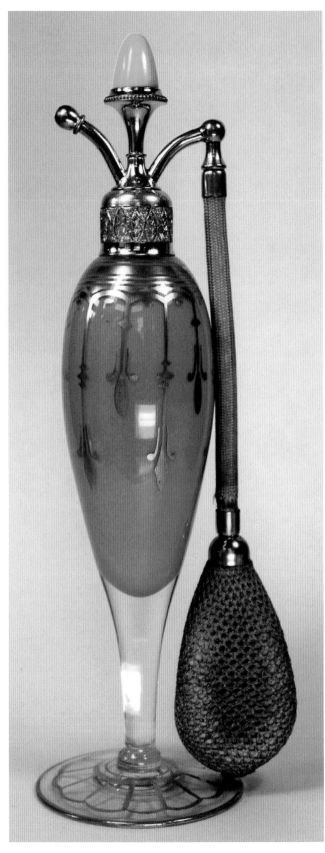

N-8 Perfumizer in clear glass supplied by the Cambridge Glass Company, with the decoration by DeVilbiss in applied gold and blue enamel, cut to clear in a floral pattern (1925). Height 9".

N-7 Perfumizer in clear glass supplied by the Cambridge Glass Company, with blue interior enamel and gold enamel on exterior and foot; decoration by DeVilbiss. Blue glass acorn on spray top (1925). Height 9". *Courtesy of Jay Kaplan. Photo by Marsha Crafts.*

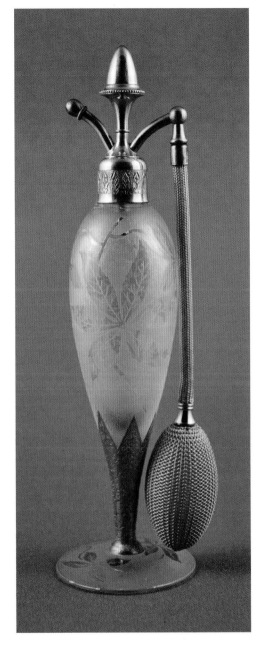

Q-3 Large Perfumizer in clear glass by Cambridge Glass Company, with DeVilbiss-applied sponge acid and leaf pattern; gold enameled stem, with the leaf pattern repeated on foot (1925). Height 9".

Perfumizer; Cambridge Glass Company clear bottle with enamel floral decoration, c. 1925 (decoration not cataloged— possibly by a third party decorator). Height 6.75". *Courtesy of Linda Roberts.*

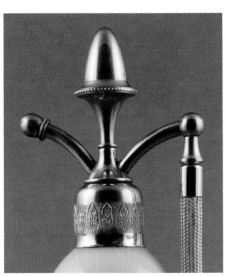

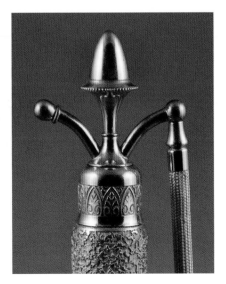

Noteworthy is the changed collar embossing pattern (right) found often, but not exclusively, on larger Perfumizers beginning in 1925. The leaf pattern at left is seen as early as 1920 and appears on most larger bottles until 1926. The collar on the right the authors call Cathedral.

The Roaring Twenties and the Great Depression

G-12 and DG-12 Perfumizer and
Perfume Dropper set in rich burgundy
flashed twist optic crystal bottles, paper
DeVilbiss label on foot of the Perfumizer
(1925). Height 7" (Perfumizer).

Close-up of DeVilbiss paper label
on the foot of the G-12 Perfumizer.

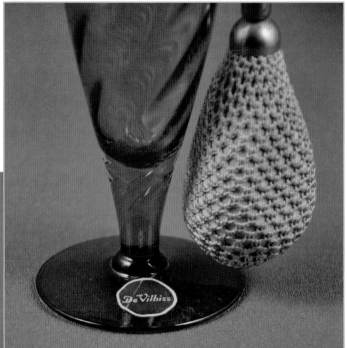

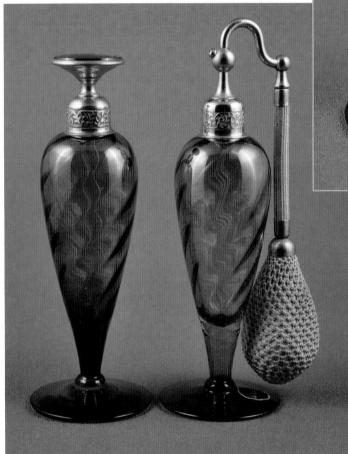

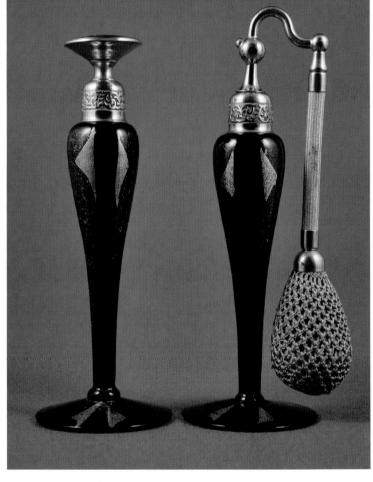

Perfumizer and Perfume Dropper set G-21 and DG-21
with Cambridge Glass Company Ebony bottles and gold
enamel triangle and splatter decoration (1925). Height
6.75" (Perfumizer).

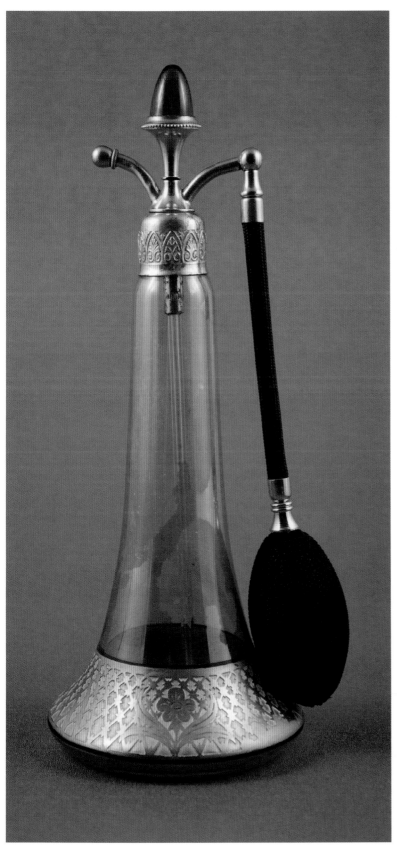

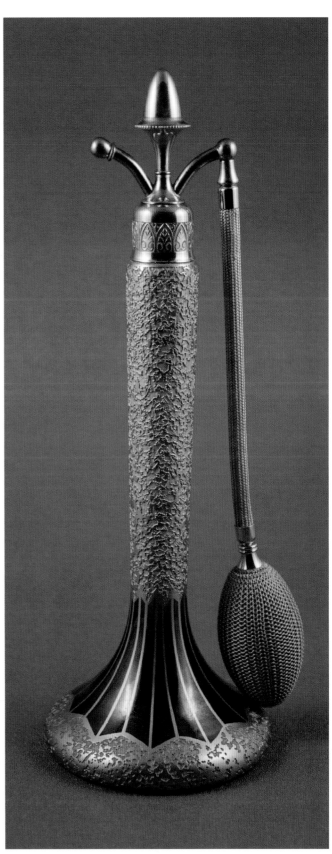

Q-2 Perfumizer with iridized crystal bottle, gold enameled etching and black enamel band border on the base; gold finished fittings and amber glass acorn (1925). Height 8.75".

Q-4 Tall Perfumizer, crystal bottle with cranberry flashed decoration and gold enamel encrusted sponge acid treatment; gold finished spray fittings (1925). Height 10".

Rarity Today—A Tale of Three Perfumizers

Millions of Perfumizers were originally sold, as DeVilbiss Perfumizers and Perfume Droppers were developed and priced to be affordable to a wide range of customers. Within certain price ranges, items were often produced in the tens of thousands, while the highest-priced models were produced in the hundreds or less.

Factory documents and specification books reveal, for example, that in 1926, DeVilbiss sold 20,096 of the very popular and reasonably-priced F-3 Perfumizer, which retailed for $4.00.

In contrast, only 531 of the N-10 Perfumizer, which retailed for $12.00, were sold.

At the extreme, in 1926, only fifty-four copies of the opulent Jade Imperial Perfumizer No. 2506, selling for $25.00, and fifteen of its D-2506 dropper bottle companion were sold.

Over the years, many DeVilbiss bottles and vanity items of all types have been lost to time and have become a challenge to find. If the original production numbers were small, it is little wonder that some items are harder to find today than others.

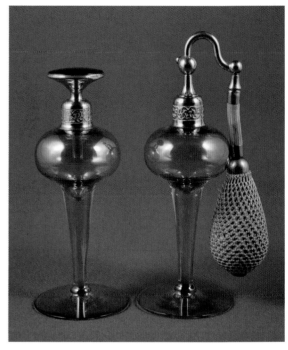

F-3 (20,096 produced in 1926) and DF-3 Perfumizer and Dropper set with topaz iridized Cambridge Glass Company bottles, gold finished fittings (1925). Height of Perfumizer 6.25".

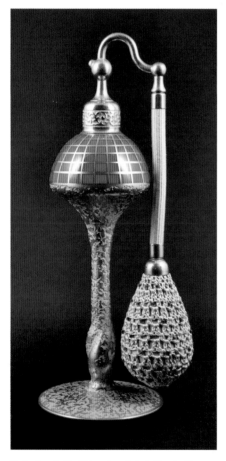

Perfumizer N-10 with hand-crocheted silk net with beads on bulb: 531 sold in 1926. Height 7". This lovely atomizer is also featured in the authors' large original display poster image by Bradshaw Crandell for DeVilbiss.

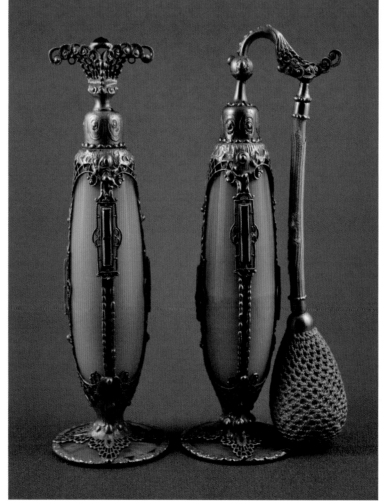

Imperial Perfume Dropper D-2506 and Perfumizer 2506, with 15 and 54, respectively, sold in 1926. Bottle by Fry. Height 8.75".

Mid–1920s DeVilbiss "Look-alikes" and Competition

Although we don't focus extensively here on the impact of changing times and the effects of increased competition, a few examples will suffice to indicate how similar some of the competitors' products were. The DeVilbiss Company's focus on innovation, artistic creativity, and developing products of high design quality, glass, and metal components, made them the industry leader.

One hesitates to use the term "knock-off" to describe some of the competitive offerings, from companies like Pyramid, Volupte, Aristo, and Van Woud, since many of their products were of demonstrable beauty and quality. But the conclusion is sometimes inescapable, as can be seen in examples from the mid-1920s. Look closely at differences in the details of the spray heads, collars, and shapes of the bottles and, in some cases, the decorations.

In the photo at right, notice the slight differences in the spray heads and collars, and the different formations and widths at the bases of the bottles. The Pyramid glass bottle on the left is also a bit lighter-weight than the DeVilbiss one pictured on the right.

In the photo at below left, the Pyramid bottle, although lovely, is not as intricate or refined in design and decoration of the bottle and spray fittings. The beads woven into the bulb netting of the DeVilbiss bottle are rarely found and add to the overall beauty of the bottle.

Both of the white bottles, below right, are by the Cambridge Glass Company, and the Vant Woud bottle on the right was also decorated by Cambridge. Notice the distinct differences of the spray heads and collars, between the DeVilbiss bottle on the left and the Vant Woud bottle on the right. Unlike Pyramid and Volupte spray heads and collars, which often mimicked DeVilbiss fittings, Vant Would fittings are more readily recognized.

DeVilbiss outlasted most of its competitors in this heated competition. By 1934, these firms were largely out of the perfume atomizer business. In fact, at a meeting in mid-1934, the DeVilbiss Executive Committee decided to decline an offer from Volupte to sell to DeVilbiss its remaining perfume atomizer inventories and production equipment.[7]

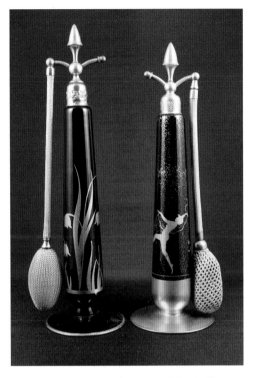

DeVilbiss (right). Height 10".
Pyramid (left). Height 10.5".

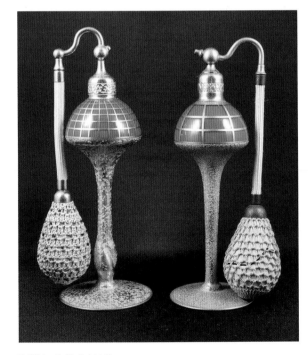

DeVilbiss (left). Height 7".
Pyramid (right). Height 7".

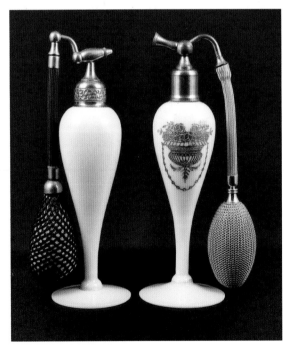

DeVilbiss (left). Height 6.75".
Vant Woud (right). Height 7".

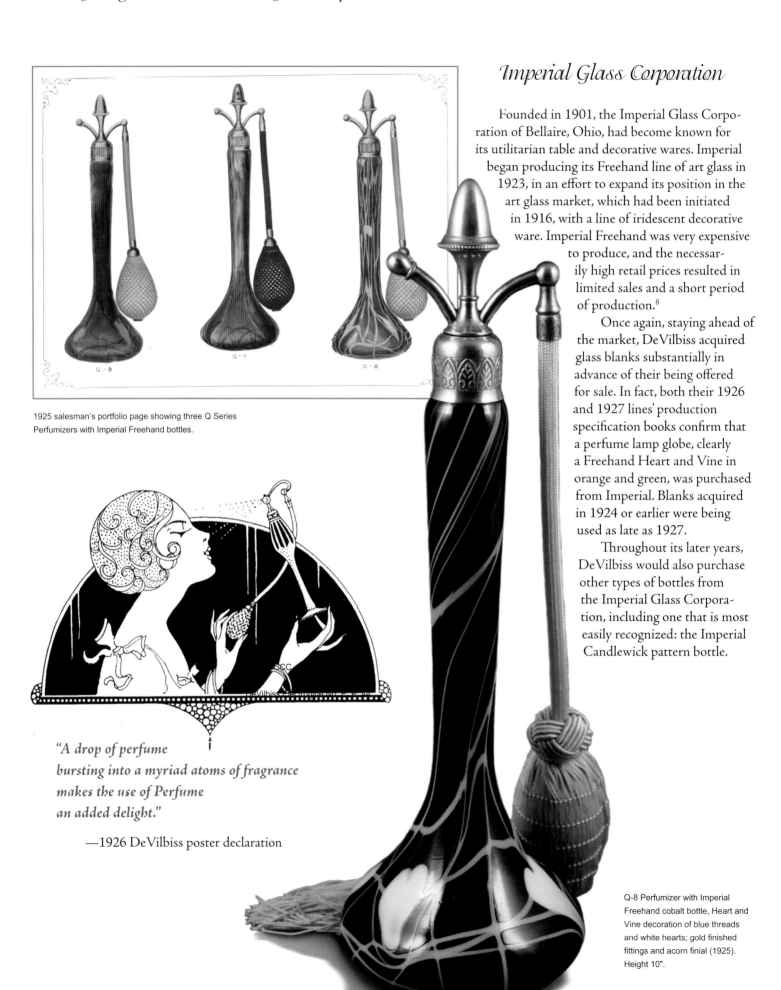

1925 salesman's portfolio page showing three Q Series
Perfumizers with Imperial Freehand bottles.

*"A drop of perfume
bursting into a myriad atoms of fragrance
makes the use of Perfume
an added delight."*

—1926 DeVilbiss poster declaration

Imperial Glass Corporation

Founded in 1901, the Imperial Glass Corpo-
ration of Bellaire, Ohio, had become known for
its utilitarian table and decorative wares. Imperial
began producing its Freehand line of art glass in
1923, in an effort to expand its position in the
art glass market, which had been initiated
in 1916, with a line of iridescent decorative
ware. Imperial Freehand was very expensive
to produce, and the necessar-
ily high retail prices resulted in
limited sales and a short period
of production.[8]

Once again, staying ahead of
the market, DeVilbiss acquired
glass blanks substantially in
advance of their being offered
for sale. In fact, both their 1926
and 1927 lines' production
specification books confirm that
a perfume lamp globe, clearly
a Freehand Heart and Vine in
orange and green, was purchased
from Imperial. Blanks acquired
in 1924 or earlier were being
used as late as 1927.

Throughout its later years,
DeVilbiss would also purchase
other types of bottles from
the Imperial Glass Corpora-
tion, including one that is most
easily recognized: the Imperial
Candlewick pattern bottle.

Q-8 Perfumizer with Imperial
Freehand cobalt bottle, Heart and
Vine decoration of blue threads
and white hearts; gold finished
fittings and acorn finial (1925).
Height 10".

1926, The Zenith Year

By the mid-1920s, DeVilbiss' Perfumizer business had enjoyed five years of dizzying growth. From 1921, when sales hit $460,000, to the zenith year of 1926, when 1.5 million Perfumizers, along with related vanity products, were produced and sold for a total of $2.2 million, the company achieved an amazing five-fold growth in five years! Flush with success, the company forecast at least equaling that performance in 1927. However, that did not happen. Sales fell sharply in 1927.

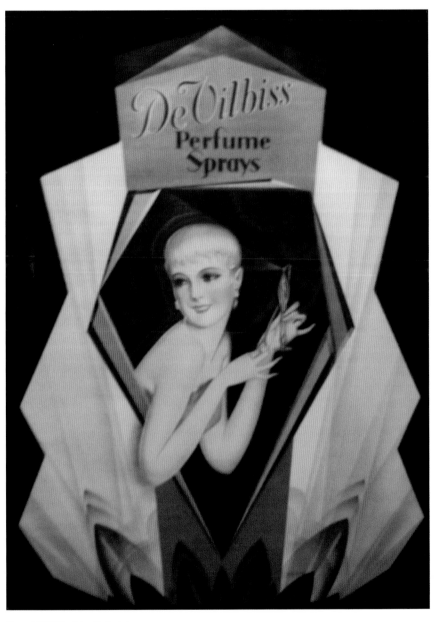

Elegant 1926 Devilbiss Perfumizer store display poster.

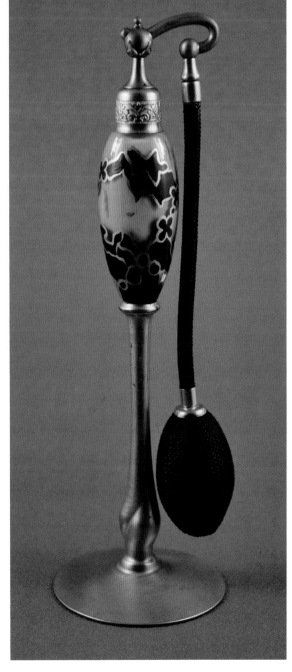

L-30 Tall elegant Perfumizer with twist stem bottle, gold enamel stem and foot, green interior enamel and black and gold decoration, and gold satin finished fittings (1926). Height 9".

Front and back panels of small (6" tall) fold-out brochure with space for retailer's information (1926).

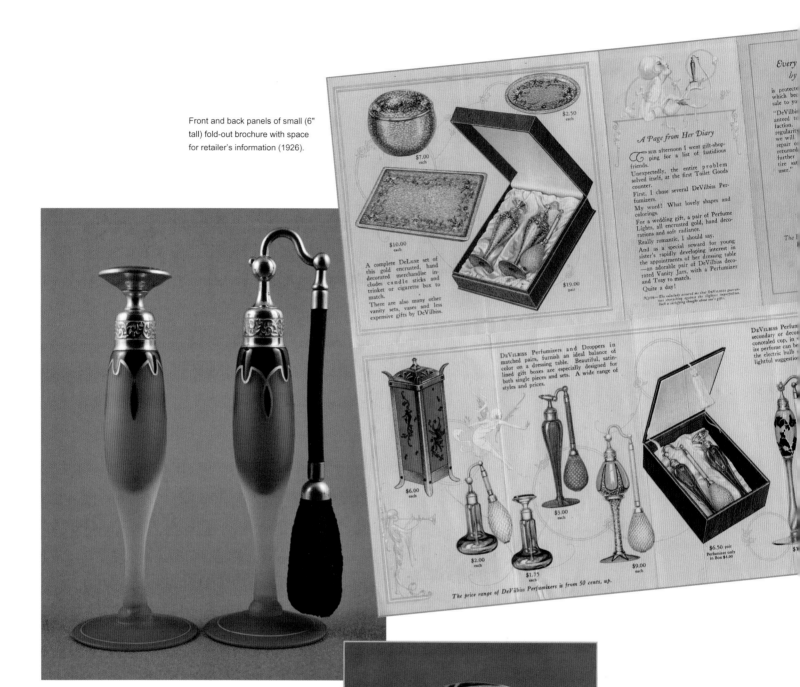

G-24 and DG-24 Perfumizer and Dropper set with orange interior enamel and foot, and gold-outlined black enamel decoration, on clear satin-finished glass; gold finished metal part (1926). Height 7" (Perfumizer).

Dauber top design for DG-24 Dropper Perfume.

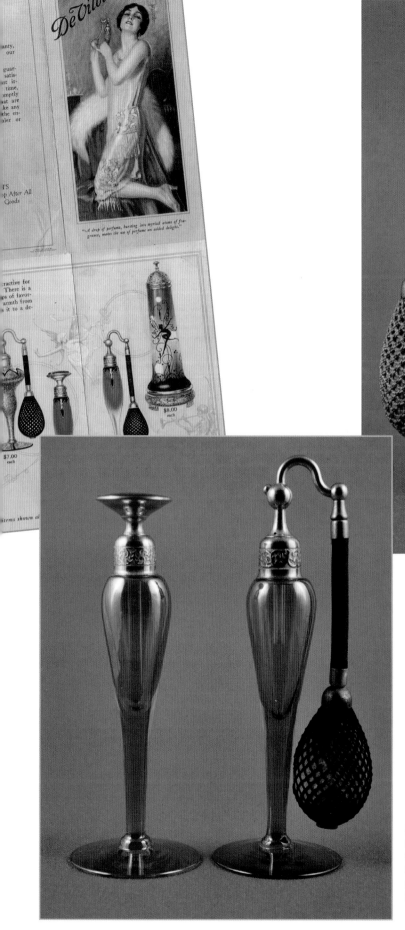

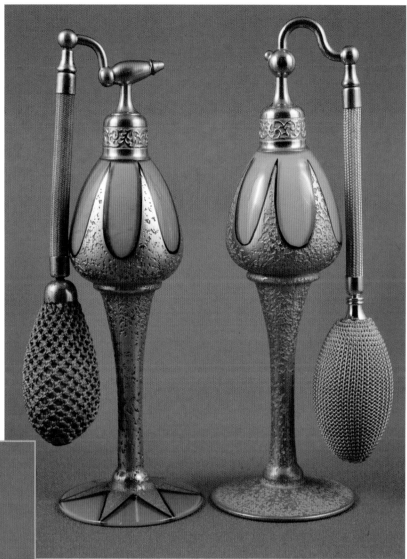

K-18 Perfumizer comparison of two DeVilbiss decorations; with gold enameled, sponge acid pattern outlined in black enamel, on a crystal glass bottle with green enamel interior and foot, and gold finished metal part (1926). Height 7.5".

F-27 and DF-27 Perfumizer and Dropper set supplied by the Cambridge Glass Company with Topaz deeply iridized bottles and gold finished spray and dropper fittings; also sold as a boxed set FDB-27 (1926). Height 7" (Perfumizer).

Notice the variation of decorations: a black enamel ring on the foot of the Perfume Dropper and gold enamel decoration on the frosted finish of the pin tray. These sets were sold in a variety of colors, finishes, and decorations. The colors were: Orange, Old Rose, Blue, Red, Coral, Lavender and Green. All but Coral, which was opaque glass, were DeVilbiss enameled crystal bottles. The widely used 0-64 bottle blank was supplied by the Cambridge Glass Company in both opaque and transparent colors. The E-23 Coral example's glass is identical to Cambridge's Crown Tuscan color, which, while appearing here in 1926, was not introduced into Cambridge's glass product line until 1932. Interestingly, the Red version, which was shown in the 1926 catalog, was replaced by the Coral bottle sometime that year, as evidenced by the substitution noted in this Perfumizer's specification below.

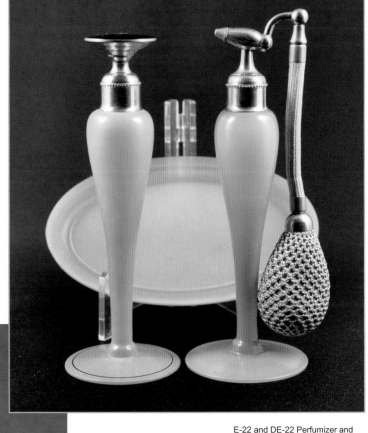

E-22 and DE-22 Perfumizer and Dropper with light blue enamel decoration and gold finished spray and dropper fittings, pin tray with gold decoration (1925). Height 6.25" (Perfumizer).

Factory specification of E-23 Perfumizer.

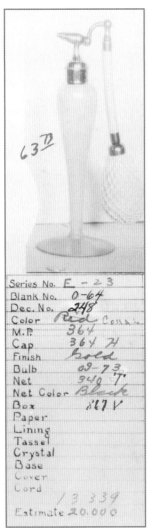

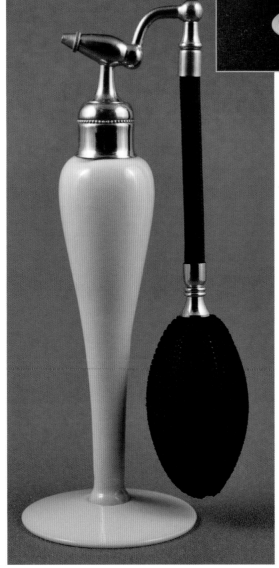

E-23 Rare Perfumizer with opaque Coral Cambridge bottle and gold finished fittings (1926). Height 6.25".

L-21 and DL-21
Perfumizer and
Dropper set with gold
enamel sponge acid
and cranberry flashed
decoration; gold finished
spray fittings (1926).
Height 8" (Perfumizer).

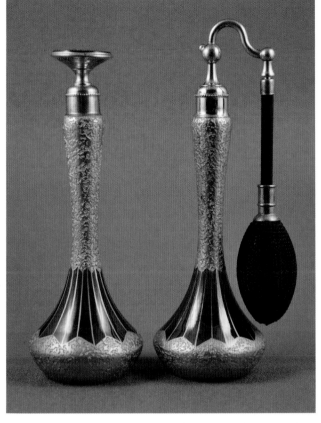

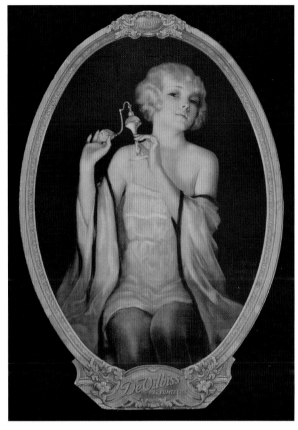

DeVilbiss store display poster
created by famous illustrator
Bradshaw Crandall to capture the
image of a beautiful young woman
in front of her mirror using the N-10
Perfumizer shown below.

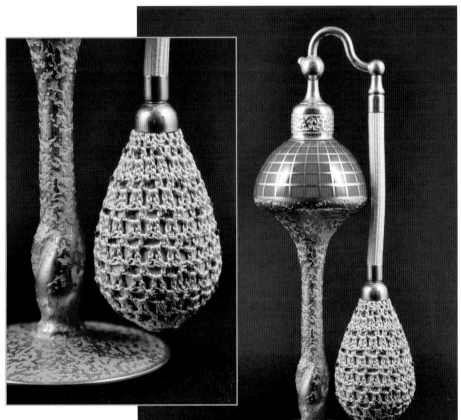

Close-up of N-10 Perfumizer
bulb with orange beads
crocheted into silk net.

N-10 Perfumizer with gold enamel
decorated sponge acid finish
on lower bowl, twist stem and
foot, with interior orange enamel
decorated bowl, gold finished
fittings (1926). Size 7.75".

Steuben Glass Works

DeVilbiss sourced beautiful bottles from the Steuben Glass Works of Corning, New York. These bottles are identified beginning in 1925, and reached a peak in the 1926 and 1927 lines. Steuben supplied bottle blanks to DeVilbiss and to (at least) its competitor Mignon Corp., with several of the same shapes appearing on atomizers from both companies.[9]

Frederick Carder (1863–1963), a gifted English designer, managed Steuben Glass Works from its founding in 1903 until 1932. At the age of 14, Carder left school and joined his family's pottery business in Brierley Hill, England. He studied chemistry and technology in night school. In 1879, he became fascinated with glass-making, after visiting the studio of John Northwood, where he saw Northwood's cameo glass replica of the Portland Vase, the most famous piece of ancient Roman cameo glass. One year later, on Northwood's recommendation, Carder went to work as a designer at Stevens & Williams, a large English glass-making company. There, as Northwood's chief assistant, he experimented with glass colors and designs.

Carder moved to Corning, New York, in 1903, at the invitation of Thomas G. Hawkes, the owner of Steuben Glass Works. For the next thirty years, Carder had a free hand in designing the firm's decorative and table glassware products, developing many brilliant new colors, designs and techniques. In 1918, Steuben was sold to and became a division of Corning Glass Works, a company founded in 1868 by the Houghton family.

In 1932, when Steuben's new president, John McKay, was appointed to succeed Carder, Steuben concentrated on colorless glass. Carder left Steuben to become design director of Corning Glass Works. Carder's glass-making career ended in 1959 when, at the age of 96, he finally closed his studio and "retired."[10]

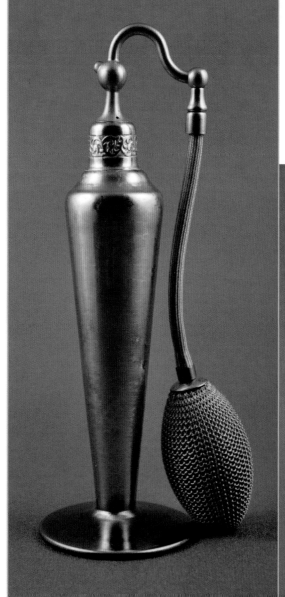

I-11 Perfumizer with Steuben Glass Works Gold Aurene bottle; Steuben shape number 6136 (1925). Height 7.5".

L-15 Perfumizer with Steuben Glass Works Gold Aurene bottle on Steuben shape number 6407, with engraved decoration on the base; gold finished fittings with amber glass acorn (1925). Height 9.75".

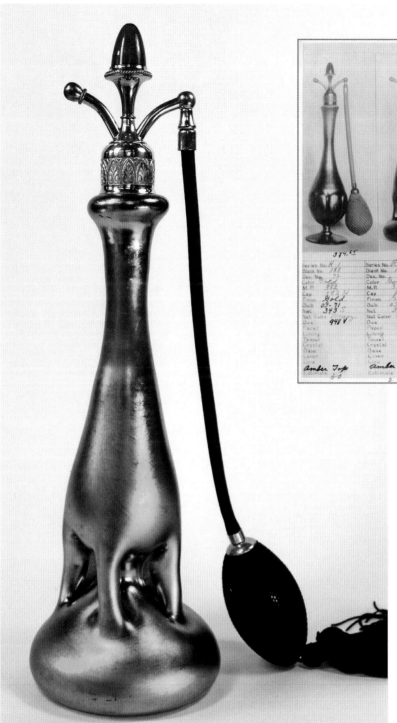

R-6 Perfumizer with Steuben
Glass Works "Atomic" Blue
Aurene bottle with platinum
finished fittings and a sapphire
jeweled acorn finial (1926).
*Courtesy of Jay Kaplan. Photo
by Marsha Crafts.*

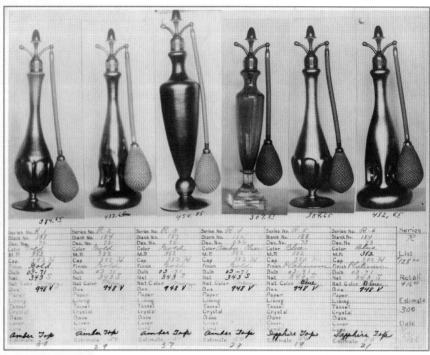

Specification book page featuring Steuben bottles.

A page from the DeVilbiss factory specification book,
dated March 29, 1926, shows six bottles, with four styles
from Steuben Glass Works. From the left, pictured are
Steuben shapes: 6411, an unnumbered shape known by
DeVilbiss collectors as "Atomic," 6137, 6410, 6411, and
again "Atomic." Repeated shapes depict the same bottle in
Gold Aurene and Blue Aurene. Gold fittings and amber
jewels were specified for Gold Aurene bottles, while the
two Blue Aurene bottles, at the far right, called for plati-
num fittings and blue sapphire jewels.

Collectors have dubbed the R-2 and R-6 shape, which
does not have a Steuben shape number, "Atomic," due to its
vague resemblance to a mushroom cloud which, ironically,
would not be first seen until a few decades afterward.

Employee Innovation

*The original, hand-crocheted nets on the squeeze
balls of both N-10 and N-13 feature sewn-in beads
(see page 107). This innovation, rarely seen today,
was implemented on some higher-end bottles as a
result of a DeVilbiss innovation contest, held with
their employees. This net decoration, with beads, was
a winning employee's suggestion. This innovation was
implemented and appears in a factory specification
dated March 29, 1926.*

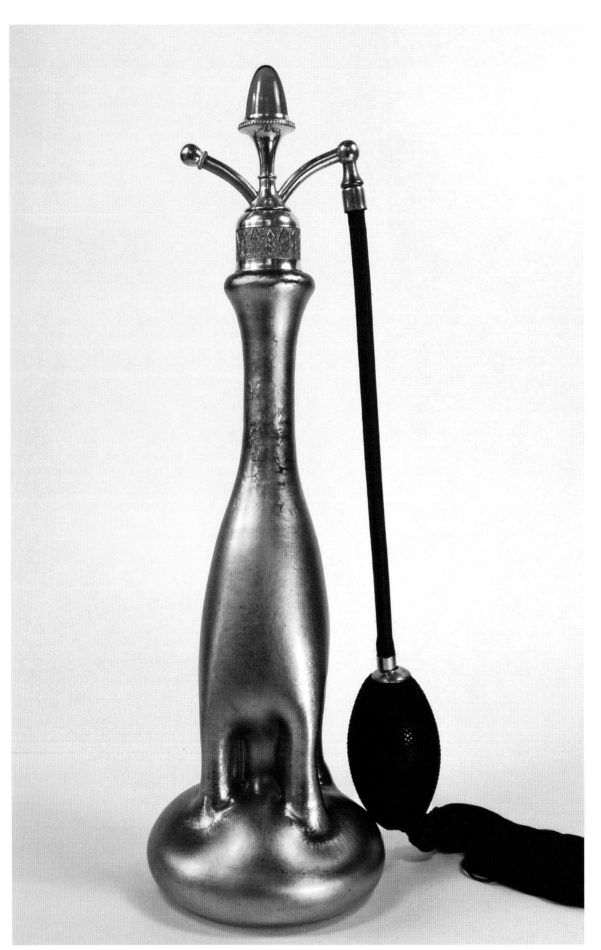

R-2 Perfumizer with Steuben Glass Works "Atomic" Gold Aurene bottle with gold finished fittings and an amber jeweled acorn finial (1926). *Courtesy of Jay Kaplan. Photo by Marsha Crafts.*

Opposite left: R-1 Perfumizer with Steuben Glass Works Gold Aurene bottle with gold finished fittings and an amber jeweled acorn finial (1926). *Courtesy of Jay Kaplan. Photo courtesy of Marsha Crafts.*

Opposite right: T-6 Perfumizer with Steuben Glass Works Blue Aurene bottle with stem and leaf cut decoration and gold finished fittings (1926). *Courtesy of Jay Kaplan.*

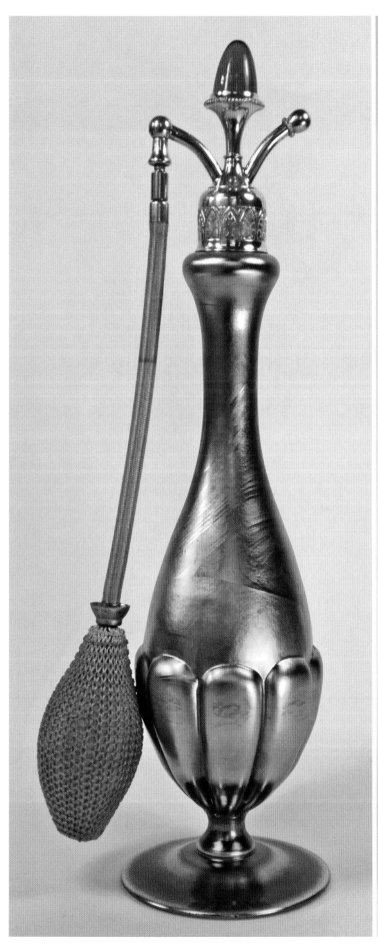
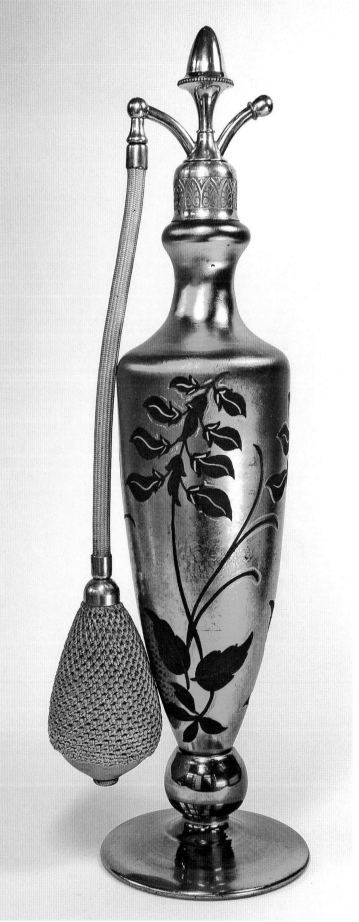

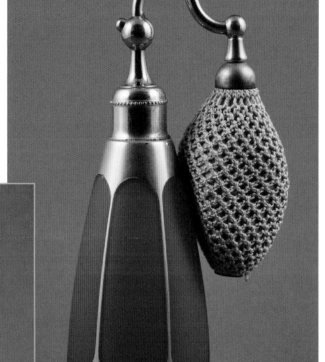

E-26 Perfumizer with interior orange enamel, satin-finished and gold enamel decoration on the outside, gold finished metal part (1926). Height 5.5".

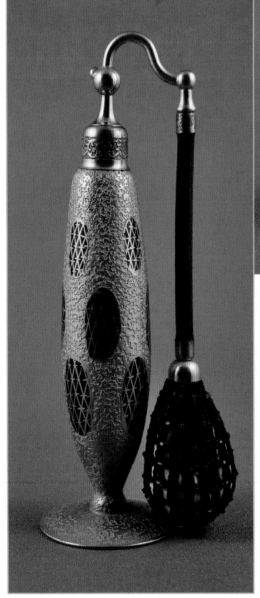

N-13 Perfumizer with gold enamel sponge acid decoration on black interior enameled bottle, shown through oval windows with cross-hatch decoration (1926). Height 7.5".

F-28 Perfumizer with satin-finished black glass decorated with raised orange enamel in a stylized floral pattern; gold finished spray fittings (1926). Height 5.5".

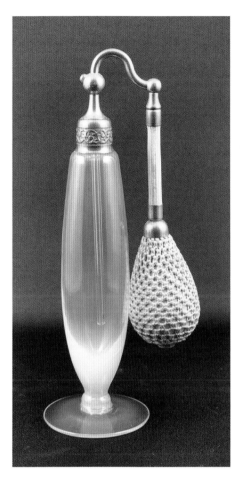

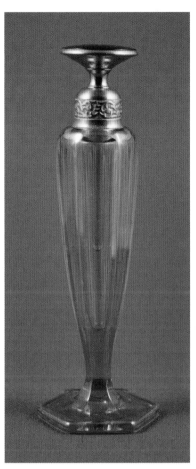

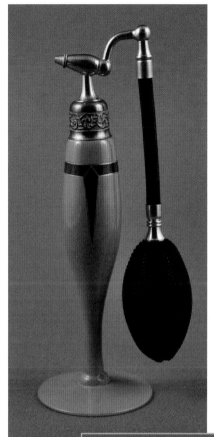

G-23 Perfumizer with green, black and gold enamel decoration, gold finished spray fittings (1926). Height 7".

Non-cataloged Perfumizer with white and rose tinted opalescent bottle from H. C. Fry Glass Company; Foval Art Glass and gold finished spray fittings (c. 1926). *Courtesy of Jim and Carole Fuller.*

DF-21 Perfume Dropper with a Topaz (iridized crystal) bottle, hexagonal foot, gold finished dropper fittings (1926). Height 6.5".

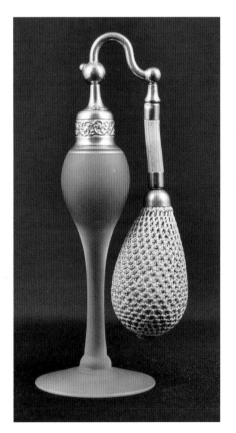

F-25 Perfumizer with satin crystal bottle and orange interior enamel; gold finished spray fittings (1926). Height 6.25".

DG-26 Perfume Dropper with silky satin-finished crystal bottle, coral interior enamel and black-outlined gold enamel decoration on bottle and foot; gold finished metal part (1926). Height 4.75". Black inset on top of dropper handle.

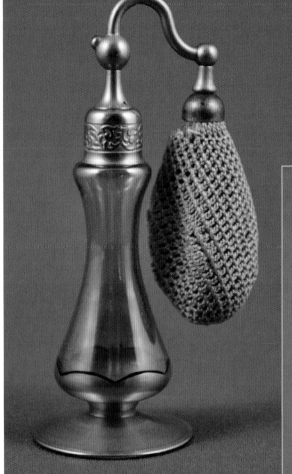

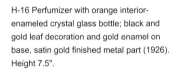

G-29 Perfumizer with Topaz iridized crystal glass bottle with black-outlined gold enamel decoration on foot and gold finished metal part (1926). Height 5.5".

H-16 Perfumizer with orange interior-enameled crystal glass bottle; black and gold leaf decoration and gold enamel on base, satin gold finished metal part (1926). Height 7.5".

I-20 Perfumizer with gold enamel on clear glass bottle, reverse and interior enameled in orange showing through cutouts (1926). Note hollow cupped foot. *Courtesy of Jim and Carole Fuller.*

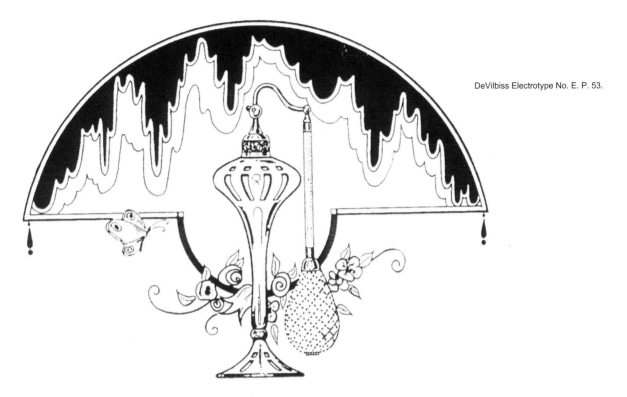

DeVilbiss Electrotype No. E. P. 53.

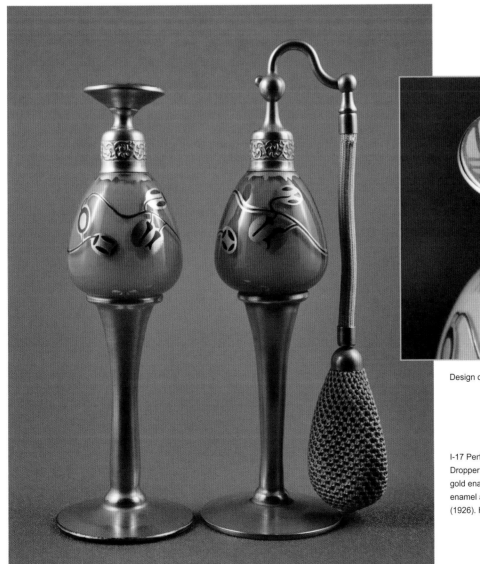

Design detail of dropper rod handle.

I-17 Perfumizer and DI-17 Perfume
Dropper with black and gold leaf pattern,
gold enamel stem and foot, orange interior
enamel and satin gold finished metal part
(1926). Height 7.5".

The DeVilbiss Reptilian Series

The Reptilian Series, a 1926 design innovation that was continued in 1927, was described in DeVilbiss catalogs as "*The New Reptilian Series*. Presenting for the first time, authentic adaptations of famous Reptilian designs, each of which has an interesting Museum history."[11] The five enamel decoration designs in the series were inspired by different reptile skin colors and patterns.

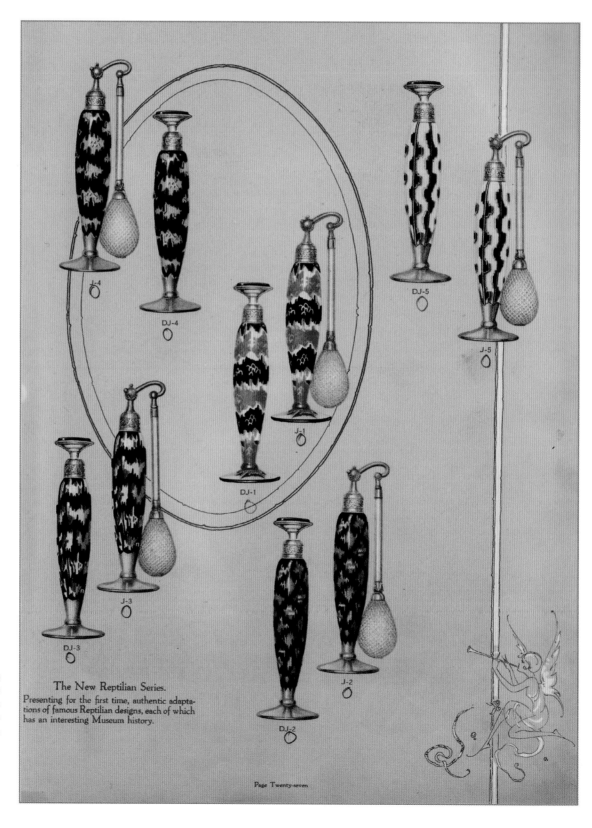

1926 sales catalog page showing the full Reptilian Series. Pencilled "0" notations indicate that the line was entirely sold out.

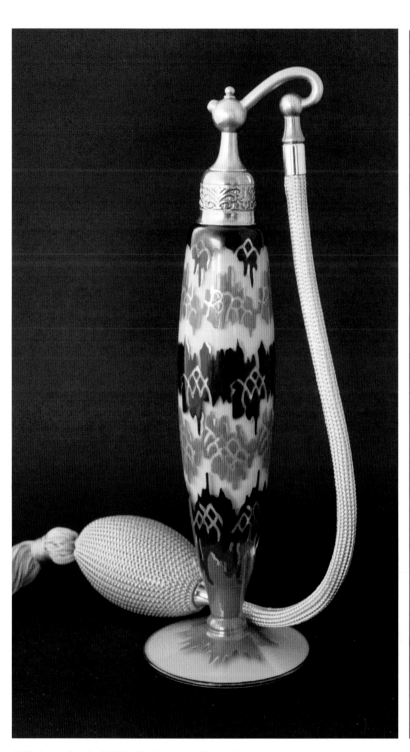

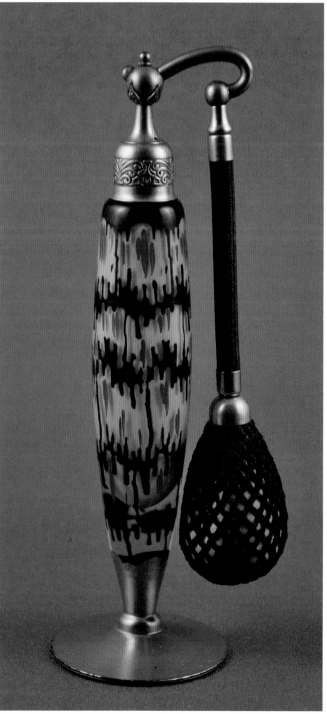

J-1 Perfumizer from the DeVilbiss Reptilian series. Black and orange enamel pattern on interior yellow enameled crystal bottle; gold finished metal part (1926). Height 7.5". *Courtesy of Cheryl Linville.*

J-3 Perfumizer from the DeVilbiss Reptilian series. Black and red exterior enamel pattern on interior yellow enameled crystal bottle, with gold enameled foot and gold finished metal part (1926). Height 7.5".

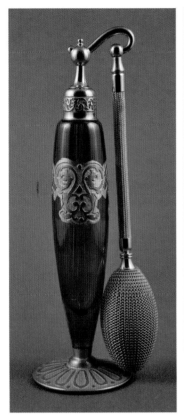

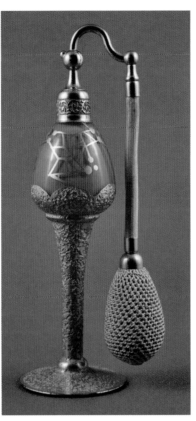

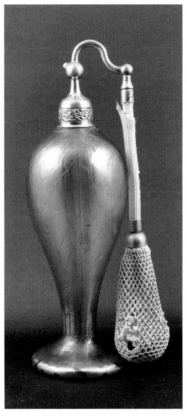

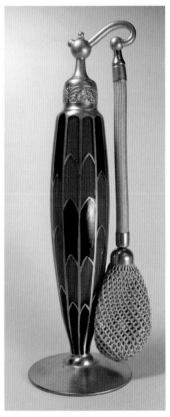

K-17 Ornate Perfumizer with burgundy-flashed crystal glass bottle and gold enameled acid cutback pattern on bottle and foot with gold finished metal part (1926). Height 8".

K-20 Perfumizer with gold enameled sponge acid on bowl, stem and foot and gold enameled line design, on a crystal glass bottle with orange enamel interior and gold finished spray head and collar (1926). Height 7.5".

Non-cataloged rare Perfumizer with gold iridescent art glass bottle and gold finished spray head and collar (c. 1926). *Courtesy of Jim and Carole Fuller.*

L-27 Perfumizer with orange interior enamel and black and gold exterior decoration with gold foot; satin gold finished spray fittings (1926). *Courtesy of Marsha Crafts.*

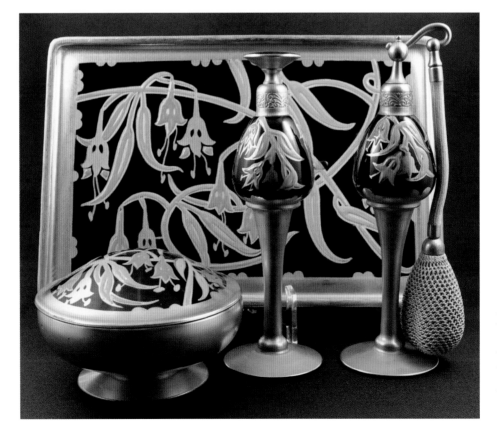

Deluxe vanity set 6952 with L-33 Perfumizer and DL-33 Dropper, with gold enameled stem and foot and raised orange and teal green enamel floral decoration on black glass bottles, and gold satin finished fittings; vanity jar VJ-1001, and vanity tray VT-1503 to match (1926). Vanity tray by Westmoreland Glass Company.

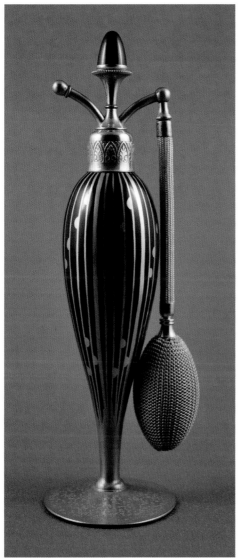

L-29 Perfumizer features a Cambridge Glass Company ebony glass bottle with a DeVilbiss decorated Art Deco gold enamel pattern, gold finished metal parts and black glass acorn (1926). Height 9".

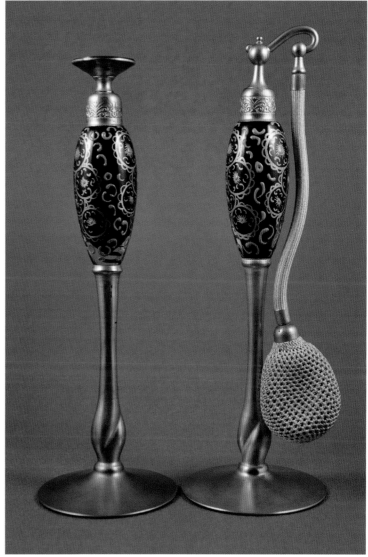

L-31 Perfumizer and DL-31 Perfume Dropper pair with tall twist stem bottle, gold enamel stem and foot, black interior enamel orange and black decoration, and gold satin finished fittings (1926). Height 9" (Perfumizer).

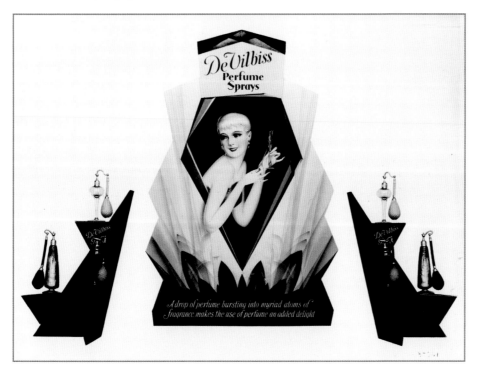

DeVilbiss 1926 photo showing how to use the store display poster and related stands to set up a perfume counter display.

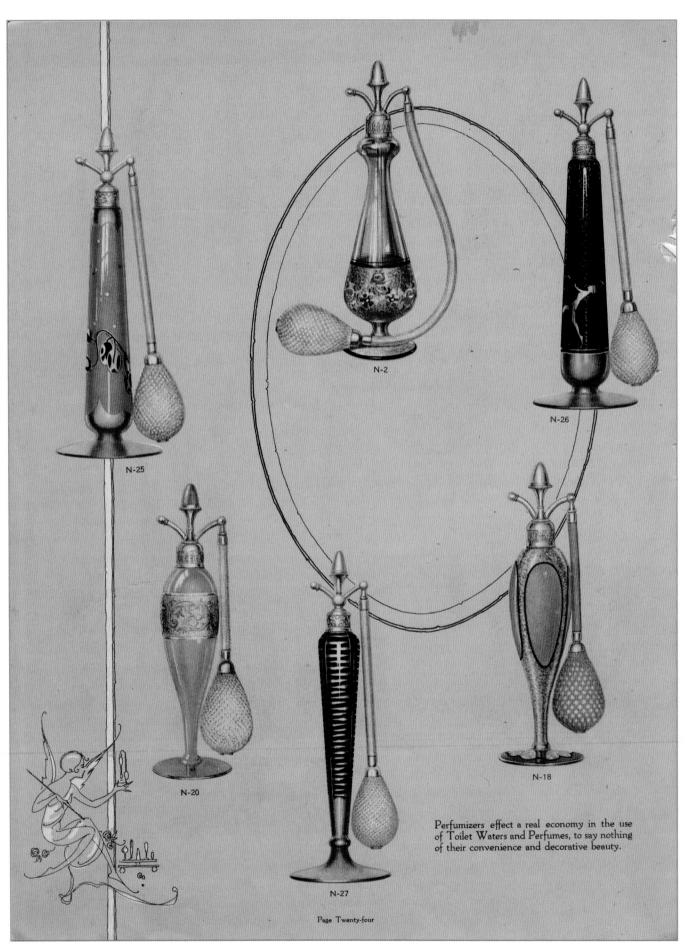

N-2

N-25

N-26

N-20

N-27

N-18

Perfumizers effect a real economy in the use of Toilet Waters and Perfumes, to say nothing of their convenience and decorative beauty.

Page Twenty-four

Page from 1926 salesman's catalog page showing N Series Perfumizers.

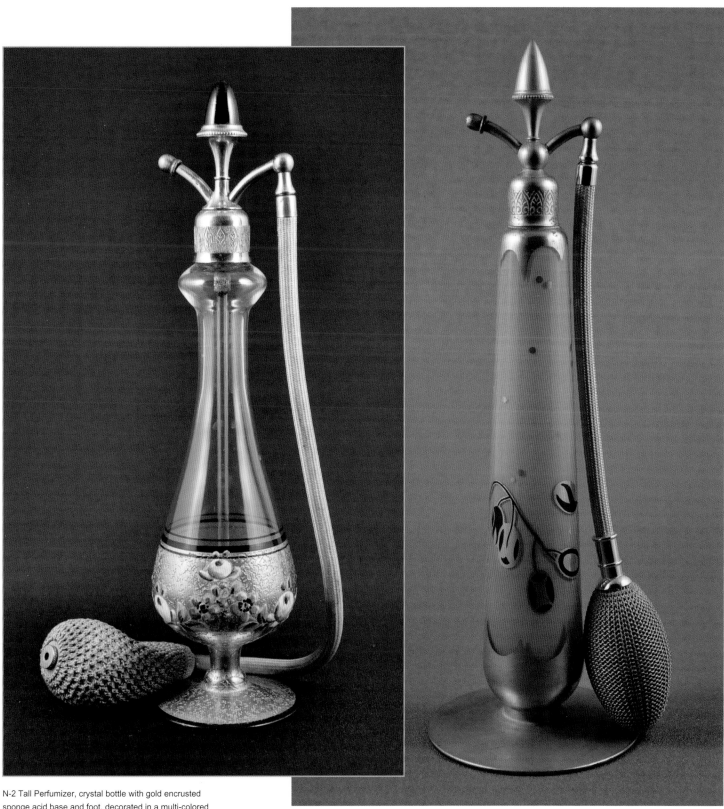

N-2 Tall Perfumizer, crystal bottle with gold encrusted sponge acid base and foot, decorated in a multi-colored enamel floral pattern with striking black enamel accent bands. Large gold finished spray fitting with black glass acorn (1923). Height 9.5".

N-25 Tall Perfumizer with orange interior enamel with black and gold leaf decoration and gold enamel foot; gold satin finished fittings (1926). Height 10".

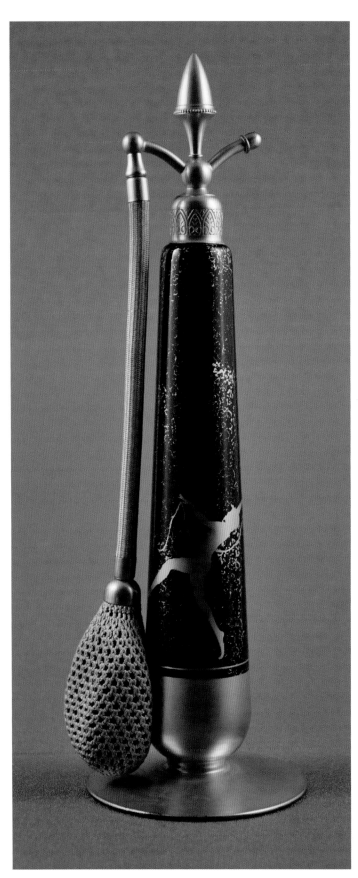

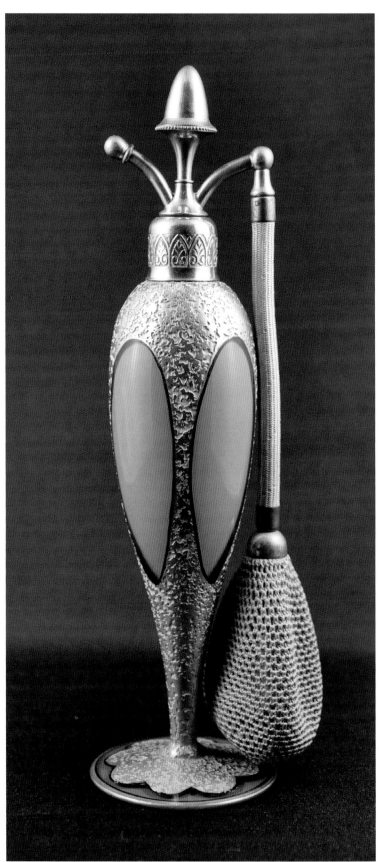

N-26 Beautiful, tall "Dancing Nymph" Perfumizer with clear glass bottle, black enamel interior and gold enamel dancer decoration and foot, with satin gold finished fittings (1926). Height 10".

N-18 Stunning Perfumizer is a Cambridge Glass Company supplied clear bottle with DeVilbiss-applied deep pink interior enamel and exterior gold enameled sponge acid treatment in a window pattern trimmed with black enamel (1926). Height 9". Note the pink silk covering on the original ball and cord to coordinate with the bottle.

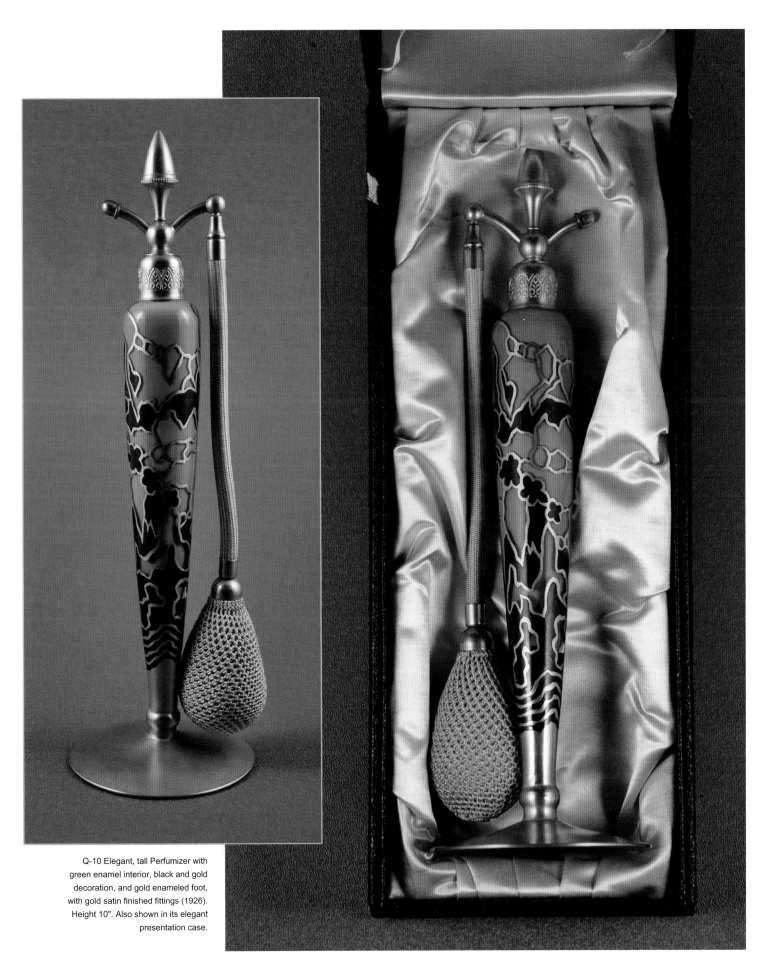

Q-10 Elegant, tall Perfumizer with green enamel interior, black and gold decoration, and gold enameled foot, with gold satin finished fittings (1926). Height 10". Also shown in its elegant presentation case.

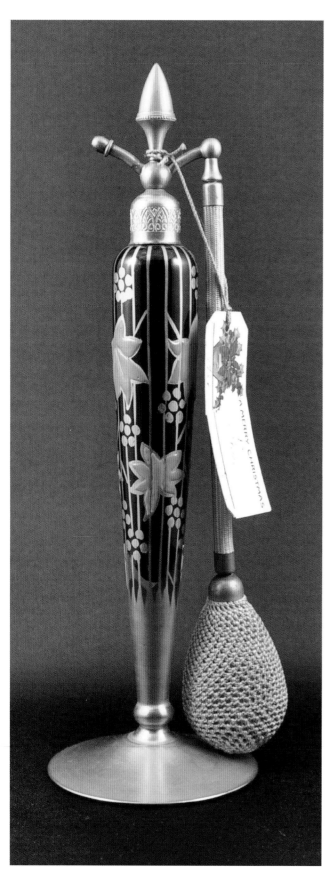

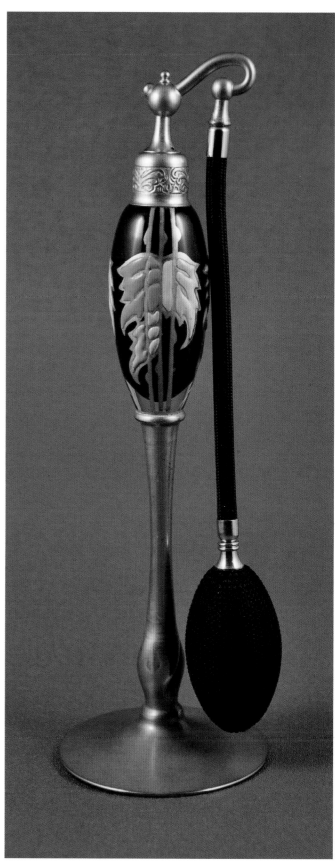

Q-13 Perfumizer with clear glass bottle, black enameled interior, orange and gold enamel floral decoration and gold foot, and gold satin finished fittings with an original Christmas gift tag (1926). Height 10". *Courtesy of Jim and Carole Fuller.*

Q-14 Stately tall Perfumizer with clear glass bottle, black enameled interior, orange and blue enamel feather decoration, gold stem and foot, and gold satin finished fittings (1926). Height 10".

Bradshaw Crandell—Illustrator Extraordinaire

Bradshaw Crandell (1896–1966) was famous for portraits of Hollywood movie stars, magazine covers, and commercial illustration. He was commissioned by DeVilbiss to produce three illustrations appearing in the 1926 sales catalog, as well as store display posters for the period. Crandell was an American artist and illustrator.

He was known as the "artist of the stars." Among the movie stars who posed for Crandell were Carol Lombard, Bette Davis, Judy Garland, Veronica Lake and Lana Turner. In 1921, he began his career with an ad for Lorraine hair nets that were sold exclusively at F. W. Woolworth stores. His first cover illustration was the May 28, 1921 issue for the humor magazine *Judge*. In later life, he moved from illustrations to oil-on-canvas paintings, which included political figures. He also provided poster work for 20th Century Fox. In 2006, he was inducted into the Society of Illustrators hall of fame. In March 2010, a Crandell illustration for the 1952 Dutch Treat Club yearbook sold for $17,000.[12]

Three illustrations from the 1926 DeVilbiss sales catalog depicting ladies past and present, by artist Bradshaw Crandell (1896–1966).

DeVilbiss Imperial Perfumizers

The cover panel of a small, 1926 brochure has an illustration of a woman using an Imperial bottle. These ten-panel, 3¼" x 6", folded brochures were printed by DeVilbiss and provided to retailers as counter handouts, mailers, or stuffers for consumers with packages of a newly purchased item. Space was provided to print the retailer's name on the back panel.

1926 small DeVilbiss brochure.

...p of perfume, bursting into myriad atoms of fra-
..., makes the use of perfume an added delight."

Ornate opulence characterized some of the higher-end models of DeVilbiss Perfumizers in 1924 and 1925. In keeping with the times of the Roaring '20s, the company seemed to challenge the limits of intricacy and ornateness with its Imperial Perfumizer Line. A combination of filigree, ormolu, overlay, and both suspended and embedded jewels were worked onto six different Foval bottle blanks supplied by the H. C. Fry Glass Company in three colors: Jade, Coral, and Yellow; with each color shading to opalescent white at the bottom of the blank.

Metal collars were layered with gold, and the spray tubes were worked with filigree and beads. Even the small caps terminating the rubber tubes were gold beaded. Finally, some models were adorned with jeweled pendants suspended from the filigree or ormolu on small chains which themselves were jeweled. The full effect of this lavishness is difficult to describe. Therefore, images of both the catalog pages and the bottles will complete the picture. At $25 retail, the equivalent of $325 today, the DeVilbiss Imperial Perfumizer was truly the top-of-the-line. All the models were produced in very limited quantities, making their rarity today assured.

DeVilbiss store display poster that the illustrator Bradshaw Crandall created to capture the image of a beautiful young woman in front of her mirror using an N-10 Perfumizer.

The H. C. Fry Glass Company

The H. C. Fry Glass Company was established in 1902 by Henry Clay Fry, in Rochester, Pennsylvania. The company was known for its heat-resistant, kitchen oven glassware. "Foval" was the company's trade name for its art glass, an acronym derived from <u>Fr</u>y <u>Ov</u>en <u>A</u>rt <u>L</u>ine, introduced in 1922.[13] Most of Fry's Foval colored items, including those used by DeVilbiss in other-than-Imperial line models, were opalescent white; Delft, an opaque blue; and Jade, an opaque green. The company also produced a very few items incorporating the color Rose, which, according to the H. C. Fry Glass Society, has "hues ranging from a pastel pink to a deeper raspberry shade."[14] For DeVilbiss' Imperial products, Fry supplied blanks with shadings of Jade and Rose (which DeVilbiss called Coral), but also an opaque yellow, not mentioned in the Society's Encyclopedia. These bottle blanks are all identified as being from Fry, not the least because the word "Foval" is written beside the bottle blank number in Imperial Line factory records. (See example on page 130.)

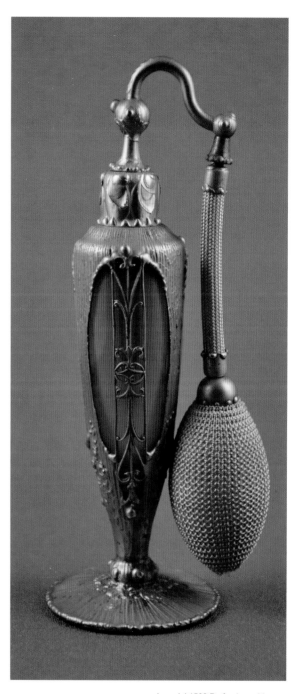

Imperial 1502 Perfumizer with Coral bottle and gold ormolu overlay with the bottle by H. C. Fry Glass Company (1926). Height 7".

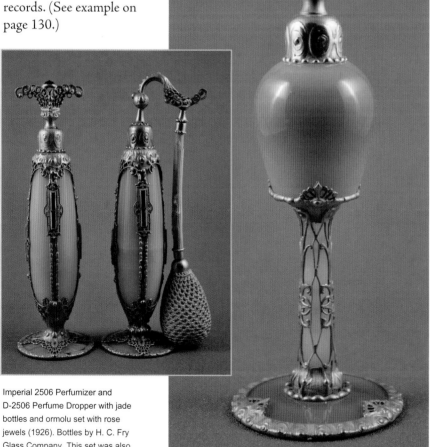

Imperial 2506 Perfumizer and D-2506 Perfume Dropper with jade bottles and ormolu set with rose jewels (1926). Bottles by H. C. Fry Glass Company. This set was also equipped with rose jewel pendants, two suspended from rings on the filigree dropper rod handle, and one suspended from the outer loop of the Perfumizer's spray tube (see catalog shown on page 130 top). Height 8.75".

Imperial D1505 Perfume Dropper with Coral bottle, opalescent stem surrounded by a delicate filigree, and filigree ornament on the dropper rod. Bottle by the H. C. Fry Glass Company (1926). Height 7".

Unlisted Imperial Perfumizer with gold ormolu on the bottle and foot. The bottle's brownish-rose color also does not appear in DeVilbiss literature, c. 1926–1927. Bottle by H. C. Fry Glass Company. Height 8.75". *Courtesy of Jim and Carole Fuller.*

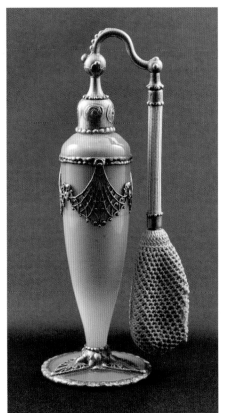

Imperial D-2006 Perfume Dropper with Jade bottle supplied by H. C. Fry Glass Company; ormolu nymph figure at the base (1926). *Courtesy of Jim and Carole Fuller.*

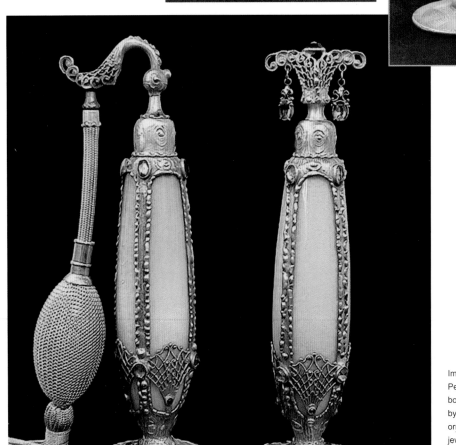

Imperial 2503 and D-2503 Perfumizer and Perfume Dropper bottle with Jade bottles supplied by the H. C. Fry Glass Company; ormolu set with topaz and rose jewels; topaz jeweled pendants suspended from the filigree dropper rod (1926). Height 8.75". *Courtesy of Woody Griffith. Photo by Marsha Crafts.*

Imperial 2003 Perfumizer with Jade bottle, gold ormolu and filigree extension on spray tube (1926). This model was originally equipped with small amethyst jeweled pendants suspended from each of four ormolu rings (see catalog shown on page 130 top). Bottle by the H. C. Fry Glass Company. Height 8.75".

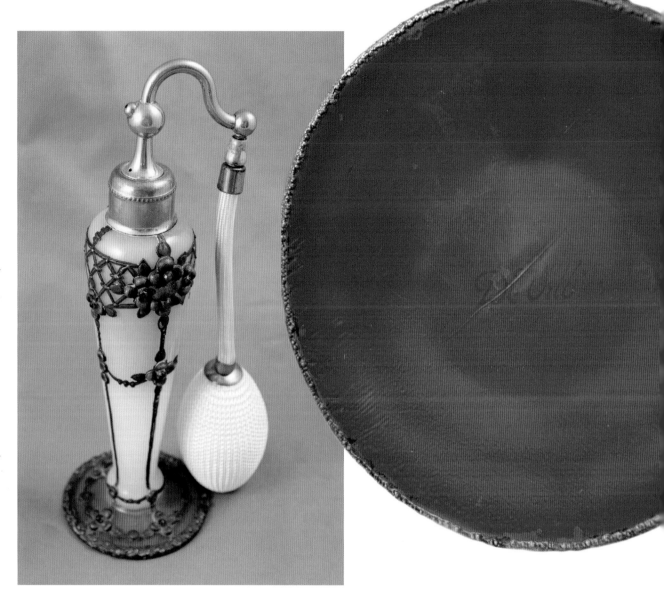

Mystery Bottle. *Courtesy of Amy and Mark Bergman. Photo courtesy of Mark Bergman.*

Red enamel with DeVilbiss script signature clearly visible on the base of the "Mystery Bottle." *Photo courtesy of Mark Bergman.*

Unlisted vanity tray with Imperial-type gold overlay on the edge of a green enameled glass tray, c. 1926–1927. *Courtesy of Jim and Carole Fuller.*

While an unknown DeVilbiss product occasionally appears in the marketplace that is not listed in the company's catalogs or factory records, it is interesting to note that an Imperial Perfumizer with a bottle of unlisted color (although which may be a variation of Coral) and ormolu configuration would show up. This bottle above uses the Foval blank from the 1504/5/6 models and ormolu components from two other models: the foot ormolu from the 1000–1003 models, and the filigree shield from the 2500 Series models.

This is a DeVilbiss Perfumizer with a Fry Foval rose bottle and jeweled ormolu. It's not shown in the Imperial line and is not seen elsewhere in DeVilbiss records, but the similarities—notwithstanding the standard spray fittings—are striking, and there is a clear DeVilbiss signature on the foot. This may have been an Imperial line design prototype, or a sample submitted by an ormolu decorating vendor. Close inspection shows that gold finishing once covered the ormolu. The style and ornateness of this ormolu is significantly different from production Imperial items.

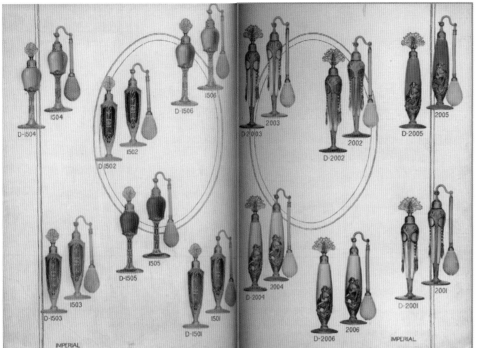
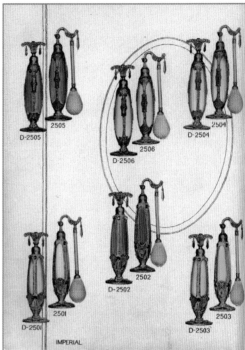

Three of four pages from DeVilbiss
Imperial sales catalog (1926).

Models from the first
catalog page (not shown
above) are pictured and
described in this 1926
factory specification page,
where the use of H. C. Fry
Foval blanks is confirmed,
jewel colors and sizes are
specified, other details are
described, and production
estimates with actual sales
are noted.

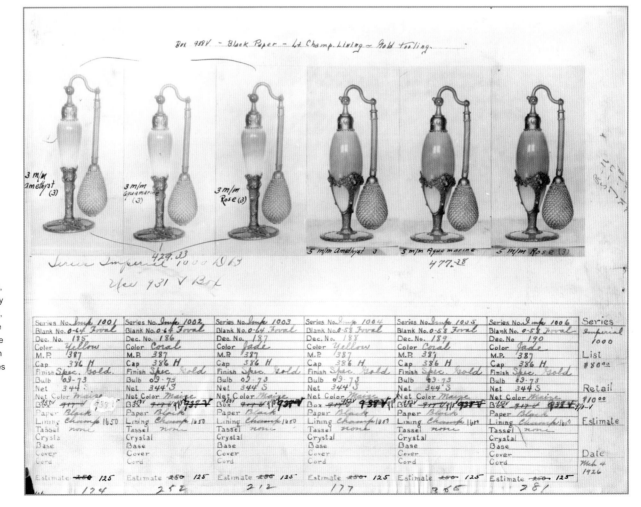

Changing Times

In late 1926, DeVilbiss executives decided not to publish a new 1927 catalog, but to continue the 1926 line with a new price list for 1927, published in a seven-page addendum. They provided salesmen with photographs of new additions during 1927, and this brief flyer indicating new changes and additions and prices, and declared that the catalog that was distributed in 1926 was now the "1926–27 Catalog." The flyer acknowledged an increase in popularity of the Perfumizer and Dropper Sets, and increased the number of offerings that would also be packaged as sets. Two new perfume lights were added, both with lovely filigree work on their bases, and six new vanity sets, each of which had been available before, but in different vanity-set combinations.

Fortunately for collectors who are interested in positive identification and dating of DeVilbiss items based on official documentation, one conclusive record of the full 1927 product line exists in the authors' collection. It takes the form of a 1927 compilation of factory assembly specifications for all items produced and sold that year. This specification book has been an invaluable resource in dating items as 1927 products, where they are not present in a similar compendium of 1926 factory specifications.

Late 1926-series Perfumizers, with metal stems and jeweled feet, were produced in Blue (G-31) with light sapphire jewels, Old Rose (G-32) with rose jewels, Jade (G-33) with aquamarine jewels, Coral (G-34) with aquamarine jewels, Yellow (G-35) with amethyst jewels, and Black (G-36) with no jewels. The Blue, Jade, Coral, and Yellow models were fitted with satin-finished-gold metal parts; the Old Rose model with green-gold finished parts, and the Black style having bright nickel metal parts. It appears, from a factory record dated September 23, 1926, that DeVilbiss originally intended to acquire (and may actually have acquired) the glass blanks for the Old Rose, Jade, Coral and Yellow models from H. C. Fry, since the notation "Foval" appears beside these models, but then the word is lined through. Jade, Coral and Yellow are colors known to be produced by H. C. Fry for the DeVilbiss Imperial line of Perfumizers produced in 1926 and 1927.

In April 1927, a modified series was offered, numbered G-38 through G-42, which were identical to the earlier G-31 through G-35, with the single exception of the absence of the inset jewels in the foot. In this later series, the black bottle with bright nickel fittings was absent.

Title page of the July 1927 price list addendum to the DeVilbiss 1926 catalog, declaring that publication as the "1926–27 catalog."

F-6 Perfumizer old rose enameled Cambridge Glass Company bottle, gold finished metal part (1927). Height 7". The rich luster of this bottle is enhanced because the underlying glass color of the bottle is an opaque ivory which enriches the effect of the enamel.

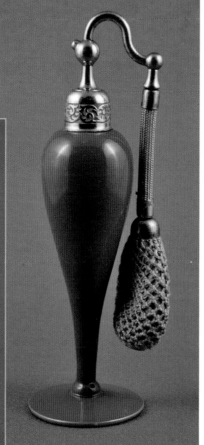

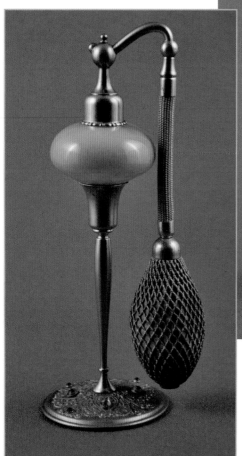

G-33 Perfumizer with gold satin finished stem, spray fittings and a foot with embossed pattern set with aquamarine jewels—of which four each were 5 millimeter and 4 millimeter in size (1926). Height 6.75".

This deeply-etched, sponge acid, cut-back treatment below is not seen on any other bottle, either in factory records or known collections. While there was a matching dropper bottle (DG-37), this model was not produced in any other color or fitting configurations. Both the Perfumizer and Perfume Dropper appear alone, on separate factory specification pages dated March 26, 1927. The bottle blank is the well-known Cambridge Glass Company-produced shape, that appeared first in the 1922 DeVilbiss product line.

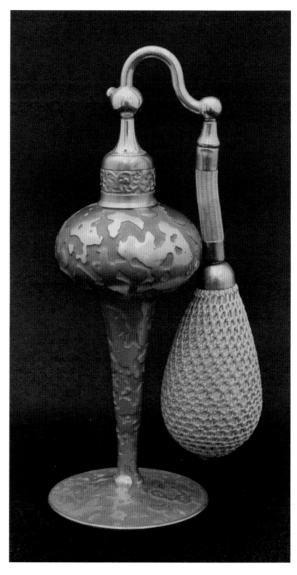

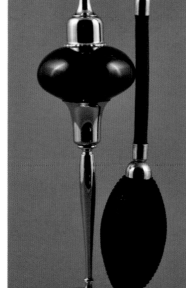

G-36 Perfumizer with black bottle and bright nickel-finished foot with embossed pattern (no jewels), stem, and spray fittings (1926). Height 6.75".

G-37 Perfumizer with coral and gold enamel in an unusual deep cut-back sponge acid decoration on a Cambridge Glass Company bottle (1927). Height 6.25". *Courtesy of Linda Roberts.*

New products were introduced at specific times throughout the year; and in August 1927, three beautiful new styles incorporated both luxury glass blanks and new Vuillemenot-designed metal spray fittings and collars, for which design patent 77,467 was filed on behalf of Thomas DeVilbiss in October 1928, a full year after its introduction. The bottles, shown in the factory record dated August 5, 1927, included a blank used with previous models, but specified as "extra heavy" to accommodate a deep acid cut-back, and an entirely new shape, with opalescent swirl glass and a metal cap, seen on only one other model (shown on page 133 bottom) from 1931. The opalescent swirl glass bottle evokes a Fenton identity, although identifiable Fenton opalescent glass does not appear in DeVilbiss catalogs until 1940. Finally, a tall Perfumizer incorporating a Durand bottle with iridescent King Tut design is shown in either pink or green. This shape appeared first in the 1925 line, with both solid blue and gold iridescent versions. Perfume Dropper versions of these three styles were also offered in 1927.

In a delightful design enhancement, the top of the DJ-9 dropper rod is decorated in the same pattern as the bottle. The gold-finished metal cap shows an embossed pattern, seldom seen in this style, that also coordinates with the bottle decoration. This model was also sold with Deluxe vanity set 4302, consisting of a matching dresser tray, powder jar, and jewel case. All of this was packaged in a wooden presentation case by F. Zimmerman & Company, with a tree design on the box's top, which was finished by DeVilbiss in Department 78, according to a factory record dated May 9, 1927.

Electrotype for 1927 Perfumizers.

List $72.00
Ret $9.00

List $56.00
Ret $7.00

List $80.00
Ret $10.00

Series No.	I-24	I-25	L-45	L-46	K-23	K-24	Series
Blank No.	O-171 Ex.Heavy	O-171 Ex.Heavy	O-255	O-254	O-132	O-132	
Dec. No.	420	421	428	429	426	427	
Color	Black+Gold	Coral+Gold	Blue-Green Transparent	Pink Transparent	Green	Pink	
M.P.	397	397	397	397	397	397	List
Cap	321-H	321-H	394-H	394-H	321-H	321-H	
Finish	Gold-Satin	Gold-Satin	Gold-Satin	Gold-Satin	Gold-Satin	Gold-Satin	
Bulb	OI-56	OI-56	OI-58	OI-58	OI-56	OI-56	
Net	341-S	341-S	340-S	340-S	341-S	341-S	Retail
Net Color	Maize	Maize	Maize	Maize	Maize	Maize	
Crystal							
Base							
Cover							Estimate
Cord							
Box	861-V	861-V	823-Y	823-Y	901-V	901-V	
Paper	Blk. Dermatoid	Blk. Dermatoid	Black Dermatoid	Black Dermatoid	Blk. Dermatoid	Blk. Dermatoid	
Lining							Date
Packing Carton							
Estimate							8-5-27

1927 Specification Book Page.

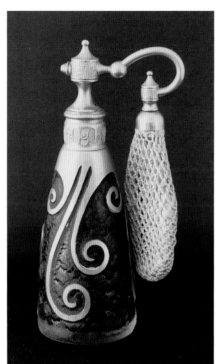

I-24 Perfumizer known by collections as Black Curl, with black interior enameled bottle and acid cutback gold decoration and ornate satin finished gold spray fittings (1927). Height 5". *Courtesy of Cheryl Linville.*

Close-up view of I-24 Perfumizer metal fittings.

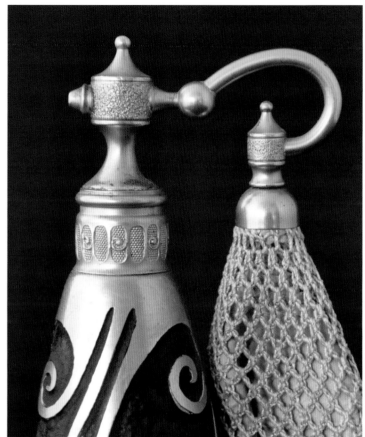

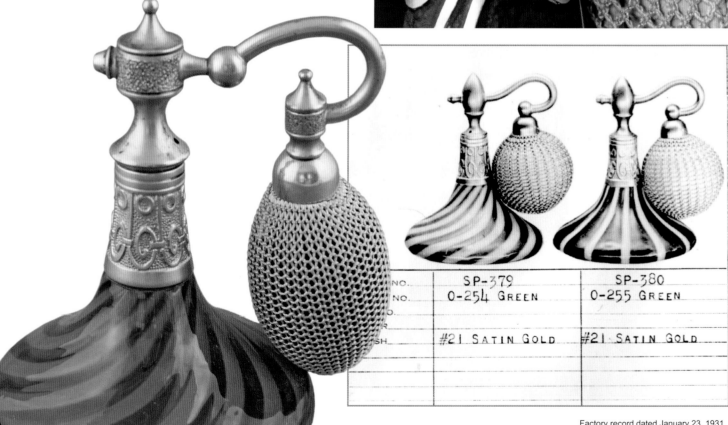

NO.	SP-379	SP-380
NO.	O-254 GREEN	O-255 GREEN
O.		
SH	#21 SATIN GOLD	#21 SATIN GOLD

L-46 Perfumizer with pink opalescent and transparent swirl bottle and satin finished gold spray fittings (1927). The collar for this model was not used on any other cataloged model, with the exception noted at right. *Courtesy of Amy and Mark Bergman.*

Factory record dated January 23, 1931 showing SP-379 and SP-380 with green bottles similar to L-46 with the exception that a different spray head—introduced in 1927—was substituted for the style used in L-46.

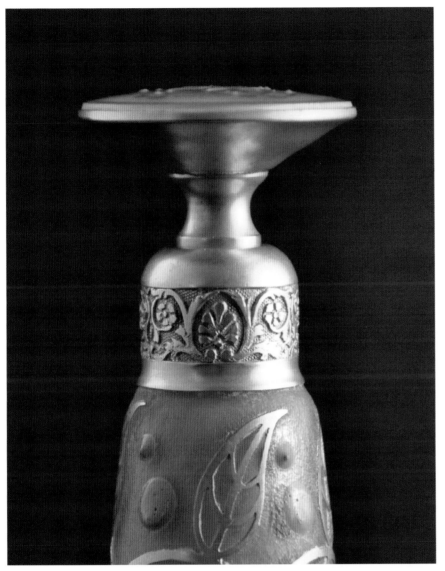

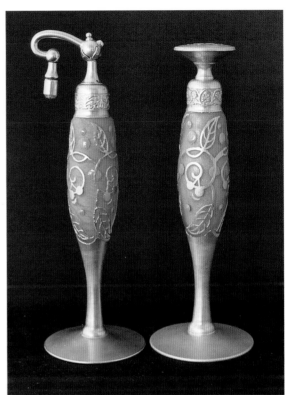

J-9 Perfumizer and DJ-9 Perfume Dropper on Old Rose enameled acid cutback bottles with gold and orange enameled leaf and vine pattern, and satin gold finished metal fittings (1927). Height 6.5". *Courtesy of Cheryl Linville.*

Close-up of metal cap design with an embossed pattern that coordinates with the bottle's decoration.

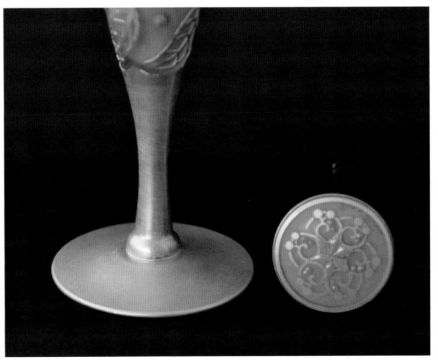

DJ-9 Perfume Dropper base with dropper handle top design matching the bottle.

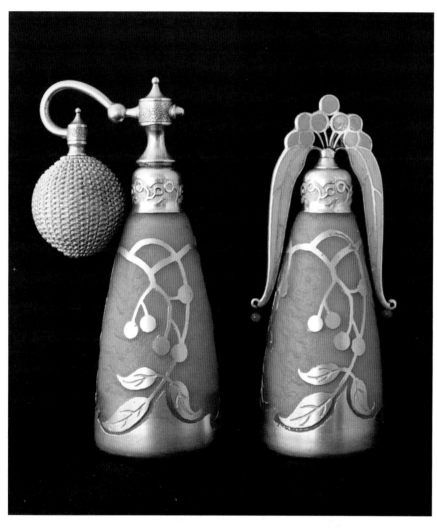

L-38 and DL-38 Exquisitely detailed Perfumizer and Perfume Dropper (known by collectors as Tiara) set with orange enamel and acid cut-back gold leaf and berry pattern; Dropper ornament is a cloisonné blue leaf and orange berry design (1927). Height 5". *Courtesy of Cheryl Linville.*

J-7 Small Perfumizer with coral enamel bottle, gold enameled acid cut-back Kingfisher bird decoration and foot, and satin gold finished metal parts. This model was introduced in late 1926 and listed in 1927 and sold as a set with a matching powder jar in a brown leather-covered box. *Courtesy of Cheryl Linville.*

DJ-11 Rarely seen Perfume Dropper on black with gold enamel pattern, satin gold finished cap and cloisonné Dropper ornament (1927). *Courtesy of Cheryl Linville.*

Salesman's portfolio page showing the L-38 and DL-38 Perfumizer and Dropper set in individual velvet-lined and tasseled clamshell presentation cases.

1927 salesman's portfolio image of DJ-11 in tasseled presentation case with clamshell opening.

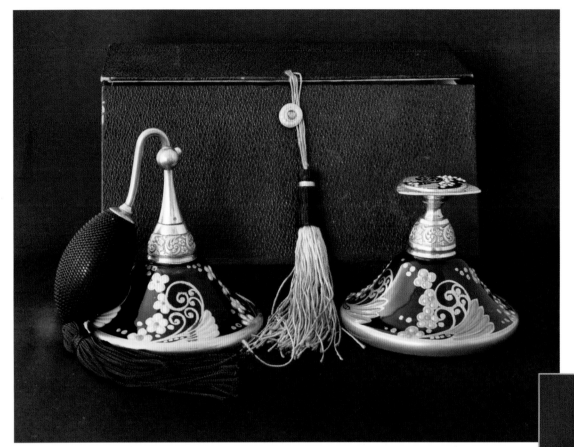

L-37 Perfumizer and DL-37 Dropper Perfume featuring bell-shaped black enamel bottles with a teal, lavender, orange and gold floral decoration which is repeated on the top of the dropper rod handle (1927). Height 4.25".
Courtesy of Cheryl Linville.

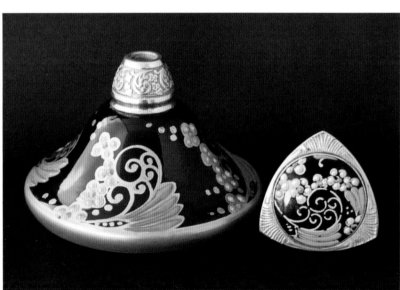

Detail of dropper handle showing design matching bottle enameling.

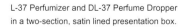

L-37 Perfumizer and DL-37 Perfume Dropper in a two-section, satin lined presentation box.

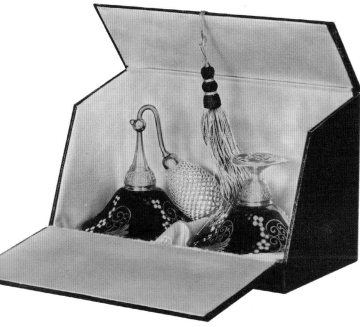

1927 salesman's portfolio image of L-37
Perfumizer and DL-37 Perfume Dropper in
two-section, satin-lined presentation box.

LDB-37

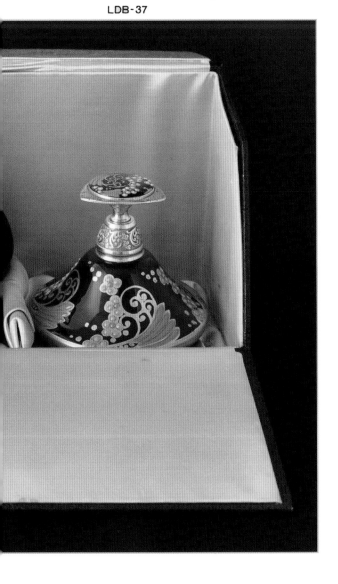

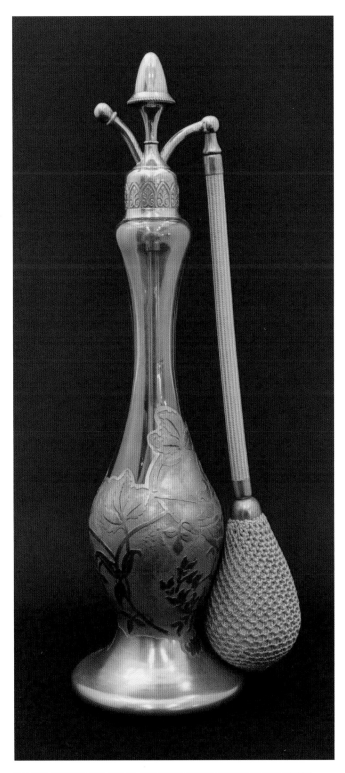

R-8 Perfumizer with acid cutback Kingfisher design heavily gold encrusted (1927).
Height 10".The clear portion of the bottle is iridized. This bottle was sold both
individually and as part of a luxury, and expensive, boxed set.

1928—An Explosion of Design Innovation on the Eve of Depression

DeVilbiss Perfume Sprays Smack of the Modern

The artists who created some of the new DeVilbiss Perfumizers have done intriguing things in making them reflect the modernistic mode. A DeVilbiss Perfume Spray, or a Perfume Spray and Perfume Dropper, for some of them come in sets, will bring sophistication to a smart woman's dressing table.

—DeVilbiss' Suggestions for Advertising, 1928

The year 1928, while seeing a continuation of a slower market and heightened competition for DeVilbiss, nevertheless also saw a remarkable range of new designs and styles. New series with distinctive and innovative designs included Le Moderne, Elegant, Rock Crystal, and Debutante, as well as models incorporating creative new metal stems and stands. They are among the items most sought-after by DeVilbiss collectors today. 1928 was a watershed year that represented a peak of design creativity, just as looming and difficult market realities would dictate a retrenchment.

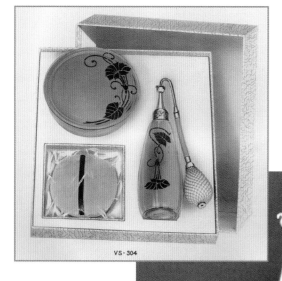

VS-304

1928 salesman's portfolio image of vanity set 304 featuring Perfume Spray D-51 and vanity jar VJ-111 in presentation box.

D-57 Perfume Spray with shell pink enamel bottle and black enamel decoration and gold finished fittings (1928). *Courtesy of Jim and Carole Fuller.*

C-51 Perfume Spray with blue and black exterior enamel design; gold finished fittings with tall spray head (1928). Height 5.75".

F-55 Slender Perfume Spray with orange interior enameled frosted crystal bottle and black enamel decoration and gold finished spray fittings (1928). Height 7".

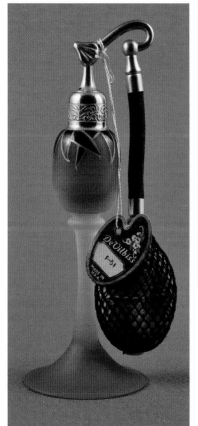

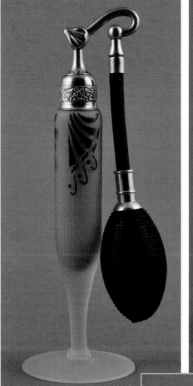

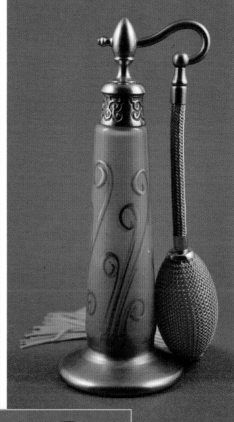

G-59 Stunning Perfume Spray with turquoise interior enamel and gold enamel decoration (1928). Height 6.75". This new metal cap and spray head style was introduced in 1927 and was used only in 1927 and 1928.

F-51 Perfume Spray with orange enameled interior and foot on a frosted crystal bottle, and black and gold enamel decoration and gold finished spray fittings and factory $4.00 price tag (1928). Height 6.5".

This rarely found bottle, right, was supplied by Tiffin Glass and was produced from a line of that company's stemware, which Tiffin collectors have dubbed "Draped Nude." Also shown from this line are a Tiffin cordial with a clear stem and pink bowl, and a wine stem with a satin finished cobalt blue stem and crystal bowl. Tiffin (also known as the United States Glass Company) supplied DeVilbiss with a variety of high-quality glass blanks throughout the 1920s, 1930s, and 1940s.

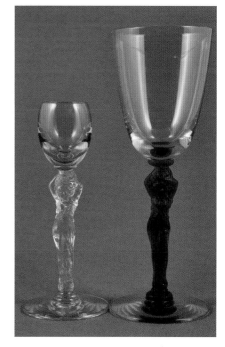

Comparison of Tiffin Draped Nude wine and cordial.

G-51 DeVilbiss Perfume Spray with rose bottle and stem from U.S. Glass Company (Tiffin) on a gilded Draped Nude stem and foot with a gold finished elongated tube and fittings (1928). Height 7.5" (Perfume Spray).

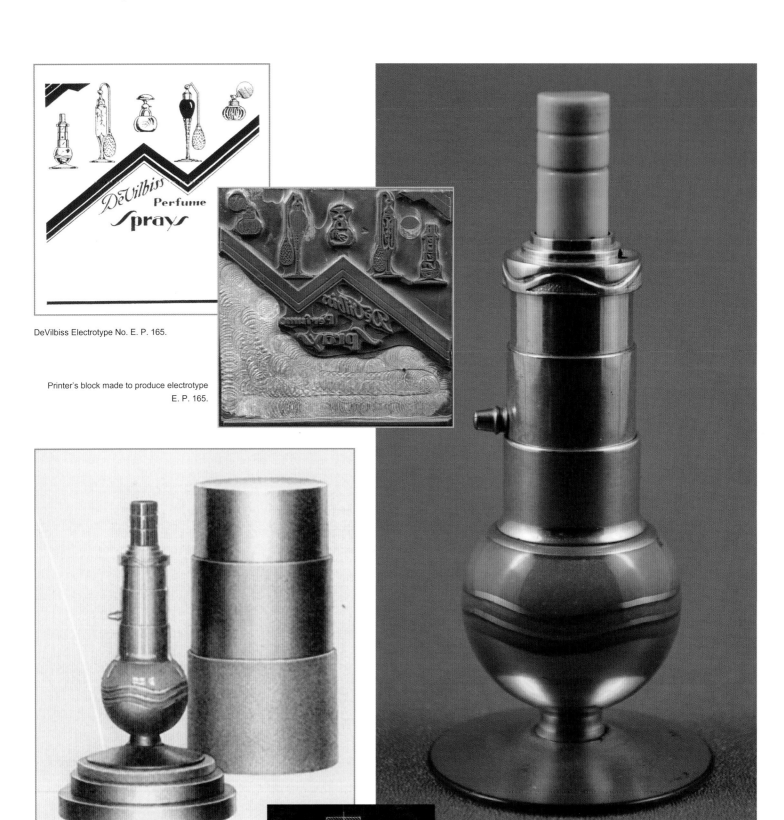

DeVilbiss Electrotype No. E. P. 165.

Printer's block made to produce electrotype E. P. 165.

Catalog image of J-52 Perfume Spray showing the beautiful design of the presentation case, which also mimics the design of the pump spray.

No. J-52

Segment of DeVilbiss engineering drawing showing inner workings of newly patented (1928) pump spray atomizer design, which made its first appearance on Perfume Spray J-52 above.

J-52 This wave-like design of turquoise and gold-footed Perfume Spray included a newly introduced gold finished pump spray mechanism and Catalin top (1928). Height 4.75". Note how the lines of the decoration are replicated in the styling at the top of cap.

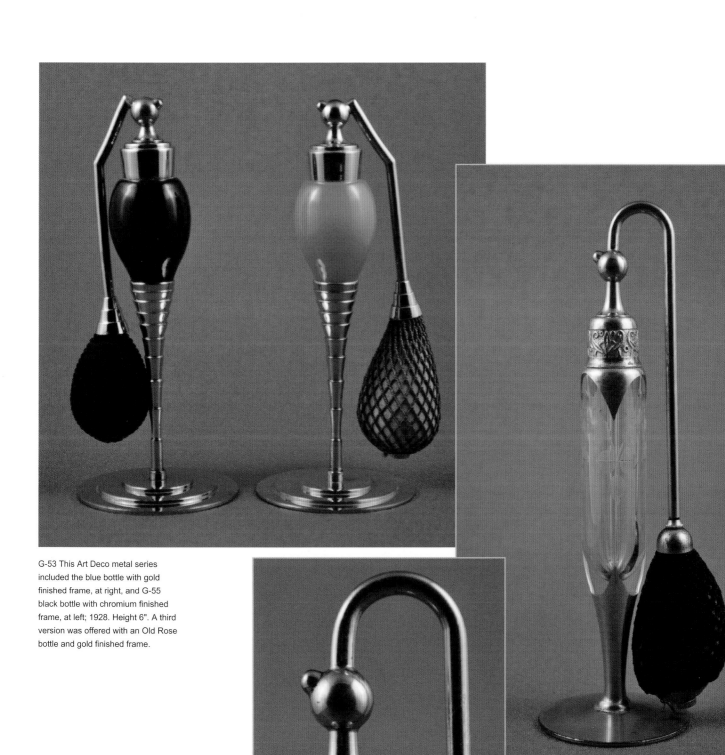

G-53 This Art Deco metal series included the blue bottle with gold finished frame, at right, and G-55 black bottle with chromium finished frame, at left; 1928. Height 6". A third version was offered with an Old Rose bottle and gold finished frame.

G-52 Perfume Spray with an engraved crystal bottle and gold enamel decoration with gold finished elongated tube and metal fittings (1928). Height 7.25". The metal cap's embossed design was new, and used only in the 1928 line.

Close-up of cap embossed design on G-52 Perfume Spray.

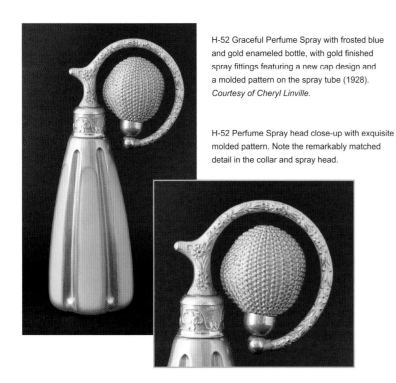

H-52 Graceful Perfume Spray with frosted blue and gold enameled bottle, with gold finished spray fittings featuring a new cap design and a molded pattern on the spray tube (1928). *Courtesy of Cheryl Linville.*

H-52 Perfume Spray head close-up with exquisite molded pattern. Note the remarkably matched detail in the collar and spray head.

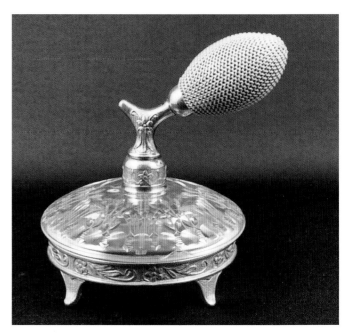

L-53 Perfume Spray in ornate metal stand with the same molded pattern on the base, collar and gold finished spray fitting (1928). *Courtesy of Jim and Carole Fuller.*

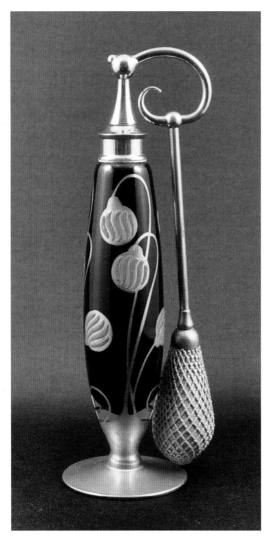

I-54 Exquisitely styled Perfume Spray with black interior enameled bottle and gold and orange enamel decoration on exterior; gold finished fittings with "Ram's Head" spray tube (1928). Height 7.5". *Courtesy of Jim and Carole Fuller.*

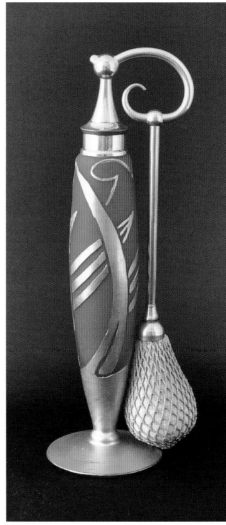

J-56 Perfume Spray with coral interior enamel and gold on acid cutback pattern and foot; gold finished "Ram's Head" metal fittings (1928). Height 7.5". *Courtesy of Cheryl Linville.*

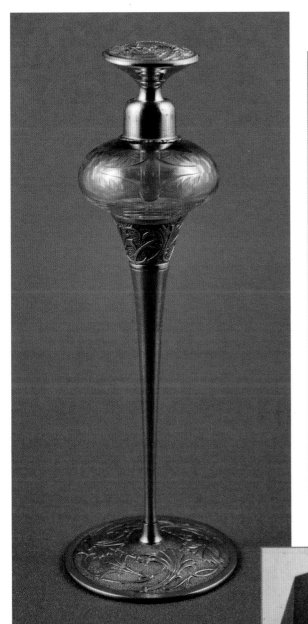

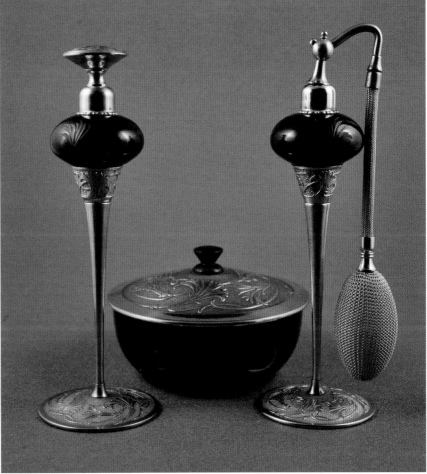

DJ-51 Classically elegant Perfume
Dropper with engraved Topaz
iridized bottle on a tall gold finished
metal stem and foot with a floral
pattern molded into the foot.
The same pattern in miniature is
repeated on the dropper rod top
(1928). Height 7".

J-53 Engraved ebony Perfume
Spray, DJ-53 Perfume Dropper
and VJ-810 vanity jar comprising
the deluxe vanity set 2507 (1928).
Perfume Spray height 7.5". This
set features black enameled glass
bottles and vanity jar bottom with
matching engravings, with all other
parts gold finished metal with the
same molded floral patterns in
the bottles' feet, the dropper cap,
and the lid of the vanity jar. The
underside of the lid is set with a
mirror, and the top knob is Catalin.

Factory photo of deluxe vanity set
2507 showing presentation case
and floral pattern on vanity jar.

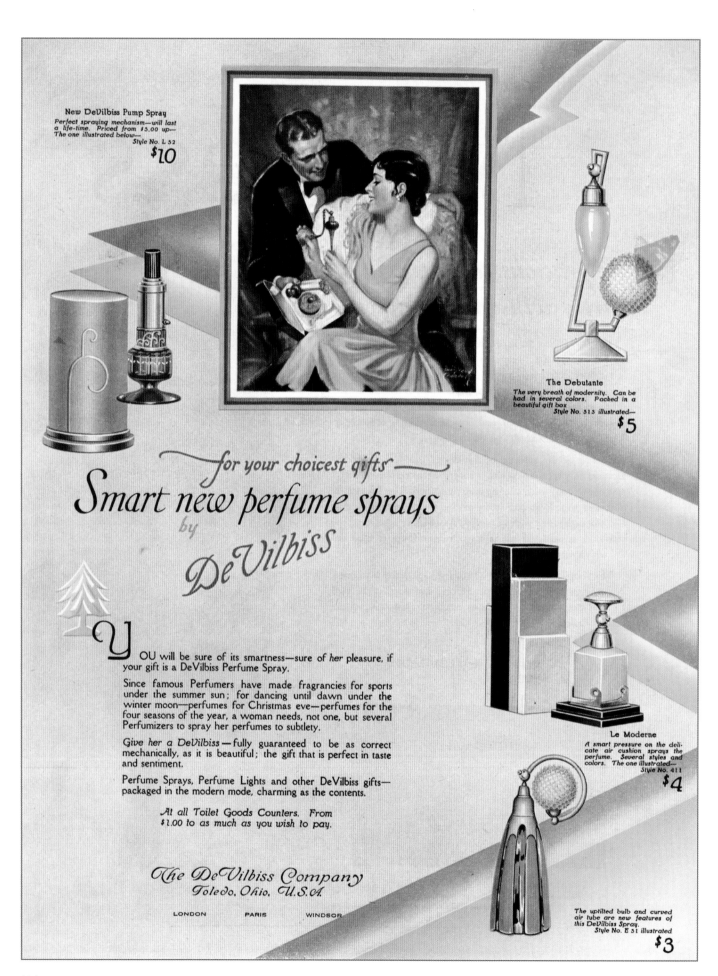

New DeVilbiss Pump Spray
Perfect spraying mechanism—will last a life-time. Priced from $5.00 up— The one illustrated below—
Style No. L 52
$10

The Debutante
The very breath of modernity. Can be had in several colors. Packed in a beautiful gift box
Style No. 513 illustrated—
$5

for your choicest gifts—

Smart new perfume sprays
by
DeVilbiss

YOU will be sure of its smartness—sure of *her* pleasure, if your gift is a DeVilbiss Perfume Spray.

Since famous Perfumers have made fragrancies for sports under the summer sun; for dancing until dawn under the winter moon—perfumes for Christmas eve—perfumes for the four seasons of the year, a woman needs, not one, but several Perfumizers to spray her perfumes to subtlety.

Give her a DeVilbiss—fully guaranteed to be as correct mechanically, as it is beautiful; the gift that is perfect in taste and sentiment.

Perfume Sprays, Perfume Lights and other DeVilbiss gifts— packaged in the modern mode, charming as the contents.

At all Toilet Goods Counters. From $1.00 to as much as you wish to pay.

The DeVilbiss Company
Toledo, Ohio, U.S.A.

LONDON PARIS WINDSOR

Le Moderne
A smart pressure on the delicate air cushion sprays the perfume. Several styles and colors. The one illustrated—
Style No. 411
$4

The uptilted bulb and curved air tube are new features of this DeVilbiss Spray.
Style No. E 51 illustrated
$3

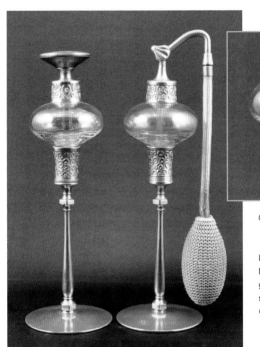

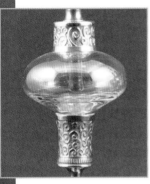

Close-up of the stem and cap detail.

L-51 and DL-51 Perfume Spray and Perfume Dropper set with Topaz iridized bottles and gold finished metal stems, feet, and cap and spray heads (1928). *Courtesy of Jim and Carole Fuller.*

Opposite:
1928 DeVilbiss magazine advertisement showing Perfume Sprays from that year's line. The illustration at top center is by Bradshaw Crandell.

1928 salesman's portfolio page showing the L-54 Perfume Spray at lower right with related models. Factory records show these four models were added to the 1928 line in late June of that year.

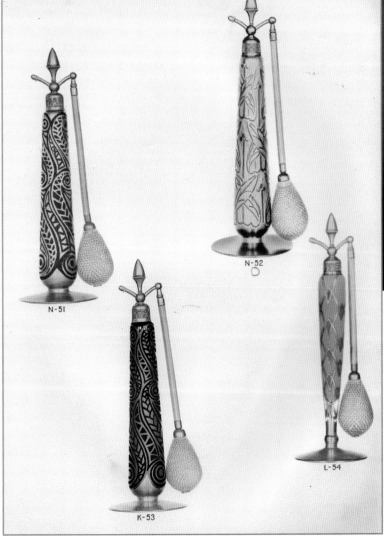

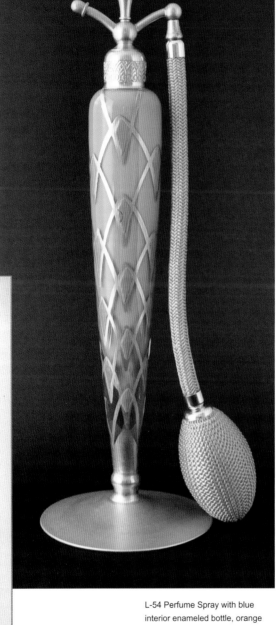

L-54 Perfume Spray with blue interior enameled bottle, orange and gold enamel decoration with gold enameled foot, and gold satin finished metal fittings (1928). Height 10". *Courtesy of Cheryl Linville.*

The 1928 "Series" Designs

Design innovation was one of the keys to DeVilbiss' great success in the 1920s. In 1928, the company introduced four new "series" of bottles: *Le Moderne* with four styles, *Debutante* with four styles, *Rock Crystal* with eight styles, and *Elegant* with three styles. Each was entirely new for the year.

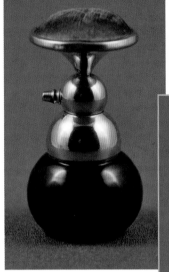

Le Moderne Series

This group was characterized by four different and elegant bottles, all but one (No. 310) of which rested in a gold plated metal stand. The four models had a retail price range from $3.00 for No. 310, $4.00 for No. 410, $5.00 for No. 510, and $7.00 for No. 710. This was the first-known instance of a practice which became universal in the 1930s and onward: coding the retail price in the product number. This system was also used in the 1928 Debutante and the Elegant lines.

The Le Moderne series introduced the velvet-covered pump-type spray actuator (except No. 510 which was satin-covered) which was the first instance of a DeVilbiss Perfume Spray not incorporating the rubber bulb. DeVilbiss named this new system the "air cushion," which would continue to be offered on selected models through 1932. Design patents 77,752 and 77,753 for the two types of pump actuators were applied for by Tom DeVilbiss on April 7, 1928. This innovation was used on several bottle styles over the next two years, but was absent from the line from 1932 forward.

Le Moderne Series No. 310 Perfume Spray with a black glass bottle and gold plated spray fittings (1928). Height 3". This model also came in Blue and Old Rose enameled bottles.

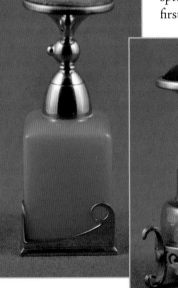

Le Moderne Series No. 410 Perfume Spray with blue enamel bottle and a gold plated wave-design metal stand (1928). Height 4". This model also came in a pink enameled bottle.

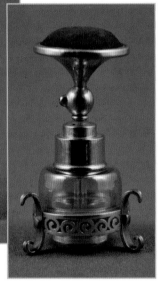

Le Moderne Series 510 Perfume Spray, with Topaz iridized bottle and embossed three-legged gold plated stand (1928). Height 3".

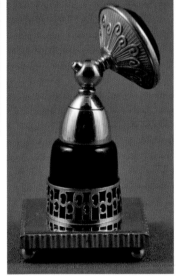

Le Moderne Series No. 710 Perfume Spray with a black bottle in a gold plated stand (1928). Height 3.75". This was also offered in a Topaz (iridized crystal) bottle. Note the intricate detail on this small Perfume Spray from the base to the inside of the spray head.

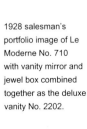

1928 salesman's portfolio image of Le Moderne No. 710 with vanity mirror and jewel box combined together as the deluxe vanity No. 2202.

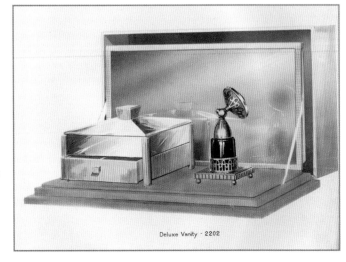

Deluxe Vanity · 2202

Air cushion spray actuator design detail.

The Rock Crystal Series

While DeVilbiss had offered many styles of cut and engraved crystal bottles from the very beginning of the company, the 1928 Rock Crystal line was the first instance of grouping them in a distinct line, capitalizing on the growing popularity at the time of hand-cut crystal glass.

The term "Rock Crystal" refers to glass engraved in such a way as to imitate the appearance of carved rock crystal. This style gained popularity in Europe and America in the late 19th century and has remained popular ever since.[15]

Each of the eight models in this line was fitted with chromium-plated metal parts and black-netted squeeze balls. Two all-new metal collar styles were introduced, seen on models G-56 and K-51. Only one design, E-55, was carried forward into the 1929 line.

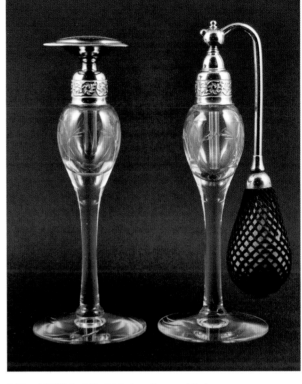

E-55 and DE-55 Rock Crystal Perfume Spray and Perfume Dropper bottles (1928). Height 6" (Perfume Spray).

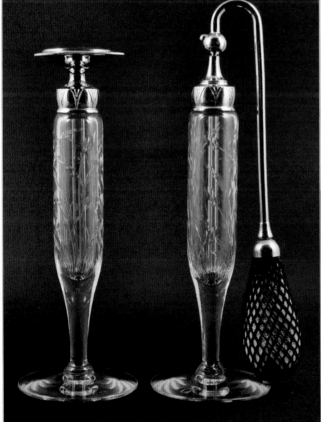

G-56 and DG-56 Slender Rock Crystal Perfume Spray and Perfume Dropper bottles (1928) Height 7" (Perfume Spray).

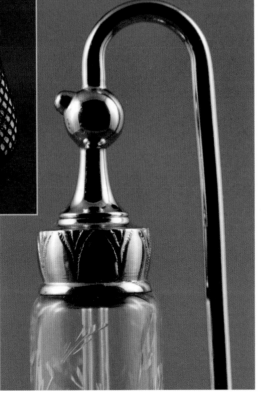

G-56 Metal cap introduced for the Rock Crystal line and used on three of eight models in the line.

I-52 Rock Crystal Perfume Spray incorporating the spray fitting style, now chromium-plated, first introduced in 1927 for several high-end bottles with gold plating (1928). *Courtesy of Jim and Carole Fuller.*

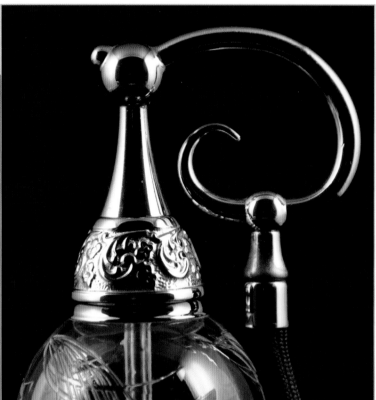

This dramatic "Ram's Head" spray fitting was introduced on one model in 1927 and used on both the Rock Crystal and Elegant series in 1928.

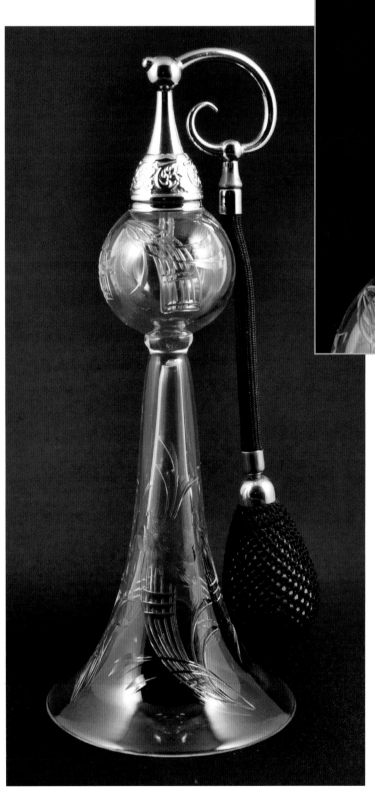

K-51 Rarely seen elegant Rock Crystal Perfume Spray with engraved blown bottle joined to a blown pedestal foot, with "Ram's Head" spray fitting (1928). Height 8".

The style of metal part for K-51 was a design change from the original specification, which called for a different spray fitting, as can be seen from the factory specification drawing below where the original spray fitting was crossed out and the final rubber-tube configuration was called for. Most will agree that the last-minute change was a definite improvement. One can imagine the superb artist's eye of Fred Vuillemenot at work here.

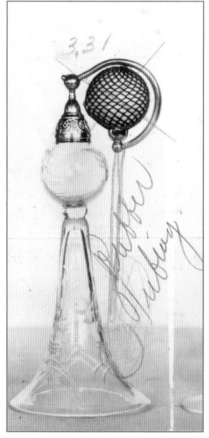

Image from 1928 factory records showing design change for spray fittings of K-51.

The Elegant Series

Another unique design innovation for DeVilbiss in 1928 took the form of a decorating technique involving lamination of highly polished gold plated metal on interior enameled glass bottles through an overlay process, in stunning abstract Art Deco patterns. The result is truly spectacular in each case. Only three models were offered, each with a unique color, and only in 1928.

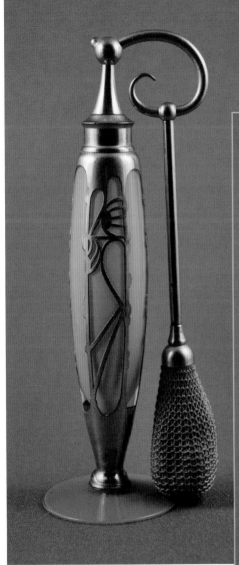

Elegant Series 1010 Perfume Spray with turquoise enamel, delicate metal work, and gold plated spray fittings of the "Ram's Head" style, and gold rather than rubber tubing extending to the squeeze ball (1928). Height 7.5".

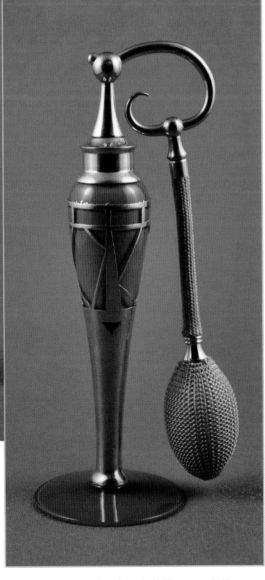

Elegant Series 1012 Perfume Spray in Old Rose enamel with a Cambridge Glass Company bottle, unique metal work, and "Ram's Head" spray fitting (1928). Height 6.5".

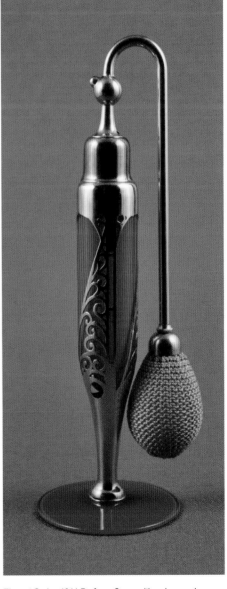

Elegant Series 1011 Perfume Spray with red enamel, delicate metal work, and gold plated spray fitting with elongated metal tube (1928). Height 7".

The Roaring Twenties and the Great Depression

The Debutante Series

The new Debutante design and spraying system incorporated a long spray tube, in various curved, coiled, and angular configurations extending from a metal pedestal and serving as the structural support for the bottle. With the squeeze ball at one end, the other end of this metal structure is suspended with a spray outlet. The design effect is decidedly Art Deco. The line proved popular, with factory estimates for aggregate sales of the four 1928 styles at 21,000 units. The Debutante Series survived into 1929, with a total of eight designs, including the four from 1928 and four more completely new styles.

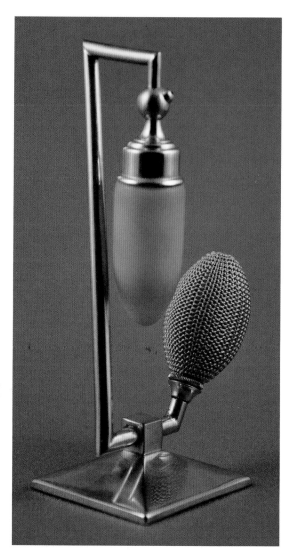

Debutante Series No. 513 Perfume Spray with angular gold finished tube and green frosted glass bottle (1928). Height 5.75".

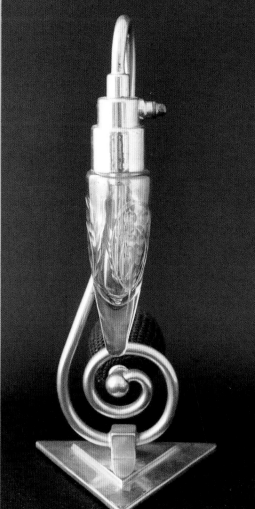

Debutant Series No. 1013 Perfume Spray with coiled air tube finished in gold and Topaz (iridized clear glass) bottle with cut pattern (1928). *Courtesy of Cheryl Linville.*

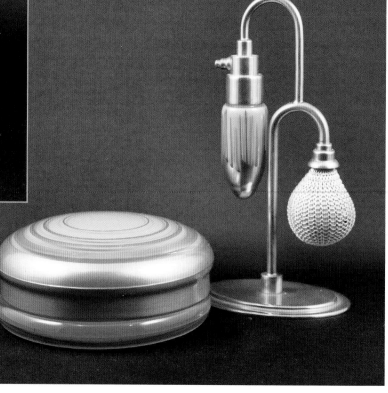

Debutante L-56 Perfume Spray with blue interior enamel and gold enamel decoration and gold plated fittings; with VJ-275 vanity jar (1929). *Courtesy of Jim and Carole Fuller.*

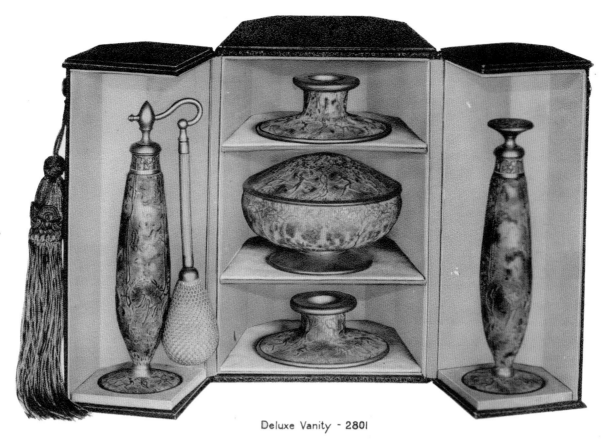

1928 salesman's portfolio page showing deluxe vanity 2801 with J-55 Perfume Spray, DJ-55 Perfume Dropper, CS-252 candle holders and VJ-503 vanity jar in a tasseled presentation case.

Deluxe Vanity - 2801

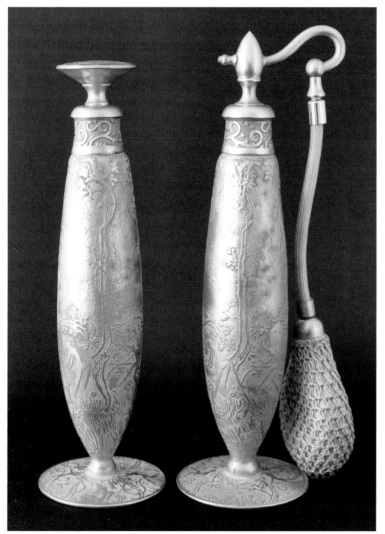

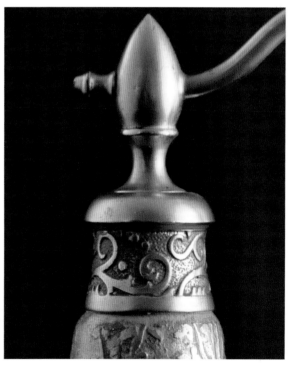

Close-up of antique finished cap with the same green patina applied to the metal as was applied to the glass items in the set.

J-55 Dramatic Perfume Spray and DJ-55 Perfume Dropper with an antique green and gold enamel finish over acid cutback wood nymph scene (1928). Height 7.5". *Courtesy of Cheryl Linville.*

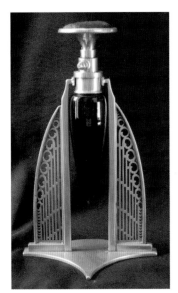

Q-51 Perfume Spray with black bottle suspended in a gold finished Art Deco metal frame, with pump spray actuator (1928). *Courtesy of Jay Kaplan.*

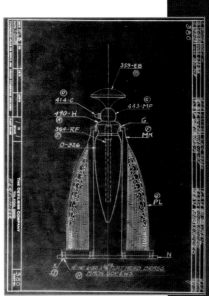

Engineering drawing of Q-51 Perfume Spray assembled, referencing separate drawings of the individual components, dated March 26, 1928, with notations of changes made through September 5, 1928.

The truly spectacular Jumbo Perfume Sprays came in three colors: Old Rose and Gold (No. 1), Green and Gold (No. 2), and Blue and Gold (No. 3). These were made to be eye-catching display bottles for retailers' counters. There is a small glass receptacle that attaches to the spray head and extends down into the top of the larger bottle, into which perfume can be placed. Few were originally made and precious few of these bottles are seen today.

This dramatic Perfume Spray also had the distinction of going to Hollywood. A 1947 DeVilbiss Company newsletter pictures actress Arlene Dahl posing with the Jumbo, in a promotional photo for the 1947 Warner Brothers movie *My Wild Irish Rose*, also starring Dennis Morgan and Andrea King.

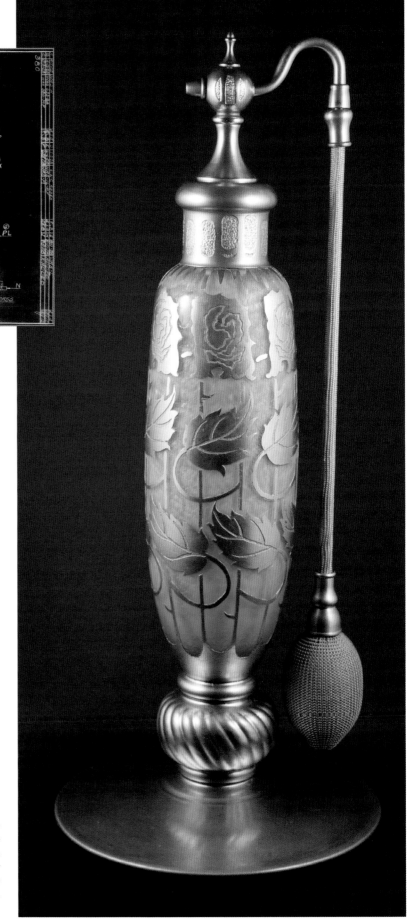

This extremely rare Jumbo No. 3 display Perfume Spray was "intended for demonstration purposes" according to the 1928 catalog; acid cutback bottle with interior blue enamel and gold enameled leaf and vine pattern and foot (1928). Height 15.5".

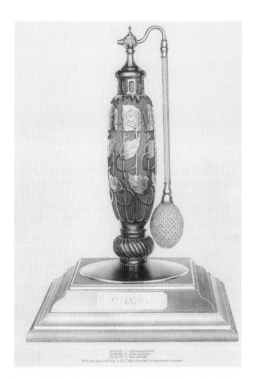

Image of Jumbo No. 1—Old Rose and Gold—from the 1928 salesman's catalog. Note the 2-inch decorated wooden base, which came with the bottle and elevated the display to a lofty 17.5".

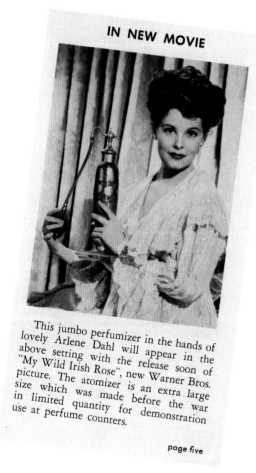

Clip from *DeVilbiss News*, April 1947 showing actress Arlene Dahl posing with DeVilbiss Jumbo Perfumizer promoting the movie *My Wild Irish Rose*."

The French Limousine Perfume Sprays

The French Limousine Perfume Spray does not appear in any domestic catalogs or specification books, the sole known documentation being the brochure shown below. It, and the model shown, were likely produced exclusively for the DeVilbiss French affiliate company.

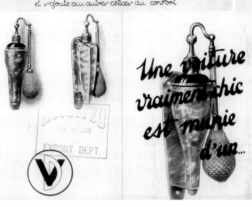

French brochure for "Limousine Perfume Sprays" with export stamp dated February 9, 1928. *Courtesy of Jim and Carole Fuller.*

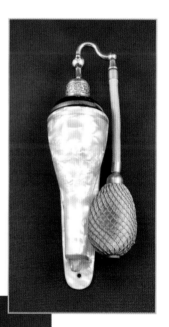

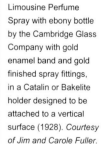

Limousine Perfume Spray with ebony bottle by the Cambridge Glass Company with gold enamel band and gold finished spray fittings, in a Catalin or Bakelite holder designed to be attached to a vertical surface (1928). *Courtesy of Jim and Carole Fuller.*

As above, removed from holder. Bottle by the Cambridge Glass Company.

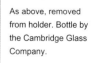

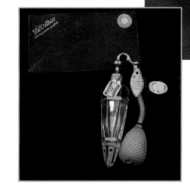

Yet another rare example of a 1928 French Limousine Perfume Spray—DeVilbiss Model 1301. *Courtesy of Jim and Carole Fuller.*

1929 Challenges

DeVilbiss Perfume Sprays—In the Modern Mode—Focused on Artistry and Utility

DeVilbiss approached the development of the 1929 line carefully. Perhaps these perspectives are best reflected in the words from their 1929 catalog, quoted below. The reader should note that the term "Perfume Spray," which was used instead of the term "Perfumizer" in 1928, was continued in 1929. DeVilbiss changed the trade name for its atomizers according to its perceptions of tastes and styles of the time.

> In issuing a new catalog of DeVilbiss Perfume Sprays we have presented this well known and long-established line of toilet requisites in such a form as will most effectively serve the trade classes using it. The preparation of this catalog was approached only after a careful study of the requirements of the retailer. The items selected for representation, the arrangement of them, and the descriptive informative data concerning them, were handled to squarely meet the convenience of the dealer.
>
> The traditional leadership of the DeVilbiss organization in Perfume Spray design and production has never before been so exactly adapted to the market. Price range and variety are adequately served by a comparatively small assortment. Quick turn-over is assured.
>
> The quality of DeVilbiss products is traditional. The materials selected for production departments are the finest obtainable. The maximum of skill and care is brought to every manufacturing detail by an organization that has for years intensively specialized in the production of beautiful things which shall also include absolute mechanical perfection.

The cataclysmic economic events in 1929 marked a major transition for DeVilbiss, as it did for most businesses and consumers. But even before the stock market crash of late September 1929, DeVilbiss was experiencing significant change in its perfume atomizer marketplace, and apparently not for the better. As one measure, the total number of "Display Rooms" went from nine to five. In 1928, DeVilbiss maintained showrooms in the United States in Chicago, Detroit, Philadelphia, New York and San Francisco, with international showrooms in Havana, Cuba; London, England; Paris, France; and Windsor, Ontario, Canada. In 1929, the showrooms had been reduced to New York, San Francisco, London, Paris, and Windsor.

1925 was a banner year, in which over 1.5 million Perfumizers were sold for around $2,500,000—a dramatic (over five-fold) increase from 1920. As a result of rapidly growing demand for its clearly best-in-market products, the company kept expanding the number of models in the product line, and by 1927 the factory's comprehensive specifications of all Perfumizers, vanity sets, and accessories offered for sale consumed 115 large (10" x 14") pages, with most pages showing five or six different models or color combinations. That year, the most expensive single Perfumizer sold at retail for $25 and the most expensive vanity set went for $83. By 1928, the equivalent product line specifications shrank to 58 pages—roughly half—and the most expensive single item and set were $15 and $28, respectively. The same book shrank again in 1929, to 40 pages—just a bit more than one-third of its size two years prior. By 1930, the most expensive single item was $10. While these may be inexact measures, and don't address the sales volumes, it was clear by late 1929, as the stock market had reached its peak before the crash, that the DeVilbiss atomizer market had undergone major contraction.

We speculate that the contraction had more to do with changing consumer tastes and increased competition. Five other U.S. companies, along with importers from Czechoslovakia, were offering lines of directly competing perfume atomizers.

Nevertheless, throughout its entire subsequent history, the company continued to produce and sell beautiful and innovative perfume atomizers and accessories. Some of the most collectible treasures found today come from that period after the peak of the mid-1920s and into the 1930s and later. Perfume atomizer production ended in 1968.

The differences among items shown in DeVilbiss sales catalogs and product line specification books can be substantial. As a modest example, in 1929, the slender Salesman's Catalog indicates 90 items in total, including bottles offered in different colors, and companion Perfume Dropper bottles. By contrast, for the same year, the specification book has 123 total items listed, not including all the vanity sets they offered during that year. In this section, readers will see some items not shown in the sales catalogs.

DeVilbiss Assortments

Throughout much of its history, DeVilbiss sold to various markets, both retail and wholesale, in different ways, including quantities of individual items and assortments. They used "assortments" to offer a variety of bottles to a single retail establishment purchaser. Assortments were described in special sales flyers. On occasion, being a good merchandiser, DeVilbiss created suggested layouts and special props, such as the two posters and stands in the illustrations below, which a merchant could use to display the assortment.

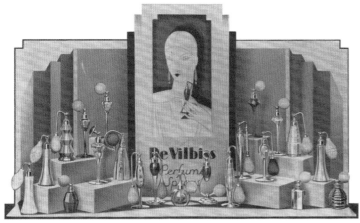

DeVilbiss Perfume Spray Assortment No. 2517—Retail Value $37.75.[16]

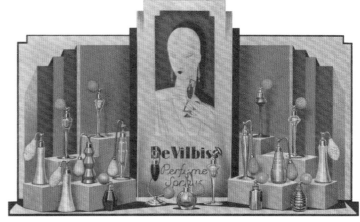

DeVilbiss Perfume Spray Assortment No. 1579—Retail Value $22.75.[17]

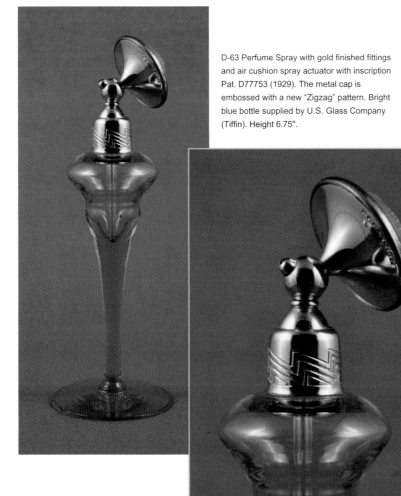

D-63 Perfume Spray with gold finished fittings and air cushion spray actuator with inscription Pat. D77753 (1929). The metal cap is embossed with a new "Zigzag" pattern. Bright blue bottle supplied by U.S. Glass Company (Tiffin). Height 6.75".

Close-up of D-63 cap and air cushion spray actuator.

Expressing the Ultimate in Design

DeVilbiss Perfume Sprays and Droppers express the most authoritative conception of modern art. Each is the creation of an artist of established reputation, specializing in the forms and colors which harmonize with the accepted modern smartness in all toilet accessories.
—*DeVilbiss 1929 salesman's catalog*

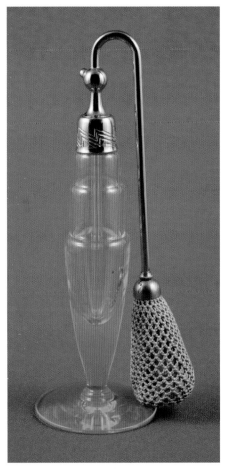

D-59 Perfume Spray, simple, modern green tiered bottle and gold finished elongated tube and spray fittings (1929). This model was also offered with a pink bottle. Height 7".

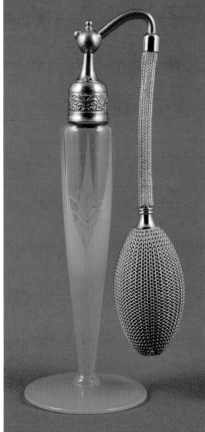

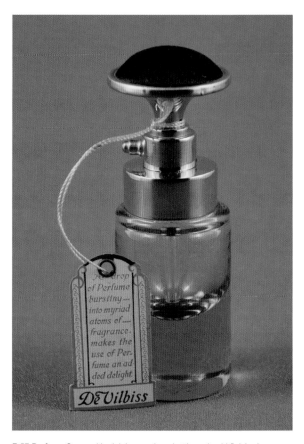

F-57 Perfume Spray with pink heavy sham bottle and gold finished spray fittings, with air cushion spray actuator with black satin covering (1929). Bottle by U.S. Glass Company (Tiffin). Height 4".

D-61 Perfume Spray with light blue enamel over frosted stem and foot and gold finished fittings; with a delicate hand cutting on clear areas (1929). Also offered in light green. Height 7".

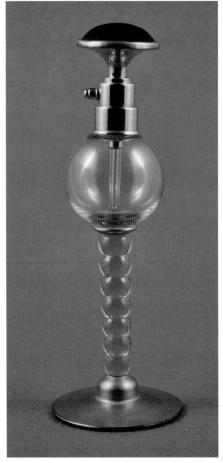

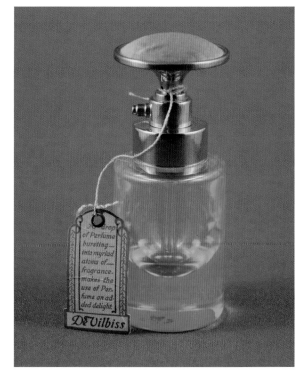

E-66 Perfume Spray with pink bottle and gold enameled foot; gold finished spray fittings with air cushion spray actuator (1929). Bottle by H. C. Fry Glass Company. Height 6.5".

F-61 Perfume Spray with green heavy sham bottle and gold finished spray fittings, with air cushion spray actuator with green satin covering (1929). Bottle by U.S. Glass Company (Tiffin). Height 4.25".

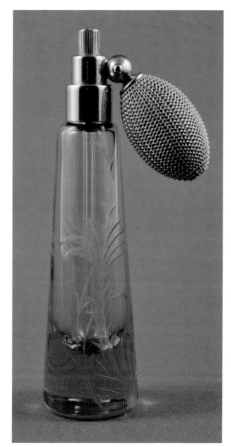

H-56 Perfume Spray with pink heavy sham bottle, cutting and gold finished fittings (1929). This model was also offered in transparent blue. Height 6".

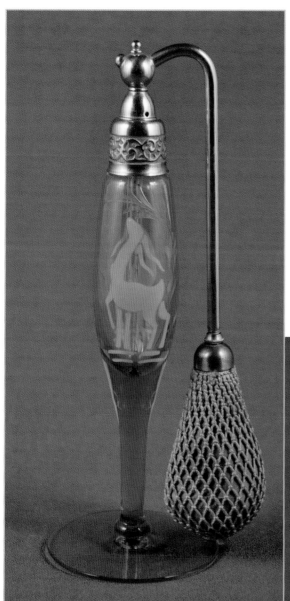

F-70 Perfume Spray with blue bottle decorated with a blue enameled deer and a hand cutting; gold finished fittings with elongated metal tube (1929). Height 7".

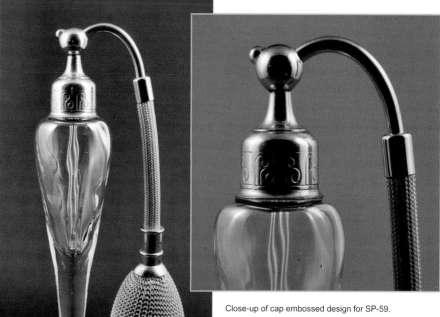

Close-up of cap embossed design for SP-59.

SP-59 Perfume Spray with Festoon Optic (DeVilbiss' term) in a yellow bottle by Morgantown Glass Works (1929), and known by Morgantown as Palm Optic in their color ginger. By virtue of its color and optic, this bottle is regarded as "super rare" by Morgantown collectors. Height 6.25".[18]

J-67 Perfume Spray with color described in factory records as "Rose Pink Lustre" with a hand cutting and enameled gold pheasant decoration and gold enameled stem and foot with bright gold spray fittings (1929). Height 9.5".

The delicate rose glass coloration of J-67 fades to clear toward the bottom of the bowl. This bottle also features a new wave pattern embossed on the metal collar, introduced in 1929. The bottle was sold with a matching vanity jar and Perfume Dropper as deluxe vanity 2251, in a brown, satin-lined, wooden presentation case, with the ship design carved on the top of the lid. The box was by F. Zimmerman & Company, Toledo, Ohio, with the color decoration added by DeVilbiss.

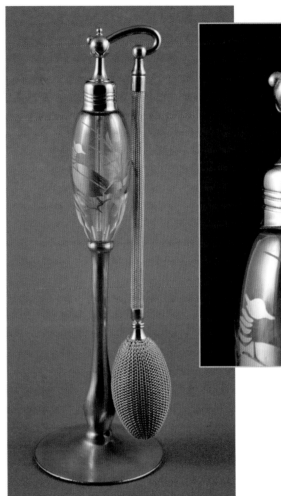

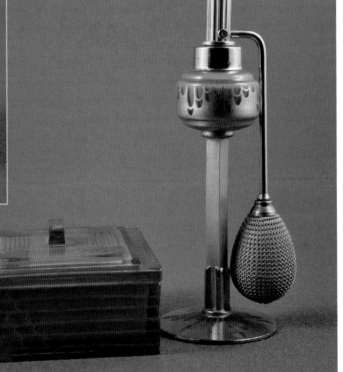

Close-up of J-67 collar embossed design.

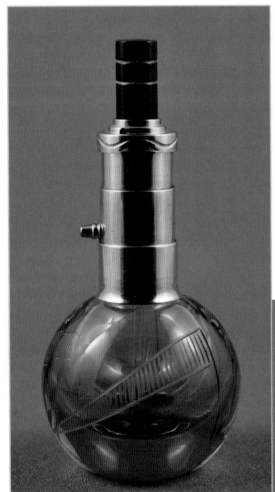

H-58 Perfume Spray with pink heavy sham ball-shaped hand engraved bottle, plunger-type Catalin spray actuator (1929). Height 5".

I-56 Rarely found Peach Bloom Perfume Spray and VJ-403 vanity jar, part of deluxe vanity set 2001 which also included a Perfume Dropper (1929). Height 6" (Perfume Spray).

Factory photograph of L-57 perfume atomizer (left) with a metal figural base in the form of a seal. At right is a metal tubular perfume atomizer which may not have gone into production in this configuration, as catalog and specification book images show a three-tiered tube and a flat, non-tiered foot (1929).

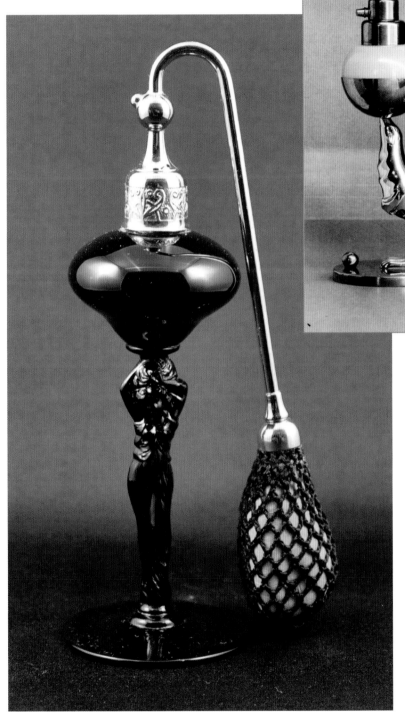

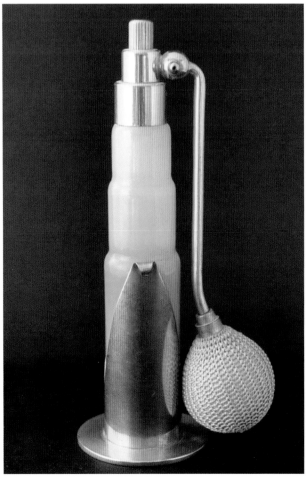

"Lucille 42P" Perfume Spray with black glass bottle and Draped Nude stem by U.S. Glass Company (Tiffin); chrome finished fittings with elongated spray tube (1929). Height 7.5". *Courtesy of Jim and Carole Fuller.*

L-55 Perfume Spray with opaque green glass bottle molded in tiers shading from dark to light green, in a gold finished metal stand (1929). *Courtesy of Sue Blue.*

DeVilbiss in the 1930s—Depression and Recovery

The decade of the 1930s started in a nationwide economic disaster of unprecedented severity. DeVilbiss was faced with challenges of keeping its perfume atomizer business running until a recovery could take hold. After 1934, business began to improve as the paint gun business expanded rapidly, and the perfume atomizer division grew again through innovation in Czechoslovakian styles, Lenox Belleek China designs, crackle glass bottles, and sleek styling of spherical and cylindrical shapes. This period produced a rich store of beautiful new models. But, just as the company's perfume atomizer business was again in solid growth mode, World War II broke out, ending bottle supplies from Czechoslovakia and Sweden; ultimately, perfume bottle production ended for the duration of the war.

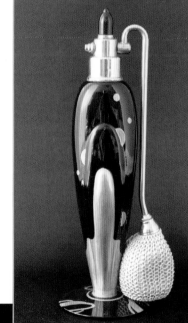

G-84 Perfume Spray with black bottle and gold enamel decoration with buffed gold finished fittings, swing-type closure mechanism and ebony Catalin ornament (1930). Bottle by H. C. Fry Glass Company. *Courtesy of Cheryl Linville.*

A Master at Design—1930 DeVilbiss catalog cover attributed to Frederic Vuillemenot.

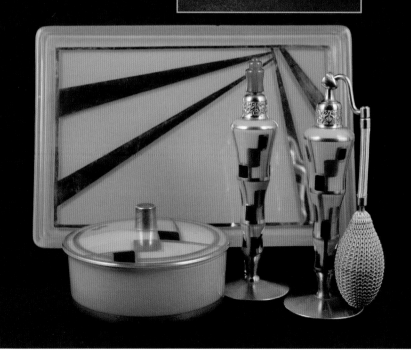

F-93 and DF-93 Perfume Spray and Perfume Dropper set with vanity jar and dresser tray; gold and black enamel decoration, gold foot, buffed gold fittings and "Green Quartz" Catalin ornament on the Perfume Dropper (1930). Height (Perfume Spray) 6.5". Tray made by Westmoreland Glass Company.

U.S. Glass Company (Tiffin)

The U.S. Glass Company was formed in the late 1800s as a conglomerate of fifteen glass factories, with headquarters in Pittsburgh, Pennsylvania. Later the headquarters were moved to Tiffin, Ohio, the location of one of the larger factories. In 1927, the company marketed decorative wares under the name "Tiffin." By the late 1930s, the company was reduced to three factories. U.S. Glass is noted for fine decorative and table glassware throughout its history, and was an important supplier of glass blanks to DeVilbiss through the 1920s, 1930s and 1940s.[19]

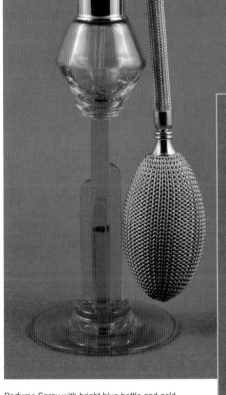

Perfume Spray with bright blue bottle and gold finished spray fittings (1930). This bottle with its unique stem was offered in the 1929 line and appears in factory records but not the published catalog. Bottle by U.S. Glass Company (Tiffin). Height 6.25".

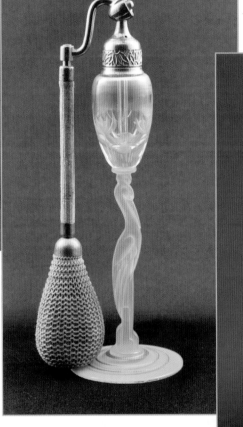

G-88 Perfume Spray with cut decoration on the bottle, a frosted pelican figural stem, and gold enamel rings on the foot (1930). Height 6.5". Bottle by U.S. Glass Company (Tiffin). *Courtesy of Jim and Carole Fuller.*

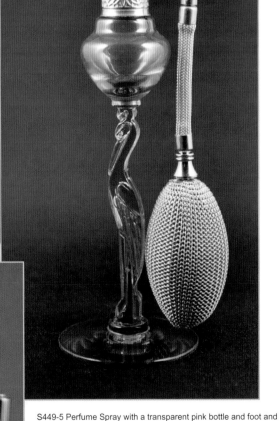

S449-5 Perfume Spray with a transparent pink bottle and foot and a molded pelican figural stem (1932). Height 6.25". Bottle by U.S. Glass Company (Tiffin). Note that in 1932 this bottle used the final supply of the 1930 and 1931 products—prior versions had a satin finished stem, and the pink bottle had a cutting.

Close-up of collar for S449-5 Perfume Spray.

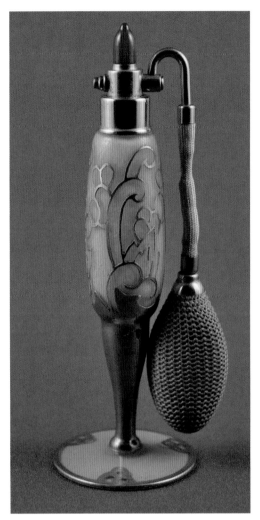

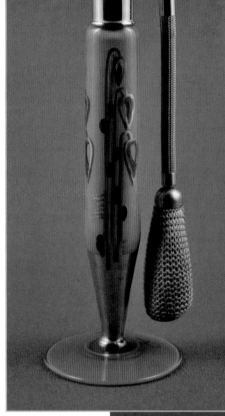

J-69 Perfume Spray with gold decorated orchid interior enameled bottle; buffed gold spray fittings with swing closure device and a Catalin ornament (1930). Height 7.5".

G-92 Perfume Spray with green interior enameled bottle decorated with gold enameled acid cutback design; buffed gold spray fittings with swing closure device and a Catalin ornament (1930). Height: 5". Note the different style spray fitting from the G-90 bottle.

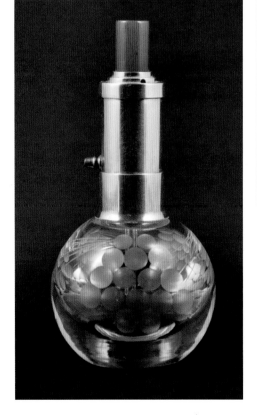

G-90 Perfume Spray with orchid interior enameled bottle decorated with gold enameled acid cutback design and buffed gold spray fittings with swing closure device and a Catalin ornament (1930). *Courtesy of Cheryl Linville.*

G-95 Perfume Spray with heavy sham yellow bottle with engraved grape pattern; reddish-brown Catalin plunger-type spray actuator and buffed gold spray fittings (1930). Height 4.75".

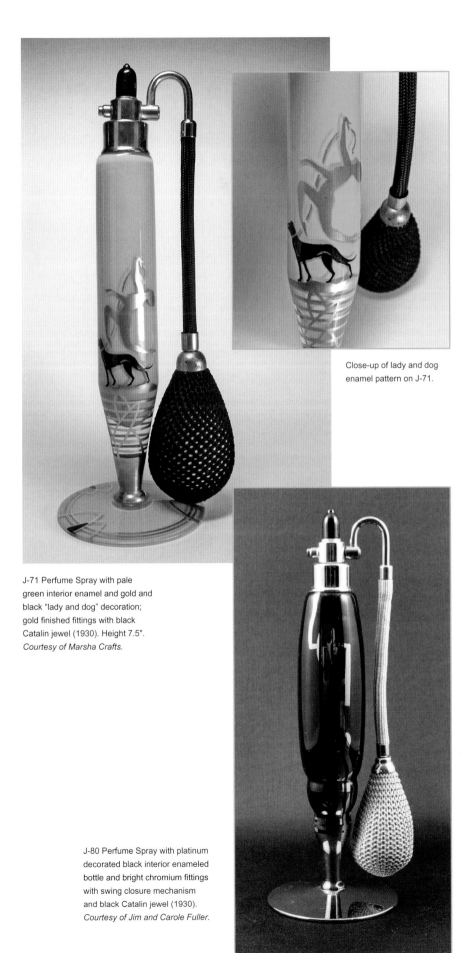

Close-up of lady and dog
enamel pattern on J-71.

J-71 Perfume Spray with pale
green interior enamel and gold and
black "lady and dog" decoration;
gold finished fittings with black
Catalin jewel (1930). Height 7.5".
Courtesy of Marsha Crafts.

J-80 Perfume Spray with platinum
decorated black interior enameled
bottle and bright chromium fittings
with swing closure mechanism
and black Catalin jewel (1930).
Courtesy of Jim and Carole Fuller.

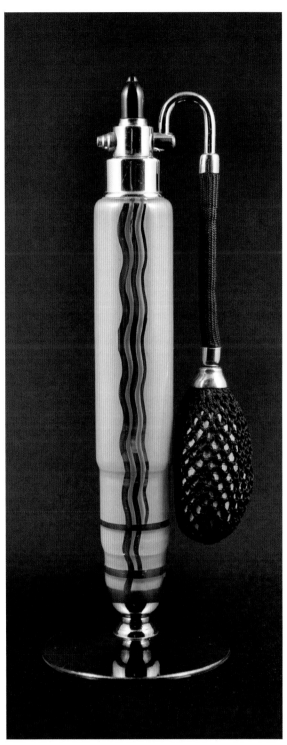

J-83 Perfume Spray with platinum decorated
orchid interior enameled bottle and bright
chromium fittings with swing closure mechanism
and black Catalin jewel (1930). Height 7.75".

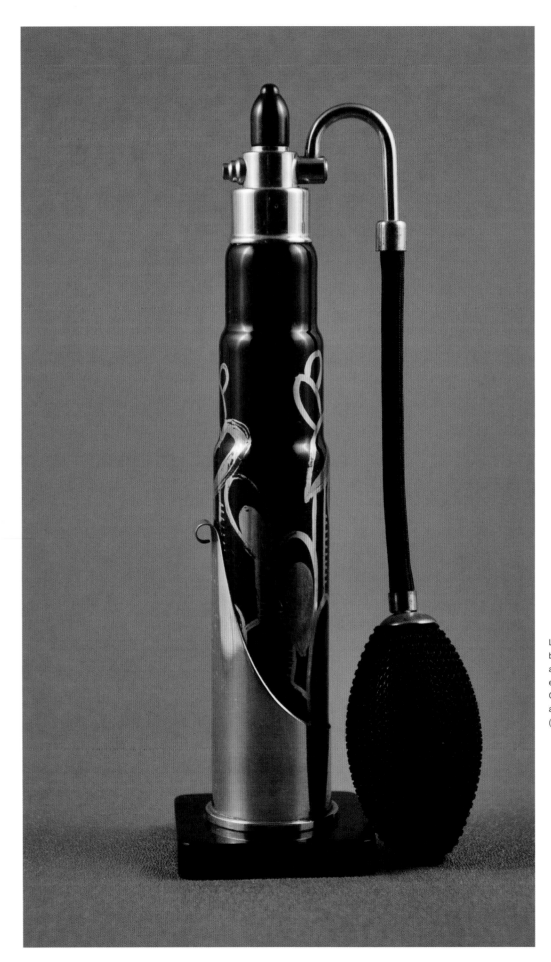

L-63 Perfume Spray with black bottle decorated with a burnished gold and silver enamel decoration; black Catalin jewel and foot and a buffed gold metal stand (1930). Height 7.75".

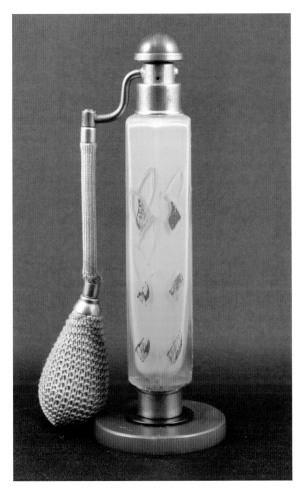

L-66 Perfume Spray with hexagonal molded green bottle with burnished silver and gold leaf decoration; gold spray fittings with swing closure mechanism and Catalin jewel and base described in factory specifications as "green quartz" in color (1930). Height 6.75". *Courtesy of Jim and Carole Fuller.*

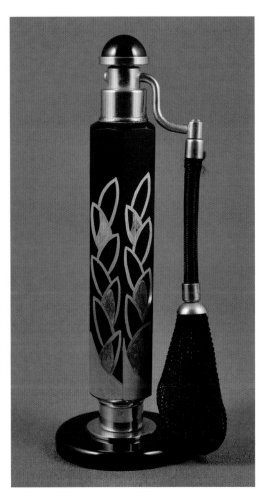

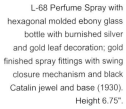

L-68 Perfume Spray with hexagonal molded ebony glass bottle with burnished silver and gold leaf decoration; gold finished spray fittings with swing closure mechanism and black Catalin jewel and base (1930). Height 6.75".

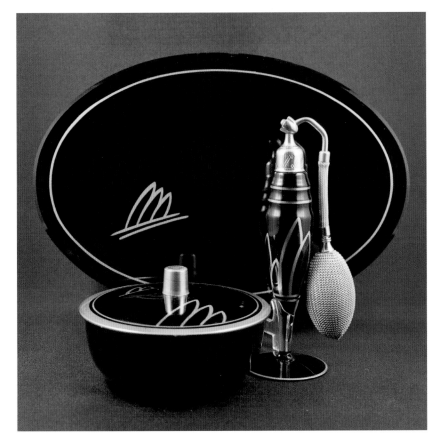

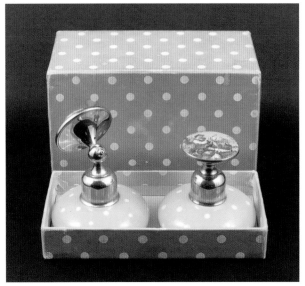

Vanity set VS 160-3 with Perfume Spray, Vanity Jar and Mirror Tray with black enamel and gold decoration; gold finished spray fittings (1931). Perfume Spray height 6.5", mirror 10.5".

SD250-1 Perfume Spray and Perfume Dropper set with green enamel bottles decorated with white enamel polka dots; bright nickel plated metal fittings with air cushion spray actuator; decalcomania transfer scene on top of dropper rod; matching green and white decorated gift box (1931). *Courtesy of Carole and Jim Fuller.*

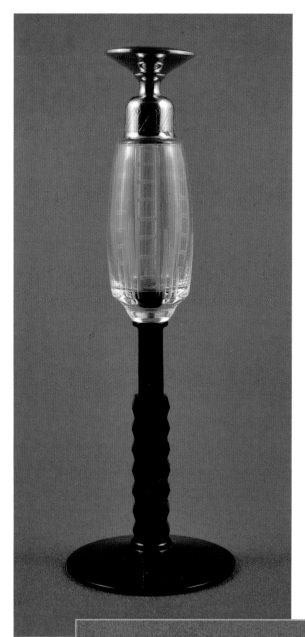

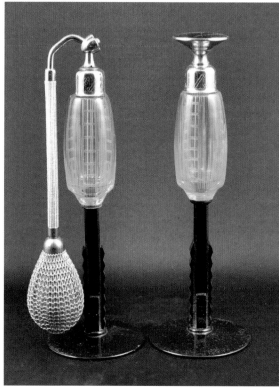

S80-2 Perfume Spray and D80-2 Perfume Dropper with engraved transparent green bottles on ebony glass molded stems and applied feet; nickel-finished fittings (1931). Again note the pattern on the glass bottle in keeping with the design of the stem. Bottle supplied by the U.S. Glass Company (Tiffin). Height 7.5". *Courtesy of Carole and Jim Fuller.*

D80-1 Perfume Dropper with an engraved crystal bottle on black glass molded stem and applied foot; nickel-finished fittings (1931). Bottle supplied by the U.S. Glass Company (Tiffin). Height 7.5".

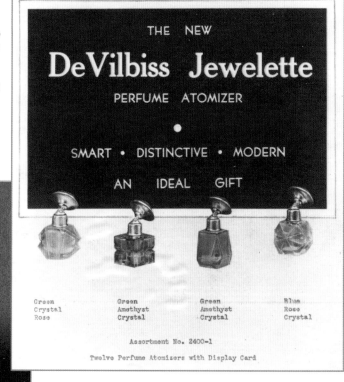

THE NEW

DeVilbiss Jewelette

PERFUME ATOMIZER

·

SMART · DISTINCTIVE · MODERN

AN IDEAL GIFT

| Green Crystal Rose | Green Amethyst Crystal | Green Amethyst Crystal | Blue Rose Crystal |

Assortment No. 2400-1

Twelve Perfume Atomizers with Display Card

Jewelette perfume atomizer store display card showing four models (1932).

S500-2 Perfume Spray with ebony faceted glass bottle and chromium finished cap and spray caps with black Catalin ornament (1931). *Courtesy of Jim and Carole Fuller.*

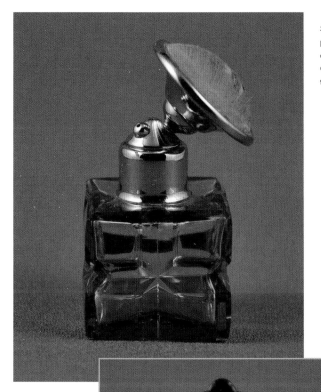

S200-37 DeVilbiss "Jewelette" perfume atomizer with hand cut and polished amethyst bottle; chromium finished spray fittings with air cushion spray actuator. Bottle acid stamped "DeVilbiss, Made in Czechoslovakia" on bottom (1932). Height 3". **Note that DeVilbiss transitioned to the name "perfume atomizer" in 1932.**

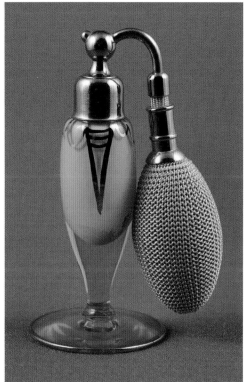

S125-2 perfume atomizer with green interior enamel and silver decoration with chromium finished fittings (1932). Height 4.75".

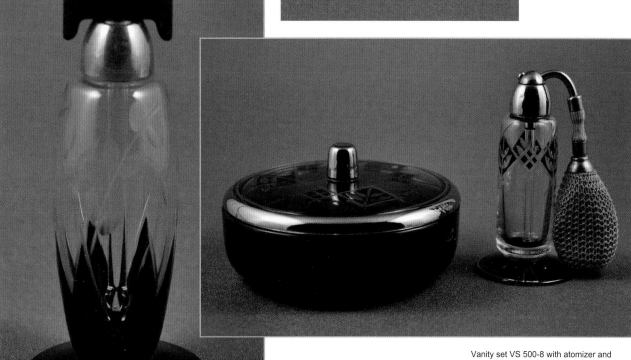

Perfume Dropper from vanity set VS 500-4, with cut crystal bottle, black enamel decoration and foot, chromium cap and black Catalin dropper handle (1932). Height 5".

Vanity set VS 500-8 with atomizer and vanity jar in cut crystal with black and silver enamel decoration; chromium finished fittings (1932). Atomizer height 3.75".

Anachronisms

In the course of studying DeVilbiss shapes, fittings, and styles as they have evolved, people may find puzzling bottles thought to be from an early period, but equipped with fittings from a later time. Sometimes, these can be "marriages"—meaning when a dealer or collector, with a bottle that has lost its fittings, installs spray or dropper fittings originally from another bottle (often even from another manufacturer), and where the two were never made and sold in that configuration in the factory.

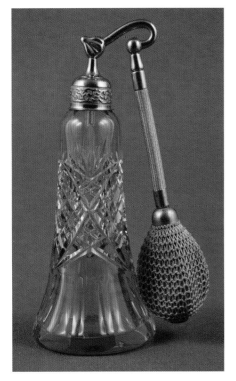

In other instances, as factory records sometimes confirm, bottles and fittings from two different eras were sometimes purposely put together and sold. This practice is discussed in company minutes, where unused inventories of bottle blanks were fitted with current fittings, given a new product number, and sold in the normal course of business, thus recovering some sales revenue from otherwise obsolete inventory. The fact that these combinations seldom are recorded in published catalogs can be confusing, but they do appear in factory production records.

One example is Perfume Spray SP-432, featuring a hand cut and polished bottle, first seen in a 1918 DeVilbiss brochure, equipped with spray fittings of the late 1920s and early 1930s.

A September 30, 1931, factory specification page (see below left) shows Perfume Spray SP-432 and four additional models, all with bottle blanks from the 1918 product line. The text specifically indicates the new spray head styles and types.

Completing the picture, a page from the 1918 line photo book (see below right) shows each bottle in its original configuration. From left to right, J1 bottle matches SP-434 of 1931; J2 bottle matches SP-435; J3 bottle matches SP-431; J4 bottle matches SP-433; and J5 bottle matches SP-432.

SP-432 Perfume Spray with cut crystal bottle (1931). Height 6.5".

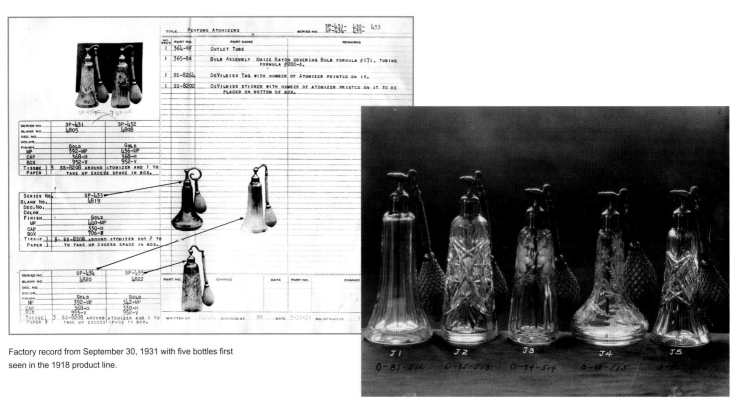

Factory record from September 30, 1931 with five bottles first seen in the 1918 product line.

7200 Series (bottles J1 and J2) and 6000 Series (bottles J3, J4, and J5) Perfumizers from 1918 company catalog.

Other Examples

Steuben's Blue Aurene bottle blank was first introduced by DeVilbiss as model number L-14, in 1924, along with L-15, its Gold Aurene counterpart. Both were equipped with the largest available spray fittings of the time, which were topped by glass ornaments that coordinated with the bottles' colors.

Both bottles were re-introduced in 1926 with the same model numbers, the same Steuben blanks, and DeVilbiss fittings, but with engraved patterns on their bases; the non-engraved bottles were no longer offered. The engraved Gold Aurene model L-15 was continued into 1927, but the Blue Aurene version was discontinued after 1925. Neither version was offered thereafter until the 1934 reprise of the Blue Aurene blank with new fittings, as SP 530-1, shown below. Steuben Glass Works ceased production of Aurene and all other Frederick Carder–era Steuben art glass in 1932. The Blue Aurene bottle blanks purchased in 1924 were still in stock and fitted and sold in 1934.

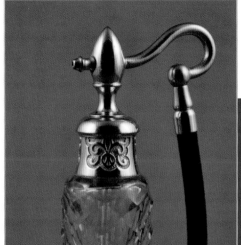

Close-up view of 1927 collar and spray head on c. 1918 cut crystal blank.

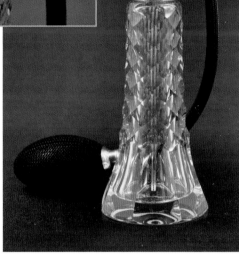

Perfumizer from 1918 with hand cut and polished crystal bottle equipped with gold finished spray fittings from 1927. Height 6.5".

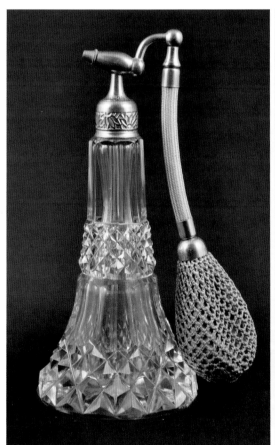

Non-cataloged Perfume Spray with hand cut and polished bottle and gold-finished spray fittings from 1930. Height 6.25".

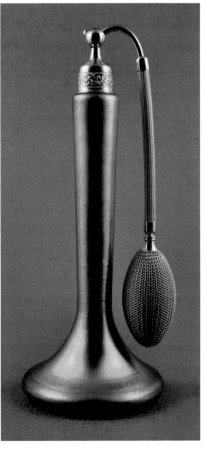

SP 530-1 Perfume atomizer with Steuben Glass Works Blue Aurene bottle and gold finished spray fittings (1934). Height 10".

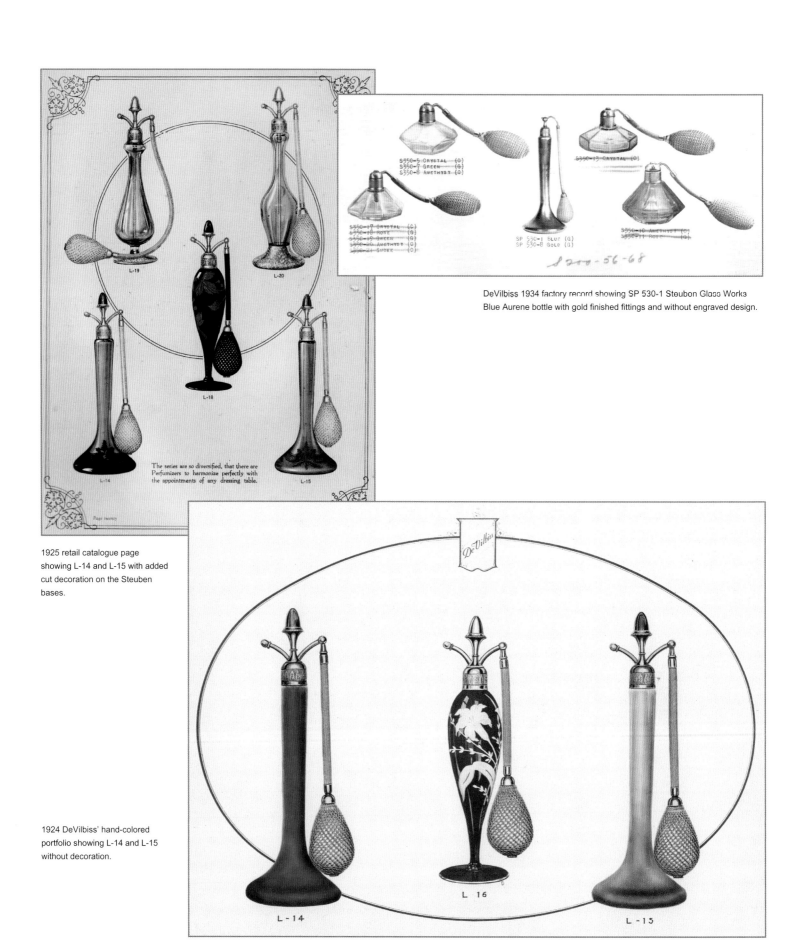

DeVilbiss 1934 factory record showing SP 530-1 Steuben Glass Works Blue Aurene bottle with gold finished fittings and without engraved design.

1925 retail catalogue page showing L-14 and L-15 with added cut decoration on the Steuben bases.

1924 DeVilbiss' hand-colored portfolio showing L-14 and L-15 without decoration.

The series are so diversified, that there are Perfumizers to harmonize perfectly with the appointments of any dressing table.

Canadian Catalog 1928–1929

Courtesy of Marsha Crafts

This catalog was found in Canada, inserted in a U.S. 1928 catalog. As Marsha Crafts has indicated, DeVilbiss, from nearly the beginning of the company, had a plant located in Windsor, Canada. The company minutes note that around this time, Canadian import regulations changed so that a given percent of the product had to be produced in Canada for it to be sold as "made in Canada." DeVilbiss designated certain bottles and quantities then to be decorated in Canada and sold.

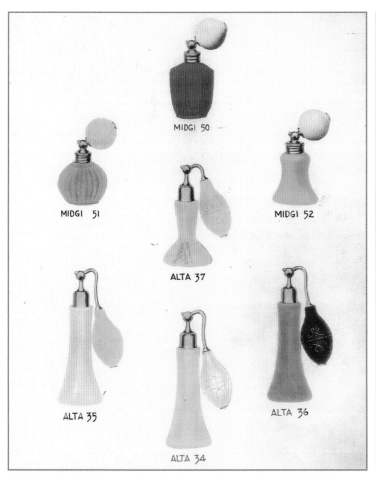

Page 1.

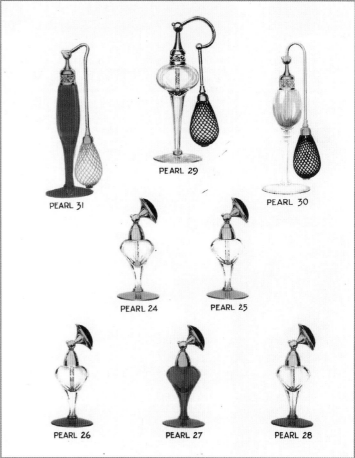

Page 2.

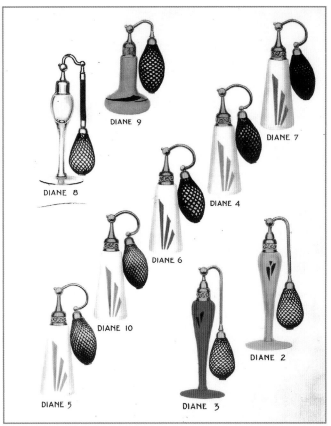

DIANE 9

DIANE 8

DIANE 7

DIANE 4

DIANE 6

DIANE 10

DIANE 2

DIANE 5

DIANE 3

Page 3.

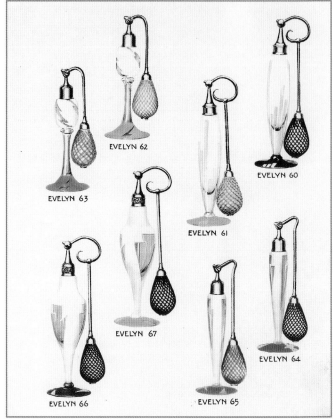

EVELYN 62

EVELYN 63

EVELYN 60

EVELYN 61

EVELYN 67

EVELYN 64

EVELYN 66

EVELYN 65

Page 4.

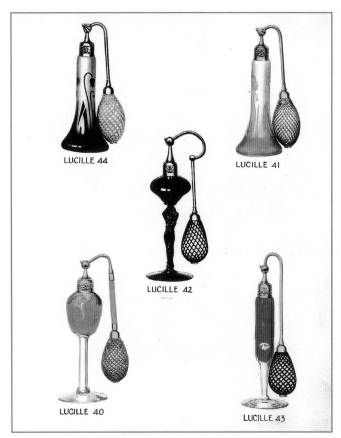

LUCILLE 44

LUCILLE 41

LUCILLE 42

LUCILLE 40

LUCILLE 43

Page 5.

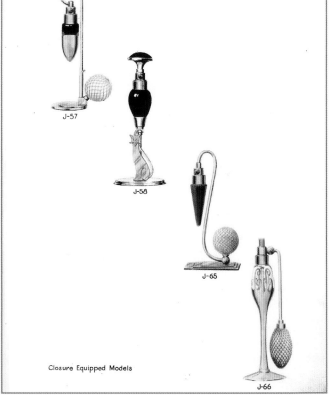

J-57

J-58

J-65

J-66

Closure Equipped Models

Page 6.

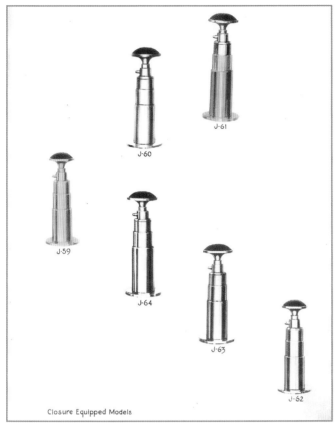

Closure Equipped Models

Page 7.

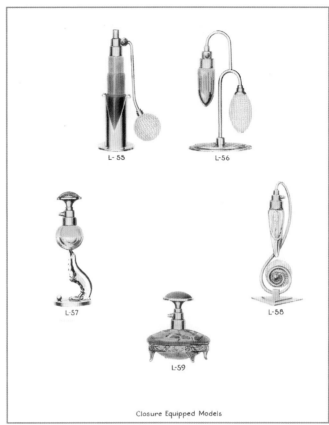

Closure Equipped Models

Page 8.

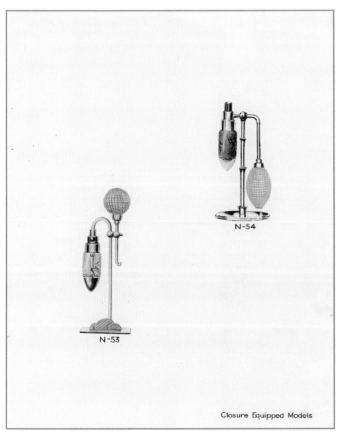

Closure Equipped Models

Page 9.

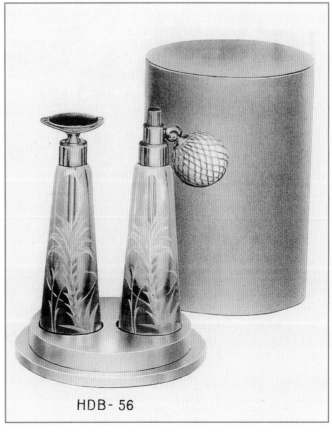

HDB-56

Page 10.

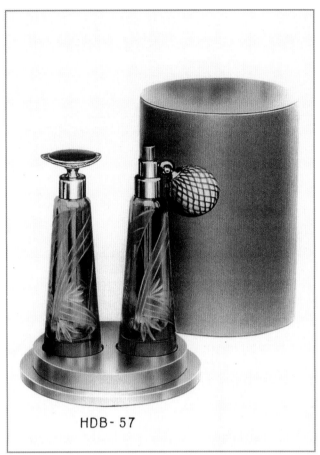

HDB-57

Page 11.

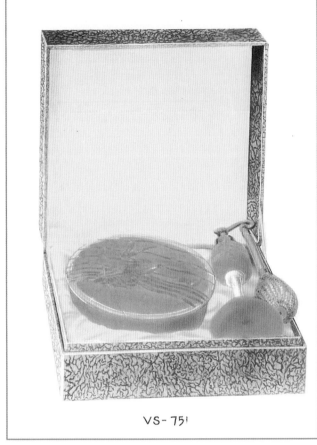

VS-75¹

Page 12.

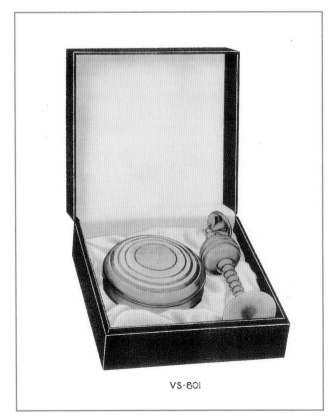

VS-801

Page 13.

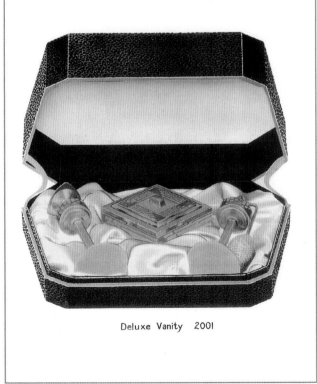

Deluxe Vanity 2001

Page 14.

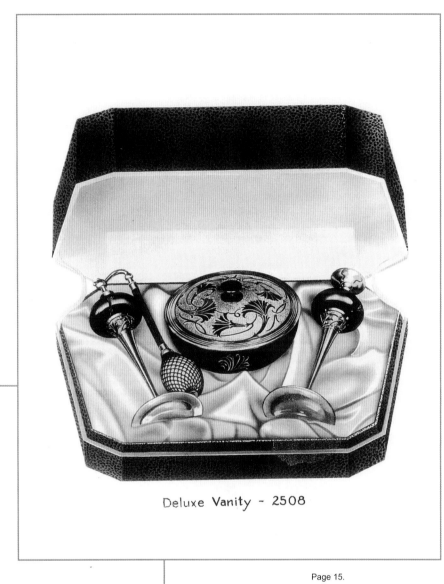

Deluxe Vanity - 2508

Page 15.

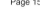

PL-1002

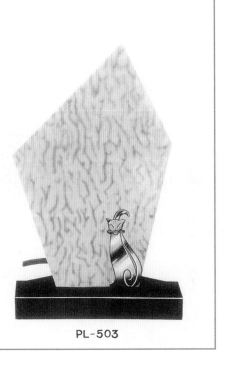

Page 16.

PL-503

Perfume Lights and Night Lights

In 1921 DeVilbiss introduced the company's first perfume lights—decorative electric lights with a small receptacle into which small amounts of perfume were to be placed. The heat of the low-wattage lamp bulb gently heated the perfume, which vaporized and diffused the perfume's fragrance into the room. DeVilbiss, in its catalogs and advertising, characterized its perfume lights as providing "gentle light and sweet fragrance." "Perfume can be placed in a small, concealed cup where it is slowly volatilized by the warmth of the electric bulb within." DeVilbiss perfume lights were also intended for and were well-suited as night lights.

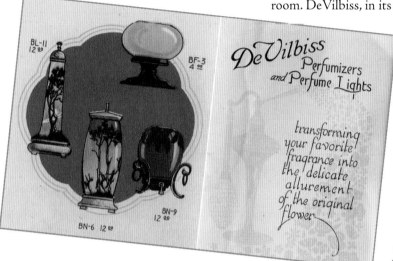

Pages from small 1925 flyer advertising perfume lights.

While DeVilbiss did not invent perfume lights, it popularized them with design artistry and skill in metal work and glass decoration. The perfume light was a natural outgrowth of the DeVilbiss business, which leveraged its capabilities in design and manufacturing, formidable sales organization, and highly regarded and widely accepted brand in perfume accessories.

Nearly all of DeVilbiss' perfume light items were made in the 1921–1931 time period. Only a few other lights were made in later years; one perfume light of Lenox Belleek china in 1938, two perfume lights by Wittig of West Germany in 1964, and a line of porcelain perfume lights and Night Lights by Fairfield, which were introduced in 1965 and sold through the closing of the DeVilbiss perfume division in 1968.

DeVilbiss entered the market with two models called "Perfume Burner and Night Light," which appeared in its 1921 product brochure (see below left). The first model was described as having hard metal parts which were "heavily gold plated." The glass globe in the brochure appears to be an iridized gold art glass.

The actual light fulfills the brochure's expectation and more. The model shown in the photo at left features a pulled pattern, gold iridized globe, which, while unsigned, is possibly from Durand.

The second model shown in the brochure (see opposite, top left) had a straight cylindrical chimney and a silver-plated metal stand and cap.

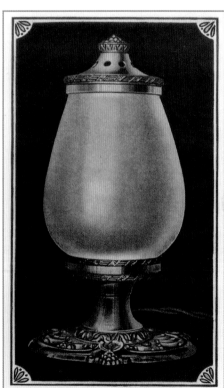

B12001 Perfume Burner and Night Light (1921).

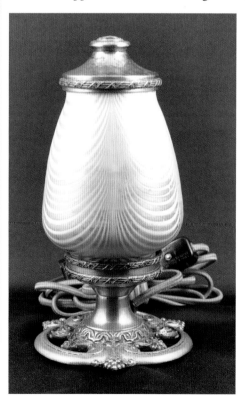

B12001 Perfume Burner and Night Light (1921).
Courtesy of Jim and Carole Fuller.

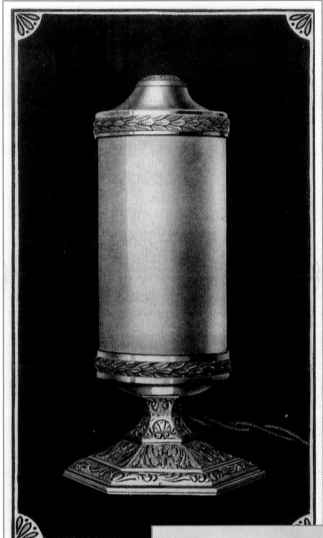

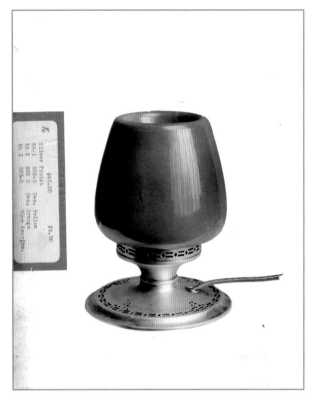

Factory photo of BA Series perfume lights, globes supplied by the Cambridge Glass Company with Cambridge Azurite (BA-3), and DeVilbiss enamel decorated Yellow (BA-1) and Orange (BA-2) indicated on the sticker; bases with silver finish (1923).

B12002 Perfume Burner and Night Light, silver plated metal parts and cylindrical chimney (1921).

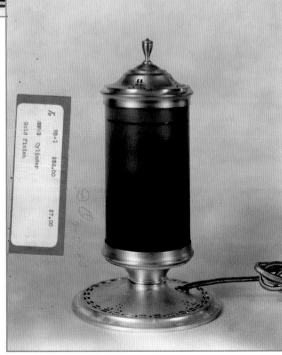

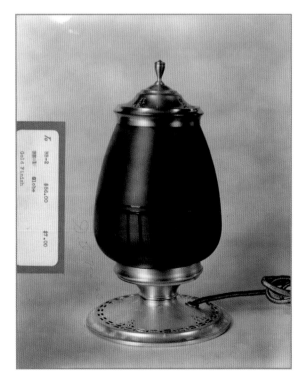

Factory photo of BB-1 perfume light with interior enamel and exterior enamel decorations; gold finished metal parts indicated on sticker (1923). Barely visible is a penciled notation of the date: "7-3-23."

Factory photo of BB-2 perfume light with interior enamel and exterior enamel decorations; gold finished metal parts indicated on sticker (1923). Barely visible is a penciled notation of the date: "7-3-23."

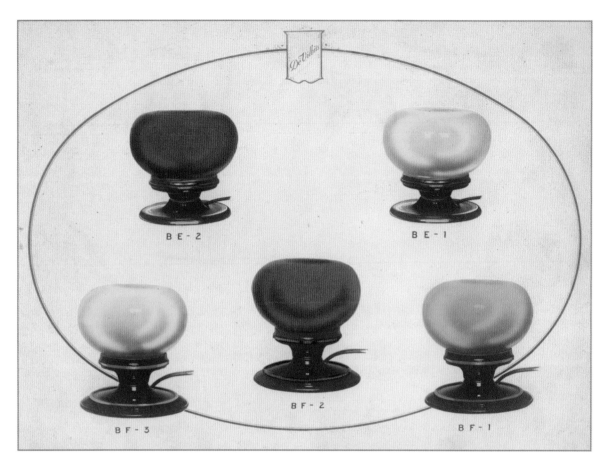

Salesman's portfolio showing BE and BF Series perfume lamps from 1923. The glass globes were made by the Cambridge Glass Company.

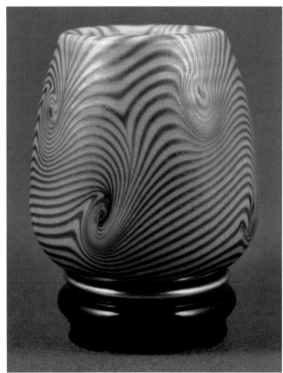

Perfume light with a Durand (Vineland Flint Glass Works) globe in an iridized gold King Tut pattern and black enamel and gold finished base (c. 1924). Height 5".

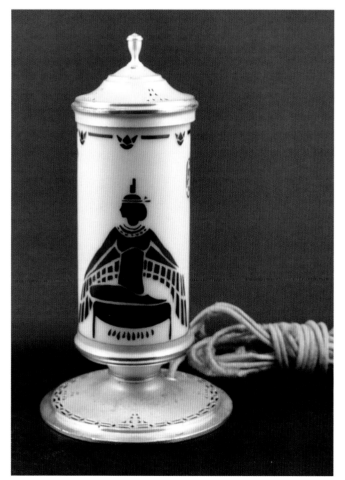

BJ-3 Perfume light with opal cylindrical chimney with a black enamel figure of an Indian princess (1925). Height 7.5". *Courtesy of Jim and Carole Fuller.*

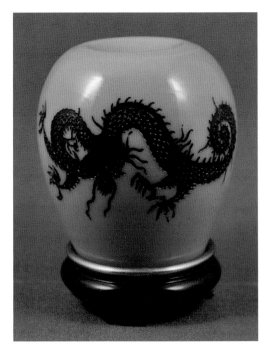

BJ-7 Rare Perfume light with a rare Cambridge Glass Company Jade globe with a Cambridge black enamel encrusted dragon etching, red enamel eyes; black and gold enamel metal base (1925). Height 4.5".

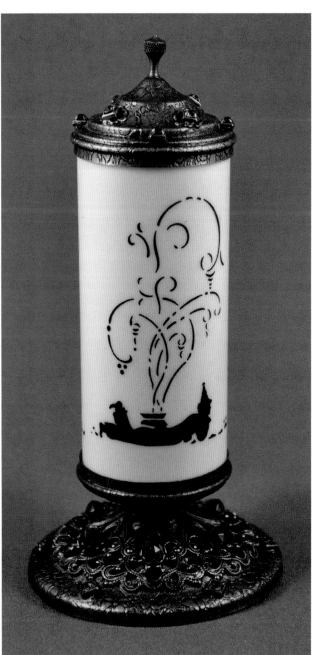

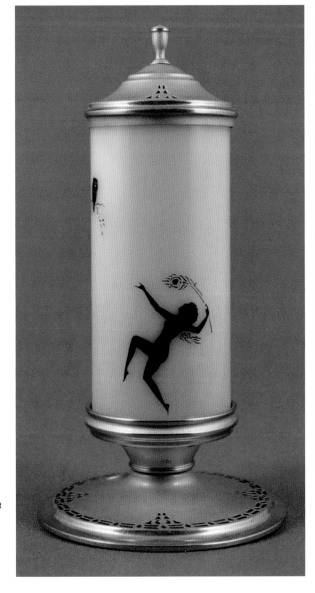

BL-1 Perfume light with opal cylindrical chimney decorated with black enamel dancing woman figure. The interior of the chimney is enameled with red at the bottom shading to blue at the top to impart a soft, multi-colored background effect when lighted (1925). Height 7.5".

Non-cataloged perfume light with enamel reverse painted opal cylindrical chimney decorated with black enamel clown figures. The base and cap have an unusual textured antique bronze finish with applied filigree and set with red and blue jewels (1925). Height 8".

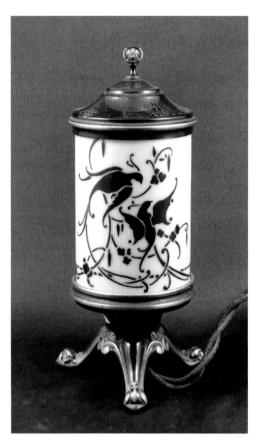

BL-6 Perfume light with an opal cylindrical chimney with black enamel bird decoration and metal tripod-style black and gold enamel base and cap (1925). *Courtesy of Jim and Carole Fuller.*

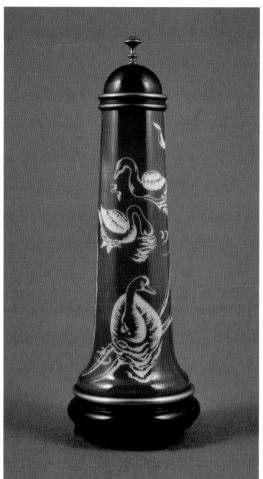

BL-7 Perfume light with opal tapered chimney, pink enameled and hand engraved back to opal in an unusual swan design with an antique gold base and black and gold enameled cap (1925). Height 8".

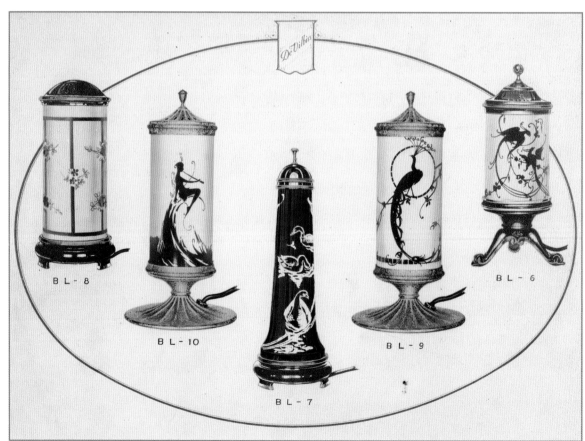

BL Series perfume light sales portfolio images from 1925.

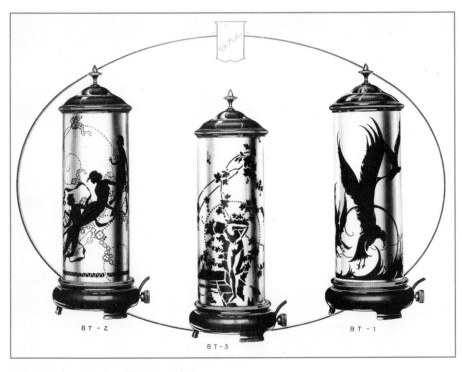

BT Series perfume lights from 1925 sales portfolio.

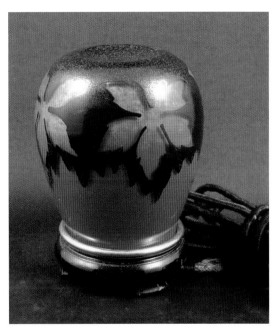

BN-9 Perfume light with crystal globe reverse enameled in red and with black enamel leaf pattern; on gold and black enamel finished base (1925). Height 4.5". *Courtesy of Jim and Carole Fuller.*

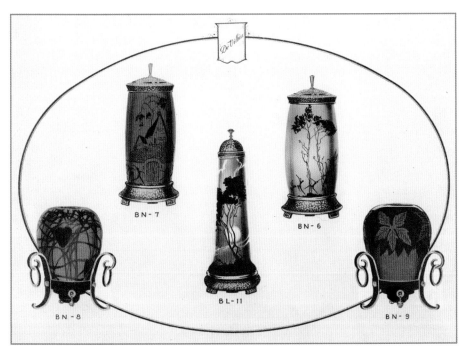

BN Series perfume light portfolio images from 1925.

BL-11 Perfume light with an orange, yellow, and black enamel tree and moon scene on a tapered opal chimney; antique gold cap and base (1925). Height 8".

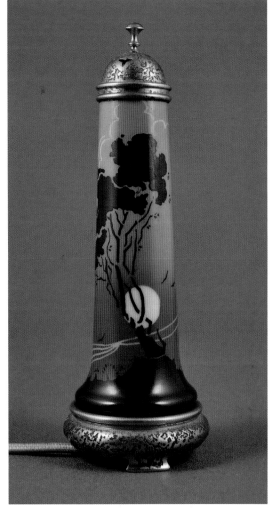

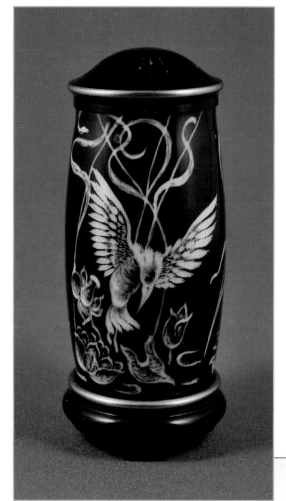

BN-2 Perfume light with an opal
rounded cylindrical chimney.
This graceful bird decoration is
achieved by first covering the
chimney in green enamel, then
black, and then cutting the bird
figure back to opal leaving green
highlights (1925). Height 6.5".

1925 sales portfolio
illustrator's image of the BN
perfume light series. The
two-layer enamel decorating
technique was also executed
in black and pink (BN-3 and
BN-5) and black and brown
(BN-6).

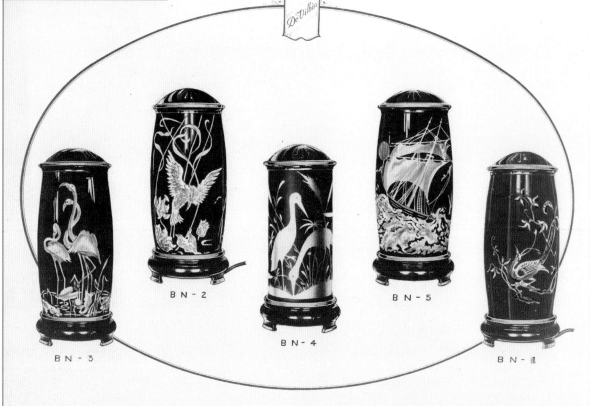

BN-3 BN-2 BN-4 BN-5 BN-6

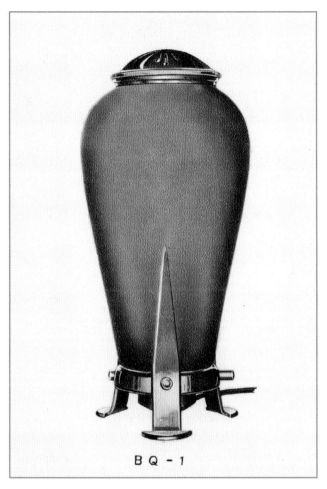

BQ-1

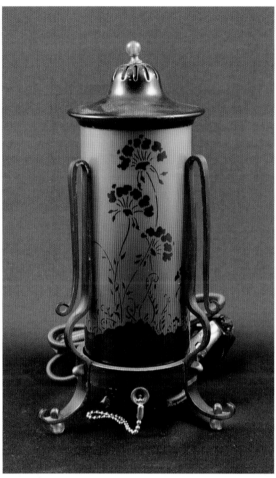

BQ-2 Perfume light with opal cylindrical chimney decorated with red shading to orange enamel and black enamel floral pattern; ornate oriental-style base and cap with amber beads as feet and on the cap's finial (1925). *Courtesy of Jim and Carole Fuller.*

BQ-1 Perfume light catalog illustrator's image from the 1925 sales portfolio; gold iridescent art glass globe produced by Quezal. Factory records from 1927 show this perfume light, BQ-1, now product number BN-11, with its art glass globe shown as supplied by Quezal. While this model remained in the DeVilbiss line from 1925 through 1927, all shown as being provided by Quezal, supplies of globes must have been acquired from Quezal during 1925, as the company went out of business that year.[20]

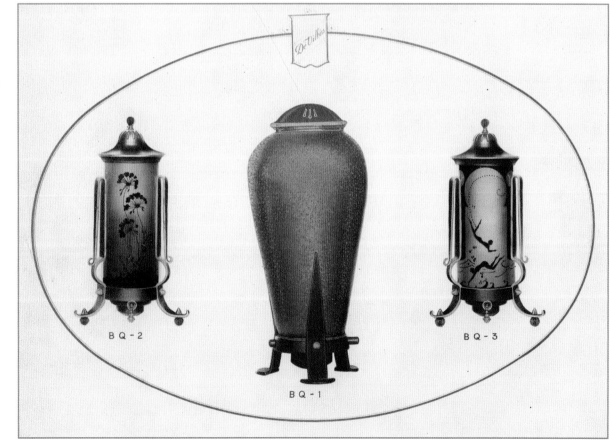

BQ-2 BQ-1 BQ-3

BQ Series perfume light portfolio images from 1925.

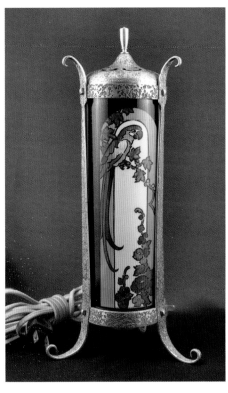

BY-1 Tall and rare opal cylindrical chimney perfume light decorated with a multi-colored parrot decoration; antique gold frame and cap (1925). *Courtesy of Jim and Carole Fuller.*

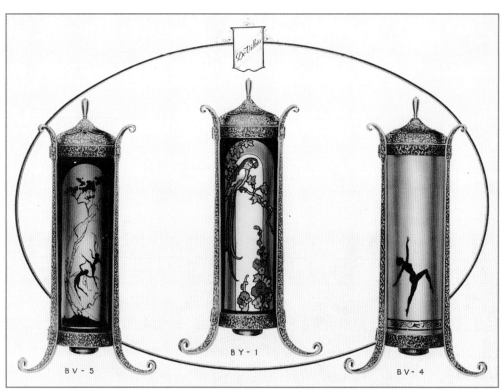

1925 sales portfolio illustrator's image of three perfume lights in the BV and BY Series.

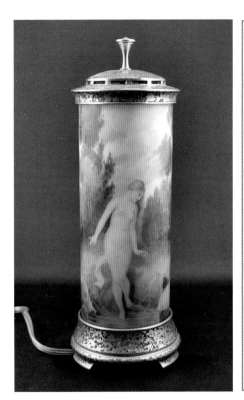

5BQ-2 Intricately and beautifully reverse painted nude in garden scene on cylindrical chimney; antique gold base and cap. This largest of DeVilbiss perfume lights was also the costliest: $75 retail (1925), equalling near $1,000 in current dollars. *Courtesy of Jim and Carole Fuller.*

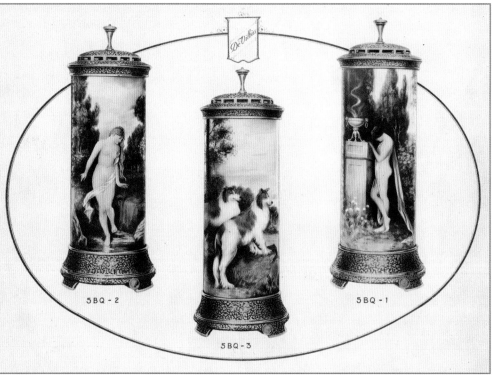

1925 sales portfolio illustrator's image of all three luxury, rarely found perfume lights in the 5BQ Series each with hand painted chimneys.

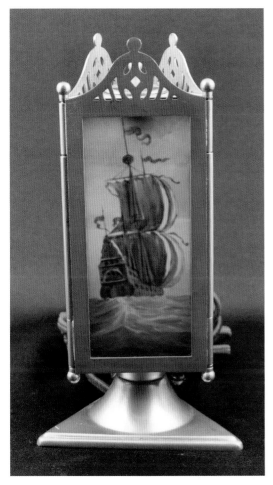

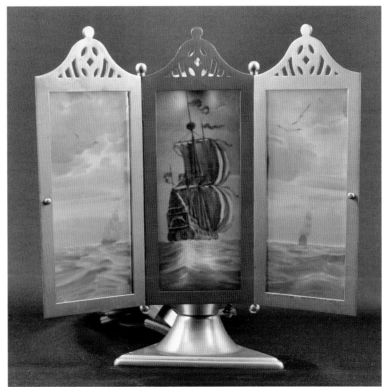

5BG-1 in open position showing all three scene panels (1926).

5BG-1 Perfume light consisting of a three-paneled frame with ship scene painted on glass panes and satin-finished gold stand in closed position (1926). *Courtesy of Jim and Carole Fuller.*

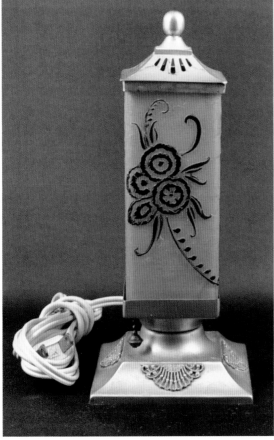

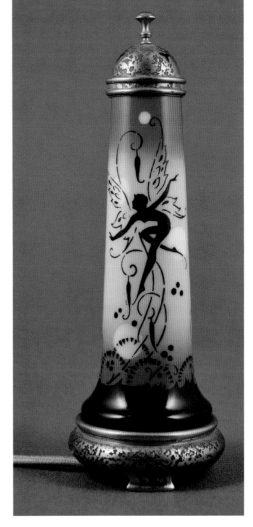

BH-6 Orange enameled square chimney decorated with black enamel floral scene; satin gold finished cap and base with applied filigree shields on the base (1926). This perfume light, in yellow, was one of only two perfume lights added to the 1927 line. *Courtesy of Jim and Carole Fuller.*

BJ-12 Perfume light with opal tapered chimney decorated with a black enamel pixie on an orange and yellow background; antique gold cap and base (1926). Height 8".

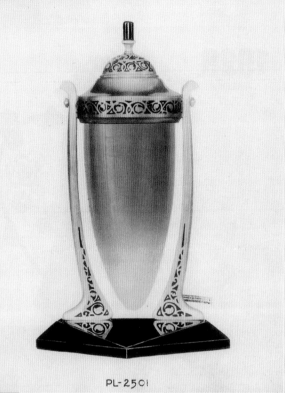

PL-2501

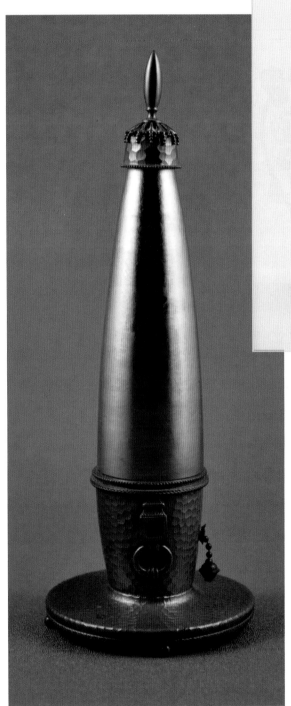

PL-2501 Perfume light illustrator's image from 1928 catalog; green gold finished metal stand on glass base. The globe in this catalog page is Old Rose and is Foval glass from the H. C. Fry Glass Company. This model remained in the DeVilbiss product line from 1927 through 1929. It appears that DeVilbiss switched glass globe sources at some point during this lamp's three-year presence in the product line. We learn from Marsha Crafts that one version is a cased glass of rose over a "clam broth," or alabaster (similar to Steuben's Rosaline over Alabaster), while the other is white opalescent Foval Art Glass with interior rose enamel shading. The 1929 factory specification lists Foval Glass, but Foval is not listed in the specs for 1927 and 1928; thus, it is likely that the cased glass versions are from 1927 and 1928.

This rare BL-14 perfume light has an elegant tapered chimney in Gold Aurene by Steuben Glass Works and is the only perfume light with metal parts composed of a hammered copper top and base (1926). Height 8".

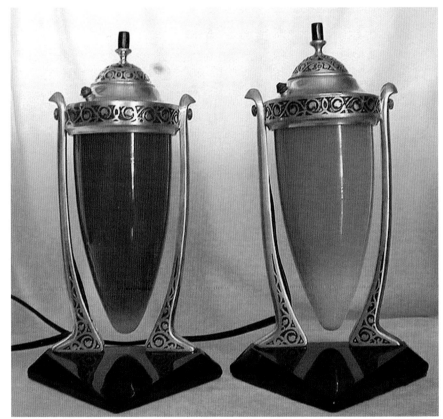

Comparison of two PL-2501 lamps with the Fry Foval version on the right. *Courtesy of Marcia Crafts.*

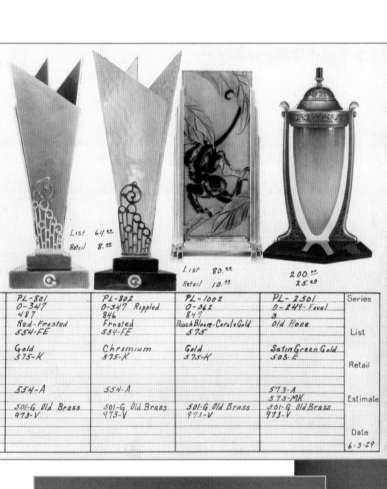

PL-801 O-347 487 Red-Frosted 554-FE	PL-802 O-347 Rippled 846 Frosted 554-FE	PL-1002 O-362 847 Peach Bloom-Coral+Gold 575	PL-2501 O-249-Foval 3 Old Rose	Series List
Gold 575-K	Chromium 575-K	Gold 575-K	Satin Green Gold 503-E	Retail
554-A	554-A		573-A 573-MK	Estimate
501-G Old Brass 973-V	501-G Old Brass 973-V	501-G Old Brass 973-V	501-G Old Brass 973-V	Date 6-3-29

DeVilbiss factory record from 1929 noting Foval as the glass blank for perfume light 2501.

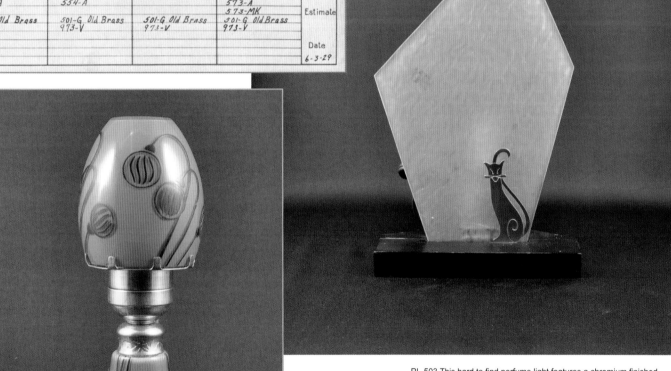

PL-503 This hard to find perfume light features a chromium finished metal cat figure on a black enameled wooden stand also holding a four-sided rippled frosted glass panel with the electric light in the rear of the lamp (1929). *Courtesy of Jim and Carole Fuller.*

PL-501 Perfume light with two-part base and shade, orange interior enamel and black enamel decoration; gold finished fittings (1928). *Courtesy of Jim and Carole Fuller.*

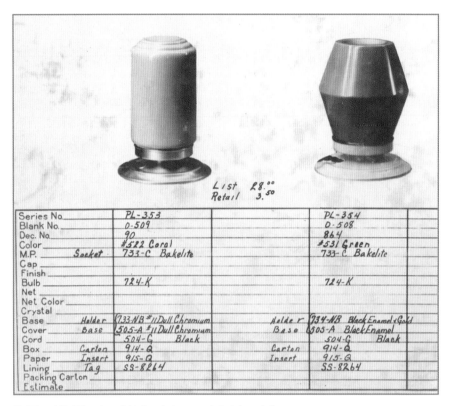

List 28.00
Retail 3.50

Series No.		PL-353		PL-354	
Blank No.		0-509		0-508	
Dec. No.		90		864	
Color		#522 Coral		#531 Green	
M.P.	Socket	733-C Bakelite		733-C Bakelite	
Cap					
Finish					
Bulb		724-K		724-K	
Net					
Net Color					
Crystal					
Base	Holder	733-NB #11 Dull Chromium	Holder	734-NB Black Enamel & Gold	
Cover	Base	505-A #11 Dull Chromium	Base	505-A Black Enamel	
Cord		504-G Black		504-G Black	
Box	Carton	914-Q	Carton	914-Q	
Paper	Insert	915-Q	Insert	915-Q	
Lining	Tag	SS-8264		SS-8264	
Packing Carton					
Estimate					

PL-353 and PL-354 perfume lights from factory records (not shown in the 1930 catalog). PL-353 (left) has a coral globe and dull chromium finished base, and PL-354 (right) has a green globe and black enamel base (1930).

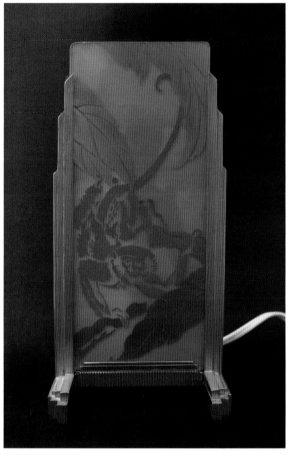

PL-1002 perfume light with a remarkable glass panel decorated with coral enamel on reverse and a peach-bloom monkey among gold enamel leaves, in a gold finished metal stand with electric light in the rear of the lamp (1929). *Courtesy of Jim and Carole Fuller.*

Colonial Lady

The next listing of a DeVilbiss perfume light was made in 1938, in the form of a Lenox Belleek China "Colonial Lady," which is described on page 228, with DeVilbiss-Lenox models.

PL-504, PL-505, PL-751, PL-751 Modern perfume lights from factory records, showing colors and finishes. The glass panels were purchased from L. J. Houze Convex Glass Company of Point Marion, Pennsylvania.

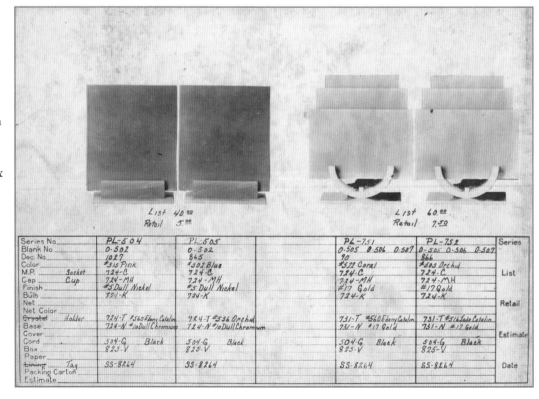

List 40.00
Retail 5.00

List 60.00
Retail 7.50

Series No.		PL-504	PL-505		PL-751	PL-752	Series
Blank No.		0-502	0-502		0-505 0-506 0-507	0-505 0-506 0-507	
Dec. No.		1027	865		90	866	
Color		#515 Pink	#502 Blue		#522 Coral	#503 Orchid	
M.P.	Socket	724-C	724-C		724-C	724-C	List
Cap	Cup	724-MH	724-MH		724-MH	724-MH	
Finish		#5 Dull Nickel	#5 Dull Nickel		#17 Gold	#17 Gold	
Bulb		724-K	724-K		724-K	724-K	Retail
Net							
Net Color							
Crystal	Holder	724-T #560 Ebony Catalin	724-T #536 Orchid		731-T #560 Ebony Catalin	731-T #516 Jade Catalin	
Base		724-N #10 Dull Chromium	724-N #10 Dull Chromium		731-N #17 Gold	731-N #17 Gold	Estimate
Cover							
Cord		504-G Black	504-G Black		504-G Black	504-G Black	
Box		825-V	825-V		825-V	825-V	
Paper							
Lining	Tag	SS-8264	SS-8264		SS-8264	SS-8264	Date
Packing Carton							
Estimate							

DeVilbiss Presentation Packaging

Early in the 1920s, DeVilbiss developed the capacity to produce luxury presentation packages for its high-end bottles and vanity sets. Referred to in a 1925 price list as "Fancy Gift Boxes," these beautiful cases were lined with satin or velvet and sold both with their Perfumizers included or without them to retailers who would offer them as an option to customers with their Perfumizer purchases. From simple gift boxes to elaborate presentation cases, they accommodated single Perfumizers, Perfumizer and dropper bottle sets, and multi-piece sets with accessories that might cover an entire vanity top.

Depending on the set, included pieces could be vanity trays, pin trays, vanity jars, small tumblers, jewel cases, bathroom bottles, candy boxes, candlesticks, candles, and vases. There were also smokers' items, including ashtrays, match holders, cigarette boxes, and even a tobacco jar. For luxury sets, carved hardwood cases were produced by outsource firms and decorated and lined by DeVilbiss. In some, cards were packaged with the contents advising that the box could be used as a handkerchief or photograph box. Some luxury sets were packaged in ladies' overnight travel cases. The theme, current throughout the 1920s, was luxury, elegance and opulence.

These examples exhibit DeVilbiss' style and attention to detail and beauty.

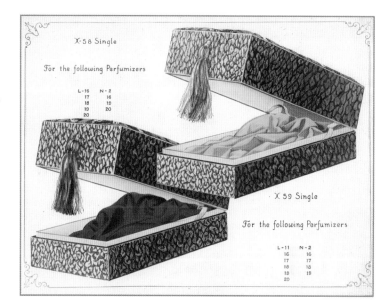

Salesman's portfolio illustration of gift boxes available for separate purchase by retailers and consumers. These boxes were designed to accommodate any of the items in the L Series from the 1925 line, both as single Perfumizer boxes and as boxes for Perfumizer and Perfume Dropper sets.

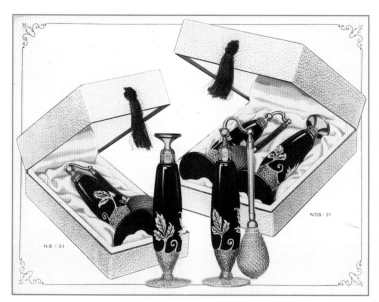

Salesman's portfolio page showing N-21 and ND-21 in presentation packaging both as a single Perfumizer and a Perfumizer and Perfume Dropper set.

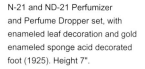

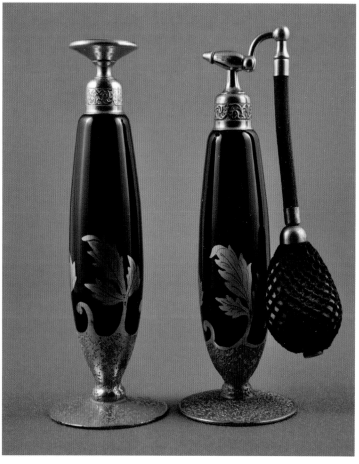

N-21 and ND-21 Perfumizer and Perfume Dropper set, with enameled leaf decoration and gold enameled sponge acid decorated foot (1925). Height 7".

Westmoreland Glass Company

In the mid-1920s, DeVilbiss greatly expanded its product lines by adding vanity accessories to match its Perfumizers and Dropper Perfume bottles. Glass blanks beyond bottles were needed in substantial variety and quantity, including vanity jars, dresser trays, pin trays, and more, to be decorated by DeVilbiss' superb decorating department to compose coordinated sets. DeVilbiss found an able supplier in the Westmoreland Glass Company.

The Westmoreland Glass Company was founded in 1889 in Grapeville, Pennsylvania, as the Westmoreland Specialty Company, changing its name to the Westmoreland Glass Company in 1924. The company remained in operation almost 100 years, finally closing production in 1984. Throughout its history, Westmoreland produced elegant, hand-made and -decorated glassware that is considered highly collectible today.

The earliest certain date of Westmoreland supplying glass blanks to DeVilbiss is 1924, the year DeVilbiss expanded its lines beyond Perfumizers, droppers, and perfume lights to include vanity and accessory items. While no DeVilbiss factory records have been found specifically referencing the relationship, it is beyond doubt that accessory items appearing in the Westmoreland 1800 and 1801 lines, both introduced in 1924, were acquired by DeVilbiss that year. Acquisition of items from those and other Westmoreland specialty lines continued through the late 1920s. Items included dresser trays, vanity jars, match holders, cigarette boxes, tobacco jars, ashtrays, candlesticks, candy boxes and a fan vase. The enameling, etching, and acid cutback decorations appearing on identifiable Westmoreland blanks were applied by DeVilbiss decorators. Where there is a clear match of a DeVilbiss item to a Westmoreland shape, it is noted in the descriptions that follow.

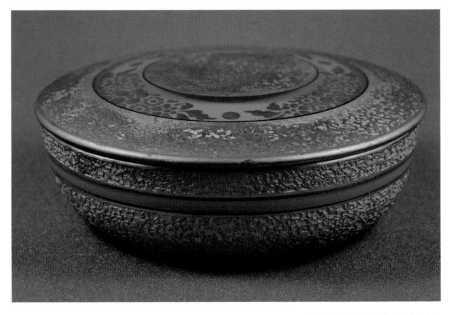

VJ-116 Vanity jar with blue interior enamel cut to clear on the lid and blue band on the base; gold encrusted sponge acid decoration on exterior (1925). Height 2"; diameter 6".

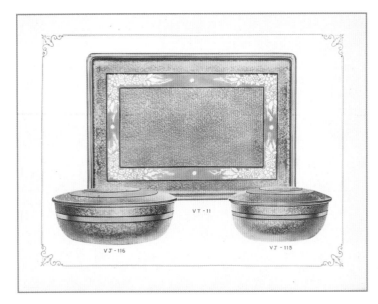

1925 sales portfolio image of vanity tray VT-11, VJ-116 vanity jar, and VJ-115 vanity jar, a smaller version of VJ-116. Glass tray by Westmoreland Glass Company.

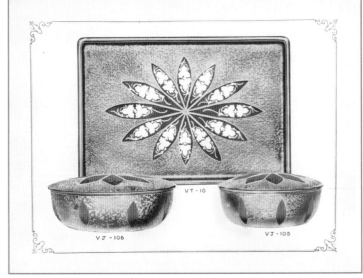

1925 sales portfolio image of VT-10 vanity tray, VJ-106 vanity jar, and VJ-105 vanity jar, a smaller version of VJ-106. Glass tray by Westmoreland Glass Company.

Vanity Sets and Accessories

In the early 1920s, DeVilbiss saw the opportunity to offer vanity accessories to complement its lines of Perfumizers and Perfume Dropper bottles. The first to appear were covered powder jars and hair receivers decorated to match its Perfumizers. Ashtray sets were also intended for the card table or general use, as seen in the club, diamond, heart, and spade enamel decorations on some of the sets.

By the mid-1920s, the accessories line had expanded to include candlesticks, pin trays, cigarette boxes, match holders, jewel cases, fan vases, and vanity trays to hold it all. These were sold both separately and as part of sets, packaged in luxury cases of carved hardwood or leatherette, with the boxes intended for secondary use as handkerchief boxes, photograph boxes, or overnight cases.

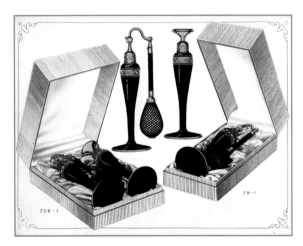

Perfumizer and Perfume Dropper set JDB-1 from 1925 salesman's portfolio.

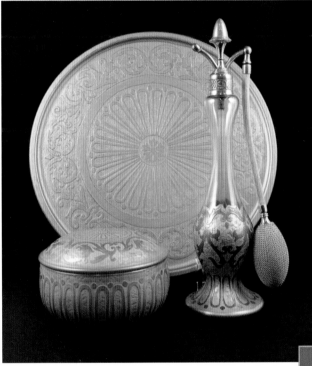

Deluxe vanity set No. 5.

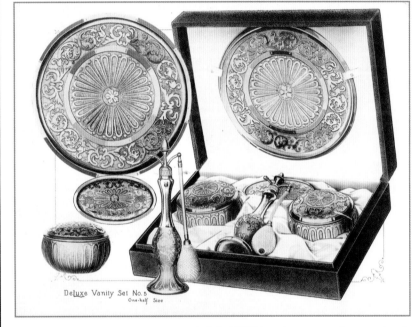

Deluxe Vanity Set No. 5
One-half Size

Salesman's portfolio illustration of the 5-piece deluxe vanity set No. 5, with the T-1 Perfumizer, two vanity jars, a vanity tray, and a pin tray (both vanity tray and pin tray from Westmoreland Glass Company); all pieces acid cut-back and gold enameled (1926).

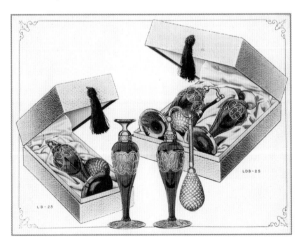

LDB-1 Perfumizer and Perfume Dropper set from 1925 salesman's portfolio.

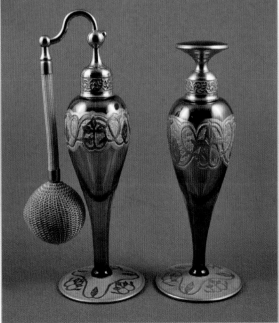

L-25 and DL-25 Perfumizer and Perfume Dropper set; burgundy stained bottles from Cambridge Glass Company with gold encrusted acid cutback design on bottles and feet, and gold finished spray and dropper fittings (1925). Height (Perfumizer) 7".

In the factory specification for this set, the individual piece retail prices were noted in the upper left corner, indicating that the components of the set were sold separately as well as in a set. At $16, the case was as expensive as the Perfumizer. The two-compartment, padded and satin-lined case was intended to be repurposed by the owner as a jewelry, handkerchief or photograph box, according to factory documents.

At $65.50 retail in 1927, this set would cost $850.00 in today's dollars, before accounting for today's higher price of gold. Consider that there would be about a half-ounce of 24-karat gold in this set, at a time when the price of gold was $35 an ounce. Today, gold is about $1,200 an ounce. The sales estimate (seen at the lower right corner) for this set was 71 units. Clearly, this was a vanity set at the top of the line. Retail sales flyers provided by DeVilbiss for the high-end vanity sets, and for the individual sales of the boxes, suggested to customers the possibility of buying an elegant box and later filling it piece by piece, a type of "layaway plan."

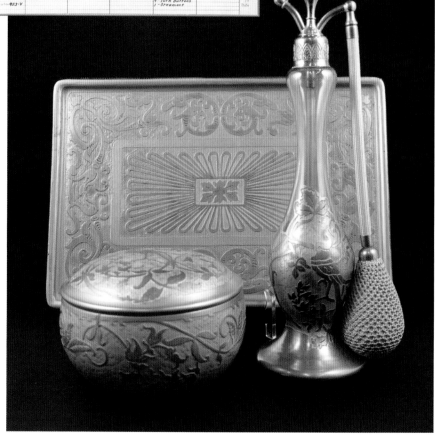

Factory specification sheet detailing the components of the 1927 Kingfisher acid cutback set with the R-8 Perfumizer, VT-1502 vanity tray, two VJ-802 vanity jars, and a PT-252 pin tray in a luxury satin-lined case. Note the retail price at $65 and $524 for a lot of 12.

R-8 Perfumizer, VJ-802 vanity jar, and rectangular vanity tray by Westmoreland Glass Company; gold enamel Kingfisher decoration on Perfumizer and vanity jar (1926). Tray 7.5" in width by 10.25" in length; Perfumizer height 10"; vanity jar height 3.25", diameter 4.75".

1925 salesman's portfolio page showing H-15 Perfumizer and DH-15 Perfume Dropper with blue satin enameled exterior and etched gold and black enamel encrusted decoration; in silk-lined single and double presentation cases.

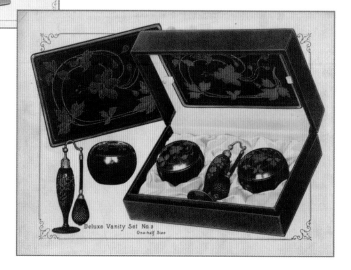

1925 salesman's portfolio page showing the K-13 Perfumizer with deluxe vanity set No. 3. This decoration was achieved by applying red reverse enamel and black exterior enamel, then cutting back the black enamel in the pattern to reveal the red design.

Deluxe vanity set 2506 had an individually boxed H-22 Perfumizer, DH-22 Perfume Dropper, VJ-402 vanity jar, and PT-151 pin tray (pin tray from Westmoreland Glass Company) in a hardwood, velvet-lined presentation box 1008V, that was suggested for use as a "photograph box" after unpacking, from the 1927 line. The top of the box lid features a carved and delicately enameled ship scene. The factory specification notes the box was purchased from the F. Zimmerman Company, Toledo, Ohio and the color decoration was by DeVilbiss. Note that even the powder puff inside the vanity jar was specifically designated to the set, with a matching silk colored rosebud. The specification books provide minute detail to control factory workers' processes in assembling DeVilbiss Perfumizers and vanity sets.

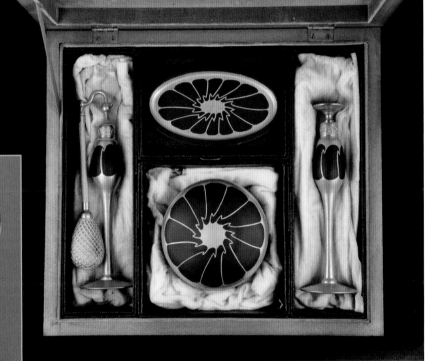

Deluxe vanity set 2506 with H-22 Perfumizer, DH-22 Dropper Perfume, VJ-402 vanity jar and PT-151 pin tray, in satin-lined wooden box with carved and enameled ship on top (1927).

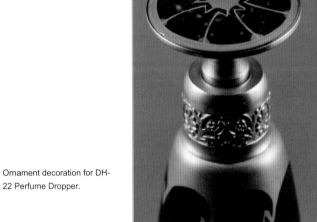

Ornament decoration for DH-22 Perfume Dropper.

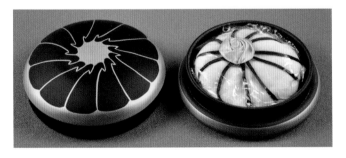

Vanity jar with powder puff with applied silk rose and embroidered pattern emulating the enamel design of the jar's lid.

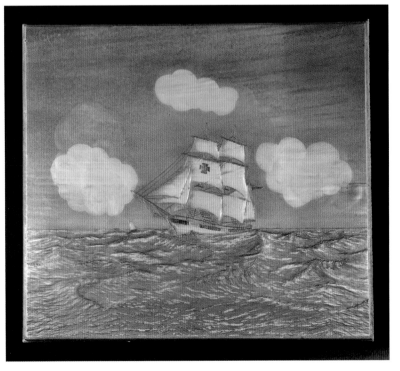

Enameled ship scene top of wooden case for vanity set 2506. Box by F. Zimmerman Company, Toledo, Ohio; color decoration by DeVilbiss.

A 1927 salesman's portfolio page shows Deluxe vanity set 6801 with the Seahorse design, with N-29 Perfumizer and ND-29 Perfume Dropper, matching vanity jar, vanity tray and jewel case, all with coral and gold acid-cutback Seahorse decoration.

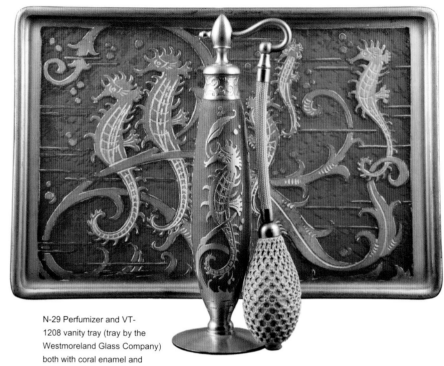

N-29 Perfumizer and VT-1208 vanity tray (tray by the Westmoreland Glass Company) both with coral enamel and acid cutback seahorse design decorated with gold enamel (1927). Height 7.5".

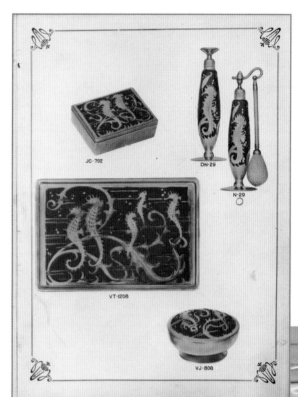

1927 salesman's catalog page showing deluxe vanity set 6801 components: JC-702 jewel case, ND-29 Perfume Dropper, N-29 Perfumizer, VJ-808 vanity jar, and VT-1208 vanity tray. Tray and box by Westmoreland Glass Company.

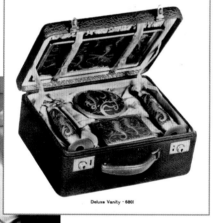

Catalog image of deluxe vanity 6801, packaged in a case intended for use as an overnight case.

1926 Deluxe vanity set 1801 in a leatherette covered, satin-lined case consisting of I-17 Perfumizer, VJ-501 vanity jar, and PT-152 pin tray (pin tray by the Westmoreland Glass Company). An included card advises *"After the contents of this package have been removed, the tray may be taken out and the box used to hold handkerchiefs or other articles."*

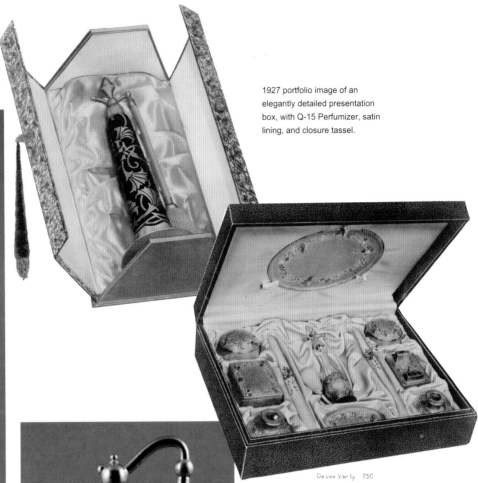

1927 portfolio image of an elegantly detailed presentation box, with Q-15 Perfumizer, satin lining, and closure tassel.

Deluxe Vanity 750

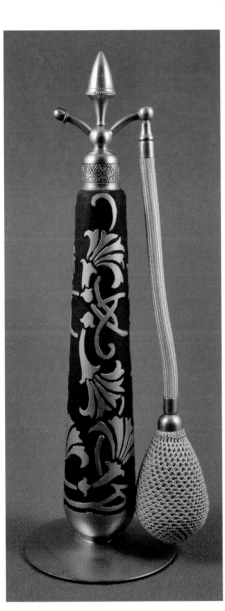

Q-15 Perfumizer, acid-cutback, black interior-enameled bottle, with gold, Art Nouveau, floral decoration and foot; satin-finished gold spray fittings (1927). Height 10".

Deluxe vanity 7501, in satin-lined presentation box that includes eleven pieces: N-2 Perfumizer, two VJ-701 vanity jars, pin tray, CB-501 cigarette box, MH-251 match holder, two CS-301 candle holders, two WC-151 candles, and the VT-1501 vanity tray. The tray, cigarette box, matchbox holder, candlesticks, and pin tray were furnished by Westmoreland Glass Company. From the 1927 line.

L-26 Perfumizer with gold, sponge-acid stem and foot, black interior-enameled bottle, orange enamel highlights, and gold-plated fittings (1927). Height 7.5".

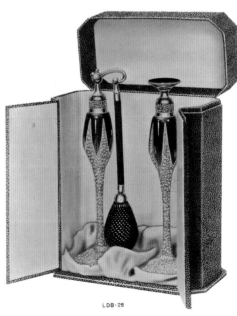

LDB-26

Multi-paneled box made for Perfumizer and Perfume Dropper set LDB-26, from a 1927 salesman's portfolio.

Deluxe vanity set 6001 components from the 1927-line salesman's catalog. The penciled "0" notation beneath the Perfumizer and Perfume Dropper indicate that the items were out of stock. Box, pin tray, tray, and candlestick furnished by Westmoreland Glass Company.

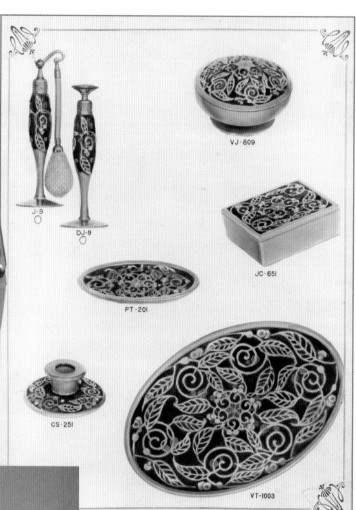

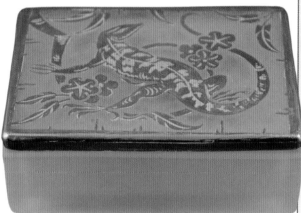

Rectangular, covered box, from Westmoreland Glass Company, with gold enameled, acid-cutback rare lizard design, on clear, satin-finished glass (1926). These boxes were described in sales materials and factory specifications as either cigarette boxes, when sold in sets with ashtrays, or as jewel cases, when sold as part of a vanity set. Length 4.25"; width 3.5"; height 1.5".

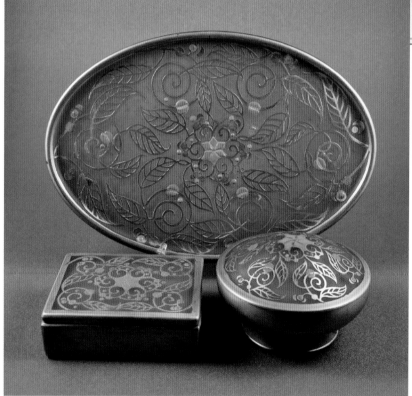

Dresser tray VT-1003, jewel case JC-651, and vanity jar VJ-809. Tray and jewel case by Westmoreland Glass Company, decorated by DeVilbiss. Tray width 10.5".

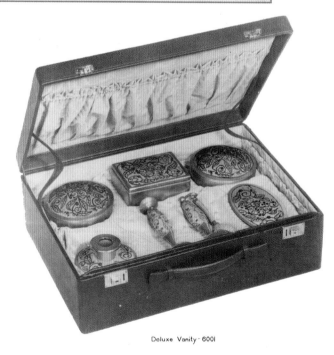

Deluxe Vanity · 6001

The 6001 set came packaged in a handled case intended as a lady's overnight travel case after the contents were removed (1927 catalog image). In this packaging, the vanity tray was not included. Cigarette box, candlesticks, and pin tray were supplied by the Westmoreland Glass Company.

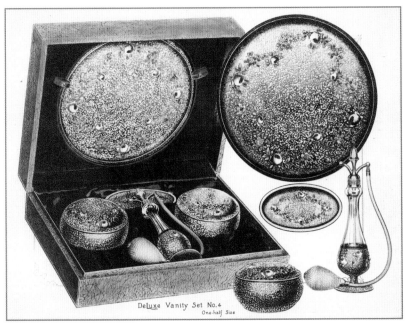

1925 salesman's portfolio illustration of deluxe vanity set Number 4.

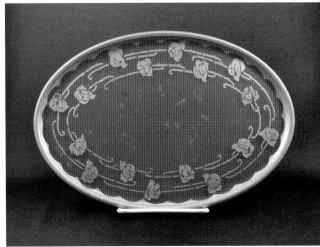

Vanity tray VT-701. Reverse-enameled coral, with gold-enamel floral pattern and scalloped border on top. This tray, supplied by the Westmoreland Glass Company and decorated by DeVilbiss, is part of deluxe vanity set 3501 (1927). *Courtesy of Carole and Jim Fuller.*

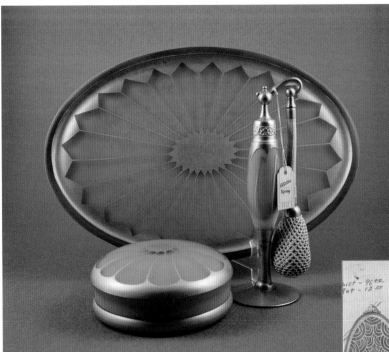

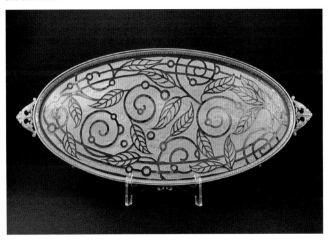

Vanity tray VT-1206, gold metal frame and handles, green gold enameled acid cutback leaf and vine pattern, four gold feet on the bottom (1927). Very few of these metal framed trays were made—factory records show sales estimates of only 25 of this style in 1927. Length 13.5"; width 6.25".

H-21 Perfumizer, VT-601 vanity tray (from the Westmoreland Glass Company), and VJ-401 vanity jar, satin finished with gold enamel DeVilbiss Art Deco decoration on reverse-enameled green (1926). Perfumizer height 7"; vanity tray width 10.5". Note the DeVilbiss hang-tag on the Perfumizer.

Factory specifications for 1927 line of metal framed and handled vanity trays with five designs.

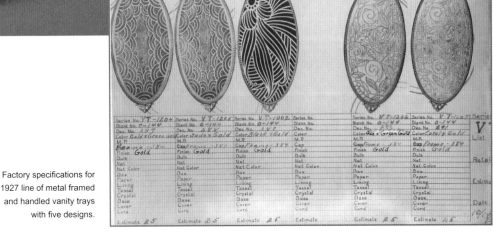

The catalog image of Deluxe vanity set 8301, below, shows the jade enamel and gold Perfumizer and dropper bottles, jewel case, powder jar, and fan vase (jewel case and fan vase supplied by the Westmoreland Glass Company). This was the most expensive set in the 1927 product line, at $83.00—or about

$1,100 in today's dollars. Of this, the costliest component was the hardwood case, costing $37.50 or $500 of today's dollars, and it was intended for use as a "photograph box" after the vanity set was removed. These boxes were made for DeVilbiss by the F. Zimmerman Company of Toledo, Ohio.

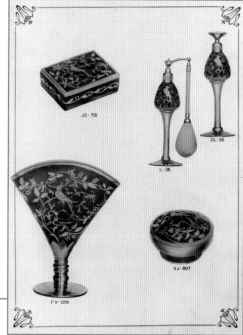

Catalog image of deluxe vanity set 8301 with the Kingfisher decoration.

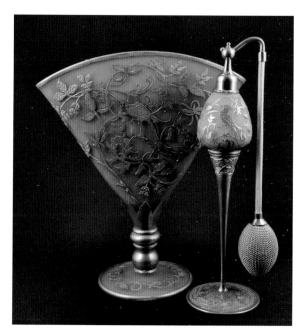

Perfumizer with green enamel and acid cutback Kingfisher pattern and gold finished metal stem with molded Art Nouveau floral pattern on the foot, with matching fan vase FV-1201, blank supplied by the Westmoreland Glass Company, decorated by DeVilbiss (1928). Height of Perfumizer 9". Height of fan vase 8.75".

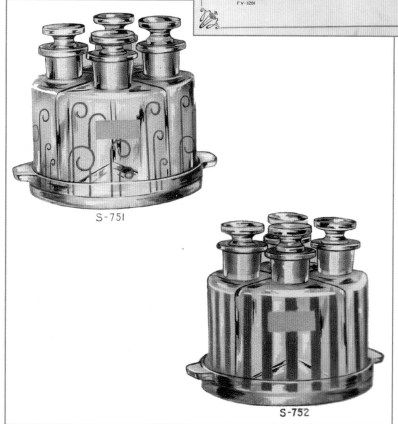

DeVilbiss S-751 and S-752 bathroom jar sets; bottles and trays by Westmoreland Glass Company (1928).

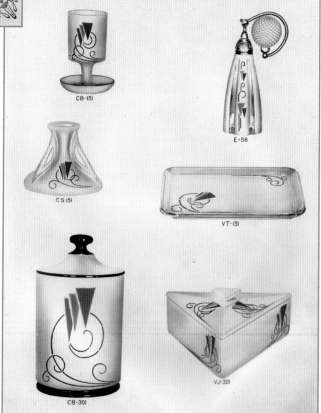

All of the items depicted on this catalog page, with the exception of the Perfumizer whose manufacturer is so far unknown, were supplied by Westmoreland and decorated by DeVilbiss. Westmoreland also sold these blanks to their own customers. For example the DeVilbiss tobacco jar CB-301 at lower left is Westmoreland's 1800-103 tobacco jar, and the vanity jar VJ-301 is their 1856-1 triangle candy box and lid.[21]

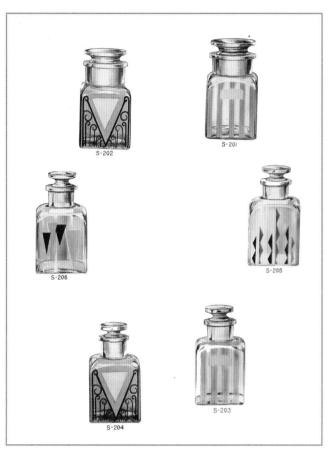

DeVilbiss, S-Series, stoppered, bathroom jars, bottles by Westmoreland (1928).

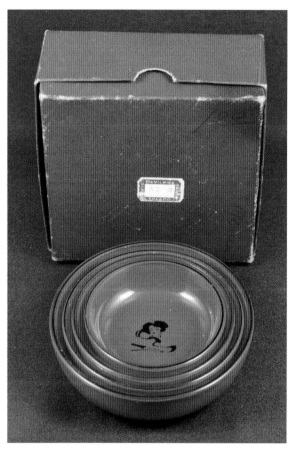

DeVilbiss AT-3, nested, set of four ashtrays, with blanks by Westmoreland Glass Company; DeVilbiss-decorated in red enamel, with black enamel rim and figure of a woman smoking (1926).

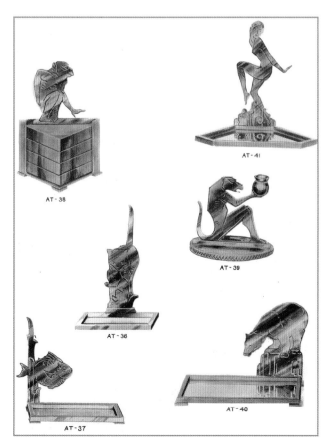

Salesman's portfolio page showing DeVilbiss ashtrays AT-36 through AT-41.

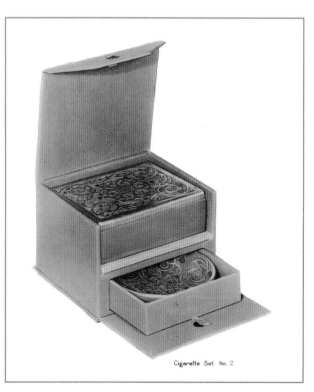

Cigarette set No. 2, with green case; includes cigarette box and ashtrays, in enameled. acid-cutback design (1928).

Salt Shakers by DeVilbiss

One mystery that may surprise collectors was DeVilbiss' brief and limited foray into the realm of tableware—in the form of a line of salt shakers. Why not try? The glass blanks used for the shakers were the same as the bodies of the bottles—minus the stem—of a number of beautiful, often acid cutback, Perfumizer models sold in 1926 through 1928. DeVilbiss's department store sales channels would also be offering tableware, so the buyers might be interested in a DeVilbiss item featuring the artistry of DeVilbiss' superb decorating department. All DeVilbiss needed to do was install a threaded fitting onto which to screw the sterling shaker cap, in place of the Perfumizer collar. The result was appealing. A 1928 salesman's catalog page shows the salt shaker line. One wonders whether the initial idea of creating salt shakers came from seeing a stem broken from its bottle in this line. DeVilbiss encouraged its employees to make suggestions and comments about product innovation.

Salesman's catalog page of salt shaker sets (1928). The "0" pencil notations show that all items were sold out.

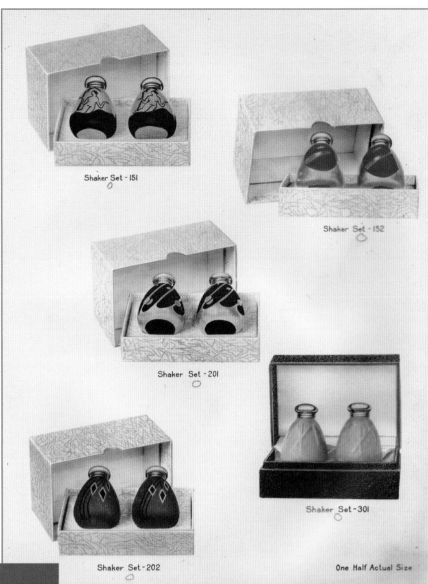

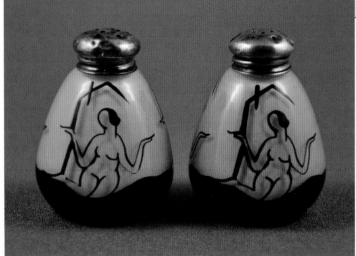

Shaker set 151, with yellow interior enamel and black enamel, nude-woman decoration; sterling caps (1928). Height 2.5".

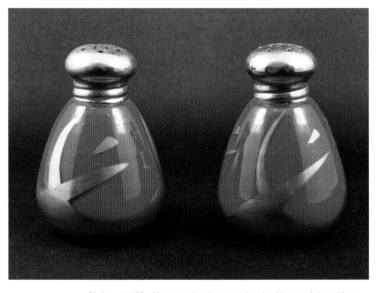

Shaker set 152 with orange interior enamel and gold enamel decoration; sterling caps (1928). Height 2.5". *Courtesy of Carole and Jim Fuller.*

These salt shakers are highly prized among salt shaker collectors. In fact, the acid cutback, blue and gold salt shaker was given the name "Dome & Icicles" by the AAGSSCS (Antique and Art Glass Salt Shaker Collectors' Society). In 1998, they were listed in *The World of Salt Shakers* by Mildred & Ralph Lechner, but thought to be of "European glass, probably English, c. 1900–1910." Even in 1998 they were listed as "Very Scarce."[22]

Notwithstanding the rarity of the DeVilbiss salt and pepper shaker sets, yet still rarer is an item unlisted anywhere but undoubtedly of the same vintage—a set of sachet shakers with the acid cutback Kingfisher pattern. Instead of sterling salt and pepper shaker caps, these are fitted instead with sterling caps designed to deliver sachet powders. These bottles, decorated, would have been in DeVilbiss' inventory already to produce the green enamel and gold Kingfisher Perfumizer with the metal stem attached to the bottom. See page 200.

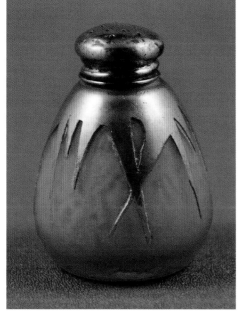

Single shaker from Shaker Set 301 with blue interior enamel and acid cutback gold enamel decoration; sterling cap (1928). Height 2.5".

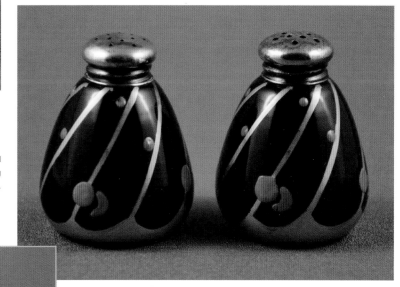

Shaker set 201 with black interior enamel and gold and orange enamel decoration; sterling caps (1928). Height 2.5".

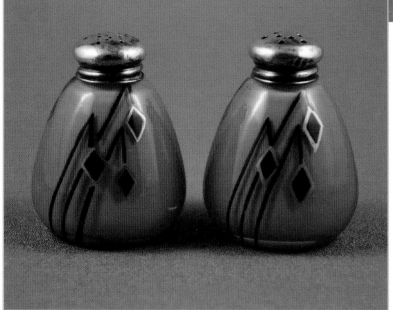

Shaker set 202 with orange interior enamel and black and gold enamel decoration; sterling caps (1928). Height 2.5".

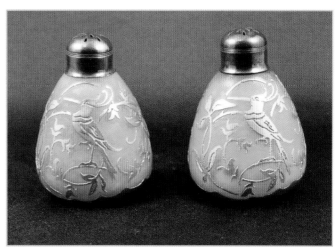

Sachet shaker set, with green interior-enameled bottle and gold-enameled, acid-cutback Kingfisher decoration (1928). Height 2.5". *Courtesy of Carole and Jim Fuller.*

The Depths of the Great Depression

1933—1941

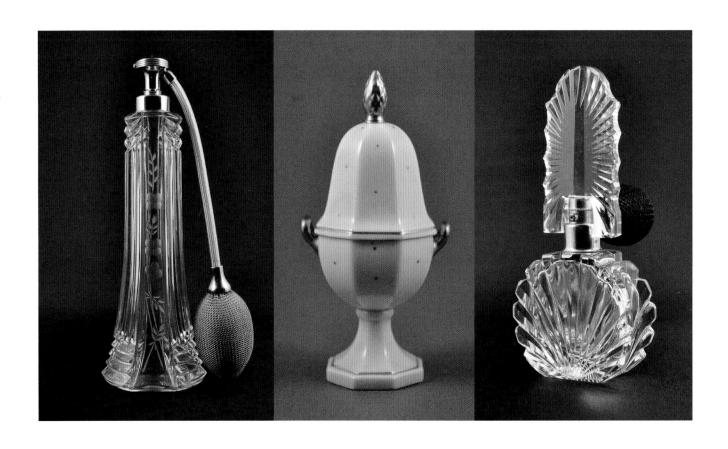

Examples from the period: domestic, Lenox Belleek China, and Czechoslovakia.

Understanding the economic and consumer context of any given period affords the reader a glimpse at the underlying conditions that affected DeVilbiss business decisions, including their purchasing and sales strategies. The Great Depression actually began in mid-1929 and was accelerated by the stock market crash in October of that year. From a peak of 381 in September 1929, the Dow Jones Industrial Average hit an interim low of 198 in mid-November. Investors breathed easier as the Dow recovered to 294 by April 1930. This held for about a year, and then the Dow began another steady and deep slide which ended with the index at 41 in July 1932, which culminated in a stunning loss of 89% in value over a little less than three years!

By 1933, 11,000 of the United States' 25,000 banks had failed. The failure of so many banks, combined with a general and nationwide loss of confidence in the economy, led to much-reduced levels of spending, demand, and production, aggravating the downward spiral. The result was drastically falling output and rapidly rising unemployment. By 1932, U.S. manufacturing output had fallen to 54 percent of its 1929 level, and unemployment had risen to between 12 and 15 million workers, or 25 to 30 percent of the work force, from its pre-Depression low of less than 5%.[1] Average annual family income tumbled 35%, from $2,300 in 1929 to $1,500 in 1933.

DeVilbiss company employment was not spared. It decreased from 987 workers in July of 1929 to 653 in July of 1930.[2] As the economy continued to deteriorate, employment at DeVilbiss dropped further to 554 by July 1, 1933, the low point.[3] With the start of gradual recovery along with significant growth of the company's paint sprayer and compressor businesses, employment increased back to 738 by September of 1933, and orders were up 53% from August of 1932.[4] Employment rose further, to 807 by October 1933, representing nearly 30% growth from just three months prior. Continuing recovery, along with the buildup to World War II, brought total company employment to 1,619 by the time of the Japanese attack on Pearl Harbor in December 1941.[5] DeVilbiss' perfume atomizer and Perfume Dropper designs and their advertising strategies in this period reflect the mood and economic realities of the country.

DeVilbiss's 1933 Proposition to the Consumer on the Value of and Need for Its Perfume Atomizers

Perfumers and beauty experts alike are now definitely recommending that perfume be sprayed. They know that this modern method of application brings out the fullest fragrance by atomizing the perfume into tiny particles. From the economy standpoint, the patented DeVilbiss Closure Device stops all waste by preventing evaporation of costly scents. Such fashion approval signifies one thing—that woman has adopted the atomizer as the best method of applying perfume.[6]

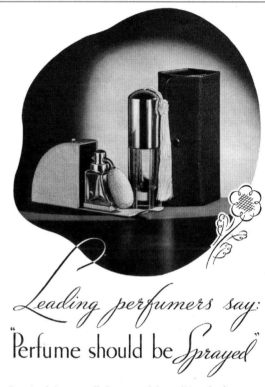

This DeVilbiss advertisement appeared in the November 1, 1935 edition of *Vogue* magazine, showing two DeVilbiss travel perfume atomizers and quoting Roger & Gallet: "We recommend the use of an atomizer. A Perfume Sprayed is always more subtle, more enchanting."

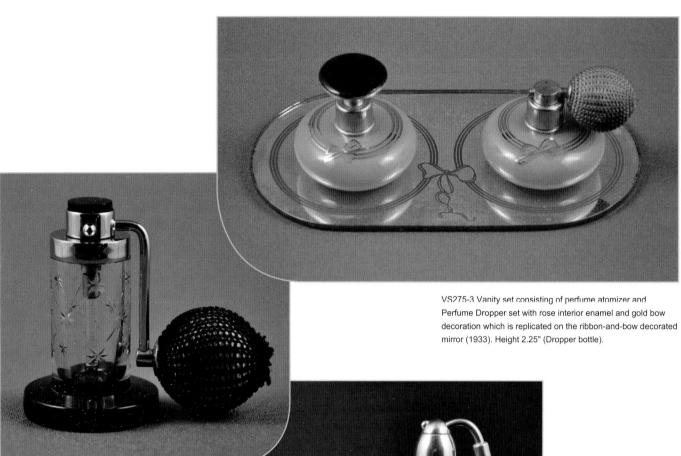

VS275-3 Vanity set consisting of perfume atomizer and Perfume Dropper set with rose interior enamel and gold bow decoration which is replicated on the ribbon-and-bow decorated mirror (1933). Height 2.25" (Dropper bottle).

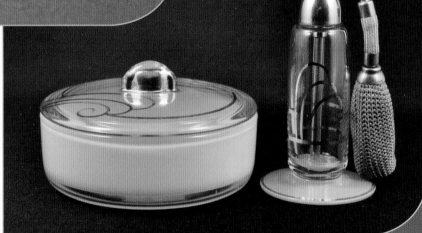

S350-23 Perfume atomizer with cut crystal bottle, black base, and chromium metal part. Button-type closure device on the top (1933). Height 3".

VS200-5 Vanity set with green and gold enamel decoration and gold finished cap and spray head on the perfume atomizer (1933). Height of atomizer 3.75".

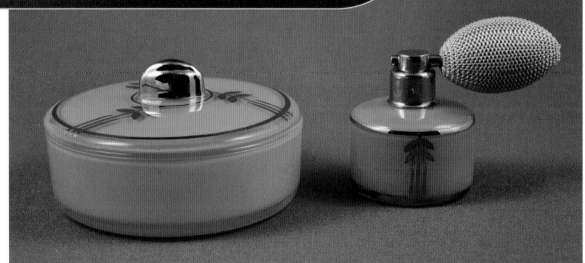

VS250-1 Vanity set, perfume atomizer and powder jar with blue interior enamel and silver decoration (1934). Height 2" (atomizer).

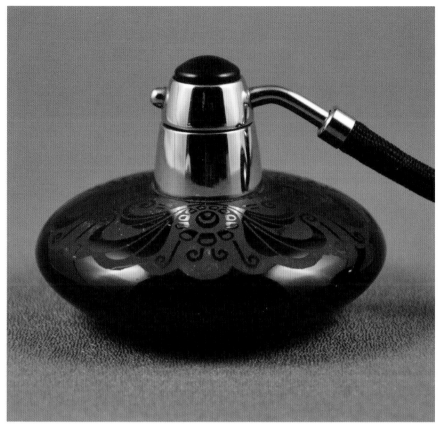

S350 Perfume atomizer of black glass with acid-etched design and chromium metal cap and spray head. Button-type closure device at top (1933). Height 2".

S200-53 Perfume atomizer with Jade opaque glass; gold finished metal part (1933). Height 3.75". Note how the cutting on the bottle flows into lines of the spray head.

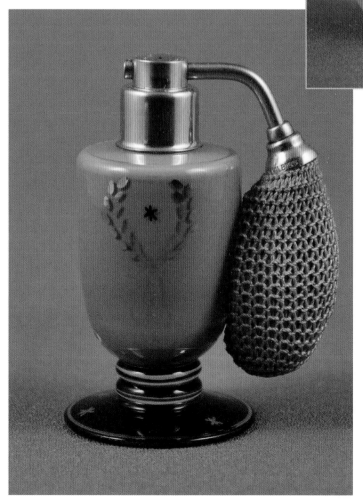

S100-71 Perfume atomizer with rose enamel interior and black enamel foot and gold decoration, including stars on the foot (1933). Height 3.5".

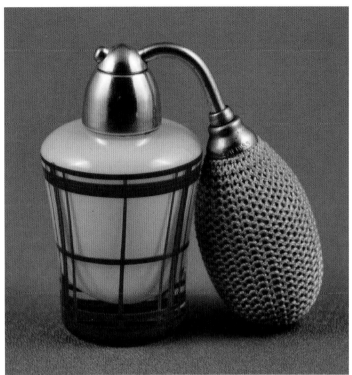

S100-97 Small-capacity yet elegant perfume atomizer with white interior enamel on heavy sham crystal bottle; red enamel decoration and gold finished spray fittings (1934). Height 2.75".

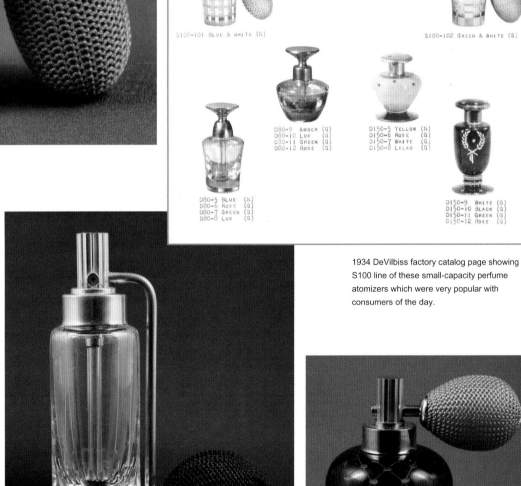

1934 DeVilbiss factory catalog page showing S100 line of these small-capacity perfume atomizers which were very popular with consumers of the day.

S100-103 Perfume atomizer with black glass base and chromium cap and spray fitting (1934). Height 4.5".

S300-17 Perfume atomizer with rock crystal cutting and ruby foot with gold finished spray fittings (1934). Height 4.5".

Perfume atomizer from vanity set VS500-13, with ruby stained cut crystal bottle (1934). Height 3.5".

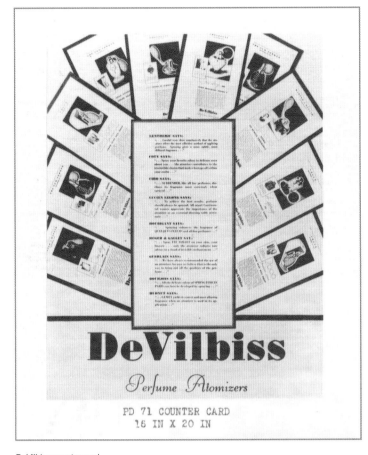

DeVilbiss counter card

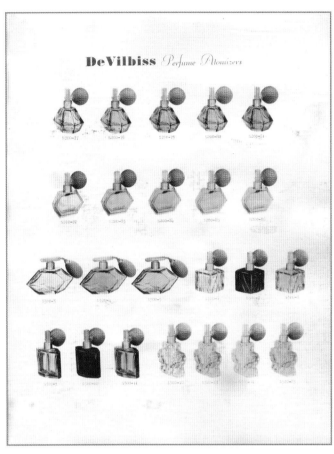

DeVilbiss 1934 hand-colorized factory catalog page.

DeVilbiss offered many sales tools for its retailers' use. This counter card is one example wherein well-known perfume companies voiced their support of using DeVilbiss perfume atomizers for their fine spray to enjoy perfume to its fullest. Among those indicating that support on this particular store card were Lentheric, Coty, Ciro, Lucien Lelong, Houbigant, Roger & Gallet, Guerlain, Bourjois, and Hudnut.

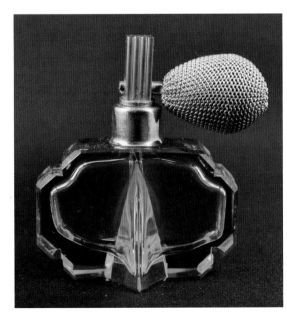

Czechoslovakian perfume atomizer with green hand cut and polished glass; gold finished spray fittings (c. 1934). Height 3.5".

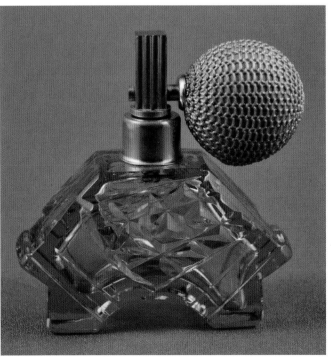

Czechoslovakian perfume atomizer with hand cut and polished amber bottle with arched foot (c. 1934). Height 3.75".

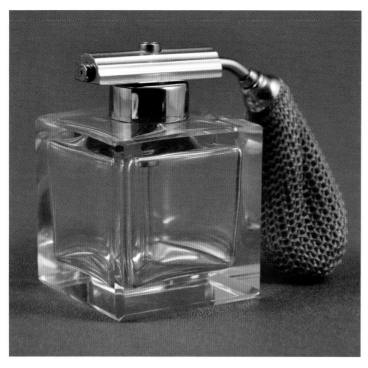

S500-50 Perfume atomizer with cube shaped crystal bottle and nickel finished spray fittings and button-type closure (1934). Height 2.75".

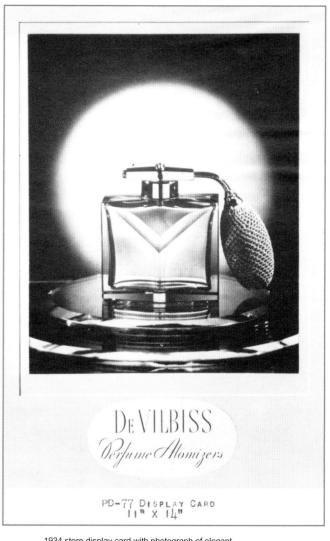

DeVILBISS
Perfume Atomizers

PD-77 DISPLAY CARD
11" X 14"

1934 store display card with photograph of elegant perfume atomizer S750-7.

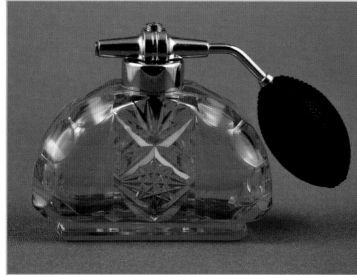

S600-13 (1935) Perfume atomizer acid stamped on bottom "DEVILBISS"; blue hand cut and polished bottle with chromium metal part and button-type closure. Height 3".

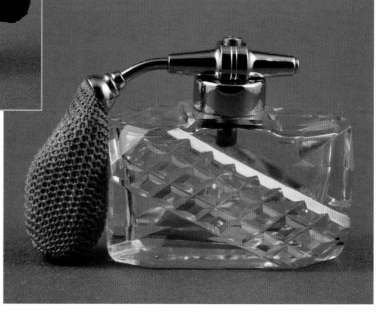

S500-64 (1934) Perfume atomizer with acid stamp "Made in Czechoslovakia"; DeVilbiss closure mechanism; instruction sticker on bottom: "To open, hold button down while squeezing ball." 3" wide by 3" tall.

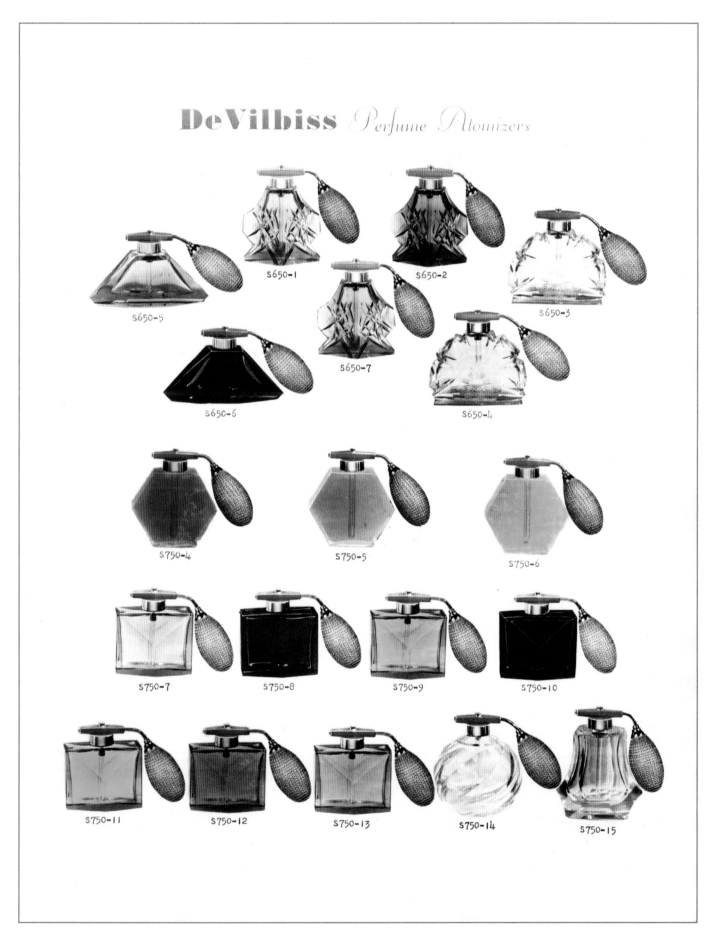

DeVilbiss *Perfume Atomizers*

S650-5

S650-1

S650-2

S650-7

S650-3

S650-6

S650-4

S750-4

S750-5

S750-6

S750-7

S750-8

S750-9

S750-10

S750-11

S750-12

S750-13

S750-14

S750-15

Hand-colorized page from a 1934 factory catalog page of perfume atomizers.

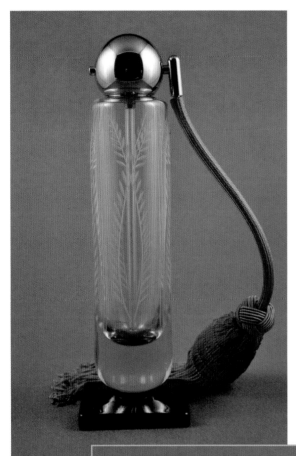

S750-16 Tall eau de cologne atomizer with cut fern pattern on crystal bottle with black foot; chromium finished spray fittings (1935). Height 8".

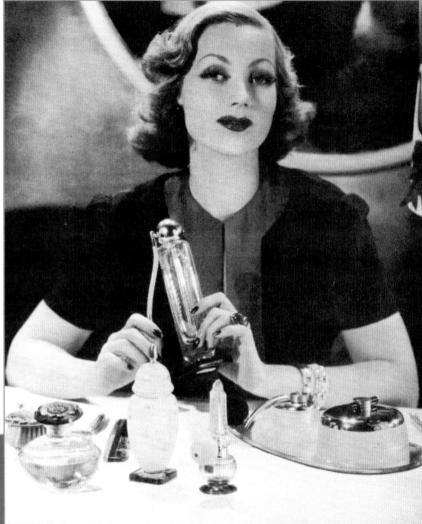

ANN SOTHERN ★ RKO RADIO PICTURES STAR

RKO star Ann Sothern posing with 750-16 eau de cologne atomizer with other offerings from the DeVilbiss 1936 product line on her dresser table.

S400-1 Tall eau de cologne perfume atomizer (1934). Height 7.5".

Offered in both the 1934 and 1935 catalogs, this Eau De Cologne Atomizer features a hand-engraved line and circle cutting, on a crystal bottle with a black glass foot. Paul Brown was issued Design Patent 93,446 on October 2, 1934 for this bottle's metal part, which is a fluted matte-finished nickel spray top on a polished chromium collar.

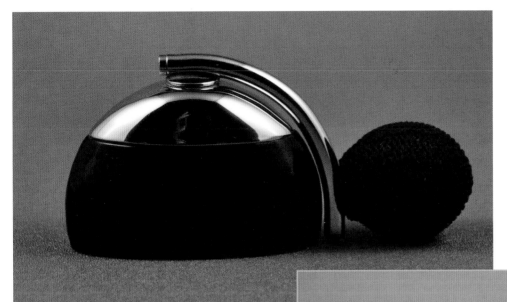

S200-107 Perfume atomizer with black bottle and chromium finished metal spray fittings (1934). Height 2.25".

Described in the 1934 DeVilbiss catalogs as an "arrestingly interesting and modern streamline design," this 2.25" tall by 3.5" wide Art Deco Perfume Atomizer was offered in five color selections: black, crystal, blue and amethyst with chromium metal parts, and amber with gold metal parts. It retailed for $2.00.

VS100-4 All-in-one vanity set with white enamel satin glass jar and a black Catalin cover containing a perfume atomizer; in original box (1936). Height 4".

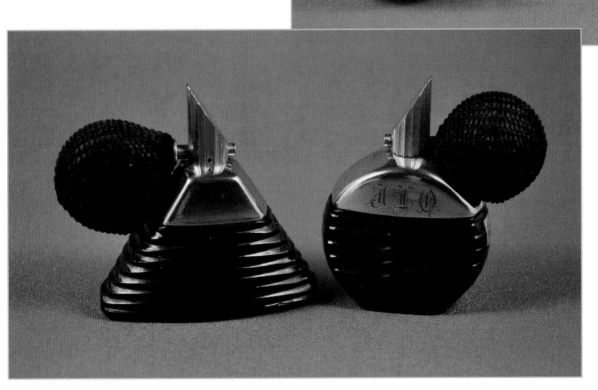

S100-162 *(left)* and S100-168 *(right)* Perfume atomizers in black glass with gold plated snap-on top which *"goes on and off with a push and a pull"* according to the 1936 catalog. These models were promoted as personalized gift items with space for engraved initials in the cap as shown on the right in S100-168.

This perfume atomizer, powder jar, and mirror vanity set is a stunning Art Deco design by Vuillemenot, with the teardrop mirror tray following the contours of its occupants. It was offered in both the 1935 and 1936 product lines. Billed as "Crystal Mist, a combination of satin finish and polished crystal," the set was produced in four color variations: (1) a silver mirror with gold metal parts and a black Catalin (similar to Bakelite) powder jar knob; (2) gold mirror and metal parts with an ivory knob; (3) blue mirror and knob with rhodium metal parts; and (4) rose mirror, gold metal parts and coral knob. The atomizer is equipped with a closure device and the set was offered in a gift presentation box. Some variations from the advertised color schemes occurred in the spec books, as evidenced by the set shown above with a gold mirror and metal parts, but a Catalin powder jar knob in coral.

VS1200 Crystal Mist vanity set with matching mirror (1935).

VS1200-1 Ivory Knob and Net, Gold Mirror, Gold finish
VS1200-2 Olympic Blue Knob and Net, Blue Mirror, Rhodium finish
VS1200-3 Black Knob and Net, Silver Mirror, Gold finish
VS1200-4 Coral Knob and Net, Rose Mirror, Gold finish

Crystal Mist bottle and jar—a combination of satin finish and polished crystal—give atomizer and powder jar a striking modern note. Mirror perfume tray harmonizes in style and color to form a complete, distinguished ensemble. Rhodium or gold tops and fittings. Atomizer equipped with closure. Retail, $12.00 each.

Retail flyer of the Crystal Mist bottle and powder jar.

Factory product description of the Crystal Mist vanity set.

The 1935 catalog notes the set offered at $12.00 retail, while the 1936 factory specification records that—while the set was being continued for the 1936 line—the price was reduced to $10.00. Thus, the product number was changed from VS1200 in 1935 to VS1000 in 1936. This demonstrates the information often encoded in DeVilbiss' product numbering schemes of the period: VS for vanity set and 1200 for $12.00 retail price, with variations assigned sequential numbers after the hyphen. Notice that the 1936 catalog photograph (below) does more justice to the set's beauty than the 1935 edition (left) does.

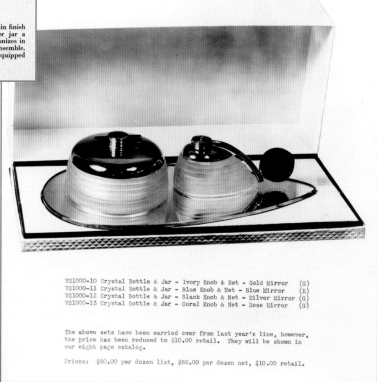

VS1000-10 Crystal Bottle & Jar - Ivory Knob & Net - Gold Mirror (G)
VS1000-11 Crystal Bottle & Jar - Blue Knob & Net - Blue Mirror (R)
VS1000-12 Crystal Bottle & Jar - Black Knob & Net - Silver Mirror (G)
VS1000-13 Crystal Bottle & Jar - Coral Knob & Net - Rose Mirror (G)

The above sets have been carried over from last year's line, however, the price has been reduced to $10.00 retail. They will be shown in our eight page catalog.

Prices: $80.00 per dozen list, $68.00 per dozen net, $10.00 retail.

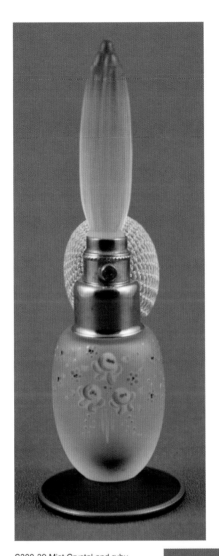

S300-39 Mist Crystal and ruby bottle perfume atomizer, with enameled blue, rose, and green floral design and a delicate ruby "Flame" ornament. Vuillemenot-designed and supplied by the Cambridge Glass Company; decorated by DeVilbiss and completed with gold-finished metal parts (1936). Height 5".

DECEMBER 15, 1936 77

YOU'LL WANT ONE YOURSELF

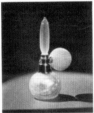

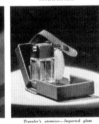
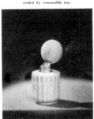

These famous perfumers say a perfume sprayed is more subtle, more enchanting:

Bourjois	D'Orsay	Pinaud
Caron	Guerlain	Prince Matchabelli
Ciro	Houbigant	Roger & Gallet
Corday	Hudnut	Yardley
Coty	Lentheric	Ybry
	Lucien Lelong	

When you buy DeVilbiss Perfume Atomizers for Christmas gifts, you will find them so attractive that you won't be able to resist getting one for yourself! And that's the real test of an acceptable gift... DeVilbiss Atomizers make ideal gifts because they are practical as well as beautiful. Spraying, according to leading perfumers, accentuates the rare, elusive qualities of a fragrance. And closure-equipped DeVilbiss Atomizers prevent costly perfumes from evaporating... The DeVilbiss line includes any color and style of atomizer—for the boudoir, for traveling, for spraying eau de cologne; also a wide selection of attractive vanity sets... At leading stores.

DeVilbiss **PERFUME ATOMIZERS**

DeVilbiss advertisement in *Vogue* magazine, December 15, 1936 issue, showing a variety of perfume atomizers from the 1936 line. Note the lower left box in the advertisement that lists famous perfume companies which agreed that "A Perfume Sprayed is more subtle, more enchanting." Each of these famous perfume houses were also Special Order DeVilbiss customers.

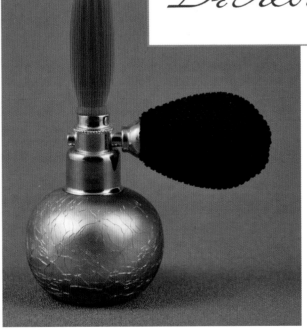

S250-30 Perfume atomizer, gold Mist Optic, with satin-finished crackle glass bottle and tall, satin-finished, amber "Flame" ornament (1936). This is the first appearance of crackle. Gold-finished metal part. Bottle and ornament by the Cambridge Glass Company. The flame ornament design patent was held by Frederic Vuillemenot. Height 4.5".

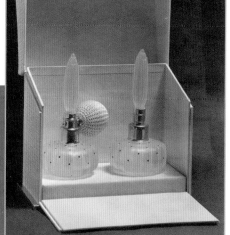

A factory-catalog photo showing the SD500 set in a presentation box (1936).

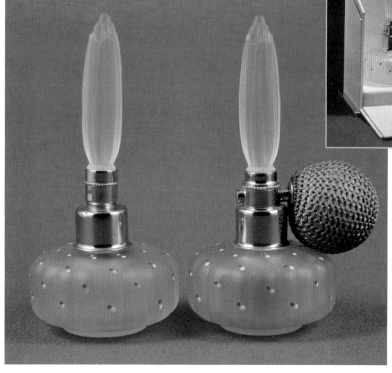

SD500-4 Perfume atomizer and Perfume Dropper set in Blue Mist, with blue and white Cambridge Glass Company-produced bottles made to DeVilbiss' design, with hand-enameled dots and chromium-finished metal part and the "flame" ornament (1937). The tall, flame-shaped glass ornament design, featured on these bottles, is recorded as "Vuillemenot Design Patent 101,903, dated September 8, 1936." Height 4".

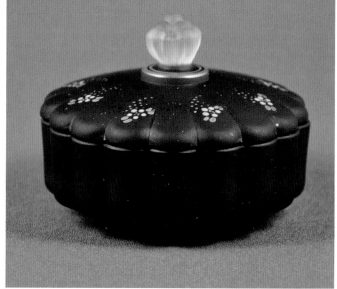

Vanity jar from S500 vanity set, with fluted, ebony glass, from the Cambridge Glass Company; green, white and gold enamel decoration, with applied crystal finial (1936). Height 2.75".

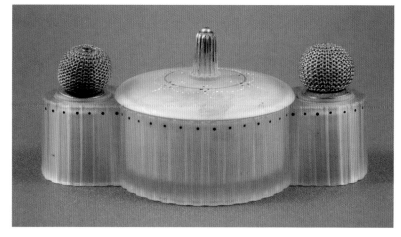

VS500-18 Vanity set, in Mist Crystal and blue; with two small, closure-equipped atomizers and a powder box integrated into a frosted-crystal base, with black enamel dots (1936). Height 3"; width 6.5".

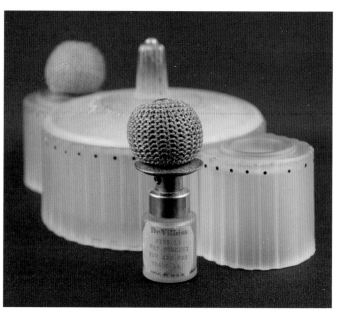

Close-up of the small atomizer insert for VS500-18 vanity set; gold-finished spray fittings, with closure.

The Decline, Fall and Resurrection of the Stem-and-Foot Design

The traditional stem-and-foot design, which had been iconic of the DeVilbiss style from 1920, finally disappeared altogether in 1933, amid a wholesale redesign of the company's perfume atomizer lines. The popularity of Art Deco styling, Czechoslovakian cut glass, and the innovative design collaboration with Lenox Belleek China on porcelain bottles in 1935 filled DeVilbiss' catalogs of the period.

Style innovation was a company hallmark. DeVilbiss' designers, led by Vuillemenot, needed to be responsive to feedback from the sales force about consumer preferences. Accordingly, it was reported to them that "there had been some demand for a stem bottle." Thus, in 1936, two stem-and-foot styles were added as a trial to the line "to see what reaction we receive from dealers."

The tentative nature of this experiment was captured in the same notation:

These numbers are not being shown in our regular Perfume Atomizer catalog as we want to be in a position to drop them from the line or change them if we find that dealers do not consider them a good value at the $2.00 retail price.

Apparently, this proved to be the case, as these styles were absent from the 1937 catalog. Since these bottles were unsigned, collectors until now have been left to speculate about the pedigrees of these lovely but not often seen bottles.

During this period, consumers were also looking for smaller capacity perfume atomizers and bottles. Recognizing this from their research and requests of their customers, DeVilbiss provided small atomizers with their usual attention to quality and detail in the glass bottles, cuttings or other decorations, and atomizer fittings.

S200-142 WHITE SATIN FINISH & YELLOW (G)
S200-143 WHITE SATIN FINISH & BLUE (G)
S200-144 WHITE SATIN FINISH & ORCHID (G)
S200-145 CRYSTAL & RUBY (G)
S200-146 CRYSTAL & GREEN (G)
S200-147 CRYSTAL & BLUE (G)

THERE HAS BEEN SOME DEMAND FOR A STEM BOTTLE THEREFORE THE ABOVE TWO STYLES HAVE BEEN ADDED TO THE LINE TO RETAIL AT $2.00, TO SEE WHAT REACTION WE RECEIVE FROM DEALERS.

THESE NUMBERS ARE NOT BEING SHOWN IN OUR REGULAR PERFUME ATOMIZER CATALOG AS WE WANT TO BE IN A POSITION TO DROP THEM FROM THE LINE OR CHANGE THEM IF WE FIND THAT DEALERS DO NOT CONSIDER THEM GOOD VALUES AT THE $2.00 RETAIL PRICE.

PRICES: $16.00 PER DOZEN LIST, $13.60 PER DOZEN NET, $2.00 RETAIL.

S200-146 Perfume atomizer, with crystal bottle, green and gold enamel and cut-to-clear decoration, gold metal part, and sapphire jewel (1936). Height 6".

Company product-description page for S-200 stem-and-foot styles (1936).

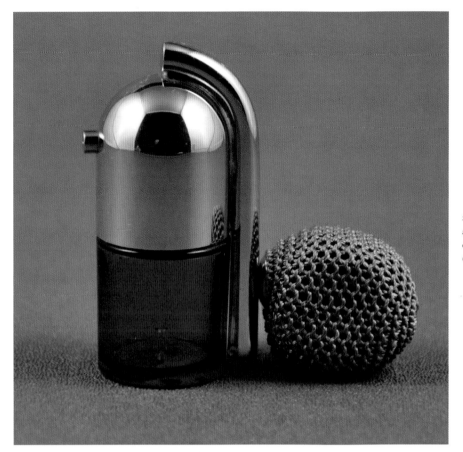

S250-20 Miniature perfume atomizer, with cobalt bottle and chrome-finished spray fittings (1935). Height 2.25".

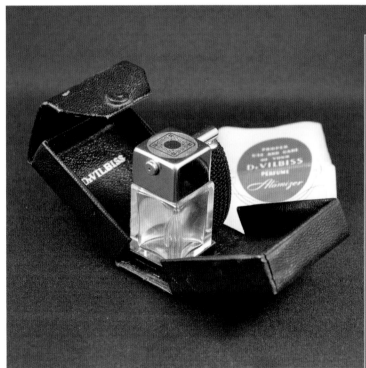

S650-8 Traveler's atomizer, with crystal bottle and chromium-finished metal fittings with closure; and black, Moroccan leather covered travel case (1936). Height 2.5".

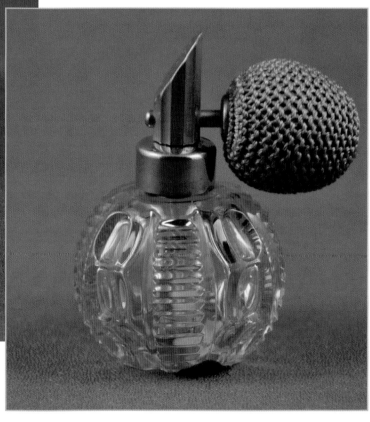

S100-216 Small-capacity perfume atomizer, with blue, Czechoslovakian bottle and nickel-finished spray fittings (1937). Height 2.5".

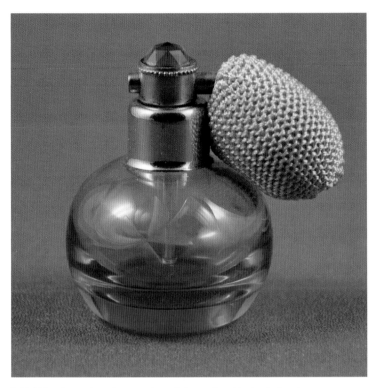

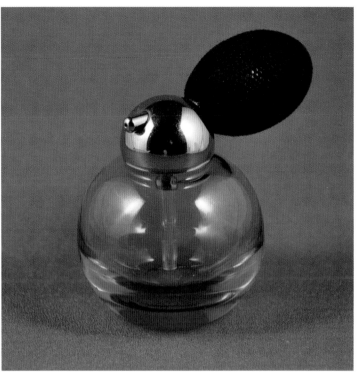

S150-80 Small-capacity perfume atomizer with heavy-sham blue bottle, featuring a hand-cut leaf decoration and acid-stamped "DeVilbiss Made in USA" on the bottom. Bottle by the Cambridge Glass Company. Gold-plated spray fittings are topped by a matching, cut, blue-glass jewel (1937). Height 2.5".

S250-33 Small perfume atomizer with heavy sham blue bottle and rhodium finished spray fittings (1937). Bottle supplied by the Cambridge Glass Company. Height 2.5".

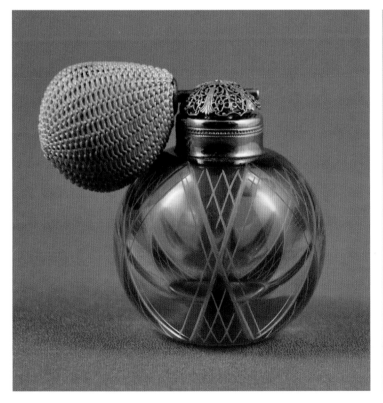

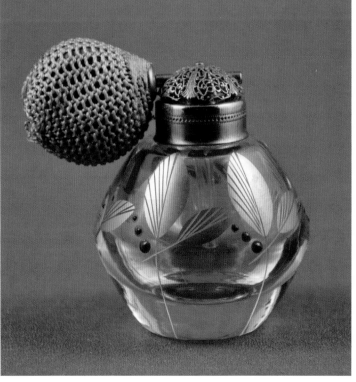

S300-49 Perfume atomizer with rock crystal cut heavy sham bottle with transparent blue flashed enamel decoration; 24-karat plated filigree top and collar (1937). Bottle by the Cambridge Glass Company. Height 3".

S350-87 Small perfume atomizer with heavy sham crystal bottle from the Cambridge Glass Company with DeVilbiss decoration of enamel gold leaf pattern and red dots; green gold 24-karat gold plated filigree top and collar (1938). Height 3".

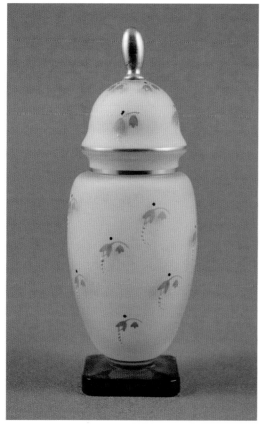

S800-2 Vase-enclosed perfume atomizer; ivory and gold leaf enameled pattern body and lid; amber foot.

The tiny atomizer bottle with gold plated fittings and closure mechanism rests in vase top (1936). Height 6.5".

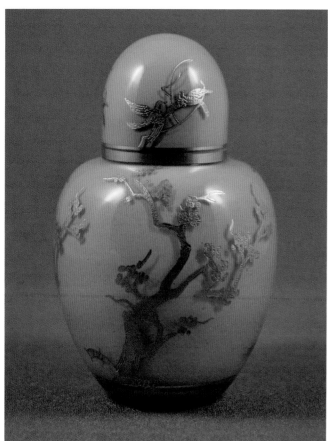

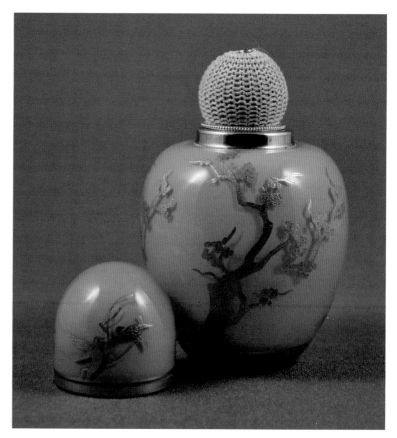

S1000-5 Chinese-style vase-enclosed perfume atomizer with jade enamel interior and an etched, gold-encrusted oriental pattern on the lid and base.

The atomizer bottle sits atop the uncovered jar and features gold-plated spray fittings with twist closure mechanism (1937). Height 4.75".

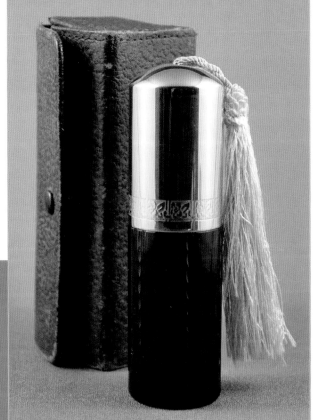

Traveler's atomizer with cap on. This traveler's atomizer features a heavy black glass cut bottle, gold-finished fittings and cap, and a silk tassel. Notice the unique spray head design. This atomizer came with a satin-lined black or brown leather case with snap closure (1938). Height 5.25".

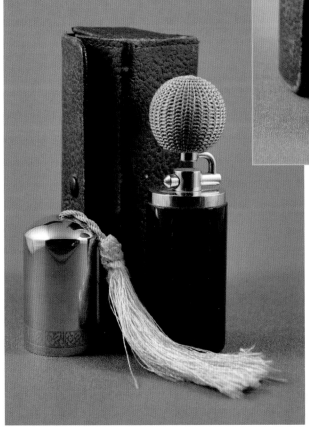

Traveler's atomizer showing unique spray head fitting and ball. This perfume atomizer style first appeared in the 1935 product line in both crystal and black glass, but the black glass version was only offered with rhodium metal fittings and cap. According to a factory record dated September 28, 1938, "about 154 of the above Perfume Atomizer will be made up to use the stock of black bottles we have on hand. The cover and finish on this number are gold."

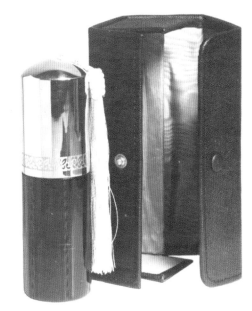

S750-40 Black & Gold - Black Case

About 154 of the above Perfume Atomizer will be made up to use the stock of black bottles we have on hand. The cover and finish on this number are gold.

This Perfume Atomizer will be sold along with S750-21 to 23 at regular prices as follows:

$60.00 list per dozen, $51.00 net per dozen, $7.50 retail.

Factory product description of S750-40 travel perfume atomizer (1938).

Lenox Belleek China: 1935 to 1938

DeVilbiss and Lenox co-branded logo—the first instance of the company associating its trade name with that of a supplier to take advantage of their popularity.

Lenox, Inc. was founded in 1906 by Walter Scott Lenox. The company remains in business today as a high-quality American manufacturer of china and glassware. Lenox was producing Belleek china from its beginnings. Belleek is a village in Northern Ireland in which fine Irish china has been produced since the mid-1800s. The prestige of the Belleek name immigrated to the United States with its artisans, in the early 1900s, when W. S. Lenox hired Irish craftsmen to help produce his wares in the new company.

In 1918, Lenox was asked by U.S. President Woodrow Wilson to produce the White House china service. In 1935, U.S. President Franklin Roosevelt ordered the Wilson set to be replaced with a new, 1,722-piece service, also by Lenox, Inc.[7] By 1935, Lenox was considered one of the premiere china houses in the United States.

Capitalizing on the prestige of the Lenox brand, beginning in 1935, DeVilbiss embarked on a co-branding partnership with Lenox that flourished through the 1937 line with a remarkable variety of innovative figural and decorative designs, including a perfume night light. This relationship was one of the first, if not the first, in which DeVilbiss promoted its products through affiliation with a supplier's brand, with the 1936 DeVilbiss catalog lauding the "recognized prestige of Lenox Belleek China."

A unique mark was used to reflect the partnership. Each piece was signed on the bottom with a green logo incorporating both the word "DeVilbiss" and the Lenox logo, a cursive "L" surrounded by a wreath, and, underneath, "Lenox Made in USA". See this logo below on the feet of the penguin.

Perhaps one of the best-known examples was also one of the first—the penguin atomizer introduced in 1935. Notice DeVilbiss's use of the term "perfume atomizer," instead of "Perfumizer" or "Perfume Spray," throughout this period.

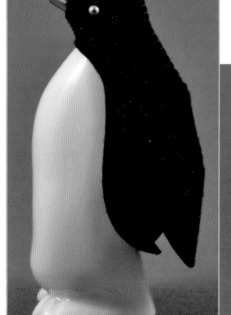

S100-121 Penguin atomizer with hand-stitched black felt cover and gold plated beads for "eyes" (1935). Height 4.5".

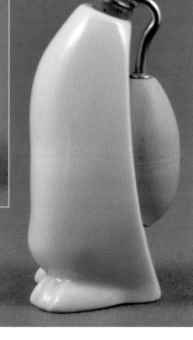

S100-121 Penguin atomizer "undressed" showing the spray mechanism and cork stopper in the porcelain bottle. Few "Penguins" survive with their felt cover fully intact.

DeVilbiss-Lenox co-branded signature from foot of the Penguin atomizer.

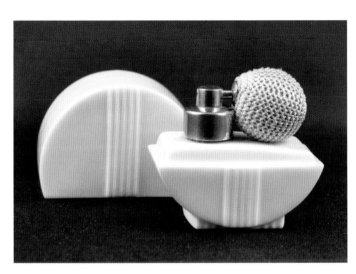

S150-71 Two-piece "Moon" atomizer supplied by Lenox
China, with gold plated spray fitting (1935). Height 3".

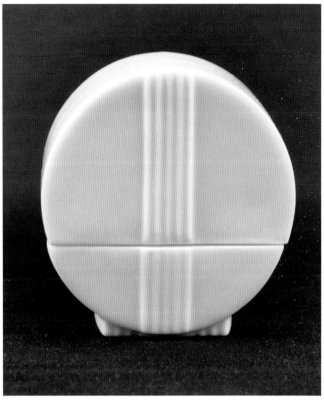

Simple, modern elegance: the S150-71 atomizer of Lenox China with
cover (1935).

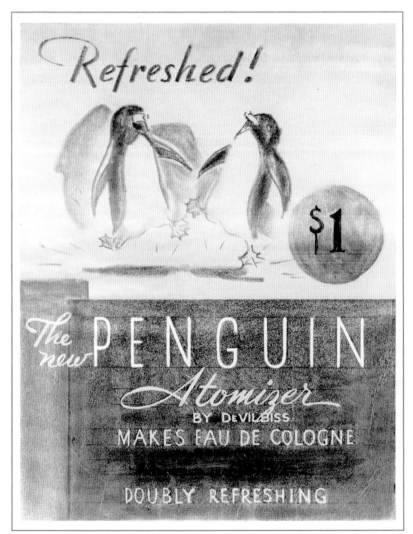

Artist's design of an advertisement for Penguin atomizers from factory records
from 1934, promoting the release of the new item to retailers.

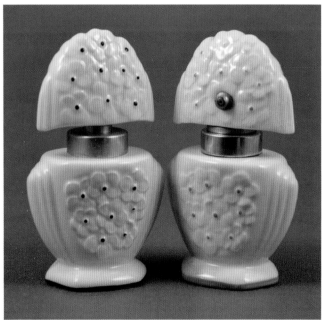

SD400 – SD-440-2. Dropper with black dots and border
on foot. On the right, S200-128 floral atomizer with blue
dots and border on foot (1936). Height 3.5".

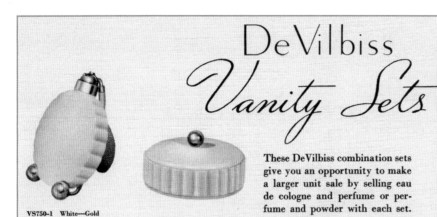

DeVilbiss
Vanity Sets

These DeVilbiss combination sets give you an opportunity to make a larger unit sale by selling eau de cologne and perfume or perfume and powder with each set.

VS750-1 White—Gold

Exceptionally lovely classic-modern vanity set in Lenox Belleek China with gold fittings. Especially styled to suit discriminating tastes. Atomizer equipped with non-evaporating closure. Retail, $7.50 each.

1935 catalog image showing vanity set VS750-1 together.

Front view of VS750-1 vanity set atomizer.

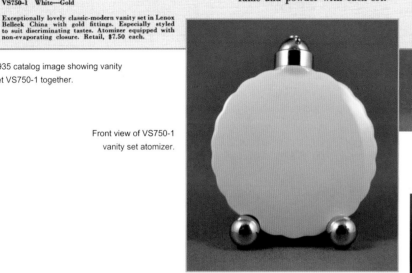

Perfume atomizer for vanity set VS750-1, a Lenox Belleek bottle with chromium fittings and a chromium stand, with a button closure mechanism; side view (1935). Height 5".

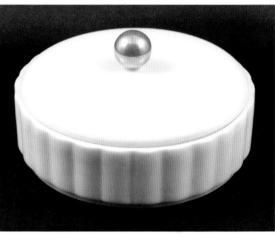

VS750-1 Lenox Belleek Powder Box for DeVilbiss vanity set VS750-1 (1935). *Courtesy of Jim and Carole Fuller.*

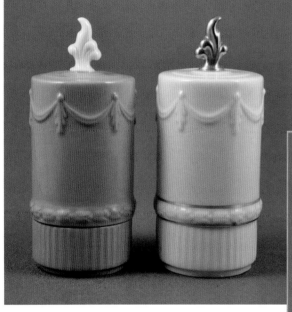

S350-51 "Celebrations" covered perfume atomizers of classic design by Lenox Belleek China, with S300-33 featuring gold enamel decoration and gold ornament on white, and S300-34 coral with white ornament (1936). Height 4.75".

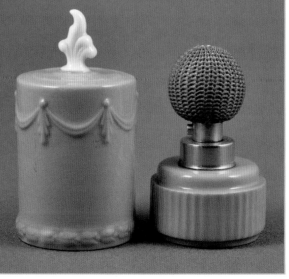

S300-34 Coral perfume atomizer with cover removed (1936). A third version, S350-50, featured blue china with a white ornament.

The DeVilbiss-Lenox Figural Dropper Series included a Scotty Dog, Cat, Squirrel and Bird. There was extensive mixing and matching of colors in this series. Bases came in white, coral, blue, and yellow, while the figural stoppers came in white, coral, blue, yellow, and black. The bases came both with and without a band of gold dots surrounding the bottom. All are approximately 3.75" tall, signed with the green DeVilbiss-Lenox mark on bottom, and have the number 2825 molded into the base, presumably the Lenox shape or mold number.

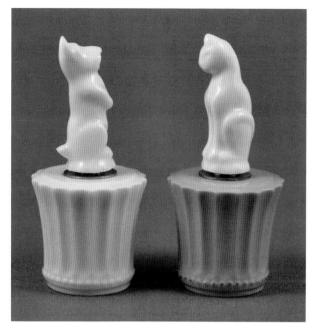

DeVilbiss Lenox Belleek China Perfume Dropper bottles with D150-25 Cat and D150-21 Scotty Dog figural dropper handles (1936). Height 3.75".

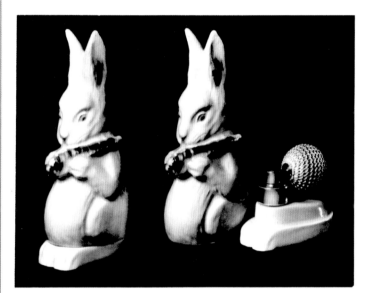

S150-76 OPAQUE CHINA WITH COVER REMOVED

THIS NOVELTY ITEM IS MADE OF OPAQUE LENOX CHINA, THE EYES AND INSIDE OF THE EARS ARE TINTED WITH PINK AND THE CARROT IN NATURAL COLOR.

PRICE $12.00 PER DOZEN LIST, $10.30 PER DOZEN NET, $1.50 RETAIL.

S150-76 Factory record dated February 21, 1936 showing rabbit atomizer of Opaque Lenox China, noting the pink tint of eyes and ears and a natural-colored carrot.

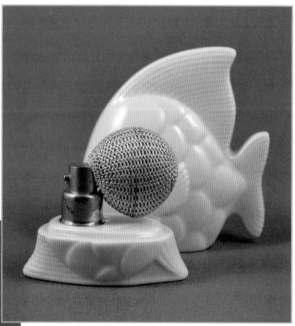

S350-52 Lenox Belleek Fish figural atomizer with gold plated spray fittings (1936). Height 4.5".

The factory specification, dated July 21, 1936, notes that "it will be shown in our eight-page catalog, along with the Penguin Atomizer, the Rabbit Atomizer, and four Animal Droppers, D200 series, as novelty items." With such a relatively large cover and small base, many of the fish atomizers may not have survived.

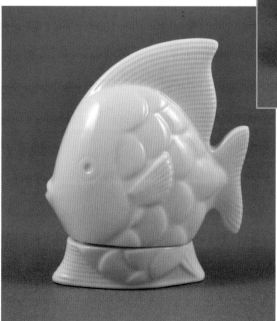

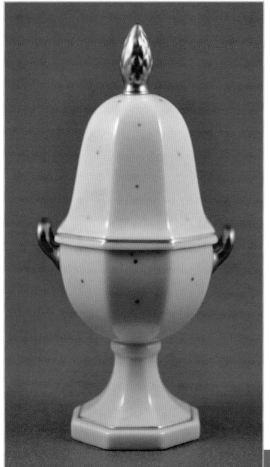

S1000-2 DeVilbiss-Lenox perfume atomizer with cover.

S1000-2 This elegant atomizer is a gold-enamel decorated, Lenox Belleek China, classic-urn-shaped atomizer, with cover (1936). The urn's bottom is the actual perfume receptacle, with the metal part equipped with a turn-type closure mechanism. Height 6.5".

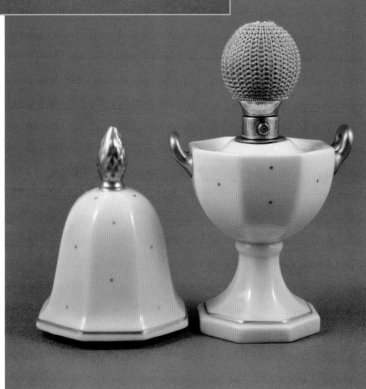

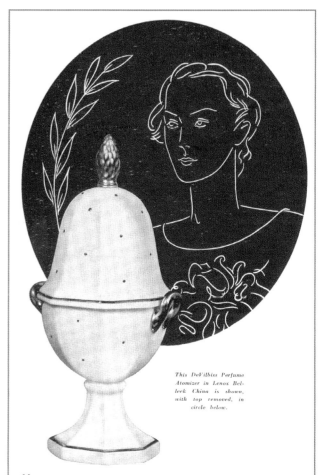

This DeVilbiss Perfume Atomizer in Lenox Belleek China is shown, with top removed, in circle below.

"PERFUME SHOULD ALWAYS BE SPRAYED" *SAYS YARDLEY*

Yardley explains—"A perfume sprayed is always more subtle, more alluring . . ." And all leading perfumers agree! To spray perfume to its best advantage, use a DeVilbiss Atomizer—it changes a single drop into 2000 radiant atoms. The DeVilbiss line includes every color and style. There are period and modern designs in imported and domestic glass and Lenox China . . . non-evaporating atomizers for traveling or boudoir use . . . special large-size models for spraying eau de cologne. Sold at leading stores.

DeVilbiss

PERFUME ATOMIZERS

Vogue magazine advertisement, from November 15, 1936, featuring a Lenox Belleek China S1000-2 perfume atomizer.

The S200 series atomizer's factory record shows this "Cathedral" model available with four different colored jewels. The record specifies that this model will not appear in the catalog and it is absent from the 1937 and later versions. This style was also produced as numbers S200-158 with gold base; S200-159 with black base, and S200-160 with black cover and gold base.

S200-160 Lenox Belleek "Cathedral" had a black enamel cover with a gold base with filigree ornament set with an emerald jewel. Its height is 3".

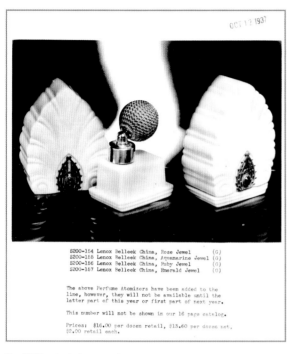

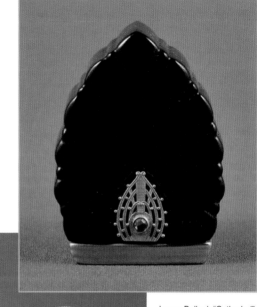

The S200 series factory record.

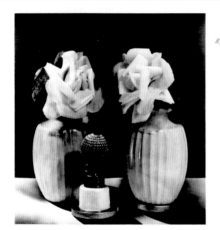

Lenox Belleek "Cathedral" with the cover on.

Lenox Belleek with the cover off, showing the atomizer.

S350-57 Factory description of the DeVilbiss-Lenox Belleek vase perfume atomizer, dated August 12, 1936. The catalog listing of 1936 describes the vase as holding "white artificial gardenia, with green leaves" held in place with a cork. The atomizer fittings are gold plated.

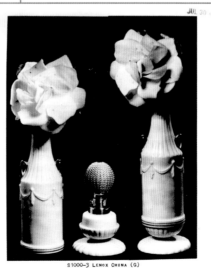

S1000-3 Factory description of this rarely found Lenox Belleek China vase atomizer, dated July 30, 1936. While artificial flowers are shown, the catalog listing of 1936 suggests the vase can also be used for natural flowers.

The factory record, dated December 15, 1938, states:

Fifty of each of the above "Colonial Lady" Perfume Night Lights were purchased and given to the New York office, A. O. Narveson, B. O. Reece, and L. H. Smock to sell with instructions to sell the glazed and unglazed in equal quantities.

Fortunate is the collector who finds this Colonial Lady Perfume Night Light.

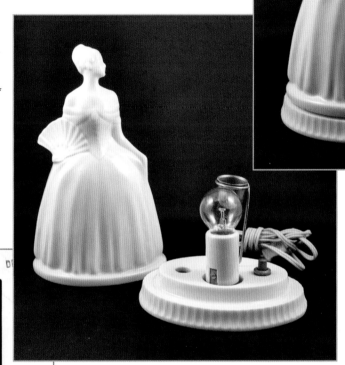

L1000-2 Colonial Lady perfume night light, with base separated, showing light bulb, power switch, and perfume cup. *Courtesy of Jim and Carole Fuller.*

L1000-2 Colonial Lady perfume night light, of glazed white Belleek China. An unglazed version was offered and numbered L1000-1. *Courtesy of Jim and Carole Fuller.*

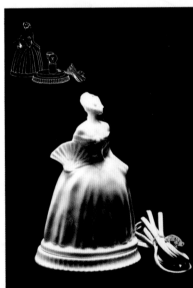

L1000-1 White Belleek China – Unglazed
L1000-2 White Belleek China – Glazed

Fifty of each of the above "Colonial Lady" Perfume Night Lights were purchased and given to the New York office, A. O. Narveson, B. N. Reece and L. H. Smock to sell with instructions to sell the glazed and unglazed in equal quantities.

Prices: List per dozen $80.00; net per dozen $68.00; retail $10.00.

Factory record for "Colonial Lady" perfume night light (1938).

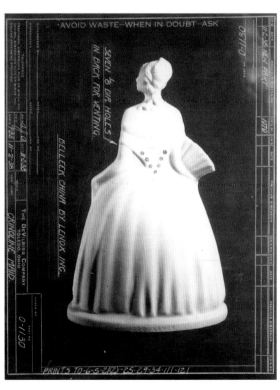

DeVilbiss factory engineering drawing dated November 2, 1938, of the Colonial Lady, showing the back of the figure with perfume venting holes. Note that in this drawing, she is referred to as the "Crinoline Maid."

The following four-page compendium is from the factory records of the DeVilbiss-Lenox product line of 1936.

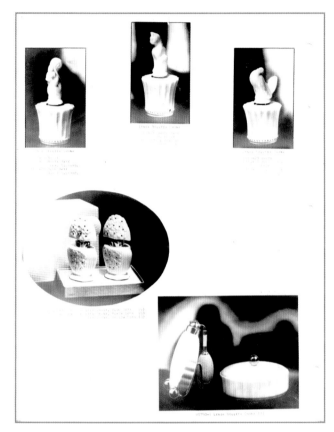

Page 1 of Lenox Belleek Line.

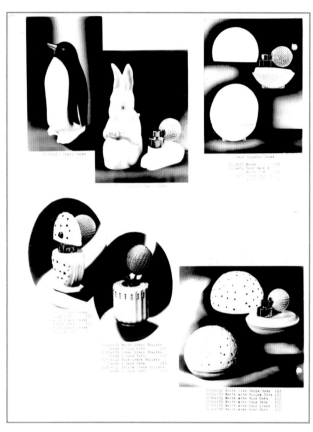

Page 2 of Lenox Belleek Line.

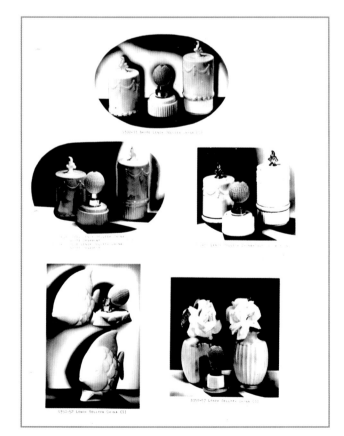

Page 3 of Lenox Belleek Line.

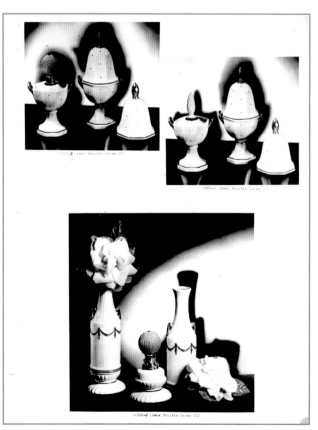

Page 4 of Lenox Belleek Line.

Czechoslovakian Design Influence

Beginning in the early 1930s, DeVilbiss got ahead of and then rode the wave of popularity for Czechoslovakian cut glass decorative items. In mid-1932 (at the depth of the economic collapse), the De-Vilbiss Atomizer Executive Committee decided to acquire Czech bottle blanks, which it noted were about one-third the cost of U.S.-made bottles. Their new and stunningly beautiful styles, often designed and patented by Frederic Vuillemenot, reflect the mid-1930s popularity of Czechoslovakian cut-glass perfume bottles. They often featured prominently cut and polished glass ornaments, mirroring the elaborate hand-cut glass stoppers seen on Czech dropper bottles of the period.

DeVilbiss worked with the finest glass houses. Many of the bottles designed by Vuillemenot were executed by the venerable Czech glass house of Josef Riedel Glass. Some were also acquired by importing companies on behalf of DeVilbiss.

In some cases, DeVilbiss imported the glass ornaments but purchased their matching bottle blanks from U.S. glass companies. Where this is known, the information is indicated in the image descriptions.

Consumers' tastes were evolving and DeVilbiss met new needs in grand fashion. DeVilbiss perfume atomizers and droppers featuring Czechoslovakian bottles were important components of the 1934 through 1936 lines and dominated the product lines of 1937 and 1938. The more remarkable of these popular bottles can be quite challenging to find in good condition today. As before, DeVilbiss produced a range of these bottles and designs to satisfy their customers' needs and budgets. Each bottle, including those in the lower ranges, was designed and produced with DeVilbiss' customary attention to quality, beauty, and detail.

The perfume atomizer series is described in the 1937 catalog as "Imported, hand-cut and polished bottles and ornamental tops." It is shown here in the S600-25 version—Champagne color with a yellow gold-plated metal part and crystal ornament. It stands 6" high to the top of the ornament and is 2.5" in diameter at the base. There is a gold enamel ring at the top of the bottle. The foil label on the bottom instructs rotating the ball one-half turn to create an air-tight closure.

This bottle was sold in Champagne (a light yellow, as shown), Blue, Rose, and Crystal. The retail price was $6.00, worth $90.00 in today's dollars. This style enjoyed a three-year run, appearing also in the 1938 and 1939 catalogs.

The 1937 catalog notes that the blue version of this Perfume Atomizer (S600-24) was offered with rhodium-finished, rather than gold-plated, metal parts. Rhodium is a precious metal in the platinum family. Collectors should not confuse rhodium with chromium (chrome)—a non-precious metal which is slightly less brilliant and less expensive.

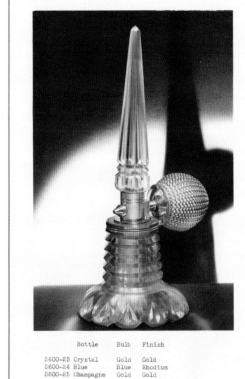

1937 factory record showing S-600 versions 23 (Crystal), 24 (Blue), 25 (Champagne) and 26 (Rose).

Bottle	Bulb	Finish
S600-23 Crystal	Gold	Gold
S600-24 Blue	Blue	Rhodium
S600-25 Champagne	Gold	Gold
S600-26 Rose	Gold	Gold

Crystal ornaments

S600-25 Perfume atomizer, in a Champagne colored hand cut and polished glass from Czechoslovakia (1937). Height 6".

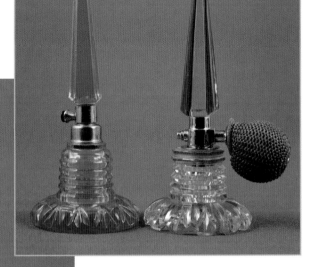

A similar, but slightly smaller, design (S500) was offered in the 1936 line only. Blue and black enamel-trimmed versions were offered with a chromium metal part, while ruby and amber-trimmed versions featured gold plating. Model S500-92, shown, stands 5" to the top of the ornament, is highlighted in blue enamel, features chromium-finished spray fittings, and is closure-equipped. It sold for $5.

Knockoff blue glass perfume atomizer (left) next to the real thing—the crystal bottle. The imposter has a chrome collar marked "Japan." The bottle is a low quality pressed glass, uncut and not polished. Height 5.25". The date is unknown.

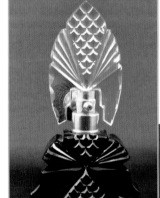

S500-98 Perfume atomizer, with cut black bottle and crystal cut ornament, from Czechoslovakia (1936). Gold-plated spray fittings with twist closure mechanism. Bottle and ornament design by Frederic Vuillemenot. *Courtesy of Jim and Carole Fuller.*

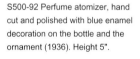

S500-92 Perfume atomizer, hand cut and polished with blue enamel decoration on the bottle and the ornament (1936). Height 5".

S500 Elegant variant of the S500-98 perfume atomizer bottle with red cut glass jewel replacing the crystal cut fan ornament (c. 1937). Height 3.5".

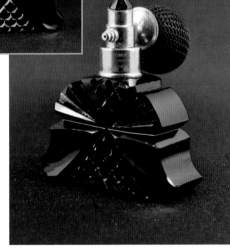

S500-94 Perfume atomizer, with hand cut and polished crystal Czechoslovakian bottle and ornament; gold finished metal part and closure device (1936). Designed by Frederic Vuillemenot. Height 6".

The S500-94 bottle was sold in 1936 as a Perfume Atomizer only, and in 1937 and 1938 both separately as an atomizer and together with a companion Perfume Dropper bottle. This beautiful bottle was Vuillemenot-designed and (Josef Riedel Glass) Czechoslovakian-made. It was cut and polished by hand and set off with a harmonizing crystal ornament that is cut in a coordinated outward-radiating pattern. In 1936, this bottle was offered in three styles: crystal (shown); with a black bottle, crystal ornament, and chromium metal part; and in topaz with a gold metal part. In 1939, it was offered in crystal, champagne, and blue. According to factory specifications, they were all "equipped with the new turn-type closure," which was operated by a turnable metal disc fitted on the forward part of the squeeze bulb.

The factory records specify that these S350 (1936) bottles were "hybrids," with a domestic blown bottle and foot and imported ornament. Coordinated flashed enameling and leaf-pattern cuttings to clear with gold lines on both bottle and ornament, were decorated by DeVilbiss. They were also offered in green and ruby enameled decorations.

Both of the SD700 bottles and their ornamental tops were "imported, heavily cut and polished," according to the factory records, and were offered in crystal, champagne, rose, and blue (as shown), with gold-plated metal parts. This style was sold both as an individual atomizer and as an atomizer and dropper set, in "a fancy gift box" retailing for $7.00. Notice that the top ornaments are of identical shape as the previously-shown S350-54 style, but with different cuttings and decorations.

IDA LUPINO ★ RKO RADIO PICTURES STAR

Actress Ida Lupino poses with S350-54 perfume atomizer, with other offerings from the 1936 DeVilbiss product line.
Ida Lupino was British-born, but found her way to Hollywood in the mid-1930s. During World War II, Lupino served as a lieutenant in the Women's Ambulance and Defense Corps of America. Organizations such as the Corps sprang up in response to American women's desire to contribute to the war effort.

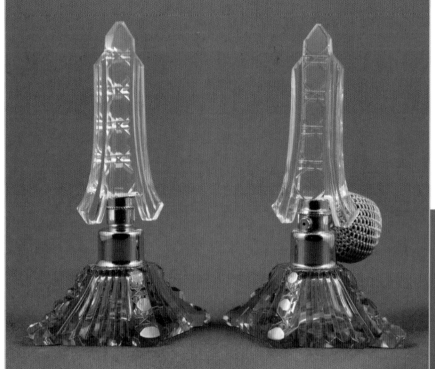

SD700-4 Perfume atomizer and Perfume Dropper, set with hand cut and polished blue Josef Riedel Glass–produced, Czechoslovakian bottles, gold-finished metal parts, and cut-crystal ornaments (1937). Height 5".

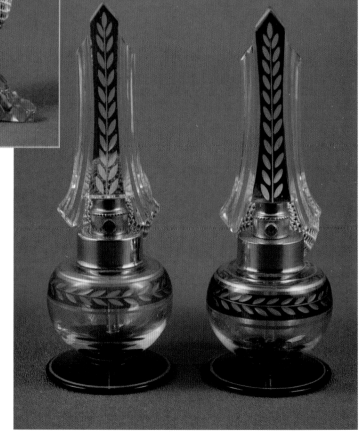

S350-54 (gold) and S350-55 (blue) Perfume atomizers, with footed blown bottles and cut crystal ornaments; gold finished metal parts and enamel flashed decoration cut to clear (1936). Height 5".

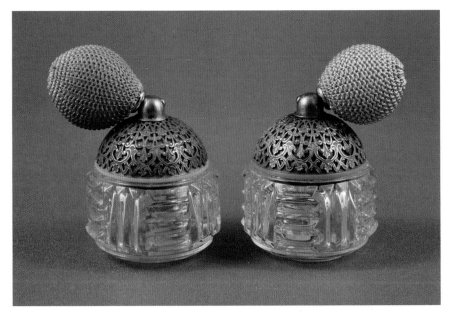

S100-223 Perfume atomizer with green Plaskon cover and S100-220 perfume atomizer with blue Plaskon cover; both with 24-karat gold-plated, filigree tops (1937). Height 2.5".

Consumers at this time often looked for small bottles to hold their perfume. These two DeVilbiss Perfume Atomizers prominently feature a 24-karat gold-plated filigree, or cage-work, ornament crowning colored (blue and green) "Plaskon" covers. The bottles are marked "Czechoslovakia" on the bottom in the mold, and are described in the 1937 catalog as being of "high luster lead glass." Plaskon is "a plastic molding compound indistinguishable from Bakelite except in its crucial capacity to accept any color—including white," and was first produced in 1930.[8] This model was offered in six colors: blue, black, red, green, ivory, and orchid.

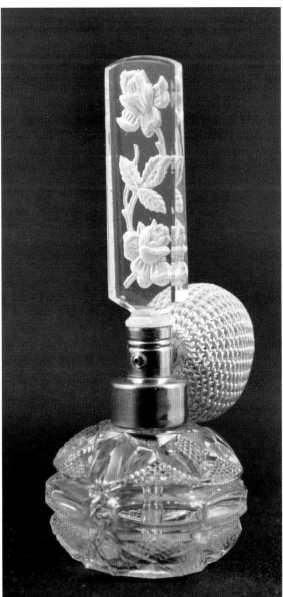

S200-149 This small perfume atomizer, blue, lead-glass bottle is marked "Czechoslovakia" in the mold (1937). The gold-finished spray fitting is topped by an intaglio etched cut crystal ornament. Height 5".

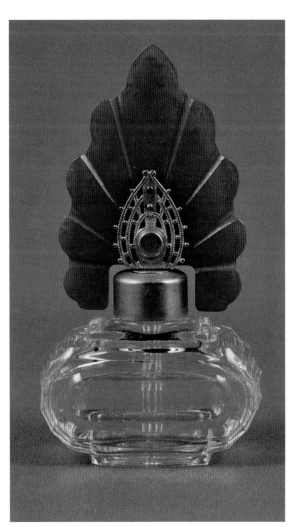

S200-151 This perfume atomizer and ornament, designed by Frederic Vuillemenot, has a crystal bottle with a swirl design and is marked "Czechoslovakia" in the mold on the bottom; with gold-plated fittings (1937). The mottled light brown fan-shaped ornament is made of Catalin, similar to Bakelite, and is hand cut with a filigree attachment to the spray head. Height 4".

SD200-11 Perfume atomizer and dropper set, with imported lead-glass, high-luster bottles, marked "DeVilbiss" in the mold, with gold-plated fittings (1937). Note the interesting spray head and dropper-handle design. Height 3.5".

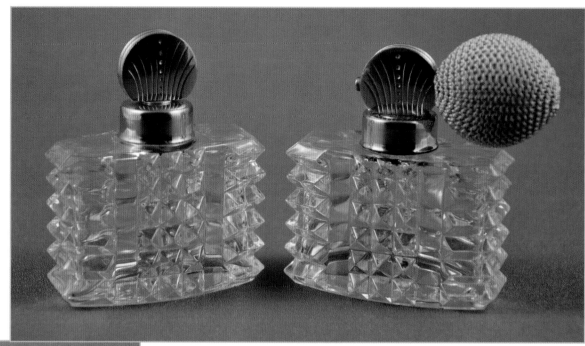

S650-28 Perfume atomizer, in an interesting shape, with a blue, hand cut and polished Czechoslovakian bottle and applied green-gold filigree ornament front and back, with swing-type closure mechanism (1937). Note the unique, triangular spray head that matches the style of the bottle. *Courtesy of Jim and Carole Fuller.*

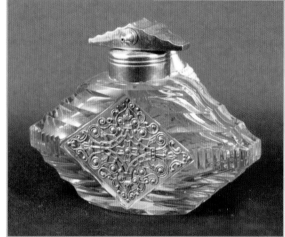

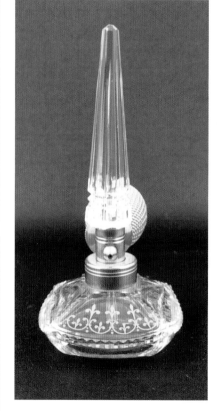

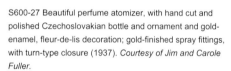

S600-27 Beautiful perfume atomizer, with hand cut and polished Czechoslovakian bottle and ornament and gold-enamel, fleur-de-lis decoration; gold-finished spray fittings, with turn-type closure (1937). *Courtesy of Jim and Carole Fuller.*

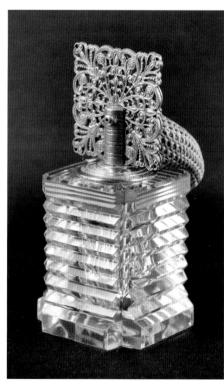

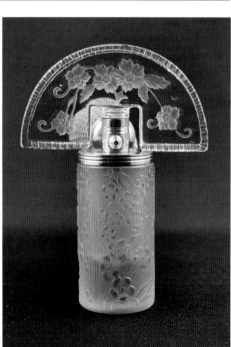

S650-17 Perfume atomizer, with U.S.-made, crystal mist, flower-designed bottle and a hand-cut and intaglio-etched, fan-style Czechoslovakian ornament (1937). Gold-finished spray fittings, with a twist-closure mechanism, at the front of the squeeze ball. Height 5".

S450-17 Beautiful hand cut and polished crystal bottle. The design patent was awarded to Frederic Vuillemenot and the bottle was produced by Josef Riedel Glass, Czechoslovakia; green-gold filigree ornament and closure mechanism (1937). Height 3.5".

Vuillemenot-designed bottles, according to factory documents, were "imported, hand-cut and polished." Style S1200-2 features a green-gold-finished, filigree ornament (see detail). Style S1200-3 includes a glass ornament cut in the same pattern as the bottle, and a metal part in 24-karat gold-plate. The atomizer fittings have swing-type closure mechanisms, which, when rotated 90 degrees, seal the contents from spillage and evaporation. Both versions were sold with beige tasseled bulbs.

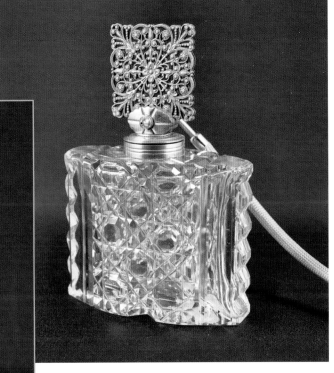

S1200-2 Hand cut and polished crystal, Czechoslovakian, perfume atomizer; green-gold filigree ornament; gold-finished spray fittings, with swing-type closure (1937). Height 5.5".

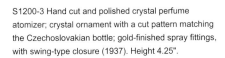

S1200-3 Hand cut and polished crystal perfume atomizer; crystal ornament with a cut pattern matching the Czechoslovakian bottle; gold-finished spray fittings, with swing-type closure (1937). Height 4.25".

"Green gold," the material of the filigree ornament on S1200-2, is an alloy of 75 percent gold and 25 percent silver, giving the appearance of a dull, greenish-yellow finish.

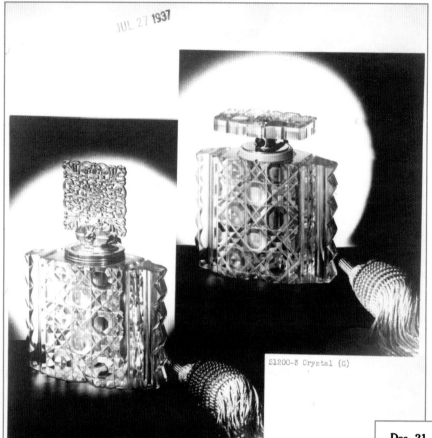

JUL 27 1937

S1200-3 Crystal (G)

S1200-2 Crystal (G)

The above bottles are imported, hand cut and polished. The ornamental top on S1200-2 is green gold filigree and the ornamental top on S1200-3 is imported, hand cut and polished glass to match the bottle.

The metal part on S1200-2 is green gold with a dull finish while the metal part on S1200-3 is yellow gold. Equipped with swing type closure.

Prices: $96.00 per dozen list, $81.60 per dozen net, $12.00 retail.

DeVilbiss factory description of S1200-2 and S1200-3 date-stamped July 27, 1937.

Sign of the Times—Crystal Bottles

The DeVilbiss 1937 catalog, produced for retailers and department stores and in which these bottles appear, proclaims, *"Crystal is in vogue and crystal predominates in the DeVilbiss line. For customers who buy expensive perfumes, these perfected leak-proof closures on higher-priced atomizers are absolutely air-tight."*[9]

The S1200 bottles shown in the 1937 factory description, minus their spray tops, measure 4" wide, 1.75" deep, and 3" high. The filigree-ornamented bottle is 5.5" tall overall, while the glass-ornamented bottle stands 4.25" high. They are signed on the bottom, "Made in Czechoslovakia." A DeVilbiss foil label on the base of each one has the model number and a diagram demonstrating the correct use of the closure mechanism. Their cost to dealers and department stores was $96 per dozen list and $81.60 per dozen net (after trade discounts). At $12 suggested retail (the equivalent of about $180 in today's dollars), these were the most expensive atomizers in the 1937 line.

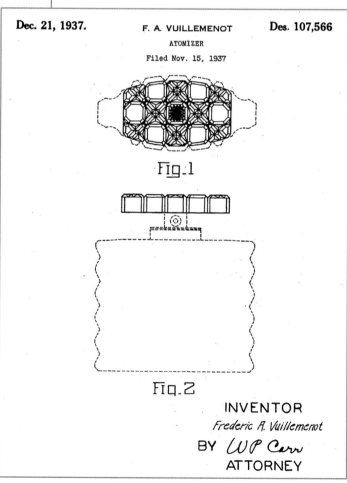

Dec. 21, 1937. F. A. VUILLEMENOT Des. 107,566

ATOMIZER

Filed Nov. 15, 1937

Fig.1

Fig.2

INVENTOR

Frederic A. Vuillemenot

BY *WP Carr*

ATTORNEY

Vuillemenot's Design Patent 107,566, for S1200-3 cut glass ornament (the ornaments and the bottle designs were patented separately).

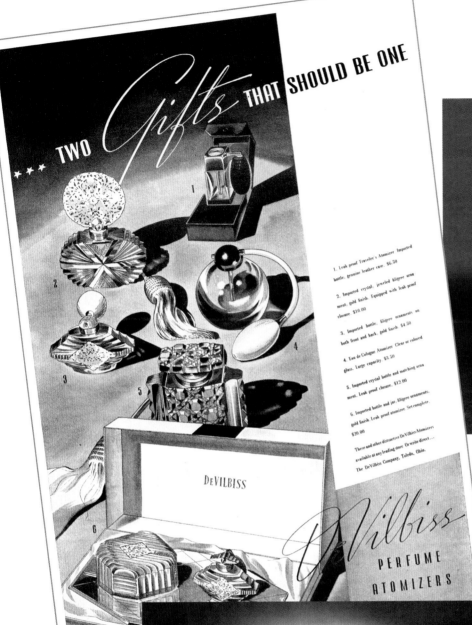

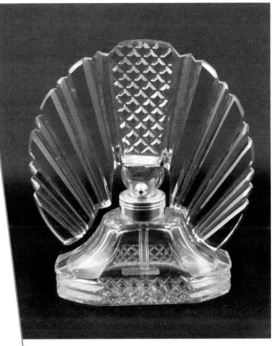

S1250-1 Perfume atomizer, with crystal, Czechoslovakian, hand cut and polished bottle and large, fan-type ornament; gold finished spray fittings with closure mechanism (1937). *Courtesy of Jim and Carole Fuller.*

DeVilbiss advertisement, in the December 1937 issue of *Esquire* magazine, promoting to men the giving of perfume atomizers as gifts for the Christmas season.

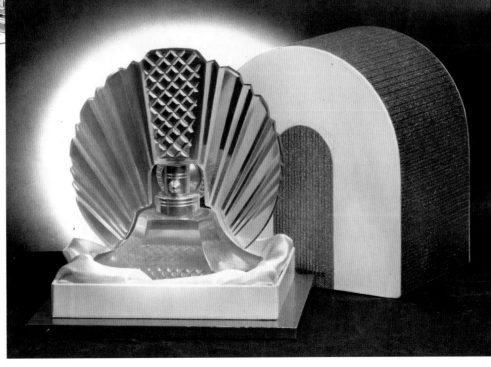

Catalog image of the S1250-1 perfume atomizer, with a domed gift box matching the overall style of the fan ornament, from the DeVilbiss 1937 retail catalog.

Josef Riedel Glass

Riedel Crystal of Austria, now a major provider of quality crystal stemware, is in its 11th generation of Riedel family leadership. During the 1930s, under Walter Riedel (8th generation), the company was thriving in the part of Czechoslovakia that was Bohemia and was a major manufacturer of perfume flacons, chandelier parts, and overlaid glass giftware. In 1938, at the onset of World War II in Europe, the Germans annexed and occupied Czechoslovakia, and soon thereafter mandated that Riedel convert to strategic war material production, thus ending the company's production of perfume bottles and glassware. After the war, the Czechoslovakian Communist regime nationalized the company and the Riedel family was evicted. In 1955, the family settled in Austria, where the Swarovski family assisted Walter Riedel in establishing the present company.[10]

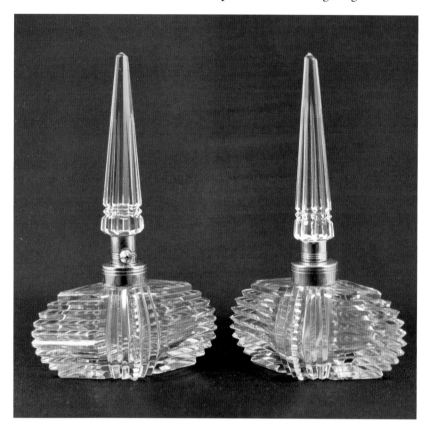

During the 1930s, Riedel's glass works supplied blank perfume bottles and decorative glass to famed Czechoslovakian glass artist Henry Schlevogt, who further worked and decorated them into items of the famous "Ingrid" brand. Riedel also was a major supplier of bottle blanks to DeVilbiss in the 1936–1938 period. Shown here are a number of confirmed examples from DeVilbiss company records. It is likely that further research will find that other DeVilbiss bottle blanks from the late 1930s, made in Czechoslovakia, are from Riedel as well.

Pair of S650-43 cut and polished perfume atomizer (left) and D450-11 Perfume Dropper to match, both acid-stamped "Made in Czechoslovakia" on bottom; gold-plated fittings and atomizer with swing-type closure mechanism (1938). Bottles designed and produced by Josef Riedel Glass. Height 6.5".

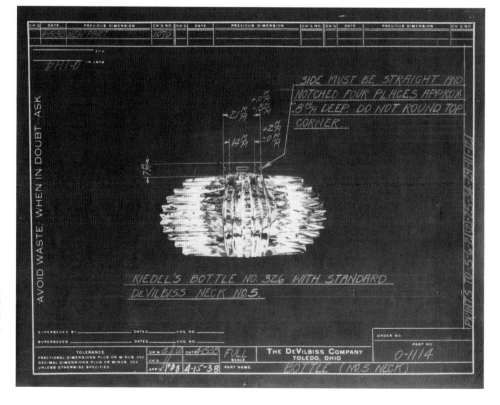

Factory drawing of bottle blank 0-1114, dated April 15, 1938, with notation: "Riedel's bottle No. 326 with standard DeVilbiss Neck No. 5." This blank was finished as DeVilbiss models S650-43 and D450-11, shown above.

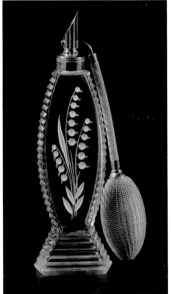

S200-198 Crystal perfume atomizer, with a cut "lily of the valley" decoration, from factory photo. The blueprint for this Vuillemenot-designed blank is number 0-1121. Bottles were produced by Josef Riedel Glass (1939). Height 7".

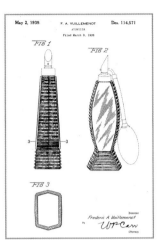

Design patent 114,571 for bottle blank 0-1121, dated March 2, 1939, awarded to Frederic Vuillemenot.

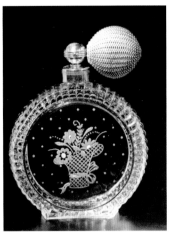

S150-100 Perfume atomizer, with Colonial Basket cutting, from a factory photo (1938). The blueprint for this Vuillemenot-designed blank is number 0-1119. Josef Riedel Glass was the glass supplier. There was a beautiful series of this bottle shape, with different cuttings done in the same period. Note the spray head's interesting design, that adds continuity to the overall bottle design. Height 4.75".

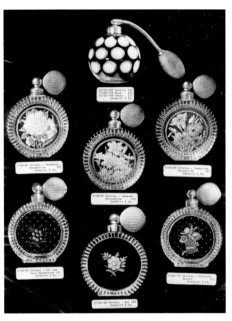

A series of S150, Josef Riedel–supplied bottles, with different cut patterns, from 1939 factory record. The bottle at the top center was supplied by Fenton.

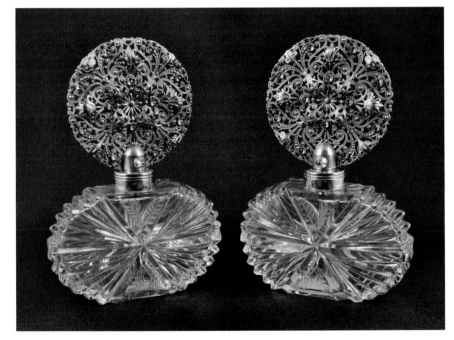

S1000-12 Perfume atomizers, hand cut, in a star-burst and fern leaf pattern and polished crystal bottle by Josef Riedel Glass, with green-gold filigree ornament; acid-stamped "Made in Czechoslovakia" (1937). Height 5.75". Versions shown are with Aquamarine and Rose jewels set in the ornaments.

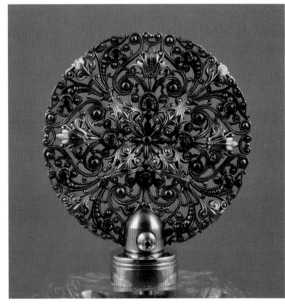

Filigree disc ornament, set with Rose glass jewels.

These remarkable green-gold filigree ornaments are 2.75" in diameter and are set with twelve Aquamarine and Rose jewels. This is the largest filigree ornament made by DeVilbiss during the late 1930s, when Czechoslovakian jeweled and filigree-decorated perfume bottles were highly popular. It is incorporated into the atomizer spray fitting, which features a swing-type closure mechanism. This model sold at retail for $10, equivalent to about $150 in today's dollars.

This model of Perfume Atomizer was offered in three versions, differing only in the colors of the jewels: Aquamarine (shown), Rose (shown) and Emerald. The bottle was also offered in 1937 with an atomizer fitting lacking the filigree ornament.

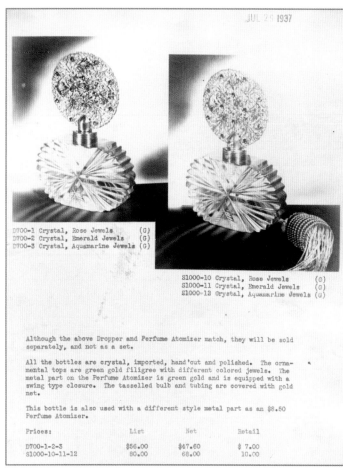

D700-1 Crystal, Rose Jewels (G)
D700-2 Crystal, Emerald Jewels (G)
D700-3 Crystal, Aquamarine Jewels (G)

S1000-10 Crystal, Rose Jewels (G)
S1000-11 Crystal, Emerald Jewels (G)
S1000-12 Crystal, Aquamarine Jewels (G)

Although the above Dropper and Perfume Atomizer match, they will be sold separately, and not as a set.

All the bottles are crystal, imported, hand'cut and polished. The ornamental tops are green gold filigree with different colored jewels. The metal part on the Perfume Atomizer is green gold and is equipped with a swing type closure. The tasselled bulb and tubing are covered with gold net.

This bottle is also used with a different style metal part as an $8.50 Perfume Atomizer.

Prices:	List	Net	Retail
D700-1-2-3	$56.00	$47.60	$ 7.00
S1000-10-11-12	80.00	68.00	10.00

DeVilbiss also produced a dropper-fitted edition of this bottle, shown in the left image of the July 1937 factory product description, which notes that the two versions were to "*be sold separately, and not as a set.*"

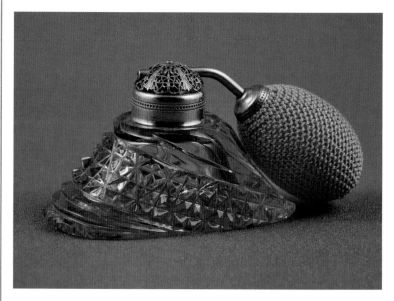

S350-81 Small-capacity, hand cut and polished Rose perfume atomizer, with a bottle produced by Josef Riedel Glass and green-gold filigree top; acid-stamped "Made in Czechoslovakia" (1938). Height 2".

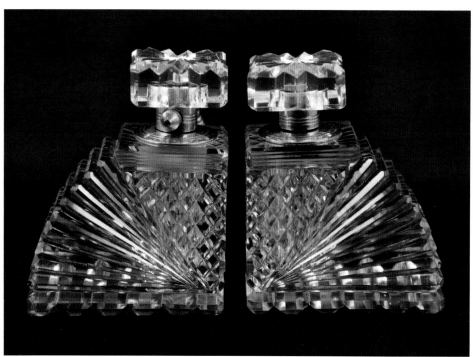

SD1500-1 Elegant perfume atomizer and Perfume Dropper set, of hand cut and polished crystal, acid stamped "DeVilbiss" on bottom. Designed by Frederic Vuillemenot. Hand cut and polished crystal ornaments to match, with swing-type closure (1938). Height 3". "This set is packaged in a fancy gift box having a transparent cover," according to a factory record dated August 23, 1938. Bottles by Josef Riedel Glass.

Peace be with you
in your christmas shopping

No need to go chasing from store to store. Just make up your mind now to get her a perfume atomizer. Size and color are no problem, yet you have the ideal gift—one she will appreciate, and you will too. Spraying makes her perfume seem so natural, that you will think that lovely, alluring fragrance really belongs to her . . . You will find these and many other beautiful DeVilbiss Atomizers at the perfume counter of any leading store . . . Prices from $1.00 to $12.50. The DeVilbiss Company, Toledo, Ohio.

DeVilbiss **perfume atomizers**

DeVilbiss 1938 magazine advertisement promoting the Christmas gift market.

Edward G. Westlake Company

Edward G. Westlake was a Chicago-based designer and importer of perfume bottles who first appears as a designer for Marshall Field & Company. He was awarded three perfume bottle design patents on Marshall Fields' behalf in 1934. He was at Chicago's Merchandise Mart, in 1936, as a principal in the firm McCoy, Jones and Westlake, which, among other products, offered a line of Czechoslovakian perfume bottles. Next, he was head of the Edward G. Westlake Company, also at the Merchandise Mart, offering a broad line of Czechoslovakian perfume bottles described as "richly cut Bohemian crystal imports." DeVilbiss acquired its Czechoslovakian bottle blanks from several sources, undoubtedly depending on quality, design, and cost. Edward G. Westlake Company was one of those sources.

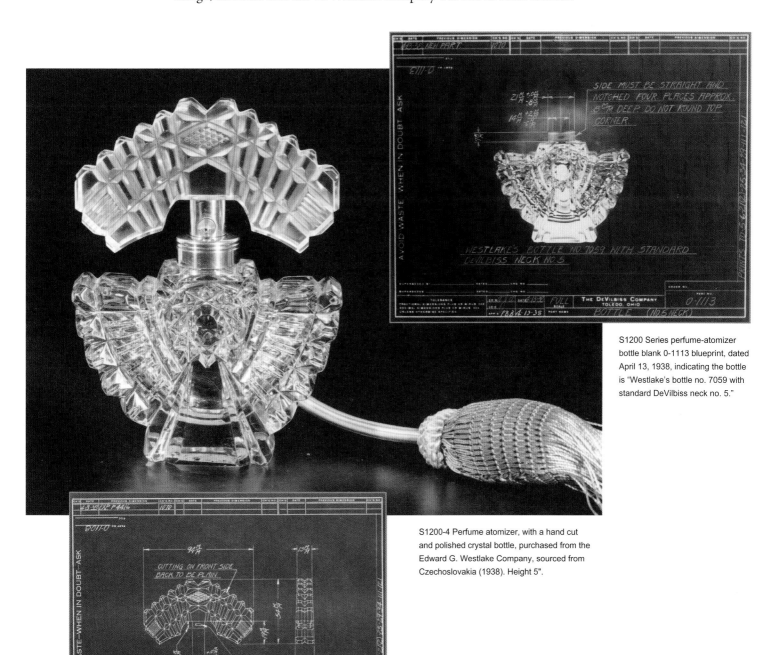

S1200 Series perfume-atomizer bottle blank 0-1113 blueprint, dated April 13, 1938, indicating the bottle is "Westlake's bottle no. 7059 with standard DeVilbiss neck no. 5."

S1200-4 Perfume atomizer, with a hand cut and polished crystal bottle, purchased from the Edward G. Westlake Company, sourced from Czechoslovakia (1938). Height 5".

Factory blueprint, dated April 8, 1938, of the Czechoslovakian imported ornament for S1200 Series perfume atomizer, with instructions for cutting and marking.

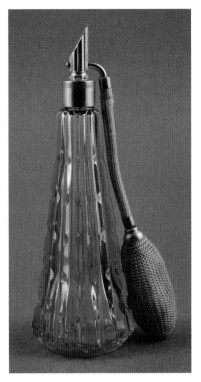

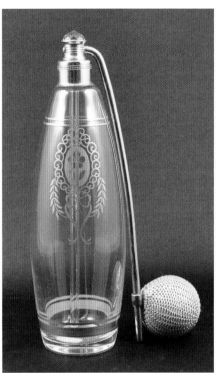

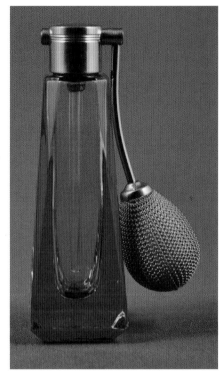

S200-174 Eau de cologne atomizer, with hand cut, blue bottle, marked "Czechoslovakia" in the mold, and acid-stamped "Bottle Made in Czechoslovakia" on bottom (1939). Height 7.25".

CS300-91 Tall DeVilbiss eau de cologne atomizer, with 3½-ounce capacity crystal bottle from the Cambridge Glass Company. DeVilbiss gold, silk-screen decoration, gold-plated fittings crowned by a Topaz, cut-glass jewel (1939). *Courtesy of Jim and Carole Fuller.*

S500-144 Perfume atomizer, with a deep-blue, heavy-sham, 1-ounce bottle, gold-plated fittings, and swing-type closure mechanism (1939). Height 5".

S300-88 Perfume atomizer, with gold wreath decoration and gold-plated spray fittings, hand-polished panels, and vertical line cuttings on the corners (1939). DeVilbiss described this as showing "Swedish influence" in these "unusually lovely modern bottles." Height 3".

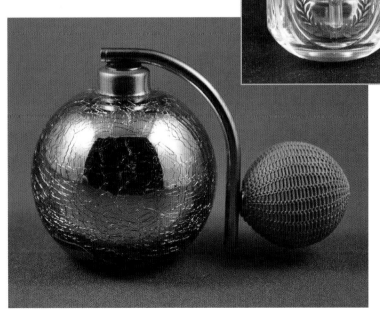

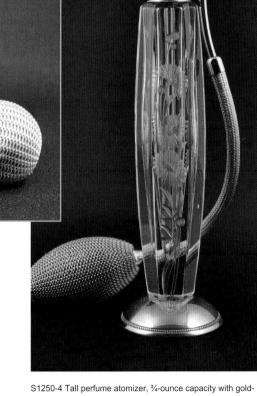

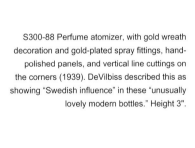

CS300-85 Gold Crackle eau de cologne atomizer (1940). Height 4".

S1250-4 Tall perfume atomizer, ¾-ounce capacity with gold-plated fittings and beaded metal foot (1939). The decoration of this bottle features a cut and faceted crystal jewel, a hand-cut leaf pattern inlaid with 24-karat gold, and a swing-type closure mechanism. Height 7.5".

1939 Return to Domestic Bottles

In 1938, Germany occupied Czechoslovakia and soon brought an end to DeVilbiss' ability to import Czech glass bottle blanks. While some Czech styles remained in the 1939 DeVilbiss catalog, it represented the use of bottle blank inventories imported prior to the German occupation.

The stunning CS500-1 tall crystal bottle is U.S.-made, heavy-sham, spherical, and features eighteen hand-cut and polished oval impressions around the circumference. The bottle's capacity is 4 ounces and the diameter is 3.75". The rarely seen closure device is a screw cap attached to the spray top and held with a small chain. All the metal parts are gold-plated. The glass is clear, high-quality crystal. The bottle was only in the 1940 line and was offered in crystal only, at $5 suggested retail.

The factory record shows production costs which appear to be per hundred units, at $1.30 per unit. The cost of the metal part, at $.66, is greater than the cost of the bottle itself, including hand-polishing, at $.64.

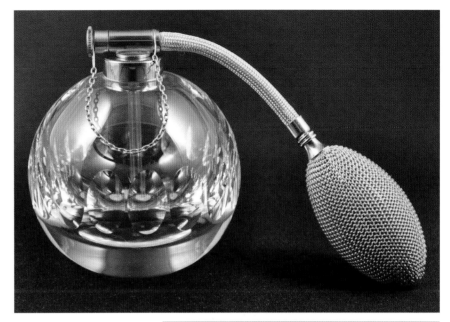

CS500-1 Eau de cologne atomizer (1940). Height 4".

CS500-1 Eau de cologne atomizer's factory record with component costs.

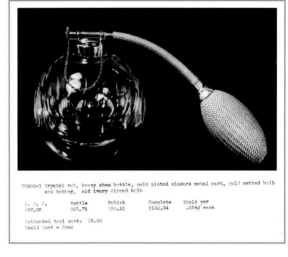

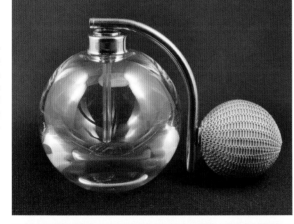

S300-83 Four-ounce perfume atomizer, with a crystal bottle acid-stamped "Bottle Made in Sweden" on the bottom (1939). Height 4".

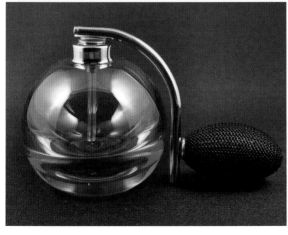

CS300-84 Eau de cologne atomizer, heavy sham blue glass bottle, with 4-ounce capacity, acid-stamped "DeVilbiss Made in USA" on bottom, and rhodium-finished metal fittings (1940). Height 4".

Swedish Bottles

DeVilbiss listed only a few bottles in 1939 that were made in Sweden; all had the same blank shape, but in different sizes. There were larger and smaller versions with the same fittings: a 6 oz. (in gold crackle only), 4 oz. (as indicated above, light blue and crystal), and 1 oz. bottle (crystal, light blue, and gold crackle) each with gold-plated fittings and acid-stamped on the bottom, "Bottle Made in Sweden." After 1939, these bottles disappeared from the DeVilbiss product lines. Although Sweden was officially neutral in the war and not occupied by Germany, the U-boat war in the Atlantic halted much routine commercial shipping between the continents.

Bottles of a similar spherical shape were included in other years, before and after the Swedish bottles, including U.S.-made. Some were made by Cambridge, Morgantown, and more, and with each there are slight sham, bottle, and color differences that may help identify the manufacturer. Where known and listed in this book, the authors identify the U.S. glass manufacturers of the bottles.

This high-quality bottle, a one-ounce capacity with molded heavy-sham, appeared only in the 1940 catalog and was offered only in the popular crystal. Described as a "charming teardrop design," the bottle is fitted with a swing-type closure mechanism. Rotating the tube in either direction, up from the bottle, opens the channel for spraying. The Perfume Atomizer's suggested retail price was $5.

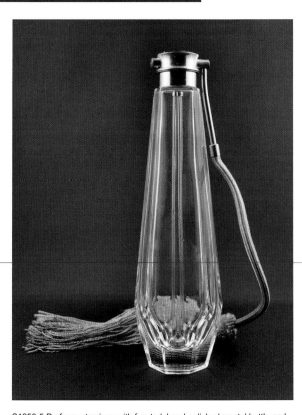

S500-149 Heavy sham crystal perfume atomizer, gold-finished spray fittings, with swing-type closure mechanism (1940). Height 5".

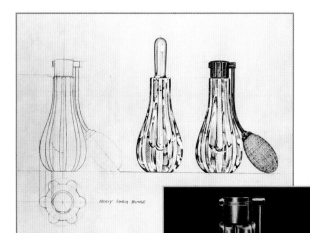

The design drawing's top-down view shows the six ribs or panels. A matching companion dropper bottle was designed but may not have been produced, as there is no reference or image that has been found in the catalogs or other factory records.

1940 DeVilbiss catalog image and description of S500-149.

S500-149 Crystal—Heavy Sham
Another charming tear-drop design with tapering paneled sides. It is highly practical, as it is equipped with a leak-proof closure. Capacity 1 oz.
Retail......................$5.00

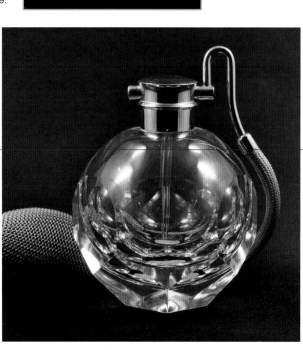

CS1250-1 Perfume atomizer, with spherical, faceted, hand cut and polished crystal bottle and gold-finished spray fittings, with swing-type closure (1940). Height 4".

S1250-5 Perfume atomizer, with faceted, hand-polished crystal bottle and gold-finished spray fittings, swing-type closure, and original, tasseled bulb (1940). Height 8".

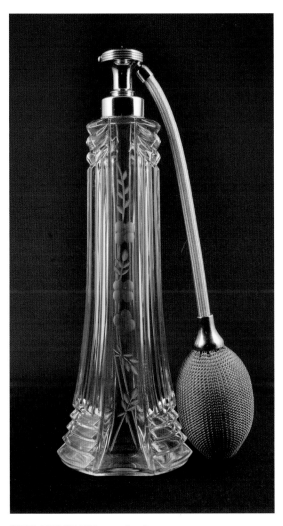

CS500-143 Tall DeVilbiss eau de cologne
3-ounce capacity atomizer (1940). Height 8.5".

Close-up of spray top of CS500-143
eau de cologne atomizer.

0-1193 Bottle blank
drawing.

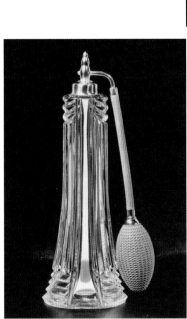

CS200-7 Bottle minus
the front panel cutting
and with lower-cost
spray fittings (1941).

This CS500-143, three-ounce, molded crystal eau de cologne Atomizer from 1940 features unique gold-plated spray fittings used only on this bottle and only for one year. The center panel is hand cut with a leaf-and-stem pattern and inlaid with 24-karat gold, also done only for that year.

The bottle blueprint for blank 0-1193 is dated October 20, 1939, and notes, "this surface must be made to accommodate silkscreen decoration," referring to the flat, front panel. The base of the bottle is polished, 3" across, and 2.25" deep at the bottom. The bottle's suggested retail price was $5.

This popular bottle blank was used again in the 1941 and 1946 lines as product number CS200-7, in blue and rose as well as crystal, but with a less ornate spray fitting and no cut and gold-inlaid decoration on the front panel. This enabled DeVilbiss to reduce the suggested retail price from $5 in 1940 to $2 in 1941.

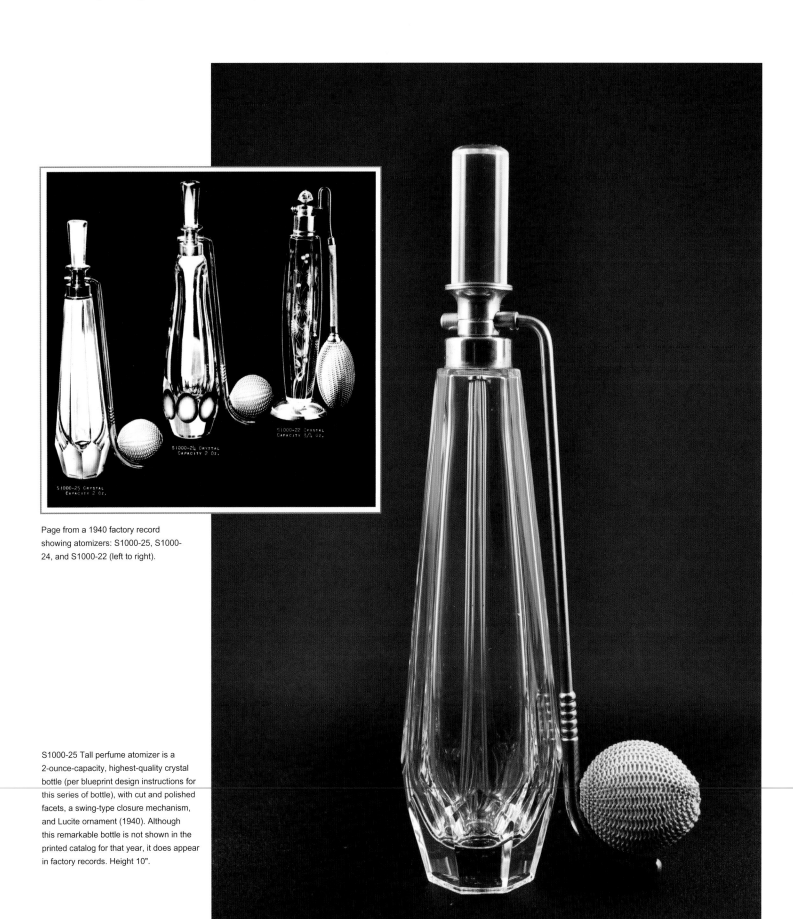

Page from a 1940 factory record showing atomizers: S1000-25, S1000-24, and S1000-22 (left to right).

S1000-25 Tall perfume atomizer is a 2-ounce-capacity, highest-quality crystal bottle (per blueprint design instructions for this series of bottle), with cut and polished facets, a swing-type closure mechanism, and Lucite ornament (1940). Although this remarkable bottle is not shown in the printed catalog for that year, it does appear in factory records. Height 10".

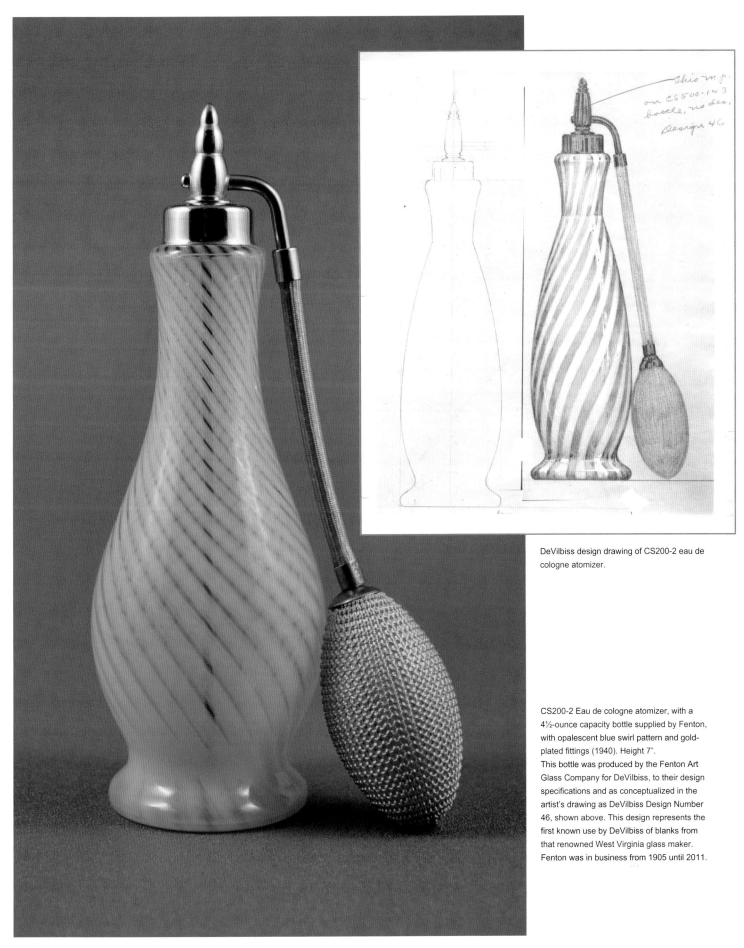

DeVilbiss design drawing of CS200-2 eau de cologne atomizer.

CS200-2 Eau de cologne atomizer, with a 4½-ounce capacity bottle supplied by Fenton, with opalescent blue swirl pattern and gold-plated fittings (1940). Height 7".
This bottle was produced by the Fenton Art Glass Company for DeVilbiss, to their design specifications and as conceptualized in the artist's drawing as DeVilbiss Design Number 46, shown above. This design represents the first known use by DeVilbiss of blanks from that renowned West Virginia glass maker. Fenton was in business from 1905 until 2011.

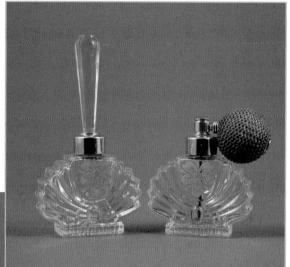

S50-83 and D50-9 Perfume atomizer and dropper set, crystal bottles marked "Made in U.S.A." in the mold. The delicate blue bow decoration is applied, ground, blue glass (1941). Height of dropper 4".

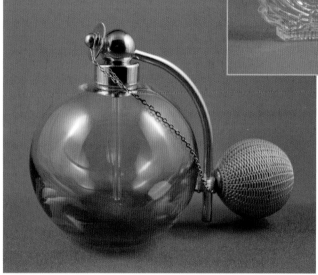

CS500-5 Rose, 5-ounce capacity perfume atomizer, with a screw-type closure cap, on a gold keeper chain (1941). Height 4.5".

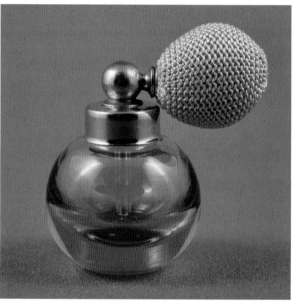

S100-312 Rose, heavy sham, ½-ounce perfume atomizer supplied by Cambridge Glass Company, with gold-plated metal fittings (1941). Height 2.5".

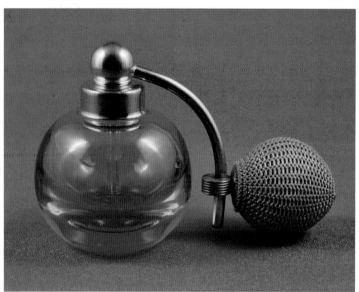

S200-224 Blue, heavy-sham, ½-ounce capacity perfume atomizer, by the Cambridge Glass Company, with gold-plated fittings (1941). This model is the same as S100-312 (above right) in all respects, but with the addition of the curved atomizer tube and the squeeze-ball position. Height 2.5".

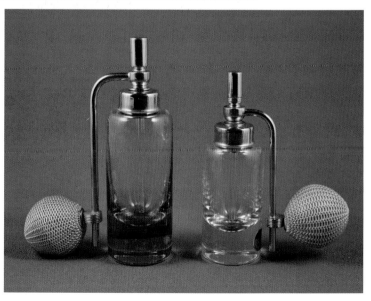

S350-5 Heavy sham, 1-ounce Rose perfume atomizer, with gold-plated fittings and S200-228 crystal, heavy-sham, smaller-capacity perfume atomizer (1941). Bottles were supplied by U.S. Glass (Tiffin). Height 5" and 4.25" respectively.

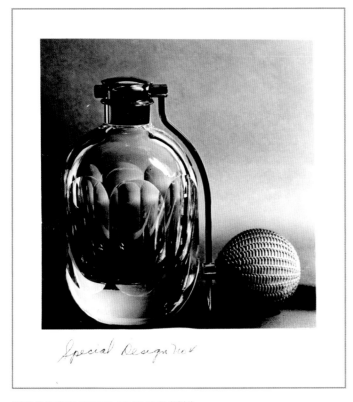

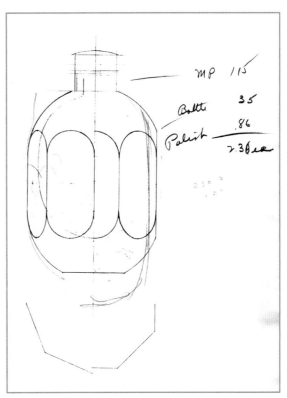

S750-45 Perfume atomizer, catalog photo (1941).

This lovely, 4-ounce-capacity crystal atomizer began life as "Special Design No. 4," an octagonal-paneled, heavy sham bottle. Beginning with the designer's concept sketch, production cost estimates were important for determining price and profitability of the atomizer.

Artist's sketch of Special Design No. 4, with production cost estimates. This perfume atomizer's production cost was estimated at $2.30 per bottle: $1.15 for the "metal part," or atomizer fitting, $.35 each for the bottle itself, and $.86 for the hand cutting and polishing.

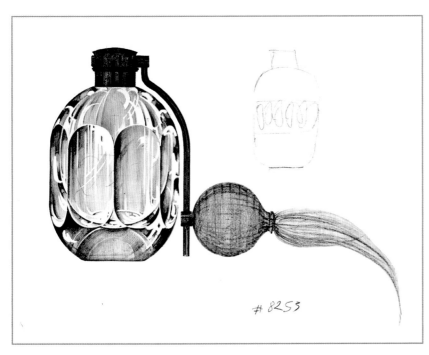

Final design rendering of S750-45 atomizer.

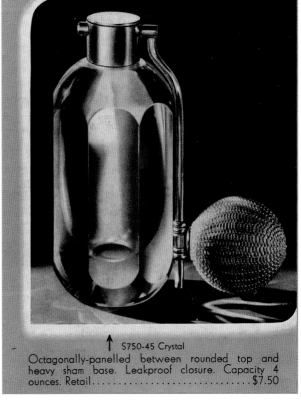

↑ S750-45 Crystal
Octagonally-panelled between rounded top and heavy sham base. Leakproof closure. Capacity 4 ounces. Retail.................................$7.50

1941 catalog page showing S750-45 atomizer at $7.50 retail price.

A DeVilbiss Atomizer in the Making

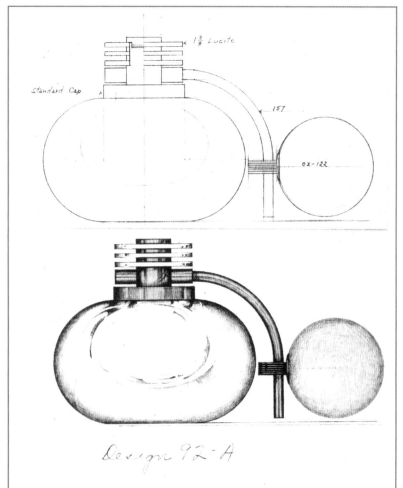

Vuillemenot Design 92-A of a new perfume
atomizer, c. 1940.

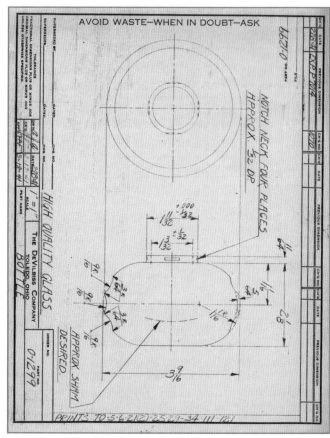

Blueprint for the bottle blank for Designs 92 and 115, which would
provide both for the dropper and atomizer versions.

Design 92-A becomes
perfume atomizer 8282
(1941).

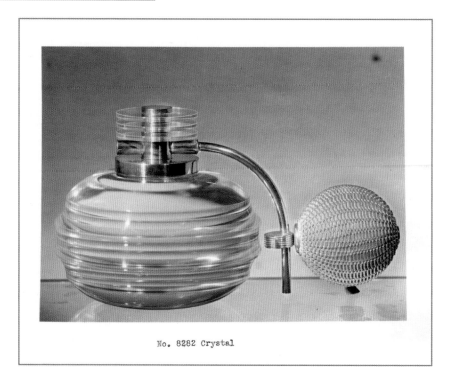

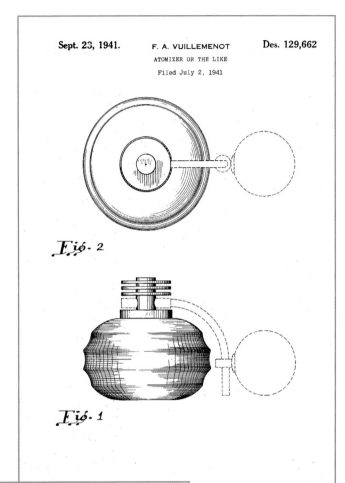

Mr. Vuillemenot - Dept. # 38

Sept. 23, 1941. F. A. VUILLEMENOT Des. 129,662

ATOMIZER OR THE LIKE

Filed July 2, 1941

Fig. 2

Fig. 1

INVENTOR.

FREDERIC A. VUILLEMENOT

BY

ATTORNEY

Vuillemenot Design Patent
129,662, granted September 23,
1941, for a perfume atomizer
based on design 923-A.

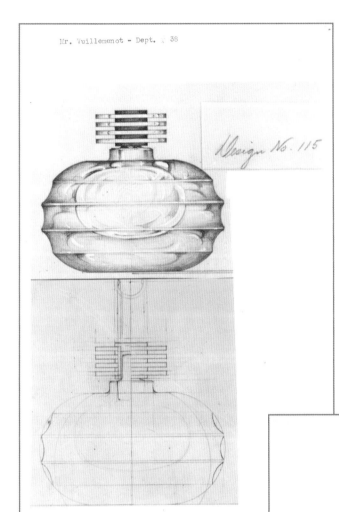

Mr. Vuillemenot - Dept. # 38

Design No. 115

Vuillemenot Design 115 for the Dropper Perfume companion.

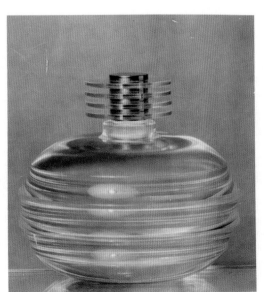

Mr. Vuillemenot - Dept. # 38

No. 8289 Crystal

Design 115 becomes Perfume
Dropper 8289 (1941).

Atomizers 8280, 8285 and 8287 do not appear in the retailers' 1941 catalog, but are seen in a factory product photograph dated 1941 and in blueprints dated in early 1941, which specified that the bottles be made of "highest quality glass."

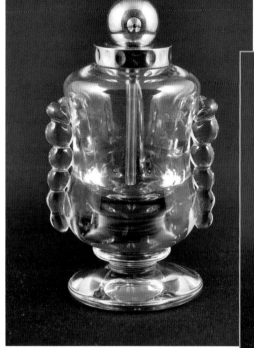

Perfume atomizer No. 8280, a crystal-footed bottle, with applied glass pearls (1941). Height 5.5". Glass manufacturer unknown, but noted by DeVilbiss as among the series of bottles, for this period, to be made with the highest quality lead glass.

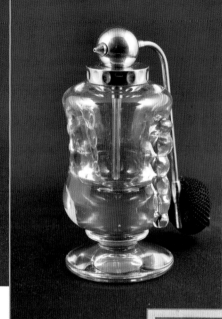

Perfume atomizer No. 8280, side view.

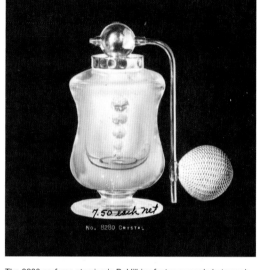

The 8280 perfume atomizer's DeVilbiss factory record photograph.

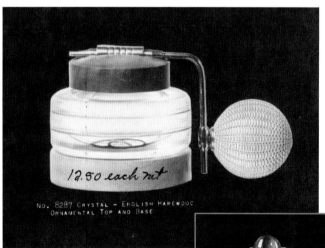

The 8287 perfume atomizer, with English hardwood top and base. DeVilbiss factory photograph.

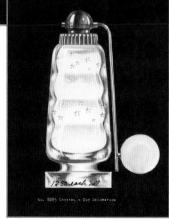

The 8285 perfume atomizer's DeVilbiss factory record photograph.

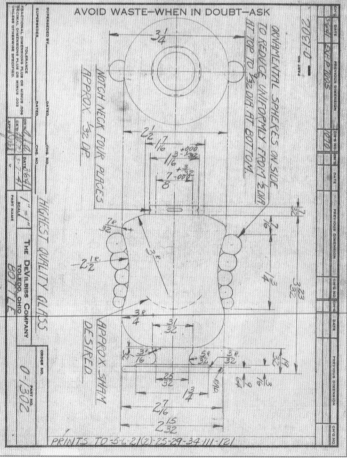

DeVilbiss blueprint for the glass blank 0-1302, for perfume atomizer 8280, dated March 7, 1941, and calling for the highest quality glass.

Fenton Art Glass Company and DeVilbiss

Founded in 1905, the Fenton Art Glass Company started producing glassware in Williamstown, West Virginia, in 1907, the same year the DeVilbiss Company began to sell Perfumizers. Under founders John, Charles, and Frank L. Fenton, the company flourished through the 'teens and most of the 1920s, and then struggled through the Depression of the 1930s, as did most American manufacturers of non-essential and luxury goods such as decorative glassware. Ironically, according to Fenton researcher John Walk, "a cologne bottle, a copy of the old Hobnail pattern introduced in the late 1930s, pulled the Fenton Art Glass Company from the depths of the Depression and in to economic renewal."[11]

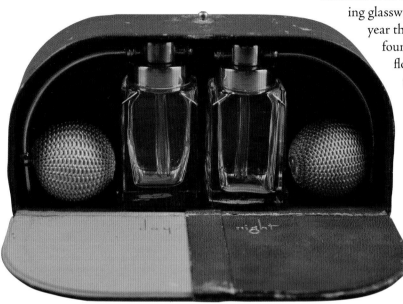

Thus, it was both the popularity of the Hobnail pattern, produced by Fenton in opalescent colors, and DeVilbiss' loss of access to European glass manufacturers due to World War II that converged to initiate the partnership between DeVilbiss and Fenton, that began in 1940 and lasted until 1953.

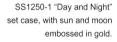

SS1250-1 "Day and Night" set "for discriminating women who prefer different scents for day and night use," according to the 1941 catalog. Fold-up two-color leather covered case.

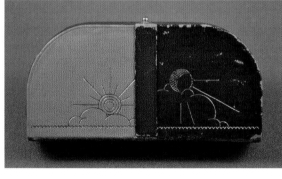

SS1250-1 "Day and Night" set case, with sun and moon embossed in gold.

One of the first shapes produced for DeVilbiss in 1940 was Fenton's Hobnail opalescent bottle in white (French Opalescent), blue, and green, adapted from Fenton's existing Mini Bud Vase mold. While some Fenton/DeVilbiss designs, like Hobnail, were adapted from existing Fenton shapes, the majority were designed by DeVilbiss to be produced by Fenton. DeVilbiss designers' drawings for Fenton-produced blanks are shown on the following pages, some of which are attributed to Frederic Vuillemenot.

As with Lenox Belleek China bottles in the 1930s, DeVilbiss chose to leverage the popularity of Fenton Art Glass and proudly noted in its catalogues of the late 1940s and early 1950s when atomizers with Fenton Art Glass bottles were shown. This was only the second major co-branding relationship DeVilbiss entered into, in its first forty years of perfume atomizer marketing.

Between 1940 and 1953, a total of eighteen DeVilbiss/Fenton shapes have been identified. After three new bottles debuted in 1940, the peak year was 1941, with eight shapes. All but two of these were carried into the post-war re-start of production, in 1946. One new shape, Beaded Melon, was introduced in 1947 and another, Backward Swirl, in 1949. Spiral Optic was introduced in 1951, a cranberry Coin Dot three-piece set in 1952, and finally a Swirled Feather atomizer in 1953.

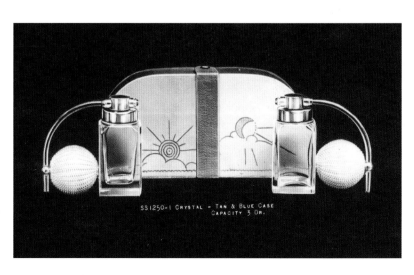

SS1250-1 "Day and Night" set's factory catalog photo.

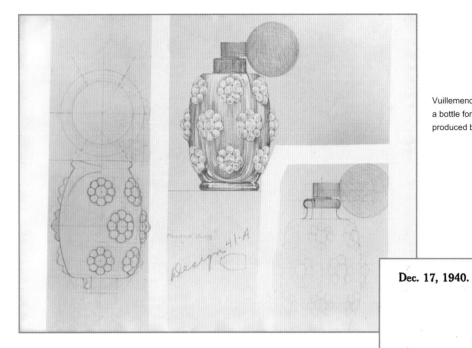

Vuillemenot design drawing 41-A, of a bottle for the CS100 Series to be produced by Fenton (1941).

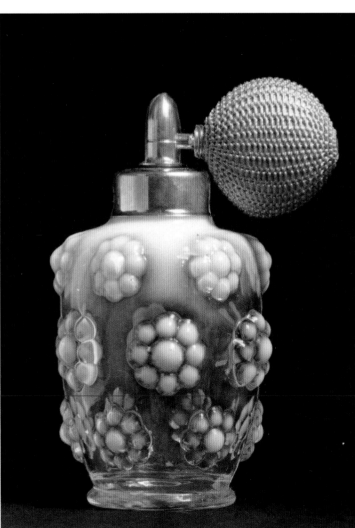

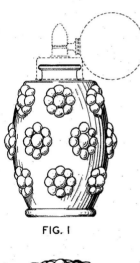

Dec. 17, 1940. F. A. VUILLEMENOT Des. 124,086

ATOMIZER

Filed Oct. 28, 1940

FIG. I

FIG. 2

INVENTOR.

FREDERIC A. VUILLEMENOT

BY WPCarr

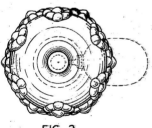

Frederick Vuillemenot design patent for the bottle produced by Fenton.

CS100 Series eau de cologne atomizer, with the bottle designed by DeVilbiss and produced by Fenton (1941).

These images show steps in the process of bringing a new atomizer to life, from the artist's design drawing to engineering specification to catalog photo to the bottle fitted with a spray top and ready for market. This Fenton-produced cranberry and white opalescent atomizer was introduced in 1941, for $3, along with several other Fenton bottles made to DeVilbiss design specifications. This is one of just a few models from 1941 that were re-introduced following the end of World War II, with the resumption of perfume bottle production and marketing in 1946.

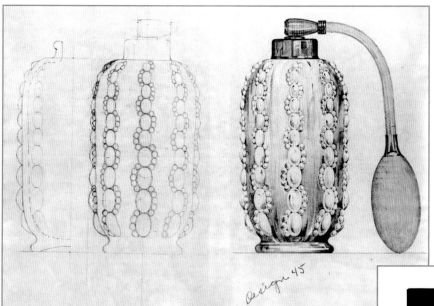

An artist's drawing of Design 45, in three stages of rendering.

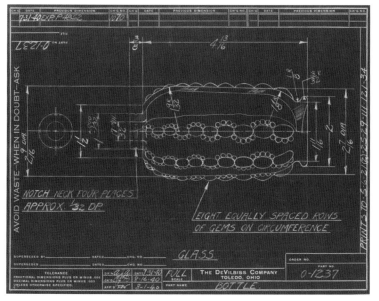

Engineering drawing of Design 45's bottle blank, number 0-1237, dated July 31, 1940, and calling for "Eight equally-spaced rows of gems on circumference."

Factory catalog photo of CS300-1 and CS300-2, listing two versions of the bottle's glass coloration.

CS300-1, a 7-ounce DeVilbiss cologne atomizer of opalescent, cranberry red glass, with white beads; bottle by Fenton dubbed "Pearls" by Fenton collectors (1941). Height 5.5".[12]

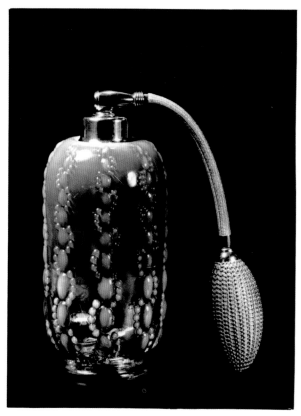

CS300-1 Gold cranberry red and white
CS300-2 White with gold cranberry red foot

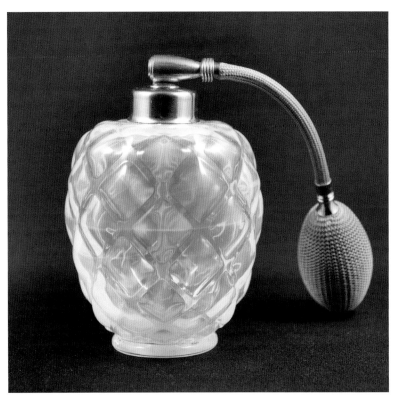

CS200-4 Cologne atomizer, 7 oz.-capacity, with a crystal and white bottle by Fenton, in opalescent pillow design, and gold-finished spray fittings.

Design drawing for CS200-4 atomizer.

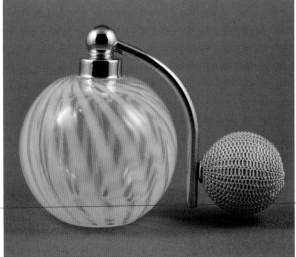

CS200-12 Opalescent Primrose Yellow and White eau de cologne atomizer, with bottle by the Fenton Art Glass Company, gold plated fittings (1941). Height 4.5". Fenton collectors' terminology for this bottle is Topaz Opalescent Spiral Optic.[13]

CS250-1 Crystal and white opalescent eau de cologne atomizer (1941). The bottle, by Fenton Art Glass Company, is called "Scroll" by collectors. This color was referred to by Fenton as French Opalescent. Note the distinctive spray head.[14]

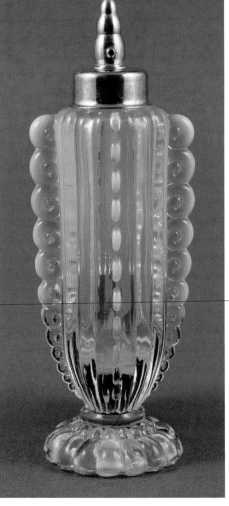

CS125-2 Blue opalescent bottle by Fenton for eau de cologne atomizer, with gold-finished spray fittings (1941). Height 4.5".

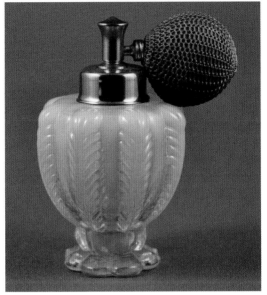

S100-307 White opalescent perfume atomizer, with bottle
by Fenton and gold-finished spray fitting (1941). Height 4".

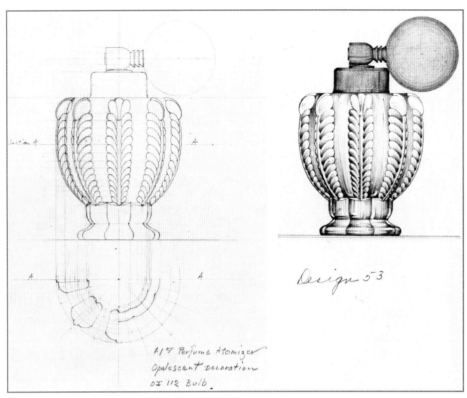

Design drawing number 53, for a perfume atomizer with a bottle produced by Fenton (1941).

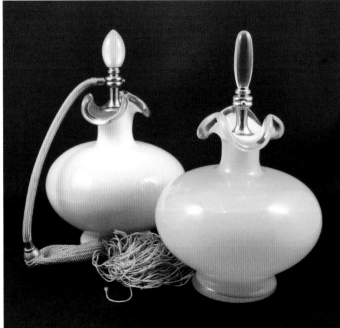

CS750-2 Peach Crest and CS750-2 Blue Crest "cruet
design" perfume atomizers, with Lucite ornaments.
Bottles made by Fenton Art Glass Company (1941).
Courtesy of Jim and Carole Fuller.

Design drawing for CS750 cruet perfume atomizer (1941).

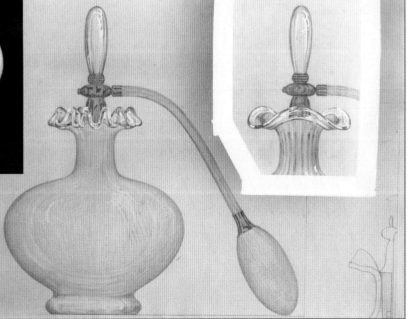

CHAPTER 5

The War Years and Post-war Return to Market

1942—1949

DeVilbiss adapted its peacetime products and services to the job of war and four times won the coveted "E" flag for outstanding performance.

DeVILBISS NEWS

VOLUME 10, NUMBER 2 THE DeVILBISS COMPANY, TOLEDO, OHIO JANUARY 22, 1943

PROUDLY WE RECEIVE THE ARMY-NAVY

THE RUBBER PRODUCTS PLANT IS

On December 7, 1941, the world changed abruptly and dramatically for America and The DeVilbiss Company. Although the country had begun a military buildup in the late 1930s, in response to growing threats in the Pacific from Japan and Germany's conquest of ever-larger parts of Europe, formal entry into World War II affected virtually all of America's productive capacity that was repurposed for war, including that of DeVilbiss.

Perfume Atomizer production was suspended in early 1942. Factory records show that Perfumizer products remaining in inventory at the end of 1941 were sold in 1942, but nothing was produced to replace them and soon supplies ran out. The brass, gold, nickel, chromium, rubber, and glass used to produce DeVilbiss Perfume Atomizers all were designated as strategic war materials and their use for non-essential purposes was prohibited. Perfume atomizers were non-essential, too.

But DeVilbiss's paint coating technologies and spray equipment production were deemed critical to applying protective coatings to military hardware, from helmets to bombs to battleships. For the next four years, all of the company's considerable talent and energy were at war, along with the rest of the United States.

DeVilbiss News, The DeVilbiss Company Newsletter of January 22, 1943, celebrating the award of the Army-Navy "E" (for excellence in war production), with company employees attending the ceremony held in the rubber plant. *Courtesy of BGSU Center for Archival Collections/DeVilbiss Corporation Collection MS-604.*

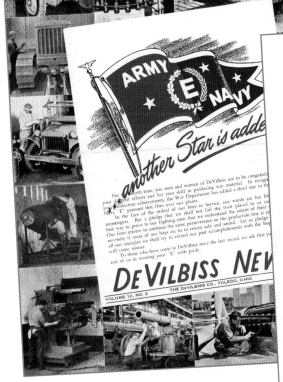

DeVilbiss company brochure dated March 1945 celebrates the fourth award of the Army-Navy "E" for excellence in production of war materials. *Courtesy of BGSU Center for Archival Collections/DeVilbiss Corporation Collection MS-604.*

ATOMIZER ASSEMBLY'S PART IN THE WAR EFFORT

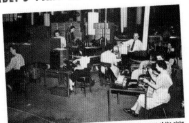

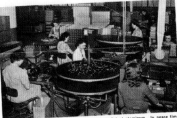

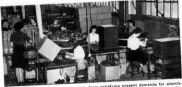

DeVilbiss News, March 1945, on "Atomizer Assembly and Its Part in the War Effort." *Courtesy of BGSU Center for Archival Collections/DeVilbiss Corporation Collection MS-604.*

In addition to ramping up paint spray apparatus production in the industrial division, DeVilbiss' Atomizer Department was repurposed to produce medical atomizers and equipment. The brochure pictures and describes a large assembly turntable with the note, "These folks are assembling spray heads for medical atomizers. In peace time, turntables like these are where immense quantities of perfume and cologne atomizers are assembled."[1] This team assembled and shipped 1.75 million medical atomizers in 1944 alone.

DeVilbiss industrial spray equipment was used to apply paint coatings to military trucks, bulldozers, Jeeps, aircraft, ships, submarines, landing craft, PT boats, artillery, bombs, depth charges, generators, Quonset huts, and even helmets. Returning to a process pioneered by DeVilbiss during World War I, which led to the method for interior enameling of Perfumizers, DeVilbiss paint spray technology was used to coat the insides of bombs, depth charges, and artillery shells, to keep the metal from corroding when in contact with explosive material. All DeVilbiss productive capacity, including tooling, worker skills, plant layout, and supply chains, was reconfigured for war production.

The End of the War

When World War II finally ended in September 1945, returning to the production of Perfume Atomizers was no simple matter. The raw materials, including metals, rubber, glass, and finishing materials, remained in short supply and the factories of components suppliers would also need time to return to normal operations. Were that not enough, household budgets for consumer products suffered from a post-war economic contraction. Millions of service men and women gradually returned home, often without jobs, and many went to school on the G.I. Bill, whereby the government paid tuitions for returning service personnel. The massive economic stimulus provided by government spending for war mobilization abruptly ended. Shipyards, aircraft factories, automotive plants, etc., which had converted their efforts to making tanks and trucks, etc., all laid their workers off their jobs as assembly lines shut down in order to convert operations to civilian production. It would take time—a couple of years—before American businesses and consumers could adjust to a peacetime economy.

The Return of the Perfume Atomizer and the Struggle to Re-enter the Market

When DeVilbiss re-entered the Perfume Atomizer business in 1946, it was a slow and difficult process. Whereas the 1941 catalog listed 48 different models, the 1946 catalog displayed only 31, all but nine of which were items carried forward from 1941 and all but two of which sold for $2.50 or less. Several of the new offerings for 1946 and 1947 were designed during the height of the war, with engineering drawings for 1946-line bottles dated in October 1944.

Underscoring the difficulty of both obtaining supplies and converting the DeVilbiss production facilities back to consumer products, Perfume Atomizer Sales Manager Floyd Green, on January 16, 1946, notified his sales force that:

> The anticipated availability of equipment and floor space for the manufacture of perfume atomizers after VJ Day did not materialize, due to an immediate influx of orders for products manufactured during the war. This unprecedented demand has absorbed our manufacturing facilities and necessitated disappointing many good customers.

On April 18, 1946, Green sent another circular to DeVilbiss salesmen notifying them that:

> A summary of the estimates of 1946 cologne and perfume atomizer requirements confirmed our belief that the production capacity of bottle manufacturers as well as facilities in our own plant would not be sufficient to supply the full demand and it would be necessary to allot them.

Salesmen were assigned reduced allotments of Perfume Atomizer products to sell and were cautioned against over-selling their allotments. On August 2, 1946, Green notified his sales force that two items from the 1946 catalog were being eliminated and production of most of the remaining items would be reduced by one-third, all due to the unavailability of bottles.

With supplies of glass blanks as the primary limiting factor on perfume atomizer sales, it is no surprise that the company's top management made finding new sources a top priority. Nothing was available from

war-ravaged Europe in late 1946, and early in 1947 DeVilbiss executives, including President Howard DeVilbiss, Floyd Green, and E. J. Etzel, toured more than thirty glass factories throughout Ohio, West Virginia, and Pennsylvania to determine their capacity, quality, and interest in providing blanks to De-Vilbiss. Several prominent glass companies, including Cambridge Glass Company, Fostoria Glass Company, Imperial Glass Company, A. H. Heisey, and Viking Glass Company, declined interest at that point, because their production capacities were fully engaged in producing their own product lines.

Several firms that did express interest ended up with large production orders for glass bottles from DeVilbiss for the 1947 product line. Fortunately a definitive record was found in the company's 1947 files that tells the story. The 1947 catalog lists seventeen products, all but one of which were new designs (the exception being a pre-war Fenton Coin Dot bottle), and with a top retail price of $5. These suppliers included Rochester Glass Company, the McBride Glass Company, U.S. Glass Company (Tiffin), Morgantown Glass Company, T. C. Wheaton Glass Company, Bryce Brothers Glass Company, and Fenton Art Glass Company. During February and March of 1947, these seven companies received orders for a total of 577,000 bottles. Shown on pages 262 and 263 are the 1947 catalog pages annotated with companies and quantities ordered.

Morgantown Glass Works

The Morgantown Glass Works was founded in 1899 in Morgantown, West Virginia. In 1903, the company discontinued production of pressed glass tableware and tumblers and was renamed the Economy Tumbler Company, producing blown stemware and barware for the bar goods market. In the late 1910s, the factory was modernized to produce colored glass decorative and tableware items.

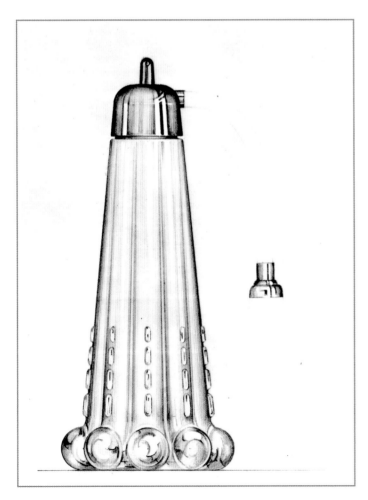

In 1923, to reflect the company's expanded product line, the name was changed, again, to Economy Glass Company. Finally, on July 1, 1929, the company name was changed back to Morgantown Glass Works, Inc. Eight years later, on October 15, 1937, the factory was closed, until January 1939, when it was restarted by Joseph E. Hayden under the name Morgantown Glassware Guild. It was a cooperative, employee-owned business, producing a high quality line of elegant colored and etched table and decorative ware.[2] During the 1940s, 1950s and 1960, Morgantown supplied DeVilbiss with large quantities of crackle glass blanks to be manufactured into perfume atomizers. Morgantown had produced crackle glass items for its own line under the brand "Craquelle".[3]

In April 1965 the Fostoria Glass Company of Moundsville, West Virginia, bought the Morgantown Glassware Guild and continued production, but in 1971 the factory closed for good.

Few Bottles in 1948

The year 1948 also offered little growth in the number of bottles presented, with only 18 known catalog items. One innovation for that year was the introduction of metal Perfumizers, including models meant to be carried in the purse, representing a return to this trade name after nearly twenty years, but for use only with metal perfume atomizers. By 1948, perfume atomizers and Perfumizers accounted for only 10% of The DeVilbiss Company's revenues.[4]

DeVilbiss artist's design of S350 Perfume Atomizer with bottle produced by Fenton (1947).

The First Post-war Catalog (1947)

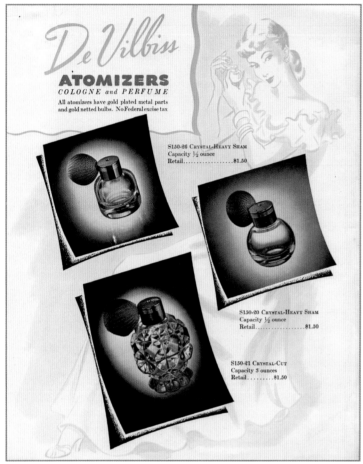

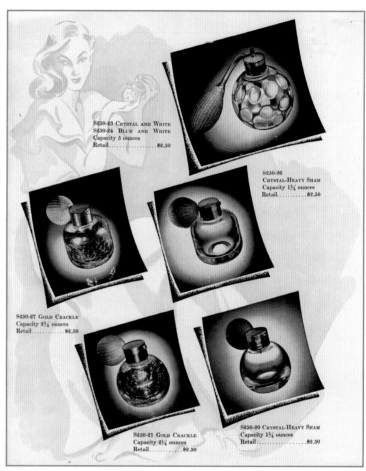

1947 DeVilbiss Catalog, page 1.

Upper left: S150-26 crystal heavy sham Atomizer,
46,000 bottles supplied by the McBride Glass Company.
Bottom left: S150-21 imitation cut (pressed) Atomizer,
200,000 bottles supplied by T. C. Wheaton Company.
Right: S150-20 crystal heavy sham Atomizer, 26,000
bottles supplied by McBride Glass Company and 20,000
of the same bottles supplied by Morgantown Glass
Company.

1947 DeVilbiss Catalog, page 2.

Upper right: S250-23 (crystal and white) and S250-24
(blue and white) Perfume Atomizers from Fenton,
order not specified as these were likely from pre-war
inventories.
Middle row left: S250-27 Gold Crackle Atomizer, 34,000
bottles supplied by the Rochester Glass Company.
Middle row right: S250-26 crystal heavy sham Atomizer,
24,000 bottles supplied by Rochester Glass Company.
Bottom left: S250-21 Gold Crackle Atomizer, 34,000
bottles supplied by Morgantown Glass Company.
Bottom right: S250-20 crystal heavy sham Atomizer,
10,000 bottles supplied by Morgantown Glass Company.

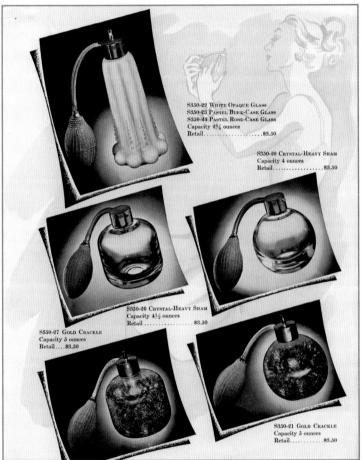

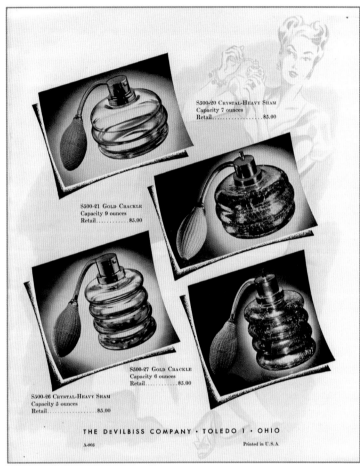

1947 DeVilbiss Catalog, page 3.

Upper left: S350-23 (Pastel Blue-Case Glass) and S350-24 (Pastel Rose-Case Glass) Perfume Atomizers, 25,000 bottles supplied by Fenton Art Glass Company (it is not known how this order was split among the three colors).
Middle row left: S350-26 crystal heavy sham Perfume Atomizer, 12,000 bottles supplied by Morgantown Glass Company.
Middle row right: S350-20 crystal heavy sham Perfume Atomizer, 12,000 bottles supplied by Morgantown Glass Company.
Bottom left: S350-27 Gold Crackle Perfume Atomizer, 24,000 bottles supplied by Morgantown Glass Company.
Bottom right: S350-21 Gold Crackle Perfume Atomizer, 24,000 bottles supplied by Morgantown Glass Company.

1947 DeVilbiss Catalog, page 4.

Upper left: S500-20 crystal heavy sham Perfume Atomizer, 12,000 bottles supplied by Morgantown Glass Company.
Middle right: S500-21 Gold Crackle Atomizer, 24,000 bottles supplied by the Morgantown Glass Company.
Bottom left: S500-26 crystal heavy sham Perfume Atomizer; 12,000 bottles supplied by U.S. Glass Company.
Bottom right: S500-27 Gold Crackle Perfume Atomizer, 24,000 bottles supplied by U.S. Glass Company.

What's in a Name? Perfumizers, Perfume Sprays, Perfume Atomizers and Back to Perfumizers

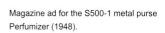

S500-1 Purse
Perfumizer in
transparent plastic case
with gold ribbon (1948).
Courtesy of Jim and Carole Fuller.

From time to time, DeVilbiss changed the trade names used in its catalogs for perfume atomizers, adjusting to consumer tastes in both bottles and perfumes. Here is the chronology:

1907—Beginning of use of the trademarked name "Perfumizer" when the division was formed
 1928—changed to "Perfume Spray"
 1932—changed to "perfume atomizer"
 1934—added "eau de cologne atomizer"
 1948—maintained use of "perfume atomizer" for glass and porcelain bottles; reverted to the use of "Perfumizer" but only for metal and purse atomizers. "Perfume atomizer" and "Perfumizer" remained in use until the close of the division in 1968. In some cases with large capacity bottles, "cologne atomizer" was used.

Why the change back to "Perfumizer"? As with most matters with companies, there was a business reason and in this case, the trademark for the brand name "Perfumizer" was due to expire, according to company records, and the "use it or lose it" rule applied. The DeVilbiss Company decided to protect and retain the trademarked name and chose to apply the term "Perfumizer" to its all-metal perfume atomizers.

Not long afterward, in the December 1948 company newsletter, the company announced that it had brought out a redesign, spurred by apparent marketplace confusion that the S500-1 purse Perfumizer was often mistaken for a lipstick. The announcement states:

It is a miniature display case in a transparent wrapper which reveals the Perfumizer ready for use—the cap separately tied down with gold cord on the tiny platform at the base. In this way there can be no confusion in buyers' minds that the Perfumizer is a lipstick. For, while the previous plastic globe packaging was very attractive, the Perfumizer was shown in assembled form and was easily mistaken for just another lipstick holder.[5]

Magazine ad for the S500-1 metal purse
Perfumizer (1948).

DeVilbiss News, December 1948, article
describing new gift packaging for the S500-5
Purse Perfumizer. *Courtesy of BGSU Center
for Archival Collections/DeVilbiss Corporation
Collection MS-604.*

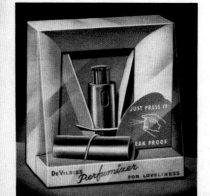

Attractive New Perfumizer Package

To spark sales of the handsome DeVilbiss purse Perfumizer in time for this year's Christmas buying, a beautiful new package has been created. It is a miniature display case in a transparent wrapper which reveals the Perfumizer ready for use—the cap separately tied down with gold cord on the tiny platform at the base. In this way there can be no continuance of the confusion in buyers' minds that the Perfumizer is a lipstick. For, while the previous plastic globe package was very attractive, the Perfumizer was shown in assembled form and was easily mistaken for just another lipstick holder.

Dealers May Insert Cards Atop Packages
For Ten Different Gift Occasions

The color combination of the new package is chartreuse and rose. An extra feature to aid gift selling on various occasions such as Valentine, Mother's Day, Easter, Graduation, etc., is a series of small cards for ten gift days which may be inserted in the top of the package and changed as the different seasons arrive.

S300-39 Classic Perfume atomizer, with gold crackle bottle and gold-finished spray fittings (1948). Height 2.5".

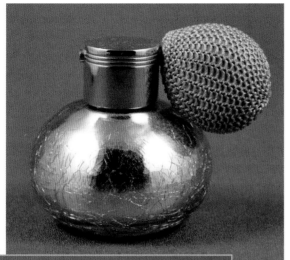

S1250-1 Classic Perfumizer in chromium finished metal container, billed as having "one-half dram capacity for precious and expensive perfumes," trade named by DeVilbiss as the "Classic Perfumizer" (1948). Height 5.25".

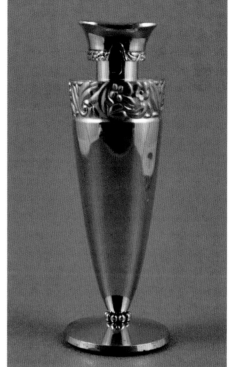

DeVilbiss News, November 1949, article describing the Classic Perfumizer, shown with deluxe gift box. *Courtesy of BGSU Center for Archival Collections/ DeVilbiss Corporation Collection MS-604.*

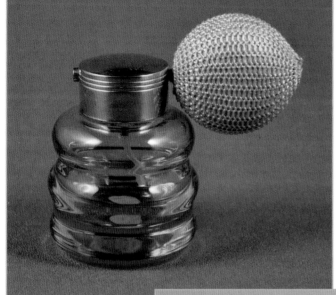

S200-34 Small-capacity (1.25-ounce) DeVilbiss perfume atomizer with a blue heavy sham bottle and gold-finished spray fittings (1949). Height 2.5".

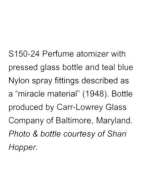

S150-24 Perfume atomizer with pressed glass bottle and teal blue Nylon spray fittings described as a "miracle material" (1948). Bottle produced by Carr-Lowrey Glass Company of Baltimore, Maryland. *Photo & bottle courtesy of Shari Hopper.*

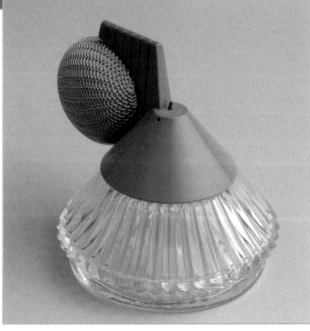

New Perfumizer Makes Appearance

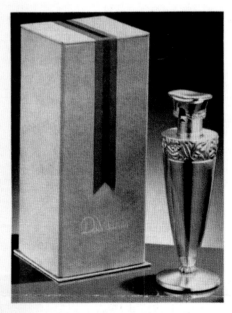

Here is the new Classic Perfumizer. Its slender vase shape has a patrician quality to its beauty, reminiscent of the early Roman period. Charmingly simple in design and fashioned of gleaming metal, it makes a unique and treasured possession. It will sell for $12.50 retail, and comes handsomely packaged in the ribbon-decked, sueded finish box shown.

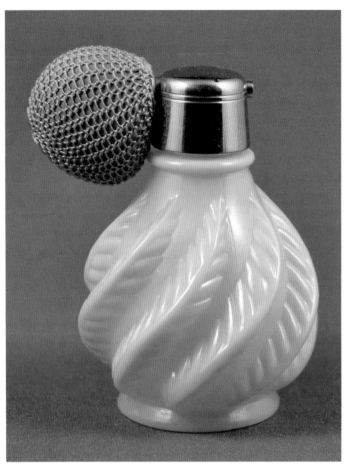

S200-36 Perfume atomizer with spiral leaf opal and crystal pastel enameled bottle from Fenton; gold-finished spray fittings (1949). Height 4".

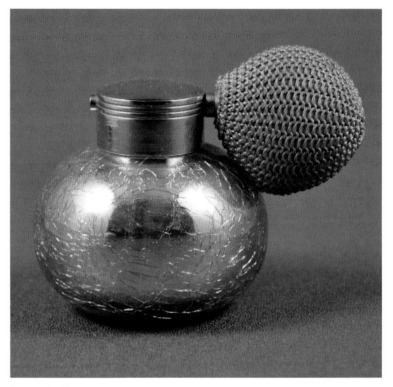

S250-39 Gold Crackle perfume atomizer, with gold-finished spray fittings (1949). Height 2.5".

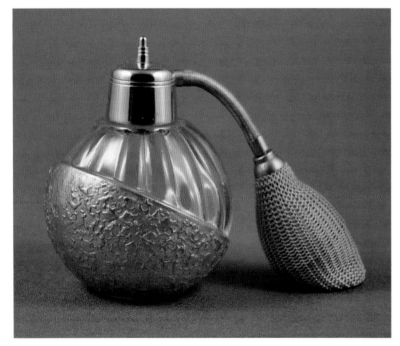

S350-38 Perfume atomizer with molded rib and half gold enameled sponge pattern bottle by the T. C. Wheaton Company, Millville, New Jersey; gold-finished spray fittings (1949). Height 3.75".

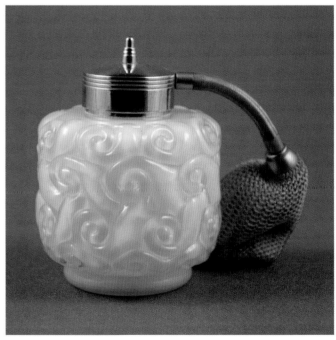

S500-36 Perfume atomizer, with a cased glass opaque pastel blue bottle by Fenton Art Glass Company; gold-finished spray fittings (1949). Height 3.25".

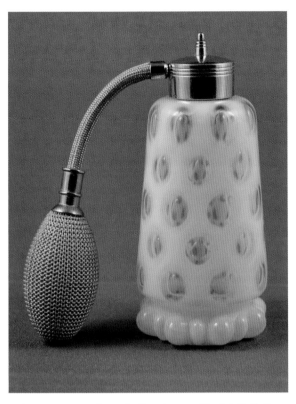

Perfume atomizer, with Fenton Art Glass Company Blue Coin Dot bottle and gold-finished spray fitting (c. 1949). Height 5".

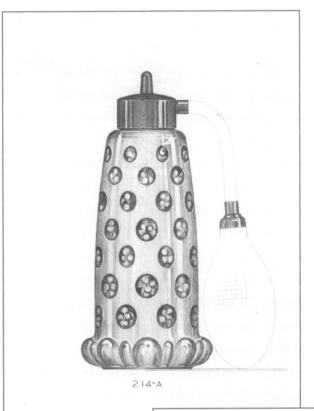

214-A

Artist's drawing of design number 214-A, perfume atomizer, with Fenton coin dot bottle, from factory records.

DeVilbiss Newsletter dated April 1949 reads, "A DeVilbiss applicator for hair lacquer or Brilliantine is a 'must' with Delores Ruth, of Dept. 78, whose attention to meticulous hair grooming was intensified when she enrolled several years ago for her first instruction in modeling as an aid to self-improvement." *Courtesy of BGSU Center for Archival Collections/DeVilbiss Corporation Collection MS-604.*

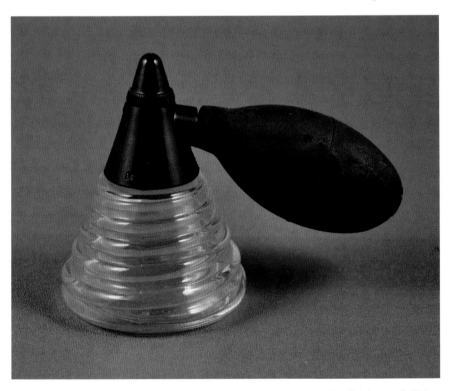

1949 DeVilbiss Brilliantine Sprayer for the application of hair lacquer. DeVilbiss developed a line of Brilliantine Sprayers (a predecessor to hairsprays).

DEMONSTRATES HAIR GROOMING

CHAPTER 6

A Return to Normalcy and
Focus on European Glass Masters

1950—1959

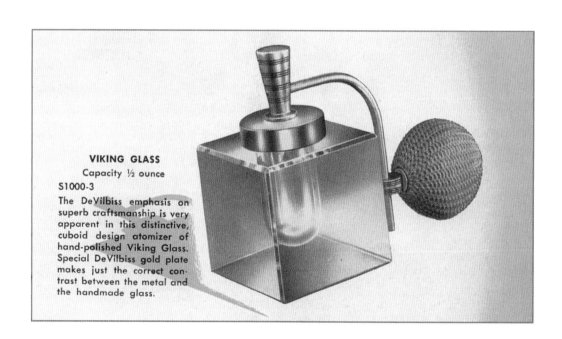

VIKING GLASS
Capacity ½ ounce
S1000-3
The DeVilbiss emphasis on superb craftsmanship is very apparent in this distinctive, cuboid design atomizer of hand-polished Viking Glass. Special DeVilbiss gold plate makes just the correct contrast between the metal and the handmade glass.

1951 retail catalog image of S1000-3 perfume atomizer with a heavy crystal cube bottle from Viking Glass.

A return to a normal peacetime economy and prosperity took place for DeVilbiss in the 1950s, with the notable exception of the Korean War from mid-1950 to mid-1953. With the industrial side of the business continuing to expand and absorb Toledo plant capacity, it was decided to move Perfume Atomizer production to a new, smaller plant in Somerset, Pennsylvania, along with the medical atomizer and instruments business; it remained there for the next seventeen years.

The Fenton bottles represent another relatively rare instance of DeVilbiss co-branding with a popular glass manufacturer, to capitalize on its brand name. Also, in 1950, the DeVilbiss retail catalog displayed a cubic crystal perfume atomizer proudly acknowledged to be of Viking Glass, another well-regarded quality glassware manufacturer of the time. And, in 1952, listed as Imported Venetian in the catalog description, the first bottle by Archimede Seguso of Italy appeared with its Seguso label clearly displayed both in the catalog and on the bottle itself.

Continuing its post-war practice of offering perfume atomizers for all budgets, and keeping the top-of-the-line still within reach, DeVilbiss offered retailers an assortment of twelve different Perfume Atomizers, of $1 to $1.25 retail, and provided that any style could be ordered, but in a minimum quantity of a dozen. The assortment cost the retailer $8.10. If they all sold for their suggested retail prices, the dealer would net a total of $13.50 and a profit of $5.40. The most expensive atomizer of the twenty-eight 1950 styles remained "the classic," a metal, chromium-plated, footed Perfumizer that had made its debut in 1948. Crackle glass remained popular with several perfume atomizers in a choice of gold or silver. Metal purse Perfumizers (with refillable glass perfume containers within) continued to be popular with three styles being carried over from the late 1940s.

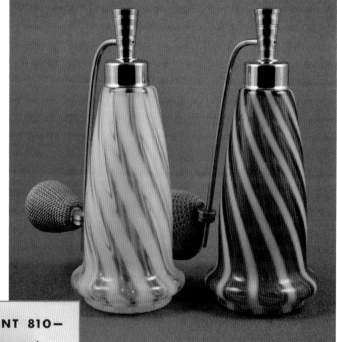

S500-51 (blue) and S500-52 (ruby) DeVilbiss perfume atomizers featuring Fenton Art Glass Company bottles with opalescent spiral ribs of white over transparent colored glass (1950). Height 6".

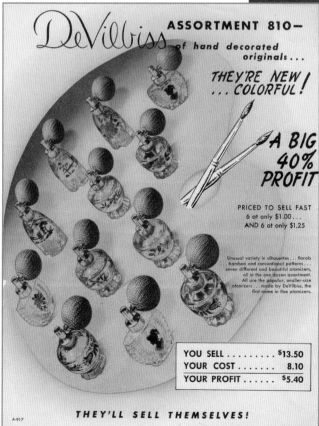

Advertisement to retailers of Gay Fad Studios for DeVilbiss assortment decorated by Gay Fad (1950).

The 1951 product line was little changed from 1950, with one exception: the addition of the S1000-3 co-branded, Viking Glass Perfume Atomizer. This may have been prudent and necessary, as 1951 was the year of moving production to the new plant in Somerset, so production and order fulfillment would have been challenging.

But 1952 was another matter, with eight new styles. Perhaps the most significant of these represented the first post-war return to the great glass houses of Europe, now beginning to resume production of beautiful art glass. The inaugural bottle was a large Perfume Atomizer from the great glassmaker Archimede Seguso, of Murano, Italy. It was the precursor of an increasing flow of new artistic glass blanks from numerous major European glassmakers, that would continue until 1968. Not only was the 1952 Seguso bottle's source significant, but it also was the first post-war attempt at a more expensive offering; at $25 it was twice the retail price of the costliest item of the previous year's line. This bottle (see opposite) was offered for only one year, 1952. Notice the Seguso labels.

DeVilbiss also purchased many bottles from G. S. Goodfriend Imports of Italy. Although they are included in the assembly specifications, these bottles (except for a few listed in the catalogs) were marketed as non-cataloged additions to the line, according to the corporate information available.

S100-40 Small perfume atomizer offered with Assortment 810 with green enamel oriental scene (1950). Height 3.5".

S100-38 Perfume atomizer offered with Assortment 810 with black enamel girl's head and neck profile decorated by Gay Fad Studios (1950). Height 3".

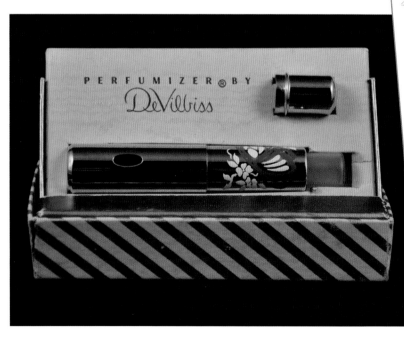

S300-3 Metal purse Perfumizer with enameled butterfly decoration in presentation box (1951). Height 4".

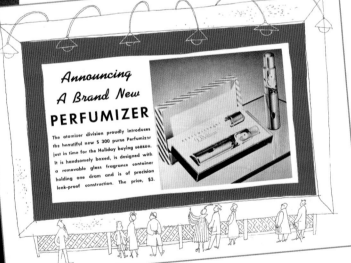

DeVilbiss magazine advertisement for S300 series purse Perfumizers (1950).

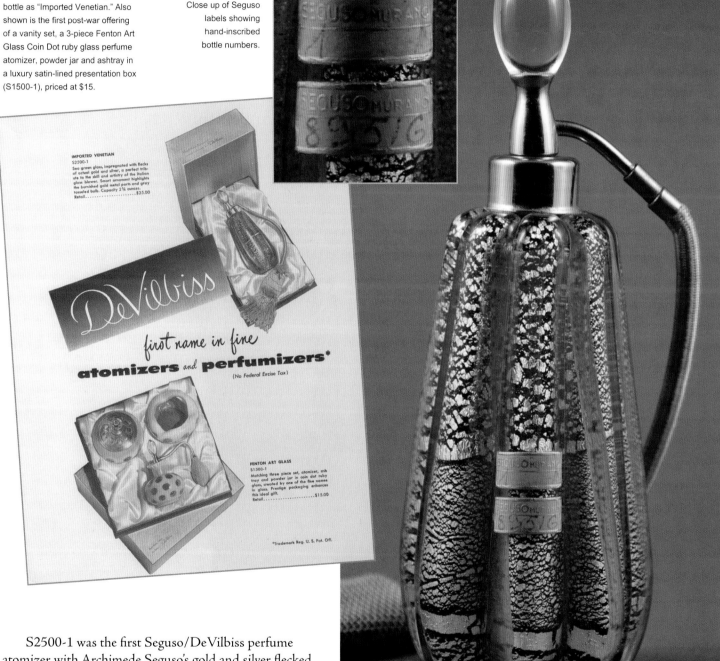

DeVilbiss 1952 catalog page advertising the S2500-1 Seguso bottle as "Imported Venetian." Also shown is the first post-war offering of a vanity set, a 3-piece Fenton Art Glass Coin Dot ruby glass perfume atomizer, powder jar and ashtray in a luxury satin-lined presentation box (S1500-1), priced at $15.

Close up of Seguso labels showing hand-inscribed bottle numbers.

S2500-1 was the first Seguso/DeVilbiss perfume atomizer with Archimede Seguso's gold and silver flecked Aventurine cased glass and ribbed bottle. It had gold-finished fittings with a Lucite ornament, original cord, and a tasseled ball. The top label on the bottle reads "Seguso Murano," and is hand-numbered "85916" on the lower label. DeVilbiss described this bottle as "Sea Green" in its 1952 catalog; its height is 7.25".

Also new in 1952 was a line of decorated perfume atomizers with star-studded plastic ornaments and stained and hand-painted decorations.

S2500-1 The first known DeVilbiss perfume atomizer bottle by Archimede Seguso (1952). Height 7.25".

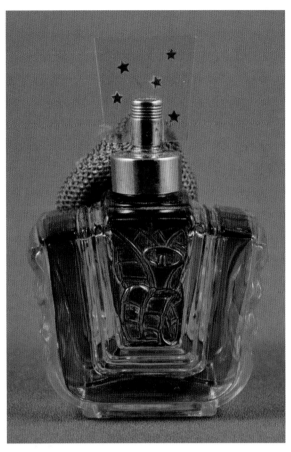

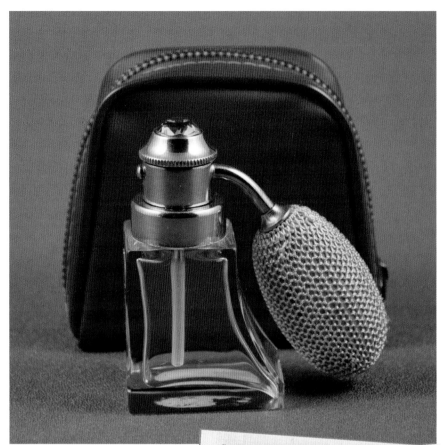

S200-6 Perfume atomizer with ruby stain, listed as "Ruby and Crystal" on keystone-shaped crystal bottle by Kimble Glass Company, Vineland, New Jersey and decorated by Gay Fad Studio of Lancaster, Ohio; "star-studded" ornament of clear plastic and gold finished spray fittings (1952). DeVilbiss patent designer Carl W. Sundberg. Height 4".

S895-2 Travel atomizer with hand-polished Carr-Lowrey crystal bottle, gold-finished fittings with amber glass faceted ornament and closure mechanism; in red nylon zippered travel case (1953). Height 2.75".

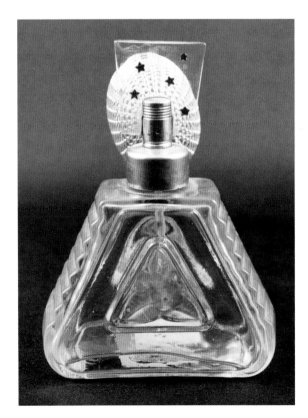

S200-8 Perfume atomizer with a yellow stain, listed as "Jonquil and Crystal" on triangular crystal bottle by the Kimble Glass Company, Vineland, New Jersey and decorated by Gay Fad Studio of Lancaster, Ohio; "star-studded" ornament of clear plastic and gold-finished spray fittings (1952). DeVilbiss patent designer Carl W. Sundberg. Height 4". *Courtesy of Jim and Carole Fuller.*

From the *DeVilbiss News* company newsletter of November 1954 showing airline stewardess with travel atomizer and case.

Atomizer Goes Everywhere

This well groomed airlines stewardess is showing you the new perfume-cologne atomizer, the DeVilbiss Traveler. It holds a half ounce of your favorite fragrance and is positively evaporation proof and leak proof. This lock-type atomizer is small enough to be contained in the palm of your hand. Naturally, it is light weight and very easily packed. The Traveler comes complete with a colorful case and is available at all leading department store cosmetic counters. It is a wonderful idea for a gift to give or get and costs just $7.50.

★ ★ ★

While the 1953 line did not feature any new imported bottles, a significant innovation was the reappearance of the turn-type closure mechanism that prevented leakage and evaporation, last seen in 1941 on the DeVilbiss higher-end bottles. Tightening the finial, or ornament, a half-turn would seal the contents in the bottle. Also, the glass bottle Travel Atomizer, in a travel case, made its first re-appearance since 1941. It used the classic, small, pre-war bottle from Carr-Lowrey Glass Company, but featured the new closure mechanism that assures, "not one single drop ever lost by evaporation or leakage." New also were the colored, zippered, nylon cases.

This bottle represented the first instance of DeVilbiss adopting, on a trial basis, a new selling technique, in widespread use ever since, of pricing a product at five cents below the round dollar amount, $8.95 rather than $9. This practice became more common for low-priced models; the high-priced models continued to be in round numbers.

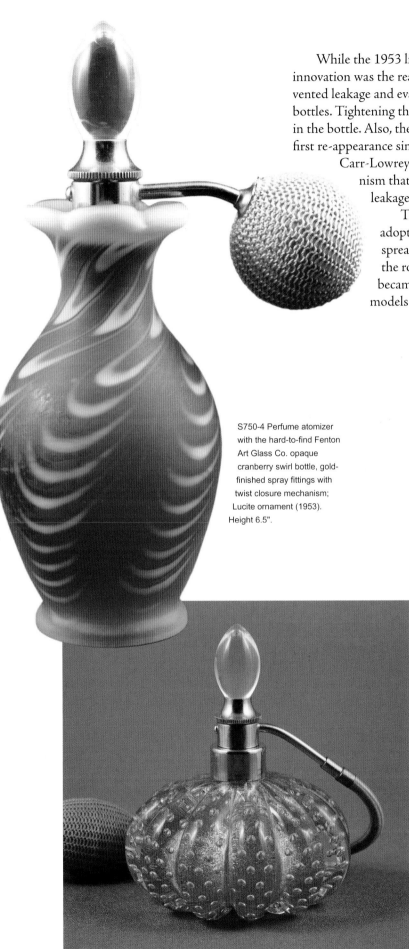

S750-4 Perfume atomizer with the hard-to-find Fenton Art Glass Co. opaque cranberry swirl bottle, gold-finished spray fittings with twist closure mechanism; Lucite ornament (1953). Height 6.5".

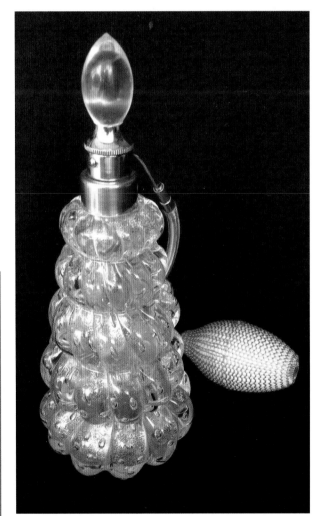

Perfume atomizer with gold Aventurine interior and controlled bubbles in a melon-ribbed crystal bottle from G. S. Goodfriend Imports, Italy; gold-finished spray fittings, Lucite ornament and closure mechanism, c. 1953. Height 5".

Perfume atomizer with gold Aventurine interior and controlled bubbles in a tiered-lobe crystal bottle from G. S. Goodfriend Imports, Italy; gold-finished spray fittings, Lucite ornament and closure mechanism (1953). *Courtesy of Cecile and Dick Miller.*

In 1954, there was an increasing number of perfume atomizers with bottles from Murano, Italy, some of which are not seen in retail catalogs but are listed in factory records. One hint for the collector to identify these is to notice the finial, or ornament, on high-end bottles. The Lucite-ornamented closure mechanism was not on bottles after 1954. In 1955, a Tiger Eye ornament was introduced on closure-equipped bottles, and in 1956 DeVilbiss introduced a gold-finished metal ornament, which constituted an additional type of closure cap on high-end bottles.

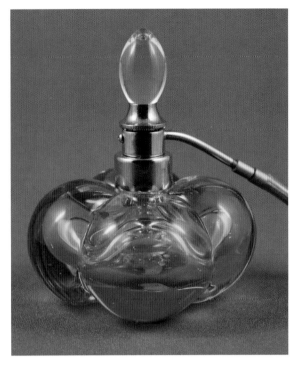

Perfume atomizer with blue four-lobe glass bottle, gold-finished spray fittings and Lucite ornament with closure mechanism, bottle from G. S. Goodfriend Imports, Italy (1953). Height 4.5".

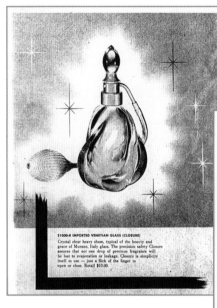

DeVilbiss 1954 retail catalog cover page image highlighting Perfume atomizer S1000-8 of *"Imported Venetian Glass…typical of the beauty and grace of Murano, Italy glass,"* offered in crystal only with a Lucite ornament and closure mechanism. Bottle by Archimede Seguso.

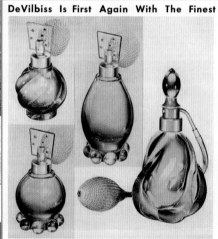

DeVilbiss Is First Again With The Finest

Over the years there have been many "firsts"—gold and silver crackle, purse atomizers, travel atomizers—just to mention a few. Now, introduced for the first time this year, there are new glass colors, new designs, new techniques in glass, new metal parts and even a new internal design which minimizes clogging. But probably the biggest "first" of all is the marvelous new closure that seals fragrances against leakage and evaporation.

Life Told The Story

The larger illustration above reveals one of the graceful Venetian glass creations for those who insist on the finest. The glass is created in the centuries-old tradition of the artisan glass blower of Murano, Italy—the story which many of you read recently in LIFE Magazine for July 31. The price of this clear crystal sham atomizer is $10. Its precision safety closure assures that not one drop of precious fragrance will be lost to evaporation or leakage.

The three other new styles shown are all topped with a star-studded crown of distinctive design. They range in price from $1.50 to $2.50 and are typical of the smart new line of DeVilbiss atomizers now being introduced.

DeVilbiss News article from August 1954 showing newly introduced bottles from Murano, Italy (right), and two styles with Imperial Glass Company's popular Candlewick pattern (center and lower left).

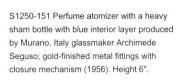

Perfume atomizer with smoke four-lobed heavy sham bottle from G. S. Goodfriend Imports, Italy, gold-finished spray fittings with Lucite ornament-topped closure (c. 1954). Height 6.5".

S1250-151 Perfume atomizer with a heavy sham bottle with blue interior layer produced by Murano, Italy glassmaker Archimede Seguso; gold-finished metal fittings with closure mechanism (1956). Height 6".

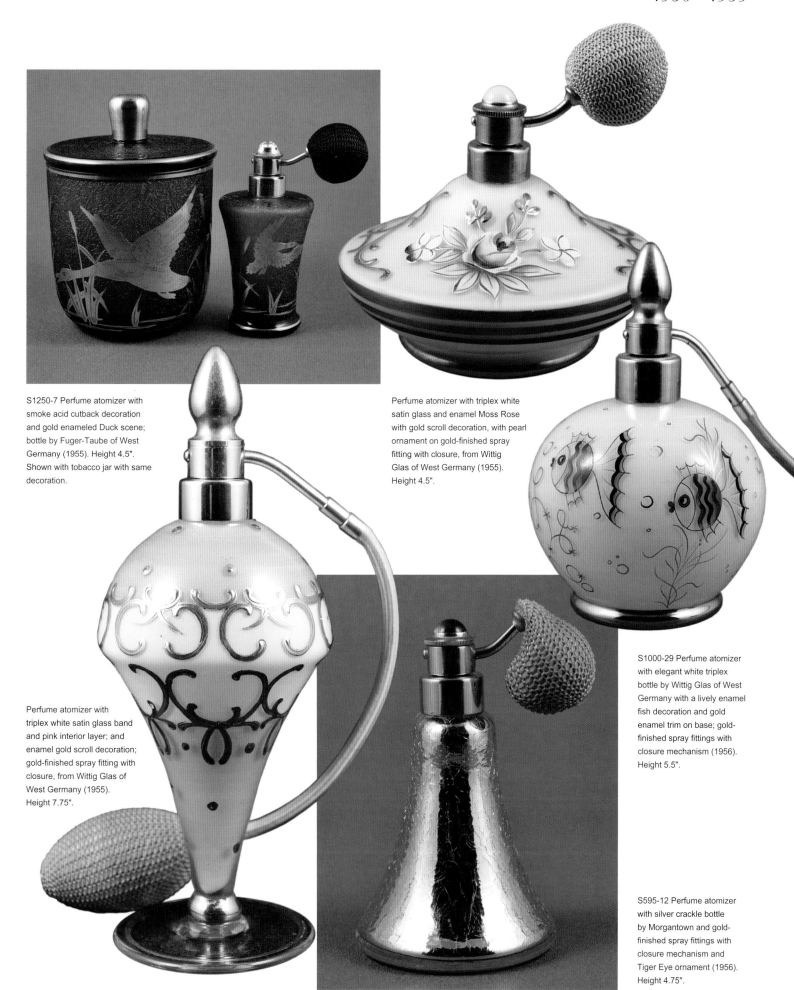

S1250-7 Perfume atomizer with smoke acid cutback decoration and gold enameled Duck scene; bottle by Fuger-Taube of West Germany (1955). Height 4.5". Shown with tobacco jar with same decoration.

Perfume atomizer with triplex white satin glass and enamel Moss Rose with gold scroll decoration, with pearl ornament on gold-finished spray fitting with closure, from Wittig Glas of West Germany (1955). Height 4.5".

Perfume atomizer with triplex white satin glass band and pink interior layer; and enamel gold scroll decoration; gold-finished spray fitting with closure, from Wittig Glas of West Germany (1955). Height 7.75".

S1000-29 Perfume atomizer with elegant white triplex bottle by Wittig Glas of West Germany with a lively enamel fish decoration and gold enamel trim on base; gold-finished spray fittings with closure mechanism (1956). Height 5.5".

S595-12 Perfume atomizer with silver crackle bottle by Morgantown and gold-finished spray fittings with closure mechanism and Tiger Eye ornament (1956). Height 4.75".

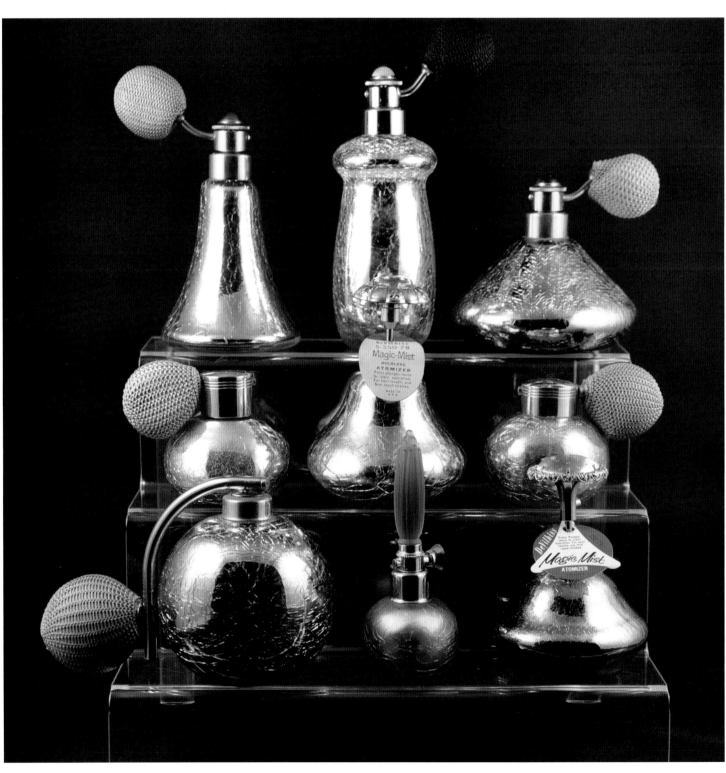

Examples of DeVilbiss Crackle Glass offered throughout the period of 1936 until factory closing in 1968. Top left: S595-12 Silver Crackle (1956); top middle: S500-66 Silver Crackle (1953); top right: S595-13 Gold Crackle (1956). Middle left: S300-39 (1948); middle center: S350-78 Gold Crackle (1961); middle right: S250-39 (1949). Bottom left: CS300-85 (1940); bottom middle: S250-30 (1936); bottom right: 350-29 (1966). S250-30 was the first Crackle Glass bottle and was supplied by the Cambridge Glass Company (bottom row center).

Crackle Glass: DeVilbiss's Longest-running Style

Crackle glass atomizers were one of the most popular and longest-running styles that DeVilbiss offered for over thirty years. Crackle glass was a popular decorating motif for a wide range of decorative and table glassware, beginning in the late 1920s. The crackle effect is created by submerging hot glass into a water bath, which creates a fracturing pattern on the surface of the glass. DeVilbiss purchased crackled glass from a number of suppliers and enhanced its appearance by applying an interior, mirror-like finish of gold or silver, and sometimes rose and blue, for a striking effect.

The first instance of a DeVilbiss crackle glass perfume atomizer was seen in the 1936 line, with a flame ornament designed by Vuillemenot and the only instance of a bottle with a satin finish, rather than a mirror finish. The bottle and flame ornament were supplied by the Cambridge Glass Company. Both crackled and non-crackled versions of the same bottle shape were offered; the crackle effect could not be produced on heavy sham blanks.

Crackle glass blanks are known to have been supplied to DeVilbiss by the Cambridge Glass Company, a Swedish glass company, and later by Morgantown, U.S. Glass, Kimble, and Rochester Glass Company, in the 1940s, 1950s and 1960s. Morgantown was the predominant crackle glass supplier in the 1950s and 1960s.

S595-13 Perfume atomizer with gold crackle bottle by Morgantown and gold finished spray fittings with closure mechanism and Tiger Eye ornament. (1956). Height 3.75".

Base of G. S. Goodfriend Imports, IT, bottle with fragment of the sticker.

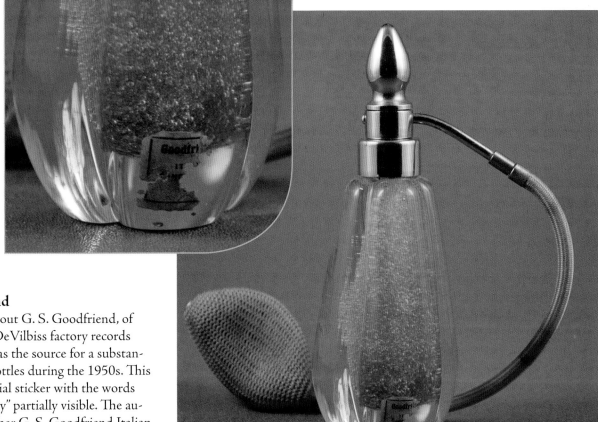

G. S. Goodfriend

Little is known about G. S. Goodfriend, of Italy, other than that DeVilbiss factory records indicate the company as the source for a substantial number of glass bottles during the 1950s. This is one, featuring a partial sticker with the words "Goodfriend" and "Italy" partially visible. The authors have found another G. S. Goodfriend Italian glass example where the full label is visible.

Perfume atomizer with four-lobed crystal bottle and "Sea Foam" interior treatment, bottle from G. S. Goodfriend Imports, Italy; gold-finished spray fittings with closure mechanism (1955). The bottle truly reminds one of a churning sea. Height 6".

The 1955 Retail Catalog

Four panels, with glassmaker attribution from the factory production records.

1955 catalog page 1. All bottles from Buschman, West Germany.

1955 catalog page 2. Top left: Morgantown; top right: Morgantown; middle right: Bryce Brothers; bottom: Carr-Lowrey.

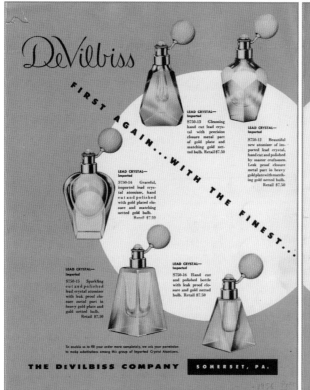
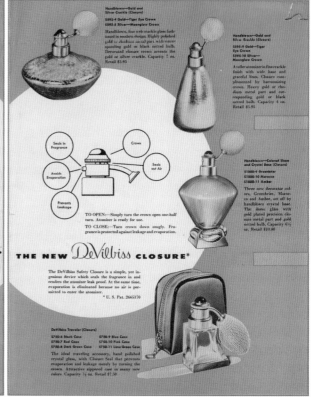

1955 catalog page 3. Top left: Kimble Glass Co.; top right: Morgantown; middle left: Morgantown; middle right: Morgantown; bottom left: Morgantown; bottom right: Morgantown.

1955 catalog page 4. Top left: Imperial Glass Co.; top right: Imperial Glass Co. Candlewick pattern; middle left: Wittig Triplex glass; middle right: Wittig alabaster glass; bottom left: Wittig Triplex glass; bottom right: Wittig Triplex glass.

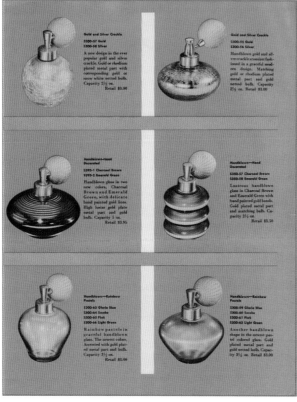
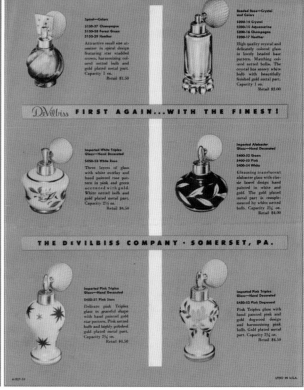

The 1956 Retail Catalog

Three panels are shown. Where known, glassmaker attribution is from factory production records. Hand notations are by DeVilbiss employees of the period.

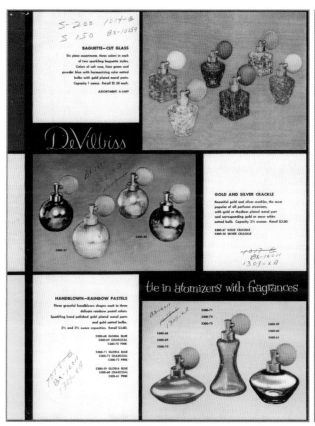

1956 catalog page 1. Middle row: all by Kimble Glass; bottom row: all by Morgantown.

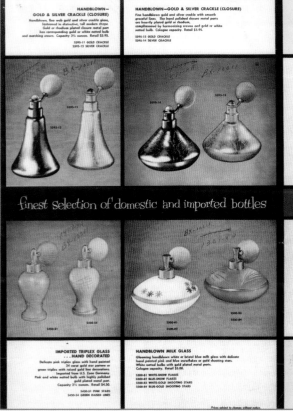

1956 catalog page 2. Top row: all Morgantown; bottom left: Wittig; bottom right: Morgantown.

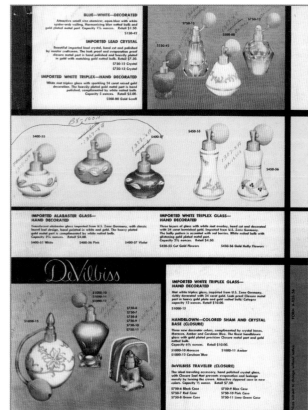

1956 catalog page 3. Top row—second from left: Buschman, West Germany; second from right: Wittig; right: Buschman, West Germany. Middle row— all from Wittig. Bottom row—left: Wittig; middle: Bryce Brothers; right: Carr-Lowrey.

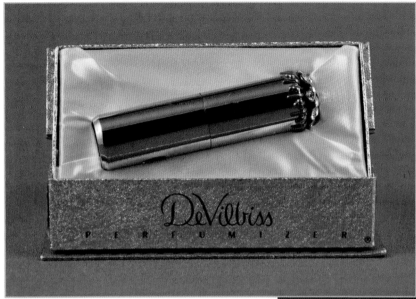

S500-10 Metal purse Perfumizer with crystal jeweled top in satin-lined presentation case (1957). Height 3.25".

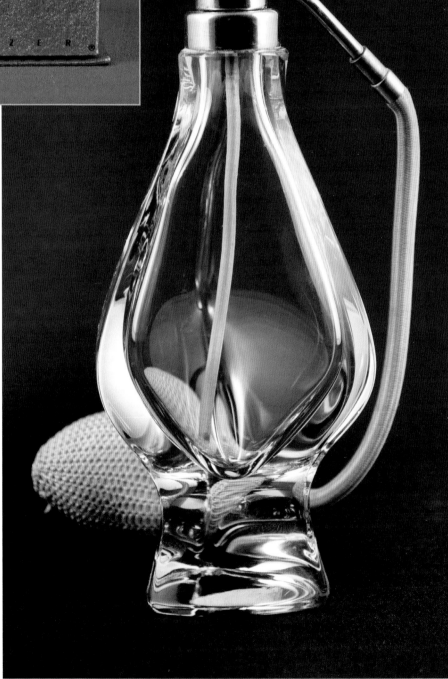

S1250-16 Perfume atomizer with Jonquil (yellow) heavy sham bottle supplied by Hessen Glaswerke, West Germany (1957). Height 6.25".

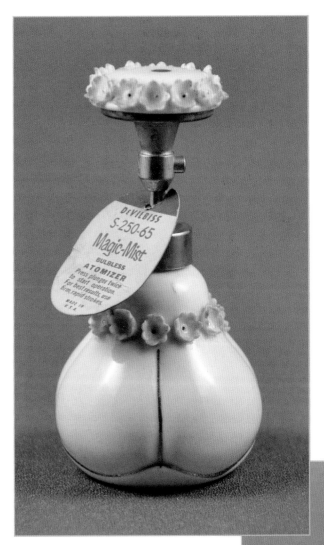

S250-65 Perfume atomizer with porcelain bottle from Fairfield of Japan, pink forget-me-nots applied to bottle and spray plunger (1958). Height 4.25".

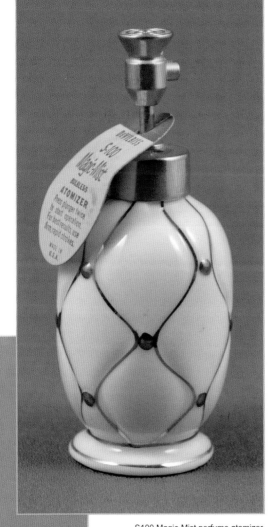

S100 Magic-Mist perfume atomizer with white porcelain bottle from Fairfield of Japan with gold enamel decoration; gold-finished plunger spray fitting (1959). Height 4".

S300-84 Perfume atomizer with white porcelain bottle from Fairfield of Japan, applied flower bouquet decoration; plunger type spray actuator (1958). Height 4.25".

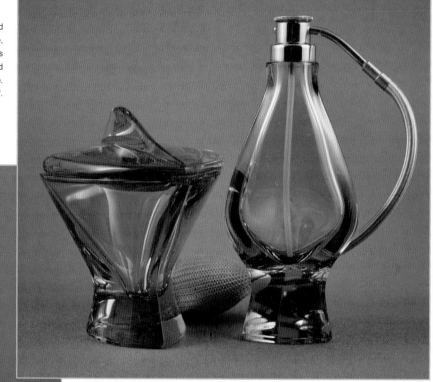

S2500-3 Amethyst perfume atomizer and powder jar supplied by Hessen Glaswerke, West Germany, in heather with blown glass heavy sham bottle and jar; gold-finished spray fittings with closure mechanism (1959). Atomizer height 6.25".

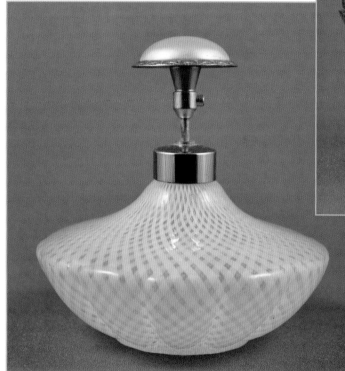

S1000-32 Perfume atomizer with Latticino glass bottle by Toso, Murano, Italy; pearl glass jewel on plunger (1959). Height 4.75".

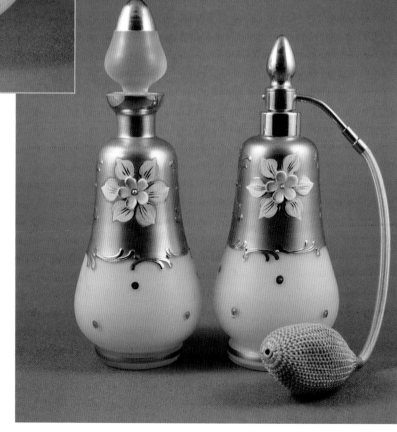

Impressive large perfume atomizer and Cologne set on white triplex glass by Wittig, West Germany, decorated with rich gold enamel and applied flowers. Perfume atomizer with gold-finished spray fittings (1959). Height (atomizer) 7".

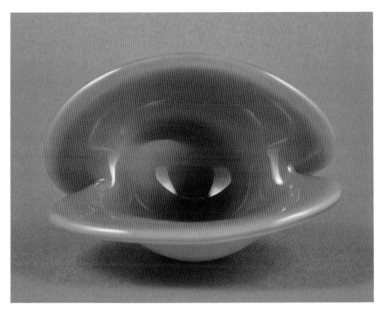

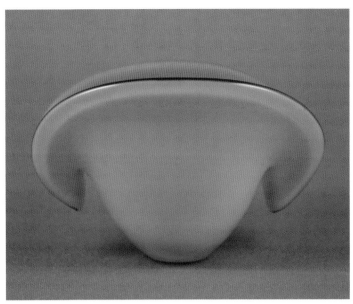

S1000-3 DeVilbiss multi-purpose dresser bowl in the form of a clam shell with three-layer cased glass using pink, white and clear layers, made by Archimede Seguso, Murano, Italy (1959). Width 6.25".

S1000-3 Second view of Seguso Clam Shell.

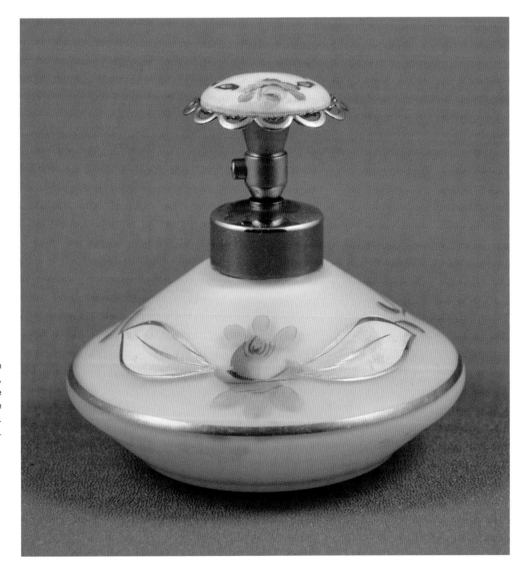

S450-63 Perfume atomizer with white triplex glass by Wittig, West Germany, enameled rose and gold decoration on bottle and plunger ornament (1959). Height 3.5".

The Final Years

1960 – 1968

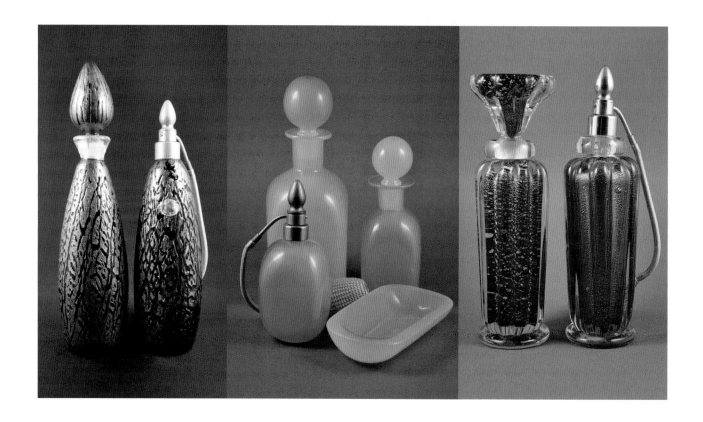

Three DeVilbiss perfume atomizer sets of the 1960s with bottles by renowned Italian glassmaker Archimede Seguso, Murano, Italy.

International Influence of the 1960s

The 1960s saw a major profusion of brilliant new designs, styles, and bottle types, until Perfumizer and perfume atomizer production was closed in 1968. Many major American glass companies went out of business in the 1950s and earlier, primarily due to higher production costs than their foreign competitors. Thus, it is not surprising that DeVilbiss turned for its bottles both to the east, to glass artists of Murano, Italy; Germany; and France; and to the west, Japan. While some U.S. companies, including Morgantown and Kimble, remained as suppliers, a growing portion of products was imported.

Beginning at the end of the 1950s, new products that became increasingly present were primarily from international sources, including Murano art glass bottles from Seguso, Toso, Moretti, Da Prato, and Goodfriend Imports; German glass from Fuger-Taube, Hessen Glaswerke, Steiner & Vogel; French bottles from Waltersperger and Brosse; and porcelain bottles and vanity accessories, including many figurals, perfume and night lights, and a children's line, from Fairfield of Japan, to name just a few that were prominent.

Large jeweled flower spray-topped ornaments gained popularity on bottles from several international sources; the metal flower spray-topped pieces were all made in West Germany. Morgantown continued to supply the ever-popular crackle-glass bottles until 1968. On all but a few higher-end models, plungers replaced squeeze bulbs as the spray actuator.

Archimede Seguso

The Italian glass company Seguso Vetri d'Arte, founded in 1933 by the Seguso family, produced signature pieces in the 1950s and 1960s, including Sommerso styles and clamshell shapes. Sommerso is one of the techniques most associated with Murano, Italy, and is produced by many furnaces to this day. It is heavy, with a thick base of clear glass containing a thin layer of a contrasting color, submerged below the main body color. A fine example in dark green and yellow was purchased by Frank Lloyd Wright and kept in his home.

Veteria Archimede Seguso was founded in 1946 by Archimede Seguso, a partner and maestro at Seguso Vetri d'Arte until 1942. Seguso was one of the great glass designers and maestros of all time, whose pieces were often featured in the Venice Biennali. He was most famous for his Merletto vases, using the ancient technique of filigrana.

Seguso supplied DeVilbiss with many stunning bottle blanks and accessories from 1952 until 1968.

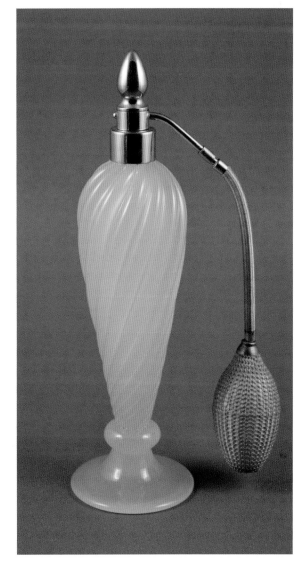

2500-38 Tall graceful perfume atomizer with yellow twist body and alabaster foot by Archimede Seguso of Murano, Italy; gold-finished spray fittings with closure mechanism (1967). Height 7.5".

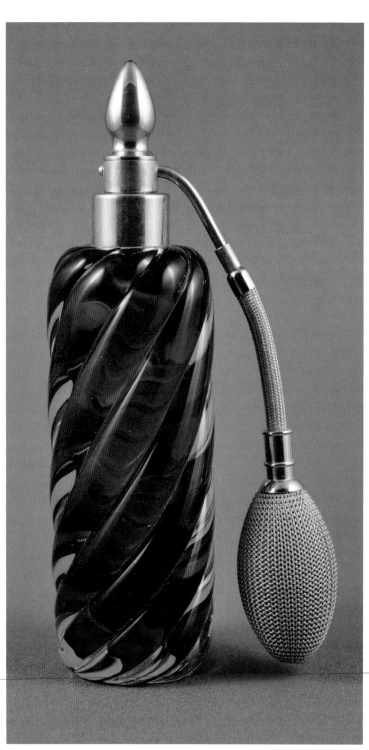

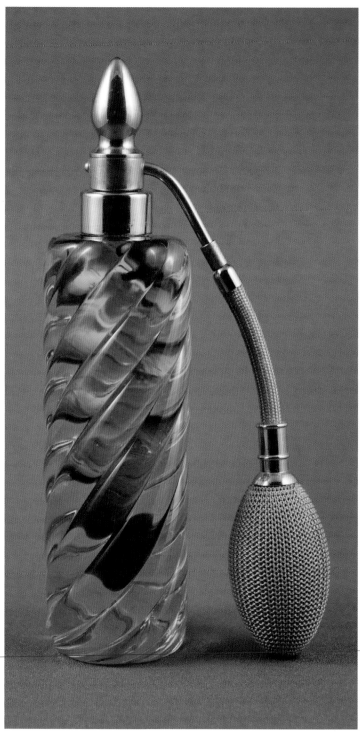

1750-23 Perfume atomizer with Sommerso bottle with crystal over red and blue glass layers in a twist construction, by Archimede Seguso, Murano, Italy; gold-finished spray fittings with closure mechanism (1964). Height 7.5".

2250-3 Perfume atomizer with bottle with aquamarine over a green interior layer in a twist construction, by Archimede Seguso, Murano, Italy; gold-finished spray fittings with closure mechanism (1965). Height 7.5". Note this bottle is more slender than the previous Seguso twist bottle and consists of only two, not three, layers of glass.

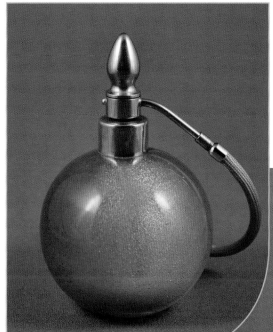

1500-65 Large round perfume atomizer with green and gold Aventurine bottle by Archimede Seguso of Murano, Italy; gold-finished spray fittings with closure mechanism (1967). Height 5.75".

1500-53 Perfume atomizer and 1500-52 Perfume Dropper with green and gold Aventurine bottles by Archimede Seguso, Murano, Italy (1965). The sales forecast was for 100 of each item in 1965. Height (dropper) 5.75".

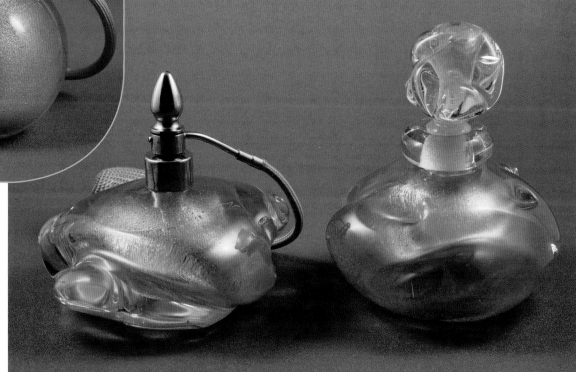

1500-66 DeVilbiss pair of Perfume Droppers with green and gold Aventurine bottles and gold on the stopper; glass by Archimede Seguso, Murano, Italy (1967). Height 4".

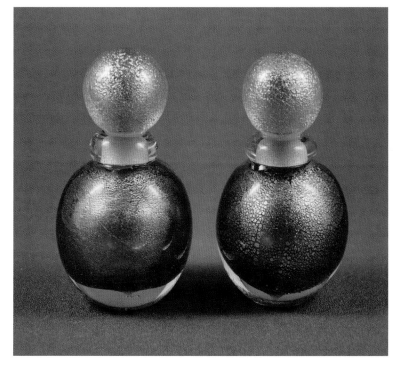

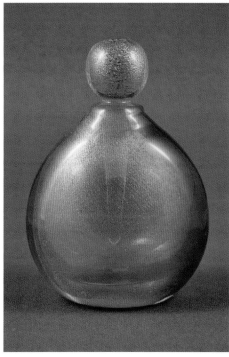

Perfume Dropper from 2500-30 perfume atomizer and dropper set; with green and gold Aventurine treatment on bottle and stopper, by Archimede Seguso (1965). Height 6.5"; width 4.5".

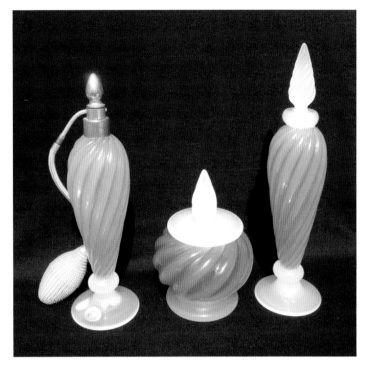

3500-4 Three-piece vanity set with a tall perfume atomizer, cologne and powder jar in a pink and alabaster Twist pattern by Archimede Seguso of Murano, Italy (1965). Atomizer height 9.75". *Courtesy of Richard and Cecile Miller.*

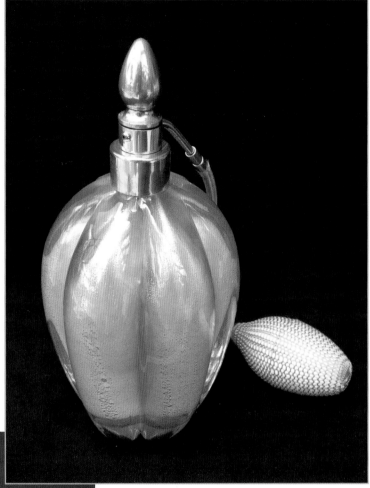

2000-33 Perfume atomizer with pink and crystal cased bottle with gold-finished spray fittings (1968). Bottle by Archimede Seguso. *Photo and bottle courtesy of Cecile and Dick Miller.*

3500-5 Tall perfume atomizer and cologne set in Red Arabesque cased glass with gold treatment on exterior supplied by Archimede Seguso; satin-finished gold spray fittings with closure mechanism (1965). Height 9.5" (atomizer).

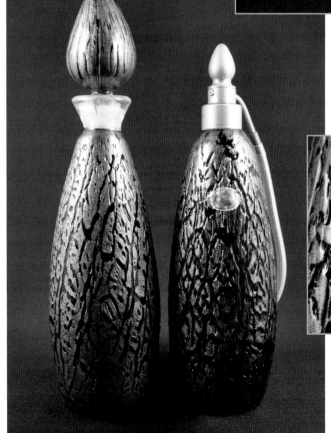

Red foil label reads "Archimede Seguso Murano Made in Italy."

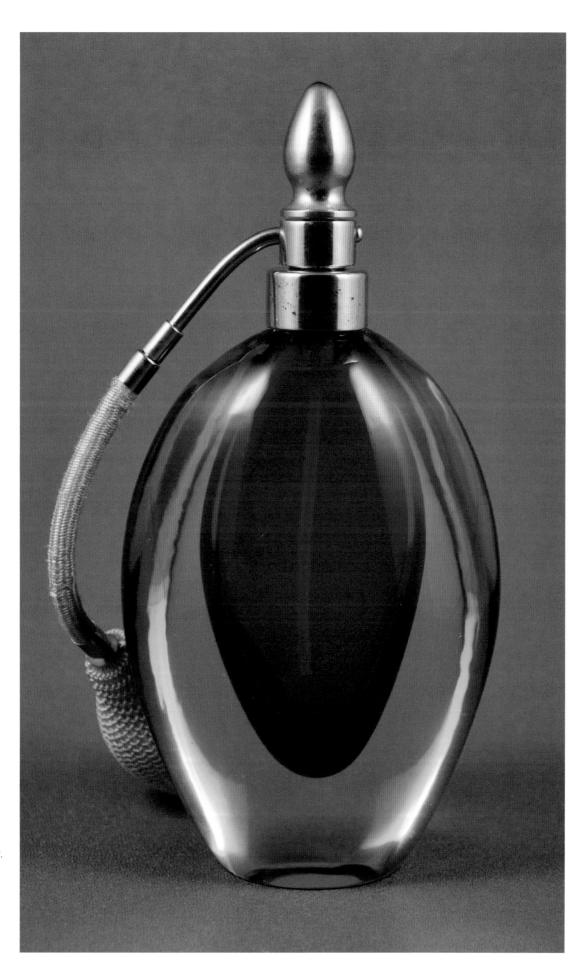

Archimede Seguso
Sommerso parfume
atomizer (1965). Height 7".

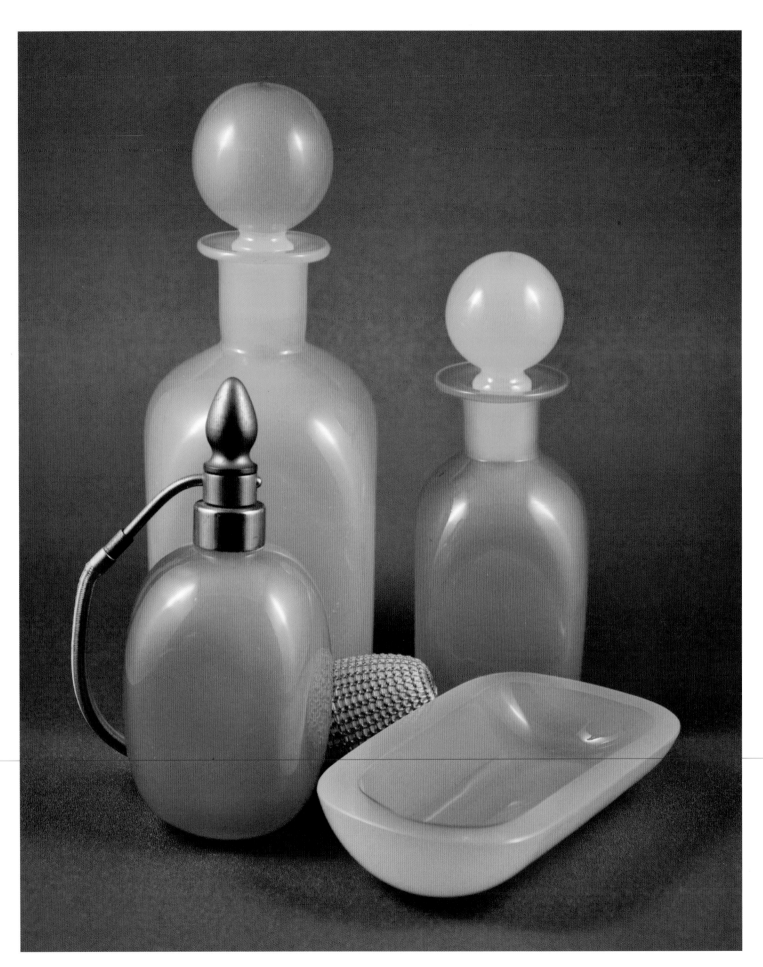

Magic-Mist and Country-of-Origin Labeling Issues

Plunger or pump-type perfume atomizers increasingly became the norm at DeVilbiss after 1957, replacing the rubber squeeze bulbs that were in almost universal use since the beginnings of the Perfumizer in 1907. The "Magic-Mist" trade name came into use for De-Vilbiss plunger-type perfume atomizers around 1960 and appeared on tags hooked to the shaft of the plunger. In 1962, increasing lower-cost imports of many kinds, from recovering companies in Japan and Europe, created price competition problems for many U.S. companies. In the early 20th century, the U.S. federal government had enacted laws requiring all imported products to bear clear labels indicating their country of origin. These laws were enforced by the U.S. Federal Trade Commission (FTC), and DeVilbiss began to run into problems.

Prior to 1962, long after the country of origin laws were enacted, the DeVilbiss "Magic-Mist" tags continued to read "Made in USA," even though the bottles were imported. The thinking at DeVilbiss was that the atomizer parts were made and the bottles were assembled in the United States. The FTC discovered this and, as with many companies, required DeVilbiss to make some labeling changes. Beginning in 1962, the DeVilbiss "Magic-Mist" tags read "Atomizer Made in USA" and "Bottle Imported." The FTC also required DeVilbiss not to affix its product stickers on top of the country of origin stickers but to put them alongside instead. "Magic-Mist" tags on perfume atomizers with crackle glass bottles supplied by Morgantown continued to correctly display the words "Made in USA."

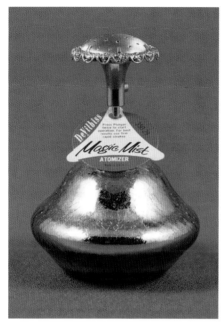

350-29 Perfume atomizer with gold crackle glass bottle by Morgantown; gold-finished spray fittings with gold-finished ornament on plunger. Magic Mist store tag. (1966). Height 4".

Opposite:
4250-2 Green alabaster deluxe vanity and bath set with perfume atomizer, two stoppered bathroom bottles and a soap dish; by Archimede Seguso of Murano, Italy; perfume atomizer with satin-finished gold plated spray fittings and closure mechanism (1965). Height of large bottle 9".

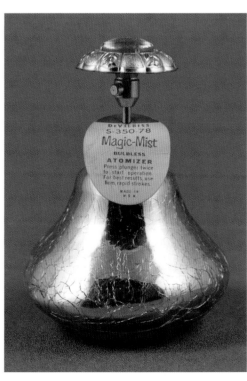

S350-78 Perfume atomizer with gold crackle bottle and gold finished fittings with floral embossing pattern on plunger; yellow glass jewel (1961). Bottle by Morgantown Glass. Magic Mist tag reads: "Bulbless Atomizer. Press plunger twice to start operation. For best results, use firm, rapid strokes." Note: DeVilbiss competitor Irice sold similar bottles as "Presto Mist". Height 4.25".

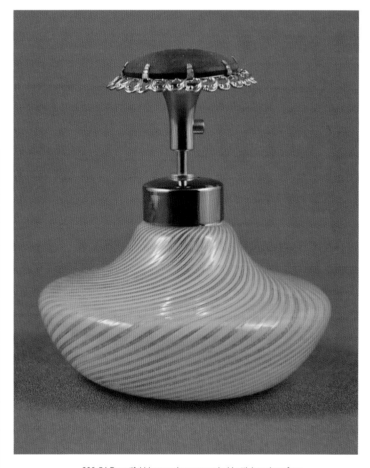

600-54 Beautiful blown pale green spiral Latticino glass from Toso, Murano, Italy; gold-finished pump atomizer fittings with frosted green glass jewel (c. 1962). Height 4".

The Umbrella Girls

In 1960, DeVilbiss introduced the popular "Umbrella Girls" line of decorated figural porcelain atomizers from Fairfield of Japan; each shows a girl holding an umbrella. These bottles would remain part of the product line until 1968.

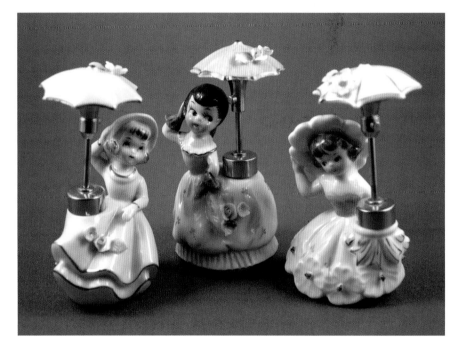

They came in a variety of figures, all with very artfully decorated glazed enamels and applied flowers, and with gold enamel highlights. For each year, the "Umbrella Girls" presented were different. Throughout their nine years as part of DeVilbiss offering, twenty-eight different figural "Umbrella Girls" are seen, all with a different girl in a slightly different pose, some with the umbrella to her right and others to her left. The umbrella served as the atomizer's plunger actuator, and the perfume was placed directly into the porcelain body of the figural. Each was five inches in height, and had a gold enamel "DeV" signature on bottom. Some are found with a paper label stating "Bottle made in Japan"; others are marked in red, "Japan." They were obviously popular as novelty gifts, as few DeVilbiss products ever remained in its offering over such a long period. They remain popular with collectors today.

DeVilbiss "Umbrella Girls" supplied by Fairfield, Japan, three different years shown.
Left: Umbrella Girl atomizer from A-7207 Assortment; porcelain figural with glazed enamel decoration from Fairfield of Japan with girl holding bonnet, umbrella on her right, applied flowers on umbrella and skirt (1961). Height 5".
Center: Umbrella Girl atomizer from A-7207 Assortment; porcelain figural with glazed enamel decoration from Fairfield of Japan with girl holding her hair, umbrella on her left, pink enamel skirt and umbrella, applied flowers on skirt and umbrella (1966). Height 5".
Right: Umbrella Girl atomizer from A-7207 Assortment; porcelain figural with glazed enamel decoration from Fairfield of Japan with girl holding bonnet, umbrella on her left, molded glazed yellow flowers on skirt, applied flowers on umbrella (1962). Height 5".

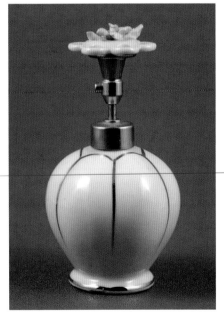

Perfume atomizer from Assortment A-4804 with white porcelain bottle from Fairfield and gold enamel decoration; lace plunger top with applied rose (1961). Height 4.25".

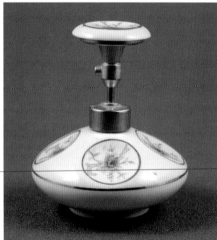

200-40 Perfume atomizer with porcelain bottle supplied by Fairfield of Japan, with cameo-style images of a rose bouquet on the bottle and plunger; gold-finished spray fittings (1962). Height 3.25".

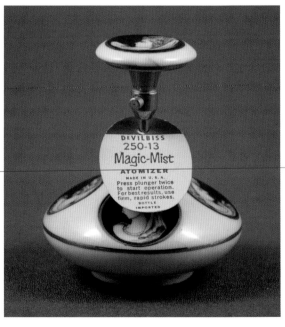

250-13 Perfume atomizer with porcelain bottle by Fairfield of Japan, with cameo-style images of two classical women on the bottle and plunger; gold-finished spray fittings (1962). Height 3.25". DeVilbiss tag with "Bottle Imported" legend.

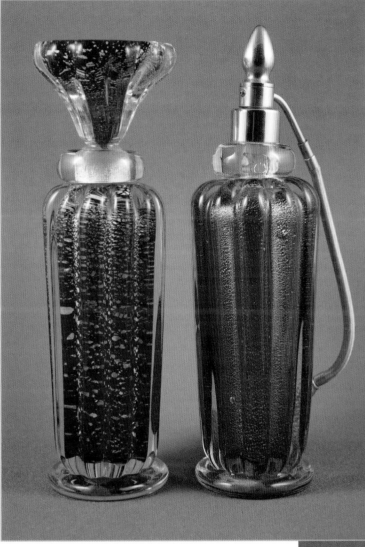

2500-15 Dramatic large ruby and gold perfume atomizer and cologne set with Aventurine gold flecks by Archimede Seguso; gold-finished spray fittings with closure mechanism (1962). Sticker on bottom "Made in Murano Italy." Height 9".

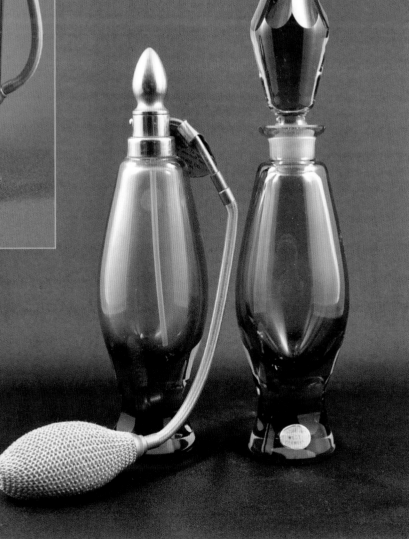

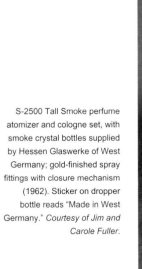

S-2500 Tall Smoke perfume atomizer and cologne set, with smoke crystal bottles supplied by Hessen Glaswerke of West Germany; gold-finished spray fittings with closure mechanism (1962). Sticker on dropper bottle reads "Made in West Germany." *Courtesy of Jim and Carole Fuller.*

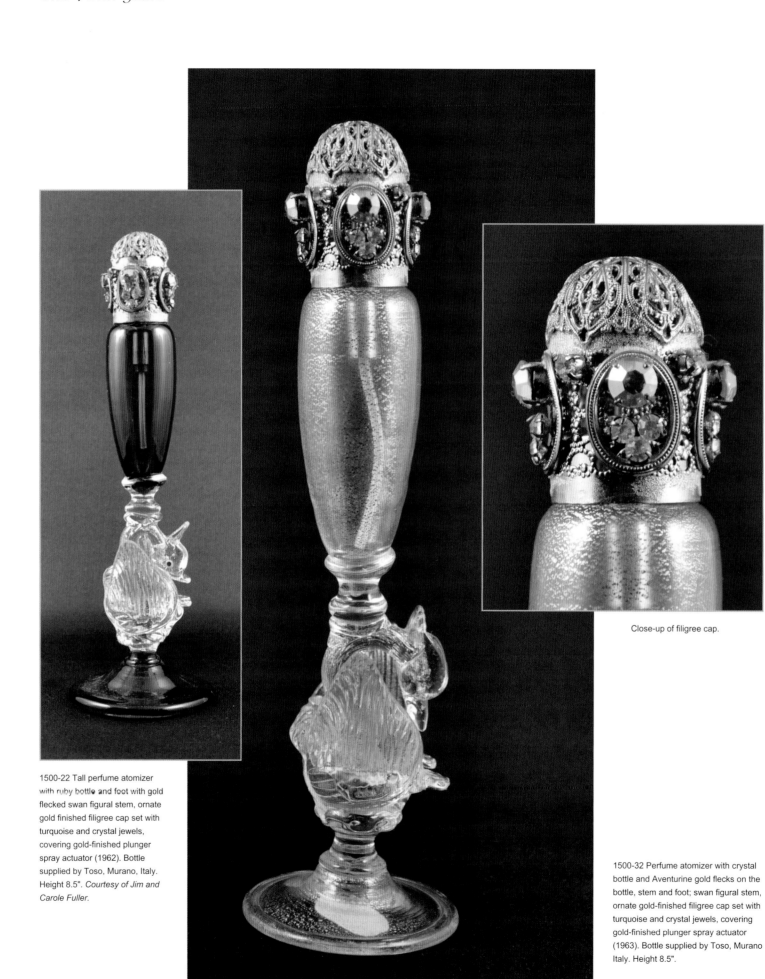

Close-up of filigree cap.

1500-22 Tall perfume atomizer
with ruby bottle and foot with gold
flecked swan figural stem, ornate
gold finished filigree cap set with
turquoise and crystal jewels,
covering gold-finished plunger
spray actuator (1962). Bottle
supplied by Toso, Murano, Italy.
Height 8.5". *Courtesy of Jim and
Carole Fuller.*

1500-32 Perfume atomizer with crystal
bottle and Aventurine gold flecks on the
bottle, stem and foot; swan figural stem,
ornate gold-finished filigree cap set with
turquoise and crystal jewels, covering
gold-finished plunger spray actuator
(1963). Bottle supplied by Toso, Murano
Italy. Height 8.5".

1000-63 Perfume atomizer with a satin finished black bottle by Fuger-Taube of West Germany; metallic gold decoration, satin black glass ornament in filigree plunger top set with crystal jewels (1964). Height 3.5".

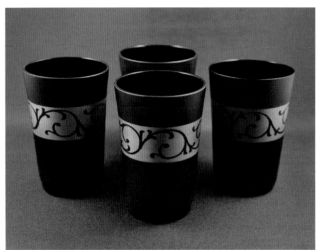

400-15 Set of four 6-ounce tumblers with satin-finished black glass and gold band decoration, by Fuger-Taube of West Germany (1965). These tumblers were also offered as part of the 2250-1 4-piece bathroom set. Height 4".

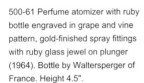

500-61 Perfume atomizer with ruby bottle engraved in grape and vine pattern, gold-finished spray fittings with ruby glass jewel on plunger (1964). Bottle by Waltersperger of France. Height 4.5".

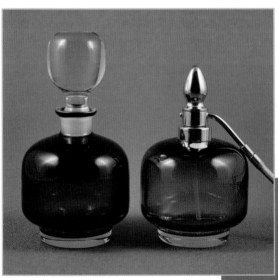

1750-26 Perfume atomizer and Perfume Dropper set with clear glass cased over amethyst bottles by Hessen Glaswerke of West Germany; gold-finished spray fittings with closure mechanism (1964). Stickers: "Made in Western Germany." Height (atomizer) 4.5".

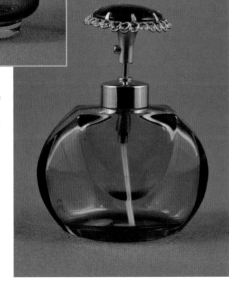

500-80 Perfume atomizer with Sea Green bottle by Hessen Glaswerke of West Germany, gold-finished spray fittings with green glass ornament on plunger matching the bottle (1965). Height 4.5".

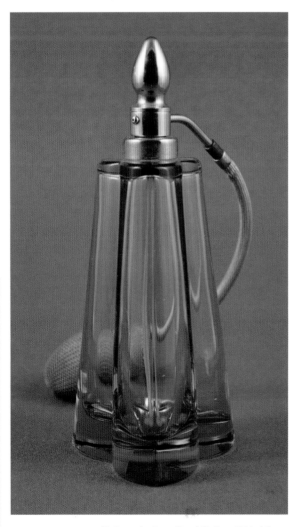

Perfume atomizer with a delicate orchid trefoil heavy sham bottle by Hessen Glaswerke of Germany; gold-finished spray fittings with closure mechanism (c. 1965). Height 6.5".

The Final Years

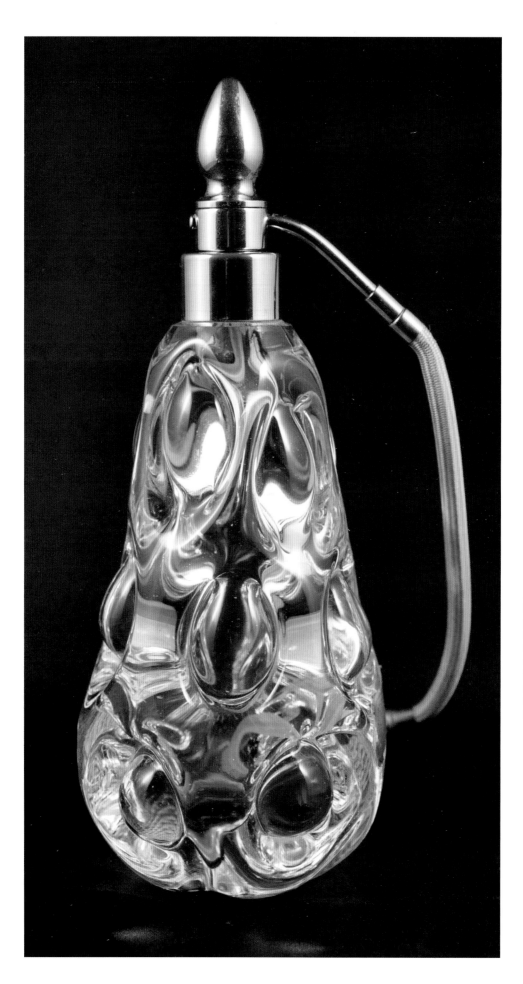

2000–19 Stunning crystal perfume atomizer with heavy crystal bottle by Waltersperger (France) and gold-finished spray fittings. This bottle was named "Coin Dot" in the DeVilbiss catalog (1965). Height 8".

This pyramid-form perfume atomizer, with faceted crystal bottle, was supplied by Buschman of West Germany, with rainbow interior stain; gold-finished filigree cap with gold-finished floral arrangement having turquoise jewels as petals (made in West Germany); plunger-type spray actuator (1963). Height 7.5".

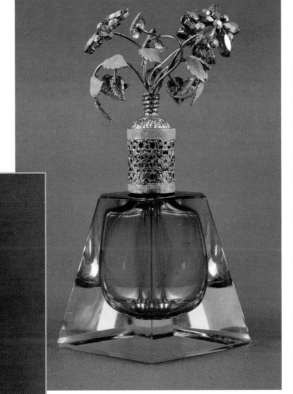

The 1750-15 DeVilbiss perfume atomizer was made with green ribs over a yellow glass bottle by Toso, of Murano, Italy; gold-finished filigree cap with gold-finished floral arrangement having aquamarine jewels as petals; plunger-type spray actuator (1962). Sticker on bottom: "Made in Italy." Height 6.5".

The metal cap with the jeweled flowers on this, and all other bottles of this type, are marked as made in Western Germany.

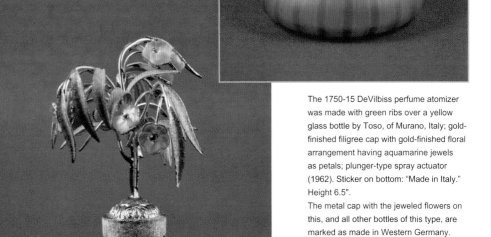

2000-5 Perfume atomizer with crystal bottle with pink opalescent Sommerso interior, by Archimede Seguso, Murano, Italy, and gold filigree top and bouquet of pink roses, opalescent jewels and gold leaves, top made in Western Germany (1965). Height 9.5".

1750-28 Perfume atomizer with blue Latticino bottle by Toso, Murano, Italy, and silver filigree cap topped by silver metal flower arrangement and blue jewel blossoms made in Western Germany (1965). Height 6".

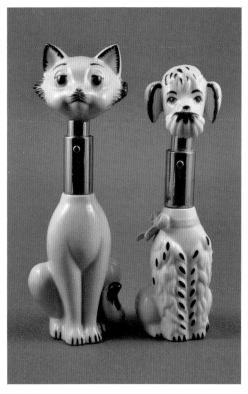

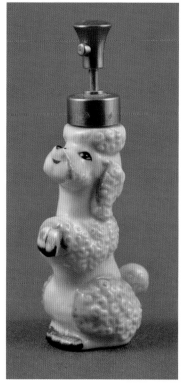

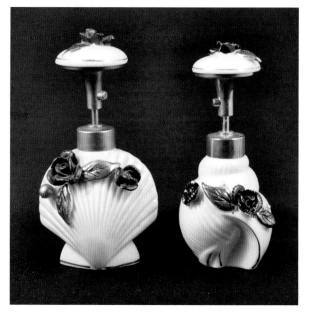

Left: 300-2 Pink glazed porcelain Siamese Cat figural perfume atomizer from Fairfield in Japan; the head is the plunger and the fittings are gold-finished (1964). Height 7.5". *Right:* 300-3 White glazed porcelain Poodle figural perfume atomizer supplied by Fairfield in Japan, with glazed black enamel spots and blue bow; the head is the plunger and the fittings are gold-finished (1964). Height 7".

Small poodle perfume atomizer from assortment A-3601 porcelain bottle from Fairfield with pink and gold highlights (1965). Height 4.5".

200 Series perfume atomizers with porcelain scallop shell (left) and conch shell (right) with applied leaf and blossom decorations on the bodies and plunger ornaments; gold enamel highlights and gold-finished spray fittings (1965). Bottles by Fairfield of Japan. Height 4.5".

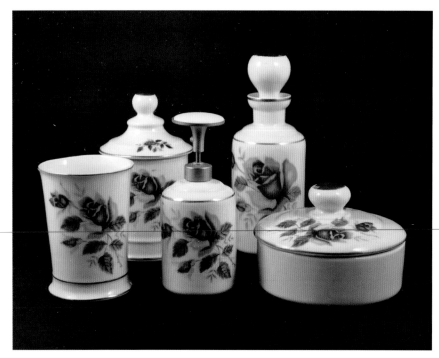

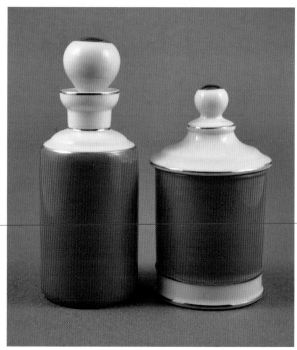

900-6 Six-piece DeVilbiss vanity and bath set in white porcelain with blue floral decoration, consisting of atomizer, bathroom bottle and stopper, powder jar, soap dish, tumbler and cotton jar by Fairfield of Japan (1966). Height of bottle and stopper 8".

Vanity jar and stoppered bottle from Fairfield of Japan, with orange and gold decoration on white porcelain (1967). Bottle height 6".

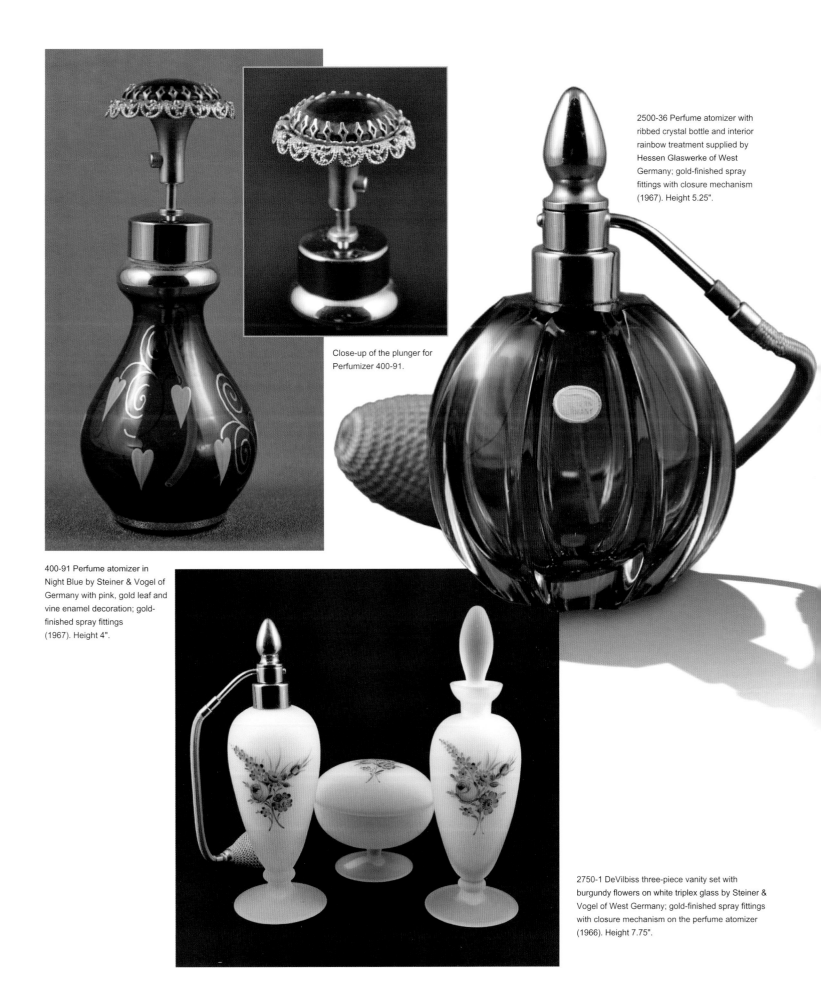

2500-36 Perfume atomizer with ribbed crystal bottle and interior rainbow treatment supplied by Hessen Glaswerke of West Germany; gold-finished spray fittings with closure mechanism (1967). Height 5.25".

Close-up of the plunger for Perfumizer 400-91.

400-91 Perfume atomizer in Night Blue by Steiner & Vogel of Germany with pink, gold leaf and vine enamel decoration; gold-finished spray fittings (1967). Height 4".

2750-1 DeVilbiss three-piece vanity set with burgundy flowers on white triplex glass by Steiner & Vogel of West Germany; gold-finished spray fittings with closure mechanism on the perfume atomizer (1966). Height 7.75".

The Final Years

The DeVilbiss Collection

Beginning in 1964, for the Pre-Christmas Gift Issue, DeVilbiss debuted the "*DeVilbiss Collection,*" which continued through the close of the division in 1968. DeVilbiss positioned their new perfume bottle collection with customers as follows:

The "**DeVilbiss Collection**" selected from the art glass centers of the world, includes fragrance containers of hand cut crystal, latticino thread glass, aurora decorated glass, convoluted stems of birds and fish, crackled silver and gold, Italian baroque art glass, alabaster, triplex, luster, rainbow, and flashed and flecked glass in unusual shapes and shades.

This collection has both an artistic and a practical side. Many of the designs and techniques have their counterparts in such famous museums as The Louvre, The British Museum, and the Metropolitan Museum of Art in New York. Artfully concealed in these containers, however, are tiny perfume pumps, efficient dispensers of whatever fragrance is placed inside.

DeVilbiss Perfume and Night Lights of the 1960s

The final DeVilbiss perfume light and night light offering came in 1966, with the introduction of a line of porcelain decorated, modern perfume lights and figural Perfume and Night Lights, as part of the *DeVilbiss Collection*. Sixteen models, nine perfume lights and seven night lights without perfume cups, were produced for DeVilbiss by Fairfield of Japan. They remained in the line, with the exception of the two modern perfume lights (995-1 and 995-2) last seen in 1967, until DeVilbiss closed perfume production in 1968. The 1966 flyer is shown here, followed by examples of this line.

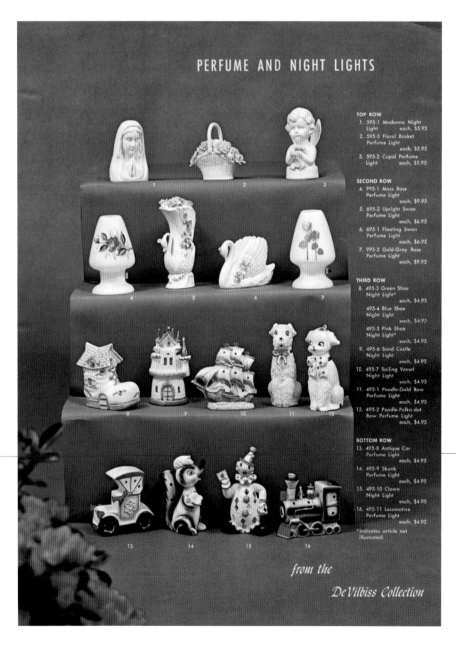

DeVilbiss 1966 catalog page showing their line of night lights and perfume lights. The two conical shapes on the second row down, far left and far right, are from Wittig of West Germany.

The text inside the catalog image reads:

PERFUME AND NIGHT LIGHTS

TOP ROW
1. 595-1 Madonna Night Light, each, $5.95
2. 595-3 Floral Basket Perfume Light, each, $5.95
3. 595-2 Cupid Perfume Light, each, $5.95

SECOND ROW
4. 995-1 Moss Rose Perfume Light, each, $9.95
5. 695-2 Upright Swan Perfume Light, each, $6.95
6. 695-1 Floating Swan Perfume Light, each, $6.95
7. 995-2 Gold-Gray Rose Perfume Light, each, $9.95

THIRD ROW
8. 495-3 Green Shoe Night Light*, each, $4.95
 495-4 Blue Shoe Night Light, each, $4.95
 495-5 Pink Shoe Night Light*, each, $4.95
9. 495-6 Sand Castle Night Light, each, $4.95
10. 495-7 Sailing Vessel Night Light, each, $4.95
11. 495-1 Poodle-Gold Bow Perfume Light, each, $4.95
12. 495-2 Poodle-Polka-dot Bow Perfume Light, each, $4.95

BOTTOM ROW
13. 495-8 Antique Car Perfume Light, each, $4.95
14. 495-9 Skunk Perfume Light, each, $4.95
15. 495-10 Clown Night Light, each, $4.95
16. 495-11 Locomotive Perfume Light, each, $4.95

*Indicates article not illustrated.

from the DeVilbiss Collection

300

495-10 Pierrot (clown) night light with multicolored enamel decoration on white porcelain (1965). Height 6".

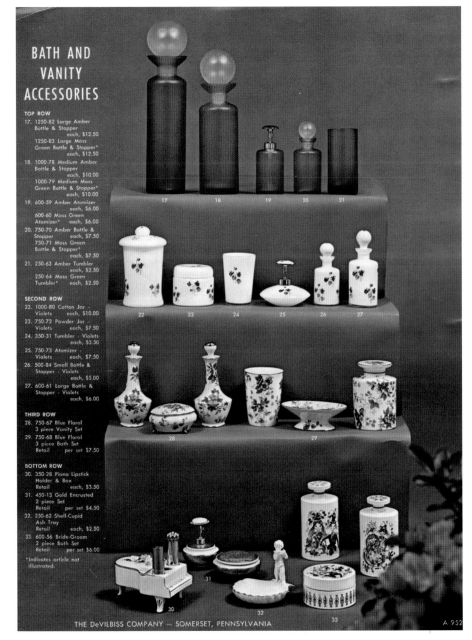

BATH AND VANITY ACCESSORIES

TOP ROW

17. 1250-82 Large Amber Bottle & Stopper — each, $12.50
1250-83 Large Moss Green Bottle & Stopper* — each, $12.50
18. 1000-78 Medium Amber Bottle & Stopper — each, $10.00
1000-79 Medium Moss Green Bottle & Stopper* — each, $10.00
19. 600-59 Amber Atomizer — each, $6.00
600-60 Moss Green Atomizer* — each, $6.00
20. 750-70 Amber Bottle & Stopper — each, $7.50
750-71 Moss Green Bottle & Stopper* — each, $7.50
21. 250-63 Amber Tumbler — each, $2.50
250-64 Moss Green Tumbler* — each, $2.50

SECOND ROW

22. 1000-80 Cotton Jar - Violets — each, $10.00
23. 750-72 Powder Jar - Violets — each, $7.50
24. 350-31 Tumbler - Violets — each, $3.50
25. 750-73 Atomizer - Violets — each, $7.50
26. 500-84 Small Bottle & Stopper - Violets — each, $5.00
27. 600-61 Large Bottle & Stopper - Violets — each, $6.00

THIRD ROW

28. 750-67 Blue Floral 3 piece Vanity Set
29. 750-68 Blue Floral 3 piece Bath Set — Retail per set $7.50

BOTTOM ROW

30. 350-28 Piano Lipstick Holder & Box — Retail each, $3.50
31. 450-13 Gold Encrusted 2 piece Set — Retail per set $4.50
32. 250-62 Shell-Cupid Ash Tray — Retail each, $2.50
33. 600-56 Bride-Groom 3 piece Bath Set — Retail per set $6.00

*Indicates article not illustrated.

THE DeVILBISS COMPANY — SOMERSET, PENNSYLVANIA

DeVilbiss 1966 catalog page showing Italian (Seguso) items on the top row and Fairfield of Japan items on rows 2–4.

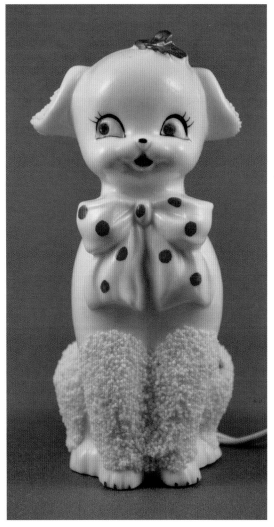

495-2 Poodle with polka dot bow perfume light with white porcelain and blue and red enamel highlights (1965). Height 6.5".

The Last DeVilbiss Catalogs (1967 & 1968)

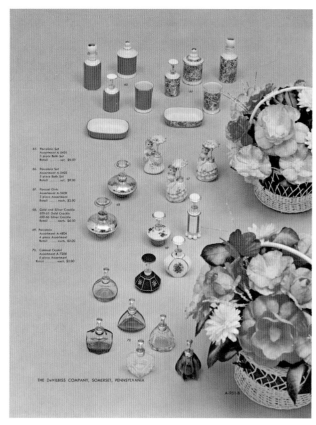

DeVilbiss 1967 catalog page 4.

DeVilbiss 1967 catalog page 1.

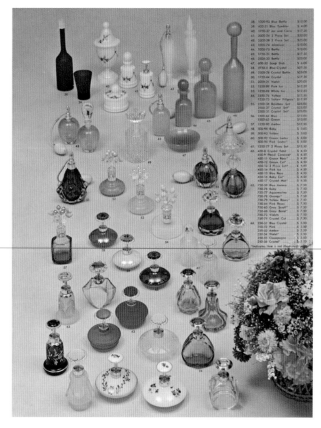

DeVilbiss 1967 catalog page 2.

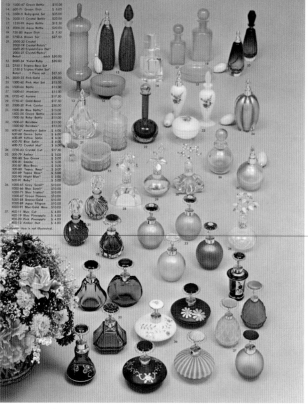

DeVilbiss 1967 catalog page 3.

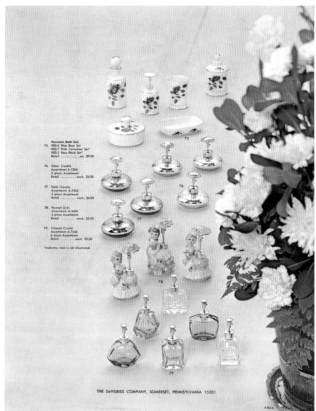

DeVilbiss 1968 catalog page 4.

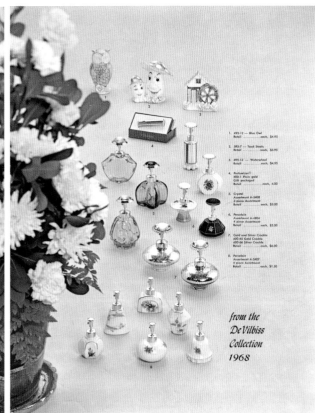

DeVilbiss 1968 catalog page 1.

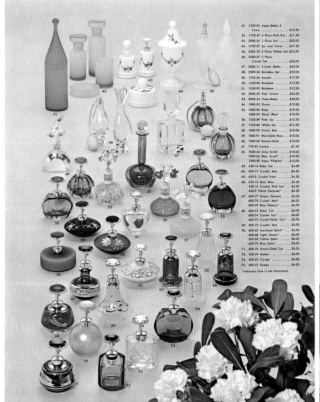

DeVilbiss 1968 catalog page 2.

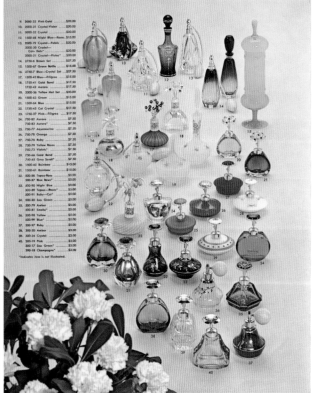

DeVilbiss 1968 catalog page 3.

CHAPTER 8

DeVilbiss Special-order Products

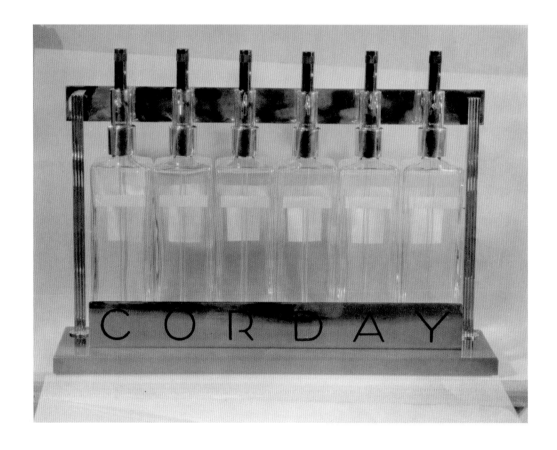

DeVilbiss factory image of a dispenser made for Corday with a name plate affixed to the front (1935).

Through much of its history in the Perfumizer business, DeVilbiss did a thriving business in special orders, including custom products produced to the customer's specifications. They provided them to a wide range of customers, including perfume houses, department stores, drug stores and chains, gift stores, consumer product companies, businesses, and community organizations. They furnished specific atomizer parts and spray tops for perfume houses to be packaged with their perfumes, and customized finished products, including the bottles and fittings. The DeVilbiss manufacturing and decorating expertise and their flexibility allowed them to produce, to order, almost anything atomizer-related.

The first recorded special order in DeVilbiss company files was to the Richard Hudnut Company, in 1913. Because they were custom made and in limited production, such items are rare and difficult to recognize as DeVilbiss. Early special-order designations are usually found in the factory specifications. Separate detailed records and documentation from 1931 through 1941, and to a limited extent beyond, have been preserved. They document special-order spray tops and/or completed bottles made for many of the major European and American perfume houses.

Because this category of DeVilbiss product is exceptionally broad, this book presents only a few examples to give a sample of the special order products that can be found by diligent and knowledgeable searching.

Completed Bottles

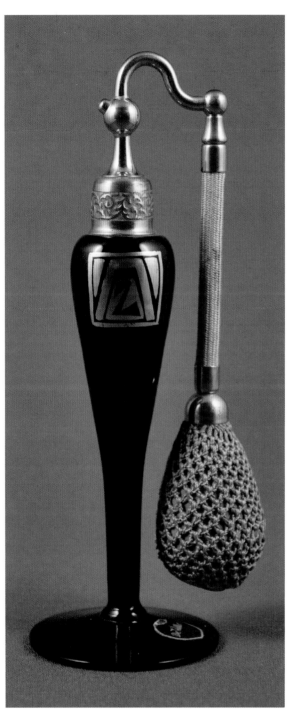

Special order Perfumizer with "Z" logo in gold enamel, gold-finished spray fittings, for unknown customer (c. 1925). Bottle supplied by Cambridge Glass Company. Height 6.75".

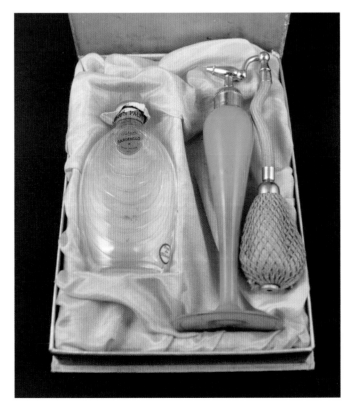

DeVilbiss special order Perfumizer sold by Solon Palmer Perfumes with "Gardenglo" perfume; atomizer decorated by DeVilbiss in a green enamel with rhodium finished spray fittings, in a Palmer presentation case with silk lining (c. 1925). Bottle supplied by the Cambridge Glass Company.

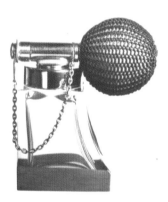

Henri Bendel sold these Perfumizers with a silk-lined and tasseled ostrich-skin zippered travel case with gold stamp "Henri Bendel New York" on the bottom.

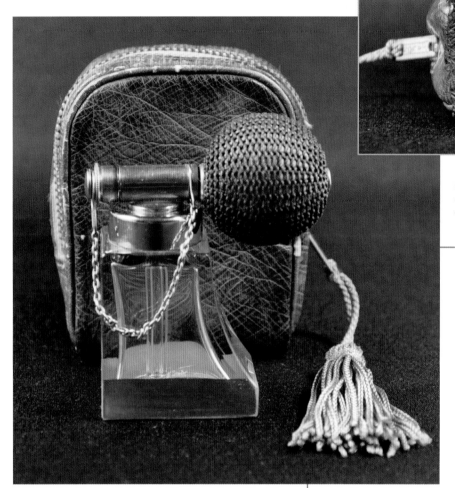

Special order number 8209: beautiful small DeVilbiss travel Perfumizer with hand polished and burnished gold decorated crystal bottle from the Carr-Lowrey Company. Note the special gold-finished spray fittings with screw cap for closure. Produced for Henri Bendel of New York (1940). Height 2".

Factory specification dated February 19, 1940 for Henri Bendel travel Perfumizer 8209, admonishing the production department to conduct tests to ensure that "these will not leak." A similar, but not identical, travel Perfumizer S300-97 is shown in the DeVilbiss 1940 retailers' catalog, with the same spray fittings on an undecorated square crystal bottle.

FEB 19 1940

No. 8209

Sold to Henri Bendel, Inc., New York City in lots of 1,000 at $2.00 each net F.O.B. Toledo.

This atomizer is made up as follows:

1477 MP
1477 P bell
1477 XA bulb with No. 34 brown net
1007 H cap
414 RF glass outlet tube
B5 gold plated
O-710 bottle with No. 1623 decoration
Bottle decorated with a 13/22" burnish gold band
 around the base
Metal part must be lined up with bottle
Test same as our S300-97
Special tests should be conducted to be sure these
 will not leak
This customer is selling this atomizer packed in a
leather case.

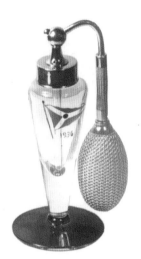

No. 8127

THIS ATOMIZER WAS MADE UP FOR THE INTER LAKE YACHTING ASSOCIATION, C/O R. D. LUEDTKE, 3434 PELHAM ROAD, TOLEDO, OHIO.

WE MADE UP 250 ATOMIZERS AT A PRICE OF 50¢ EACH, NET.

THIS ATOMIZER CONSISTS OF THE FOLLOWING:

O-728 BLANK BOTTLE WITH RUBY FOOT AND SPECIAL DECORATION IN BLUE — 1020-H CAP — 586 M.P. — 760 BA MAIZE NETTED BULB WITH 1½ INCHES OF TUBING.

Factory record dated August 14, 1936 of a Perfumizer, 250 of which were made for the Inter Lake Yachting Association of Toledo, Ohio as a favor or logo gift (1936). Tom DeVilbiss was Commodore of that Yacht Club until shortly before his untimely death in 1928, giving this Perfumizer special meaning to its owners.

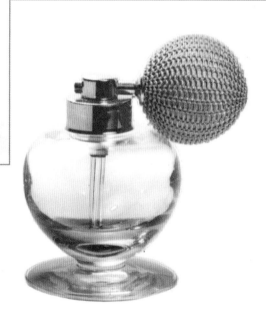

SP 561-0

THE ABOVE ITEM CONSISTS OF AN O-790 CLEAR BOTTLE, 1020-H CAP, 1032 METAL PART, GOLD PLATED, AND 796-XA MAIZE BULB.

MR. SMOCK SOLD SIX DOZEN TO MARSHALL FIELD & COMPANY, CHICAGO, ILLINOIS AT A PRICE OF $6.00 PER DOZEN NET.

Factory record of special order Perfumizer SP 561-0 made up from standard parts for Marshall Field & Company of Chicago, Illinois (1936).

Spray Heads

Another thriving business of the 1930s was supplying atomizer attachments to the leading perfume houses, which they would package and sell with their own perfumes. These typically were designed for the consumer to replace the original perfume bottle cap with the atomizer fitting, when ready for use. The fittings were designed in conjunction with (or by) the perfume company, to match their bottle designs and packaging. Atomizers were made and sold to many of the major commercial perfume houses, including Coty, Hudnet, Bourjois, Lucien Lelong, Lentheric, Elizabeth Arden, Lengyel, Houbigant, Corday, and Prince Matchabelli.

DeVilbiss' special order spray top business continued after World War II. In a memo from a salesman, Mr. Graham of New York, dated August 19, 1946, it was reported to Sales Manager Floyd Green that, "Mr. J. Martin of Coty, 423 W. 55th St., New York City, called this office this morning. He wanted to put in an order for one million and a half spra-tops." Spra-top was a trademarked name.

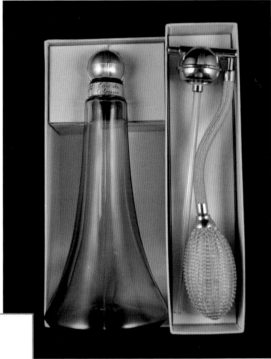

Atomizer attachment with coordinating cap made by DeVilbiss for and packaged with Richard Hudnut Eau de Cologne (1935).

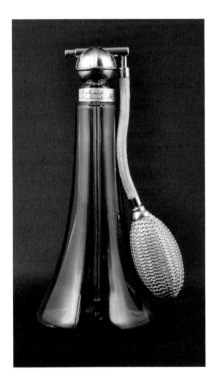

Richard Hudnut Eau de Cologne with atomizer attachment in place (1935).

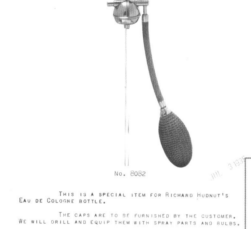

DeVilbiss factory record of Hudnut special order 8052 for cologne spray fittings, dated July 3, 1935.

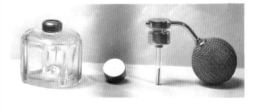

A DeVilbiss factory record, dated April 9, 1937, relates to a special order atomizer device, made for Richard Hudnut for packaging with the Fragrance Gemey (1936).

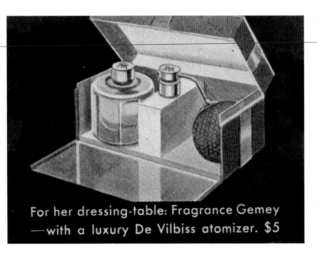

Inset from advertisement displaying custom DeVilbiss atomizer attachment.

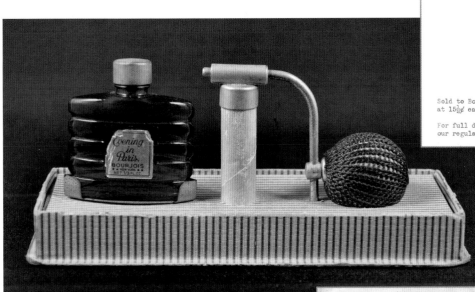

No. 8220

Sold to Bourjois, Inc., New York City in lots of 150,000 at 15½¢ each net, f.o.b. Toledo.

For full details as to plating, color of net, etc., see our regular specification sheet for this number.

DeVilbiss factory record of Bourjois special order number 8220 for atomizer fittings, dated April 9, 1937.

Bourjois' Evening in Paris, 1/3 ounce perfume bottle packaged with DeVilbiss atomizer device (1936). Height 2.5".

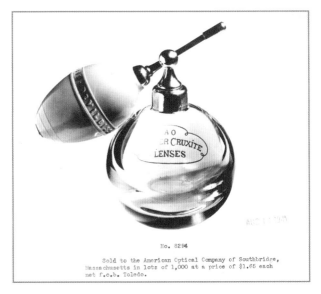

No. 8294

Sold to the American Optical Company of Southbridge, Massachusetts in lots of 1,000 at a price of $1.65 each net f.o.b. Toledo.

Special atomizer for lens cleaning solution produced and decorated for American Optical Company's Tillyer Cruxite lens division in 1941. Note the DeVilbiss-imprinted bulb developed for medical atomizers. Perfume was not the only use for an atomizer!

McCall's magazine carried a 1936 advertisement for Richard Hudnut's Fragrance Gemey, showing various modes of packaging available, including (as an inset) a dressing table version with a "luxury DeVilbiss atomizer."

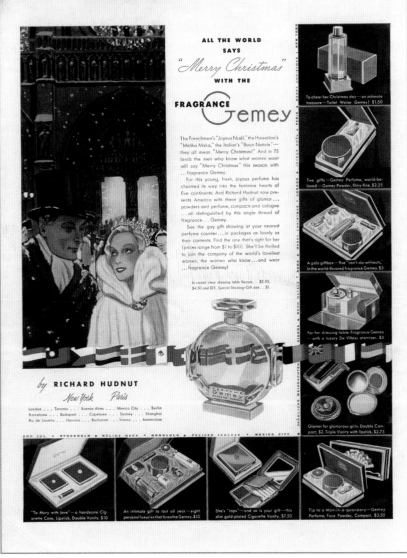

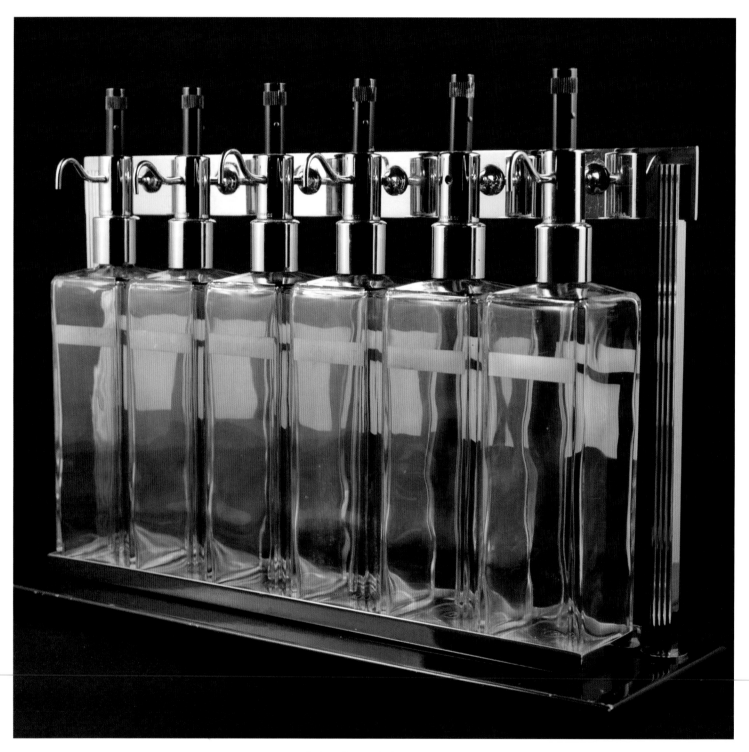

Perfume dispenser bottles and stand made by DeVilbiss for perfume counter dispensing of perfume in bulk to customers. The top device can be turned to seal the bottle (1935). The bottles for these dispensers were made by Carr-Lowrey Glass Company. Height 10"; width 13.75".

Appendix

Glass and Porcelain Company Suppliers to DeVilbiss

The following companies have been identified and documented as supplying DeVilbiss with perfume bottle and vanity accessory glass or porcelain "blanks." In a few cases, they provided decorating services to DeVilbiss for the completion and sale of the final product. Some of the companies provided many blank shapes to DeVilbiss, others only a few, or even one or two. Many of the companies supplied DeVilbiss with bottle blanks during specific periods. Whenever possible, the authors have listed known companies in the descriptions of the bottles and vanity accessories throughout the chapters of this book.

The list is as complete as current information allows. New company sources may be identified in the future. Check the website http://www.devilbisscollectors.com where the authors will have updates as they uncover new information.

Archimede Seguso, Italy

Bohemian Glass Companies

Brosse, Vieux-Ruben-sur-Bresle, France

The Bryce Brothers Company, Mt. Pleasant, Pennsylvania

Buschman, West Germany

Cambridge Glass Company, Cambridge, Ohio

Carr Lowrey Glass Company, Baltimore, Maryland

Central Glass Works, Wheeling, West Virginia

Czechoslovakian Glass Companies

DaPrato, Italy

Daum Nancy, France

Durand (see Vineland Flint Glass Works), Vineland, New Jersey

Edward G. Westlake Company, Chicago, Illinois

Fairfield, Japan

Fenton Art Glass Company, Williamstown, West Virginia

Foster-Forbes Glass Company, Marion, Indiana

Fostoria Glass Company, Moundsville, West Virginia

Fuger-Taube, West Germany

Gay Fad Studios, Lancaster, Ohio

G. S. Goodfriend Imports, Italy

Hackel

Hawkes & Company, TG, Corning, New York

Hazel Atlas, Wheeling, West Virginia

H. C. Fry Glass Company, Rochester, Pennsylvania

Hessen Glaswerke, Stierstadt, West Germany

Imperial Glass Company, Bellaire, Ohio

Josef Riedel Glass (see Riedel Glass)

Kimble Glass Company, Vineland, New Jersey

Kristallglas, Oberusel, West Germany

Libbey Glass Manufacturing Company, Toledo, Ohio

Lenox, Inc., Trenton, New Jersey

L. J. Houze Convex Glass Company, Point Marion, Pennsylvania

Marquot & Fils, France

Meltzer

Moretti, Carlo, Murano, Italy

Morgantown Glass Works, Morgantown, West Virginia

Moser A.S., Czechoslovakia (Bohemia)

Oertel Crystal, originally Czech and re-established after WWII in West Germany

Owens-Illinois, Perrysburg, Ohio

Paden City Glass Manufacturing, Paden City, West Virginia

Phoenix Glass, Monaca, Pennsylvania

Quezal Art Glass & Decorating Company, Queens, New York

Riedel Glass, Czechoslovakia

Silberstein

Steiner & Vogel (S&V), West Germany

Steuben Glass Works, Corning, New York

Sweden Glass

Tiffin (see U.S. Glass Company)

Toso, Murano, Italy

U.S. Glass Company (Tiffin), consolidated main office in Tiffin, Ohio

Vapo Harold, Italy

Vapo Milan, Italy

Viking Glass, New Martinsville, West Virginia

Vineland Flint Glass Works (Durand), Vineland, New Jersey

Waltersperger, Bresle Valley, France

Westmoreland Glass Company, Grapeville, Pennsylvania

Wheaton Glass Company, Millville, New Jersey

Wittig Glas, Hadamar, West Germany

Notes

Chapter 1

1. *The Rotarian*, Dec. 1913, Vol. IV, No. 4, p. 111, and Jan. 1915, Vol. IV, No. 1, p. 10.
2. The DeVilbiss Company Annual Report, *courtesy of BGSU Center for Archival Collections/DeVilbiss Corporation Collection MS-604*, 1953.
3. DeVilbiss Corporate Records, *courtesy of BGSU Center for Archival Collections/DeVilbiss Corporation Collection MS-604.*
4. The DeVilbiss Company *Salaried Employees' Retirement Income Plan*, 1964, *courtesy of BGSU Center for Archival Collections/DeVilbiss Corporation Collection MS-604,*
5. The DeVilbiss Company Employee Booklet, *courtesy of BGSU Center for Archival Collections/DeVilbiss Corporation Collection MS-604*, 1948.
6. The DeVilbiss Company Annual Report, *courtesy of BGSU Center for Archival Collections/DeVilbiss Corporation Collection MS-604*, 1950.
7. *Directions*, Volume Two, Issue One, June 1978.
8. Corporate Records, *Courtesy of BGSU Center for Archival Collections/DeVilbiss Corporation Collection MS-604.*
9. *DeVilbiss News. Courtesy of BGSU Center for Archival Collections/DeVilbiss Corporation Collection MS-604*, December 1938.
10. *Thomas Alexander DeVilbiss*, A Biography Compiled by the Students in an English Class of Barbara Grace Spayd during their Junior and Senior Years at DeVilbiss High School, Toledo, Ohio, 1938–1939, pp. 9 and 35.
11. Ibid.
12. Corporate Records, *courtesy of BGSU Center for Archival Collections/DeVilbiss Corporation Collection MS-604.*
13. Ibid.
14. Thomas A. DeVilbiss' Memoriam Booklet, 1928. *Courtesy of BGSU Center for Archival Collections/DeVilbiss Corporation Collection MS-604.*
15. *DeVilbiss News*, December 1938, p. 2.
16. Ibid.
17. March 1932 Atomizer Committee Minutes, *courtesy of BGSU Center for Archival Collections/DeVilbiss Corporation Collection MS-604.*
18. *Fortune* magazine article, DeVilbiss and Gun, March 1933, p. 48, *courtesy of BGSU Center for Archival Collections/DeVilbiss Corporation Collection MS-604.*
19. Ibid.
20. January 1934 Atomizer Executive Committee Minutes, *courtesy of BGSU Center for Archival Collections/DeVilbiss Corporation Collection MS-604.*
21. DeVilbiss Corporate Records, *courtesy of BGSU Center for Archival Collections/DeVilbiss Corporation Collection MS-604.*
22. *Courtesy of BGSU Center for Archival Collections/DeVilbiss Corporation Collection MS-604.*
23. 1949 DeVilbiss Shareholders Report, *courtesy of BGSU Center for Archival Collections/DeVilbiss Corporation Collection MS-604.*
24. 1950 *DeVilbiss News. Courtesy of BGSU Center for Archival Collections/DeVilbiss Corporation Collection MS-604.*
25. DeVilbiss 1953 Shareholders Report, *Courtesy of BGSU Center for Archival Collections/DeVilbiss Corporation Collection MS-604.*
26. *DeVilbiss News. Courtesy of BGSU Center for Archival Collections/DeVilbiss Corporation Collection MS-604.*

Chapter 2

1. *Fostoria—Its First Fifty Years*, Hazel Marie Weatherman (Springfield, MO: The Weathermans, 1972), p. 79.
2. DeVilbiss company financial records, 1912 and 1913, *courtesy of BGSU Center for Archival Collections/DeVilbiss Corporation Collection MS-604.*
3. *Fostoria—Its First Fifty Years*, Hazel Marie Weatherman (Springfield, MO: The Weathermans, 1972), p. 67.

Chapter 3

1. 1921 DeVilbiss Company brochure.
2. *The Krall Family of Grass Engravers*, Tom & Neila Bredehoft (Weston, WV: The West Virginia Museum of American Glass, Ltd., 2009).
3. DeVilbiss Company 1925 Catalog.
4. Ibid.

5. Wheaton Arts and Cultural Center 1988 exhibit, *Distinctively Durand*, http://www.wheatonarts.org/museumamericanglass/exhibitions/pastexhibitions/1988distinctively durand

6. *Durand—The Man and His Glass*, Edward J. Meschi (Marietta, GA: The Glass Press Inc., 1998).

7. DeVilbiss Executive Committee minutes, 1934.

8. National Imperial Glass Collectors Society, http://www.imperialglass.org/site/library1.htm; "Imperial's Art Glass Gamble," Cliff McCaslin

9. www.cardersteubenclub.org, "About Frederick Carder."

10. *The Glass of Frederick Carder*, Paul V. Gardner, Corning Museum of Glass (New York: Crown Publishers, 1971), pp. 29–43

11. 1926 Catalog, The DeVilbiss Company, Toledo, Ohio, p. 27.

12. http://en.wikipedia.org/wiki/Bradshaw_Crandell

13. *Pearl Art Glass: Foval*, James R. Lafferty, Sr. (self-published, 1967), p. 7.

14. *The Collector's Encyclopedia of Fry Glassware*, The H. C. Fry Glass Society (Paducah, KY: Collector Books, 1990), p. 146.

15. http://www.brilliantglass.com/about_abcg/engraving_4.html

16. 1929 Catalog, The DeVilbiss Company, Toledo, Ohio, p. 11.

17. Ibid.

18. *A Handbook of Old Morgantown Glass*, Jerry Gallagher (Old Morgantown Glass Collectors' Guild, 2001), p. 217.

19. *U.S. Glass Company—Decorated Satin Glass and Lamps of the 1920s*, Tiffin Glass Collectors Club (Atglen, PA: Schiffer Publishing, Ltd., 2004), pp. 5–11.

20. *Collector's Encyclopedia of American Art Glass*, John A. Shuman III (Paducah, KY: Collector Books, 1988), p. 38.

21. *Westmoreland Glass Volume 3, 1888–1903*, Lorraine Kovar (Marietta, OH: The Glass Press, Inc. DBA Antique Publications, 1997), p. 88.

22. *The World of Salt Shakers*, Mildred & Ralph Lechner (Paducah, KY: Collector Books, 1998), p. 204.

Chapter 4

1. http://en.wikipedia.org/wiki/Wall_Street_Crash_of_1929

2. DeVilbiss Executive Committee meeting minutes, July 28, 1930.

3. DeVilbiss Executive Committee meeting minutes, July 31, 1933

4. DeVilbiss Executive Committee meeting minutes, September 30, 1933.

5. DeVilbiss Executive Committee meeting minutes, December 21, 1941.

6. DeVilbiss 1933 Salesman's Catalog.

7. Lenox and the White House, http://en.wikipedia.org/wiki/White_House_china

8. *American Plastic: A Cultural History*, Jeffrey L. Meikle (New Brunswick, NJ: Rutgers University Press, 1995), p. 120.

9. The DeVilbiss Company 1937 Catalog.

10. http://www.riedel.com

11. *Fenton Rarities, 1940–1985*, John Walk (Atglen, PA: Schiffer Publishing, Ltd., 2002), p. 9.

12. *Fenton Art Glass*, Margaret Whitmyer (Paducah, KY: Collector Books, 2005), pp. 50–51.

13. Ibid.

14. Ibid.

Chapter 5

1. *DeVilbiss News*, March 1945, *courtesy of BGSU Center for Archival Collections/DeVilbiss Corporation Collection MS-604.*

2. *A Handbook of Old Morgantown Glass*, Jerry Gallagher, Old Morgantown Glass Collectors' Guild (Manassas, VA: Payne Publishing, 2001).

3. *Morgantown Glass: From Depression Glass through the 1960s*, Jeffrey B. Snyder (Atglen, PA: Schiffer Publishing , Ltd., 1998).

4. DeVilbiss Employee Booklet 1948, *courtesy of BGSU Center for Archival Collections/DeVilbiss Corporation Collection MS-604.*

5. DeVilbiss Corporate minutes, *courtesy of BGSU Center for Archival Collections/DeVilbiss Corporation Collection MS-604.*

Glossary of Terms

Acid Cutback. Acid etching process where the pattern remains masked off and un-etched, and the background is deeply etched in the acid bath.

Acid Stamp. Method using a stamp dipped in acid to permanently apply a signature to the surface of the glass.

Acorn. A DeVilbiss knob or finial, usually at the top of the piece, used to serve as a handle (as with a dropper rod), or for decorative purposes.

American Brilliant Glass. Period from the late 19th to the early 20th centuries (ending with WWI) when exceptionally high quality glass was cut by the world's finest artisans working in America.

Art Deco. A decorative style characterized by elegance, modernity, and functionality which was popularized in France in the mid-1920s, and remained popular into the WWII era.

Art Nouveau. Artistic decorative style most popular in Europe from 1890 to 1920, inspired by floral and other natural forms, often with flowing and curving lines.

Aventurine. A process, originating in Murano, Italy, of combining metallic salts with glass which, when cooled, creates a flecked appearance, often gold or silver depending on the type of salt used.

Bakelite. An early type of synthetic plastic used for electrical and industrial purposes, as well as in jewelry, kitchenware and other decorative uses.

Blank. A blown or molded glass shape, intended for further decoration, and in the case of perfume bottles, for fitting with atomizer or dropper hardware and ornamental treatments.

Bulb. A rubber ball attached to a tube or hose, which, when squeezed, creates the air flow through the tube that actuates the atomizer.

Cap. The decorated metal fitting, attached to the top of the glass blank by adhesive, onto which the atomizer spray or dauber hardware is attached (also referred to as a "Collar").

Cased Glass. Process of overlaying, onto hot glass at the furnace, one or more successive additional layers of glass, usually of a different color or composition.

Catalin. A plastic popular in the 1930s that replaced Bakelite, partly because it exists in a transparent, colorless state and can accept a wide range of dyes and colors.

Chromium. A silver metal that is highly resistant to corrosion and discoloration, and can be applied as plating to other metals and polished to a high shine.

Closure. A mechanical device that when actuated, seals a liquid such as perfume or cologne into its container to prevent spillage or evaporation.

Collar. The decorated metal fitting, attached to the top of the glass blank by adhesive, onto which the atomizer spray or dauber hardware is attached (also referred to as "Cap").

Cord. The rubber hose, usually covered with braided silk, that attaches the bulb or squeeze ball to the atomizer tube, through which the air passes to actuate the atomizer spray.

Crackle glass. Decorative method of finishing glass, in which a hot piece of glass is immersed in cold water, causing a decorative web of surface fractures, or "crackles."

Crochet. Process of creating fabric from thread, such as silk, using a crochet hook. Crocheted fabrics, usually silk, were often used to cover DeVilbiss atomizer squeeze bulbs.

Crystal. Colorless glass of high quality.

Cut, cutting, cut glass. Hand decorating technique where the artisan uses a rotating grinding wheel to grind a decoration into the surface of the glass.

Cut to clear. Hand decorating technique where the glass object has a cased or enameled colored outer layer over a colorless inner layer, and where outer layer is cut or engraved in a pattern exposing the clear layer underneath.

Dauber. A glass or metal rod extending into a perfume bottle, with a handle, which is withdrawn to apply the perfume to the skin. (Also referred to as a dropper rod or dropper.)

Decoration. Any type of cutting, etching, enameling, staining, crackling, ornamentation, or other technique to apply decoration to a glass blank.

Dropper perfume. Perfume bottle fitted with a dropper (sometimes also called a dauber).

Dropper rod. A glass or metal rod extending into a perfume bottle, with a handle, which is withdrawn to apply the perfume to the skin. (Also referred to as a dauber.)

Eau de Cologne atomizer. An atomizer, usually of larger capacity than a perfume atomizer, intended for spraying eau de cologne.

Embossed, embossing. A metal stamping technique which leaves a raised or indented pattern in the metal item, such as a perfume bottle collar.

Enamel, enameled. A paint that is applied and then usually fired on at high temperature, in a lehr or other type of heat source that gradually raises and then lowers the temperature to prevent breakage.

Encrusted. Decoration by applying enamel into the etched or cut pattern of the glass.

Engraving, engraved. Any process where a design is cut into a hard surface, such as glass or copper, using cutting wheels or hand tools.

Etched. A glass decorating process whereby the item is covered with a resistive wax, except for the pattern desired, and then submerged into acid causing the pattern to be etched into the glass.

Facet. A flat face on a geometric object, such as a pattern of flat surfaces ground and polished onto a perfume bottle.

Figural. A shape created in glass, pottery, porcelain, wood, etc., that replicates a human or animal figure.

Filigree. Ornamental work of delicate or intricate design usually in gold, silver or copper, and applied to the surface or as an ornament of another object.

Finial. A decorative device applied to the apex of an object—such as the top ornament of a perfume atomizer.

Finish. A decorative coating, plating or treatment on the surface of metal or glass.

Fire polished. Glass, such as pressed glass, which is removed from the mold, cooled and then reheated to eliminate any surface roughness imparted by the mold.

Fitting. Metal atomizer or dropper part or assembly attached to a glass bottle.

Flashed, flashing. Process of dipping a glass piece into hot glass of another color so that only a very thin layer adheres.

Foot. The base, often in the shape of a disc, upon which an object stands and which is integrally molded or attached to the object.

Gilding, gilded. Process of applying gold leaf, powder or gold-infused enamel to a solid surface for purposes of decoration.

Green Gold. A term used by DeVilbiss to describe gold alloy, typically using 75% gold and 25% silver, that produces a greenish gold color.

Intaglio. Deep etching of a decorative pattern on the surface of glass.

Interior enamel. Decorating technique involving coating the interior of a bottle with fired on enamel, allowing a greater range of decorating techniques and effects on the exterior. DeVilbiss had very high quality interior enameling.

Iridized, iridescent. Glass finish resulting from a process of spraying metal oxides on hot glass, creating vivid colors and reflections.

Jewel. Faceted, cut glass ornament set (usually on top) in a spray fitting; or set in an ormolu or filigree decoration or ornament, or hanging as a pendant.

Jumbo. Extra-large perfume bottle made primarily for store display purposes.

Latticino. Italian decorative glassblowing technique using colored glass threads in swirl or crosshatch patterns.

Lehr, decorating. A temperature-controlled kiln or oven that fires on enamel decorations by gradually heating, then cooling, the enameled glass object.

Lucite. A clear plastic sometimes used as a shatter-resistant substitute for glass, first introduced in the mid-1930s, and used by DeVilbiss for jewels and ornaments in the 1940s and 1950s.

Magic Mist. A DeVilbiss registered trademark used in conjunction with atomizers in the 1960s.

Mary Gregory. A decorating style or motif, originally produced mainly in Bohemia, that involved scenes of white enamel on glass depicting children in various activities; later animals and other scenes might be referred to as such as well. The term itself first appeared in the 1920s.

Medicinal or medical atomizer. Atomizer produced to spray medications in the nose or throat.

Metal part. A term used by DeVilbiss assembly operations to describe the spray or dropper rod assembly fitted to the bottle. Term does not refer to the bulb or cord.

Nebulizer. A device that converts a medication into a mist to be inhaled.

Net. The crochet fabric covering on an atomizer squeeze ball or bulb.

Nickel. A corrosion-resistant, durable silvery metal used as a plating for brass or iron parts.

Opalescent. Glass that is partially transparent and partially opaque, through which light can pass in a diffused manner.

Opaque. Glass of a solid color that is not transparent and through which light does not pass.

Ormolu. Metalwork decoration of glass bottles.

Ornament. A decorative element, such as a glass or Lucite jewel, the glass or filigree top of an atomizer or dropper rod handle, or any metal or glass element applied to a bottle for decorative purposes.

Glossary of Terms

Overlay. A deposition of metal, such as silver, brass or gold, on the surface of glass by a chemical process, for decorative purposes.

Perfume Atomizer. A perfume container or bottle equipped with fittings for spraying the perfume.

Perfume Burner, Perfume Lamp. Variations of the names used by DeVilbiss to describe a perfume light.

Perfume Light. The DeVilbiss trade name for a decorative electric lamp equipped with a receptacle into which perfume is placed, which is evaporated into the surrounding area by the heat of the lamp bulb.

Perfumizer. The DeVilbiss Company's registered trade name for a perfume atomizer, used from 1907 until 1928, and again in the 1940s, 1950s and 1960s for metal and purse perfume atomizers.

Pipe point top. DeVilbiss' name for the hexagonally-shaped atomizer spray barrel used from 1907 until 1916.

Plaskon. A molded plastic material used by DeVilbiss that is similar to but later than Bakelite, different in its greater ability to incorporate bright colors. Plaskon was invented by and was a registered trade name of the Toledo Synthetic Products Company.

Polished. Glass which has been made smooth and polished by applying water with a very fine abrasive compound on a turning wheel. A "hand cut and polished" surface is created by polishing out the scratches left by the cutting wheel.

Pressed glass. Glass into which a pattern has been imparted by the mold.

Regular weight. A glass container produced without a sham bottom.

Reverse enameled. A decorating technique of enameling a scene or decoration on the reverse side of the glass, such that the decoration is intended to be viewed through the glass.

Satin finish. A decorative technique achieved by spraying or dipping a glass object with acid, leaving an opaque or dull matte finish on the surface, either in a pattern or applied to the entire surface.

Series. Term used by DeVilbiss to describe a grouping of similar designs. Series were usually assigned a number such as "6000 Series" or a trade name such as "Debutante Series."

Sham; heavy, medium, etc. A thicker portion of glass at the base of a bottle or other glass container. A sham bottle will have larger dimensions but a smaller cavity for containing the liquid.

Silk screen. Technique for applying enamel decoration to glass using a very fine mesh through which the enamel is applied, usually in a stenciled pattern.

Siphon tube. The metal, glass or plastic tube extending down into the bottle from the atomizer top. The perfume is drawn up through the tube and out through the spray opening by action of the vacuum created when the bulb or pump is actuated.

Sommerso. A glassblowing technique from Murano made popular in the 1950s by Archimede Seguso. It involves submerging colored glass into molten glass of clear or another color.

Specification book. DeVilbiss manufacturing control records that record and describe all of the components necessary to assemble each specific product in the product line for that year. "Spec Books" ensured that all instances of a given product would be assembled using the same components.

Sponge Acid. Method of using a sponge or similar device to apply etching acid to the surface of the glass to achieve a dappled, random texture, usually decorated further with enamel and/or gold.

Spray head, spray top. The metal part of the atomizer device which attaches to the collar, and to which is attached the bulb and cord or other spray actuating device.

Squeeze ball/bulb. The rubber device which, when squeezed, produces the air flow through the tube or cord to actuate the atomizer.

Stain. Process of applying a coloring agent to cold glass, and then firing it on to develop the color, and for permanency.

Stem. The thin length of glass connecting the bowl of the perfume or liquid container to the foot upon which it stands.

Stipple. Decorating effect using small dots of enamel applied with a brush or sponge on the surface of glass to create a textured effect.

Swing Closure. Type of DeVilbiss closure device where the metal air tube is rotated 90 degrees to open the air passageway from the tube to the atomizer, to enable use. In the un-rotated position, usually down, the fragrance is sealed within the container.

Triplex. Three-layered glass blanks, one of which is usually opaque white, supplied to DeVilbiss from West Germany in the 1950s and 1960s.

Tube. The metal part of the atomizer air pathway to which the rubber cord or bulb is attached.

Selected Bibliography

Avila, George C. *The Pairpoint Glass Story.* (New Bedford, MA: Reynolds DeWalt Printing, Inc., 1968.)

Baker, Larry, and Bert Kennedy. *Share the Vision—The Morgantown Etching Plates.* (Mesquite, TX: Blue Dart, 2003.)

Baldwin, Gary, and Lee Carno. *Moser—Artistry in Glass: 1857–1938.* (Marietta, GA: Antique Publications, 1988.)

Baldwin, Gary D. *Moser Artistic Glass Edition Two.* (Marietta, OH: The Glass Press Inc., 1997.)

Ball, Joanne Dubbs, and Dorothy Hehl Torem, *Fragrance Bottle Masterpieces.* (Atglen, PA: Schiffer Publishing Ltd., 1996.)

Bennett, Harold and Judy. *The Cambridge Glass Book.* (Des Moines, IA: Wallace-Homestead Company, 1970.)

Bickenheuser, Fred. *Tiffin Glassmasters—Book I.* (Grove City, OH: Glassmaster Publications, 1979.)

Bickenheuser, Fred. *Tiffin Glassmasters—Book II.* (Grove City, OH: Glassmaster Publications, 1981.)

Bogess, Bill and Louise. *Identifying American Brilliant Cut Glass, 6th Edition.* (Atglen, PA: Schiffer Publishing Ltd., 2009.)

Bredehoft, Tom & Neila. *The Krall Family of Glass Engravers.* (Weston, WV: The West Virginia Museum of American Glass, Ltd., 2009.)

Breslin, Jeanne. *Lotus: The Lotus Glass Company Barnesville, Ohio.* (Evanston, IL: J. Breslin & Associates, 2002.)

DeVilbiss High School English Students of Barbara Grace Spayd. *Thomas Alexander De Vilbiss - A Biography.* (Toledo, OH: 1939.)

DeVilbiss News. *In Memory of Our Beloved President, Thomas A. DeVilbiss.* (Toledo, OH: The DeVilbiss Company, 1928.)

DeVilbiss, Thomas D. *History of the DeVilbiss Family in the United States - 200 Years.* (Fort Wayne, IN: Thomas D. DeVilbiss, 1927.)

Dimitroff, Thomas P. *Frederick Carder and Steuben Glass: American Classics.* (Atglen, PA: Schiffer Publishing Ltd., 1998.)

Ettinger, Roseann. *Antique Dresser Sets 1890s–1950s.* (Atglen, PA: Schiffer Publishing Ltd., 2005.)

Farrar, Estelle Sinclaire. *H. P. Sinclaire, Jr., Glassmaker: Volume I - The Years Before 1920.* (Garden City, NY: Farrar Books, 1974.)

Farrar, Estelle Sinclaire. *H. P. Sinclaire, Jr., Glassmaker: Volume II - The Manufacturing Years.* (Garden City, NY: Farrar Books, 1975.)

Fauster, Carl U. *Libbey Glass Since 1818 Pictorial History & Collector's Guide.* (Toledo, OH: Len Beach Press, 1979.)

Feller, John Quentin. *Dorflinger: America's Finest Glass—1852–1921.* (Marietta, OH: Antique Publications, 1988.)

Felt, Tom. *H. C. Fry in the 1920's—Ovenware, Art Glass & More, 1917–1933 (with circa 1921 catalog reprint), #86.* (Weston, WV: West Virginia Museum of American Glass, Ltd., 2009.)

Felt, Tom. *T. G. Hawkes & Co.—Cut Glass, 1880–1962: Patents, Advertisements, Reprints of a ca. 1960 Catalog. #73.* (Weston, WV: West Virginia Museum of American Glass, Ltd., 2007.)

Florence, Gene. *Stemware Identification Featuring Cordials with Values—1920s–1960s.* (Paducah, KY: Collector Books, 1997.)

Frost, Marion and Sandra. *The Essence of Pairpoint—Fine Glassware 1918–1938.* (Atglen, PA: Schiffer Publishing Ltd., 2001.)

Gable, Carl I. *Murano Magic: Complete Guide to Venetian Glass, Its History and Artists.* (Atglen, PA: Schiffer Publishing Ltd., 2004.)

Gallagher, Jerry. *A Handbook of Old Morgantown Glass—Volume I: A Guide to Identification and Shape.* (Manassas, VA: Old Morgantown Glass Collectors Guild/Payne Publishing, 2001.)

Gardner, Paul V. *The Glass of Frederick Carder.* (New York, NY: Crown Publishers Inc., 1971.)

Garrison, Myrna and Bob. *Imperial's Boudoir, Etcetera: A Comprehensive Look at Dresser Accessories for Irice & Others.* (Arlington, TX: Collector's Loot, 1996.)

Goshe, Ed, Ruth Hemminger, and Leslie Piña. *Depression Era Stems & Tableware: Tiffin.* (Atglen, PA: Schiffer Publishing Ltd., 1998.)

H. C. Fry Glass Society. *The Collector's Encyclopedia of Fry Glassware.* (Paducah, KY: Collector Books, 1990.)

Hammond, Dorothy. *Confusing Collectibles—A Guide to the Identification of Contemporary Objects.* (Des Moines, IA: Wallace Homestead Book Company, 1979.)

Heacock, Wiliam. *Collecting Glass, Volume 2.* (Marietta OH: Richardson Printing Corporation, 1985.)

Selected Bibliography

Hejdová, Dagmar, Olga Drahtová, Jarmila Brožová, and Alena Adlerová. *Czechoslovakian Glass 1350–1980.* (New York, NY: Dover Publications, 1981.)

Jones North, Jacquelyne. *Czechoslovakian Perfume Bottles and Boudoir Accessories.* (Marietta, OH: Antique Publications, 1990.)

Kovar, Lorraine. *Westmoreland Glass Volume 3 1888–1940.* (Marietta, OH: The Glass Press Inc., 1997.)

Lafferty, James R. Sr. *Pearl Art Glass Fova.* (Printed by the Authors, 1967.)

Leach, Ken. *Perfume Presentation: 100 Years of Artistry.* (Toronto, CA: Kres Publishing Inc., 1997.)

Linn, Alan. *The Fenton Story of Glass Making.* (Williamstown, WV: The Fenton Art Glass Company, 1969.)

Luther, Louise. *Miller's Art Glass: How to Compare and Value.* (London, UK: Octopus Publishing Group, Ltd., 2002.)

Measell, James. *Imperial Glass Encyclopedia: Vol. 1: A–Cane; Vol. 2: Cape Cod–L; Vol. 3: M–Z.* (National Imperial Glass Collector's Society, 1995.)

Meschi, Edward J. *Durand—The Man and His Glass.* (Marietta, GA: The Glass Press Inc., 1998.)

Museum of American Glass. *Vanity Vessels: The Story of the American Perfume Bottle.* (Millville, NJ: Museum of American Glass, 1999.)

Museum of the City of New York. *Scents of Time: Reflections of Fragrance and Society.* (New York, NY: Fragrance Foundation, 1987.)

National Cambridge Collectors, Inc. *Colors in Cambridge Glass II - Identification and Value Guide.* (Paducah, KY: Collector Books, 2007.)

Page, Bob, and Dale Frederiksen. *Tiffin Is Forever - A Stemware Identification Guide.* (Greensboro, NC: Replacements, Ltd., 1994.)

Palmer, Lori and Michael. "Fenton Vanity Items through the Years with a Special Concentration on DeVilbiss." http://www.glasshousenc.com/charleton18sep/devilbiss1.html

Piña, Leslie. *Archimede Seguso: Mid-modern Glass from Murano: Lace & Stone.* (Atglen, PA: Schiffer Publishing Ltd., 2007.)

Piña, Leslie. *Italian Glass Century 20.* (Atglen, PA: Schiffer Publishing Ltd., 2003.)

Piña, Leslie, & Jerry Gallagher. *Tiffin Glass: 1914–1940.* (Atglen, PA: Schiffer Publishing Ltd., 1996.)

Piña, Leslie, & Paula Ockner. *Depression Era Art Deco Glass.* (Atglen, PA: Schiffer Publishing Ltd., 1999.)

Revi, Albert Cristian. *American Art Nouveau Glass.* (Nashville, TN: Thomas Nelson Publishers, 1975.)

Schmidt, Tim. *Central Glass Works: The Depression Era.* (Atglen, PA: Schiffer Publishing Ltd., 2004.)

Six, Dean. *Lotus Depression Glass & Far Beyond.* (Atglen, PA: Schiffer Publishing Ltd., 2005.)

Smith, Bill and Phyllis. *Cambridge Glass—1927–1929.* (Springfield, OH: Printed by the Authors, 1986.)

Snyder, Jeffrey B. *Morgantown Glass: From Depression Glass Through the 1960s.* (Atglen, PA: Schiffer Publishing Ltd., 1998.)

Spillman, Jane. *The American Cut Glass Industry - T. G. Hawkes and His Competitors.* (Corning, NY: Corning Museum of Glass, 1996.)

Swan, Martha Louise. *American Cut and Engraved Glass of the Brilliant Period in Historical Perspective.* (Radnor, PA: Wallace-Homestead Book Company, 1986.)

Taylor, Gay LeCleire. *Glass Threads: Tiffany, Quezal, Imperial and Durand.* (Millville, NJ: Museum of American Glass at Wheaton Village, 2004.)

Tiffin Glass Collectors Club. *U.S. Glass Company Decorated Satin Glass and Lamps of the 1920s.* (Atglen, PA: Schiffer Publishing Ltd., 2004.)

Truitt, R. & D. *Mary Gregory Glassware: 1880–1990.* (Rockville, MD: Beach Brothers Printing Inc., 1992.)

Truitt, Robert & Deborah. *Collectible Bohemian Glass 1880–1940, Volume I.* (Kensington, MD: B & D Glass, 1995.)

Truitt, Robert & Deborah. *Collectible Bohemian Glass 1915–1945, Volume II.* (Kensington, MD: B & D Glass, 1998.)

Weatherman, Hazel Marie. *Colored Glassware of the Depression Era 2.* (Ozark, MO: Weatherman Glassbooks, 1974.)

Weatherman, Hazel Marie. *Fostoria—Its First Fifty Years.* (Springfield, MO: The Weathermans, 1985.)

West Wilson, Charles. *Westmoreland Glass—Identification & Value Guide.* (Paducah, KY: Collector Books, 1996.)

Western Carolina University. *DeVilbiss Perfumizers & Perfume Lights: The Harvey K. Littleton Collection.* (Asheville, NC: Biltmore Press, 1985.)

Whitmyer, Margaret & Kenn. *Fenton Art Glass Colors and Hand-Decorated Patterns 1939–1980.* (Paducah, KY: Collector Books, 2005.)

Index

International Perfume Bottle Association

 The International Perfume Bottle Association (IPBA) is the international organization for perfume bottle collectors. It was founded in 1987 and comprises almost 2,000 members, from the United States, Canada, Europe, and around the world. IPBA holds an excellent annual convention each year in May, which attracts hundreds of collectors and dealers. It features a Perfume Bottle Show, Perfume Bottle Auction, Collectors' Market, and numerous workshops and presentations related to collecting. It is a not-to-be-missed opportunity to learn about the field, make wonderful new friends who share an interest, and expand a collection. Membership is available on the organization's website, at www.perfumebottles.org.

 Separate documentation and more DeVilbiss information also can be found at www.devilbisscollectors.com.

Fin... Finis... The End

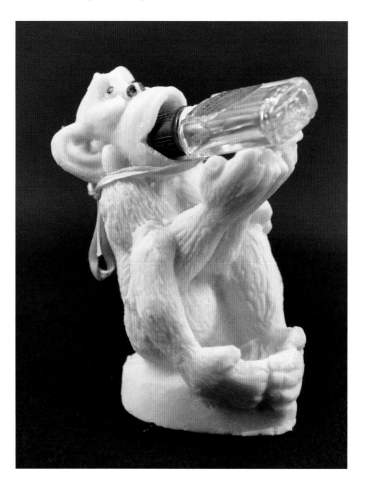